JOHN POPE-HENNESSY
ESSAYS ON
ITALIAN SCULPTURE
PHAIDON

JOHN POPE-HENNESSY

ESSAYS ON ITALIAN SCULPTURE

WITH 248 ILLUSTRATIONS

PHAIDON

LONDON · NEW YORK

SBN 7148 1327 3

MADE IN GREAT BRITAIN
PLATES PRINTED BY R. & R. CLARK LTD · EDINBURGH
PRINTED BY WESTERN PRINTING SERVICES LTD · BRISTOL

Contents

Foreword

ART history is a vocation, not a profession in the conventional sense. I embraced it at thirteen, when I bought Crowe and Cavalcaselle's *History of Painting in North Italy* in Washington during the Christmas holidays, and for five years thereafter such prizes as I won at school were books about Italian painting: first, volume by volume, Crowe and Cavalcaselle's *History of Painting in Italy* and then Berenson's *Study and Criticism of Italian Art.* At the time this interest was an eccentric one. The term 'art-historian' was not yet in common use, and it was generally explained that I was destined to be a *Kunstforscher*. For better or worse there were no facilities in England for training in *Kunstforschung*, and in the absence of the academic curriculum of lectures and seminars I was compelled to look and read and think.

The distinction between the autodidact and the trained art-historian is more fundamental than it may appear. The indoctrinated art-historian is trained to teach. From a comparatively early stage he is expected to have a working knowledge of the literature of great artists and a grasp of the methods by which they were studied in the past, and his prospects of professional success are in the ratio of his academic armament. The self-trained art-historian, on the other hand, forges his own weapons. Establishing a bridgehead in some subject, he develops outwards as taste and opportunity dictate. In my own case the bridgehead was at Siena, and at first I operated on what seems in retrospect to have been a dangerously narrow front. One reason for this was that I was conscious (as were most people who embarked on academic study in the years immediately before the war) that time was short. What mattered was to achieve results.

This concentration may have been excessive, but it produced two monographs. When the first, on Giovanni di Paolo, was in the press, I wished to leave Siena, but I was dissuaded from doing so, and instead, in 1939, I completed a volume on Sassetta. I had never up to this time looked seriously at sculpture and I was woefully ignorant of the Seicento, but when, at a late stage in the war, I was invited to take part in the cataloguing of the drawings in the Royal Library at Windsor Castle, I chose the drawings of Domenichino. The choice was dictated by the considerations, first that the painter was stylistically congenial—if one cohabits with an artist for a long period of time the importance of compatibility cannot be overstressed—and second

vii

that the corpus of Domenichino drawings in the Royal Collection was so large that one could hope to reconstruct his creative machinery almost in its entirety. The experience of this work confirmed me in a belief that I already held, that the art-historian's legitimate concern is with the creative process and that no display of learning, no intellectual sleight-of-hand is of avail if the creative process has not been understood. After the war I spent two barren years working on a monograph on Matteo di Giovanni, but the focus of my interests had changed, and the unpublished manuscript lies in my desk. Instead there appeared commissioned volumes on Paolo Uccello and Fra Angelico, and the first timid contributions to the study of Italian sculpture that are reprinted in this book. They were timid because the study of Italian sculpture was less highly developed than the study of Italian painting, and it was some years before I felt confident enough to start work, first on a large-scale introduction to Italian sculpture, and then on the catalogue of Italian sculptures in the Victoria and Albert Museum.

This is the background of the present book. The essays in it fall into three types. The first comprises four Museum Monographs issued by the Victoria and Albert Museum, which were written in an attempt to show how much and in what way an art-historical approach can contribute to the appreciation of sculptures as works of art. The second type of essay is factual, in that the work discussed can be explained by documents or inventory references; the articles on Calcagni, Sirigatti and Fanelli are of this class. The third group depends on analysis of style through the unaided observation of the eye. What is involved here is not proof in a judicial sense, but degrees of probability. To the end of time a little band of zealots will continue to believe that the Martelli David was carved by Donatello and the Palestrina Pieta by Michelangelo, and I cannot claim to have done more than chip away a few of the assumptions on which these mistaken judgments rest. Some of the articles reprinted here were addressed to a specialised and some to a non-specialised audience, but it is my hope that the difference between them may not in practice prove very great. I deplore the art-historian's habit of sheltering in a covert of footnotes; his findings are best promulgated in a form that enables the ordinary reader to follow and if necessary to reject his arguments.

Though art-historians, like other people, cherish the illusion of free will, their course is set by forces external to themselves; they are controlled by guardians like those in Eliot's *Cocktail Party*. A concern with attributions was instilled in me by early visits with Evelyn Vavalà to the Accademia in Florence, where one learned to distinguish the chubby children of one

artist from the chubby children of another. At Assisi I was admitted by Perkins to the sodality of students of Sienese painting. My books about Italian sculpture grew from seeds sown by Jenö Lanyi before the war, and my interest in small bronzes goes back to lunch-time conversations with Saxl about Riccio's works at Padua. One of my most vivid memories is of reading for the first time at Oxford that paragon of imaginative criticism, Offner's *Italian Primitives at Yale University*. From the perspective of today it seems to me that I owe more to the constructive discouragement of Offner than to the encouragement of other scholars, with the exception of Berenson, to whom my debt is greater still, and whose work is discussed in a review reprinted in this book. This and the essay on Michelangelo's letters first appeared in *The Times Literary Supplement*, and are reproduced by permission of the editor. I am indebted to the editor of the *Burlington Magazine* for authority to reprint ten of the other articles.

June 1967 JOHN POPE-HENNESSY

ESSAYS ON ITALIAN SCULPTURE

New Works by Giovanni Pisano—I

FROM time to time our knowledge of the great Italian sculptors is enriched by the addition of new works, but very seldom are they of the quality of the bust of a Prophet by Giovanni Pisano (Fig. 1), which has recently been purchased for the Victoria and Albert Museum with the aid of a Special Grant from the Exchequer and with the assistance of the National Art-Collections Fund.[1] Strictly speaking the term 'bust' is a misnomer, for the figure terminates at the base in an irregular break through the left elbow, and evidently formed the upper part of a full-length, life-size statue. The only sculptures executed by the artist on this scale are the figures from the façade of the Cathedral at Siena, on which he was engaged between 1284 and his unexplained departure from Siena in 1296,[2] and it requires no close examination to establish that the bust is in fact part of one of the two missing statues.

The twelve statues from the first register of the façade, which are now shown in the Museo dell'Opera del Duomo at Siena, vary in structure, scale and size, but the measurements tally at many points with those of the new Prophet. The height of the head corresponds with that of the *Isaiah*, and the width, measured across the shoulders, is 5 cm. less. The depth, measured from the back of the block to the front plane, is 41 cm.; the depth of a comparable figure at Siena, the *Mary sister of Moses*, is 49 cm. Most of the Siena figures are hollowed out behind from a point below the shoulder blades, but one, the *Sibyl*, is carved fully in the round, and another, the *Balaam*, is in the round save for a narrow excavated area on the right. The back of the new figure is broken diagonally beneath the shoulders, but between these fractures the marble seems to have been cut away.

In one respect the new bust differs from the statues in the Museo dell'Opera del Duomo, that the head is separated from the body. The reason for their separation can be established from the Siena statues. The defective condition of the marble of the statues seems to have caused difficulty from comparatively early times; in three cases only is the whole statue, from head to feet, preserved.[3] One of the most damaged of the figures, the *Balaam*, may have been restored as early as the sixteenth century,[4] and another, the *Aristotle*, was supplied in the eighteenth century with a new head.[5] The most thoroughgoing piece of restoration undertaken in the last century was

1

that of the statue, now in storage, which till a few years ago occupied the place destined for *Haggai* (Fig. 3). In what are probably the earliest of the statues, the *Joshua* and *Balaam*,[6] the fractures in the marble are predominantly vertical, but elsewhere the block tended to split horizontally. Thus in the *Mary sister of Moses* (Fig. 2) incipient horizontal fractures can be followed round the figure below the level of the shoulders and on the crown of the head. The replacement of the head of *Aristotle* seems to have been necessitated by a horizontal fracture through the neck. In the case of all those figures of which the lower parts date from the nineteenth century the body was cut horizontally, and when that was done the weathered edge of the part that was original tended to crumble in precisely the same fashion as the collar of the present bust. Perhaps the head and shoulders were separated in the nineteenth century to avoid the risk of damage when the figure was removed from the façade. The continuity of chiselling at the back leaves no doubt that they were originally one.

There is no evidence as to the date at which the statue was taken down.[7] A campaign of restoration was initiated by the sculptor Manetti in 1836, and the rate of work seems to have been speeded up after the appointment of a supervisory commission in 1867. The head, though weathered, is much better preserved than the heads of the statues at Siena, and it is likely that the figure was removed by the middle of the nineteenth century. At Siena the definition of the forms is blunter, and much of the detail has been effaced. But the scooping-out of the top of the nose of the new Prophet is found again in the *Simeon* and the *David*, the form of the eyes is closely similar to those of the much damaged *Plato*, and the folds of skin beneath the eye-sockets are repeated in the *Simeon*. The Siena statues also offer exact analogies for the technical devices used in the new bust. To take no more than two points, the drilling in the fringe of the robe is indistinguishable from the drilling in those parts of the robe of Moses that were not made up in the nineteenth century, and a particularly telling comparison can be made between the hand, where the bases of the third and fourth fingers are connected by a web of marble, and the hand of the *Sibyl*, which is treated in precisely the same way.

It remains to determine what Prophet is represented and where the figure stood on the façade. The *Mary of Moses*, the only one of the surviving statues in which the head is thrust forwards as sharply as in the new bust, stood on the south side of the façade and faced towards the west. It might, therefore, be supposed, as a working hypothesis, that the new Prophet stood on the north side of the façade and faced in the same direction.

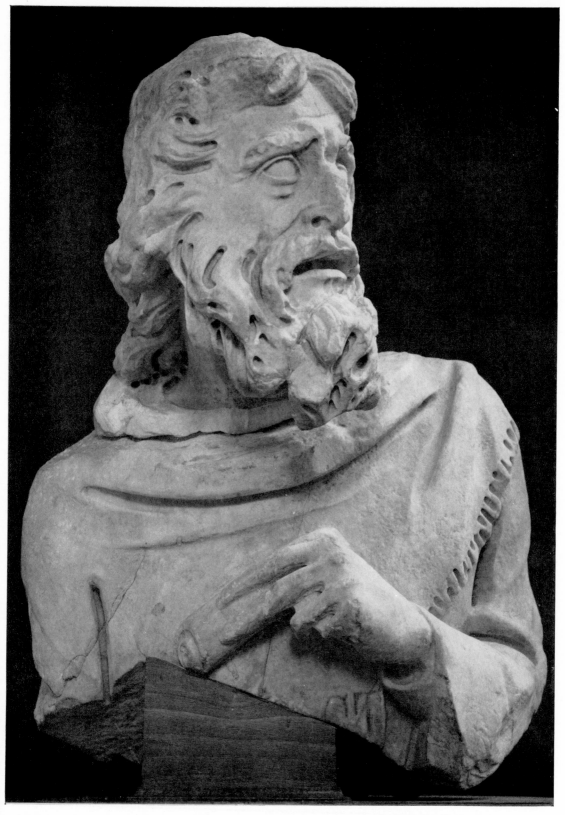

1. Giovanni Pisano: *The Prophet Haggai*. Marble, height 63·8 cm. London, Victoria and Albert Museum

3. Giovanni Pisano (restored): *The Prophet Daniel* (?). Marble. Siena, Magazine of the Opera del Duomo

2. Giovanni Pisano: *Mary, sister of Moses*. Marble. Siena, Museo dell'Opera del Duomo

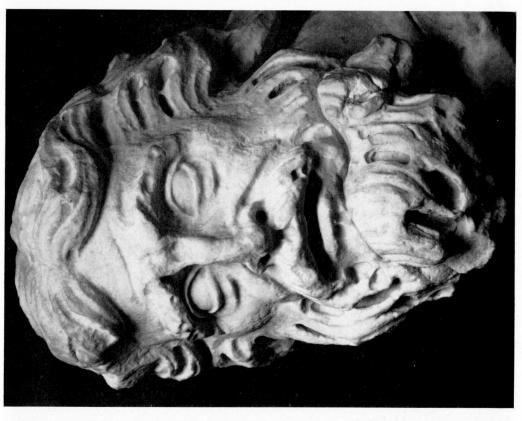

5. Giovanni Pisano: *Head of the Prophet Haggai.* Marble.
London, Victoria and Albert Museum

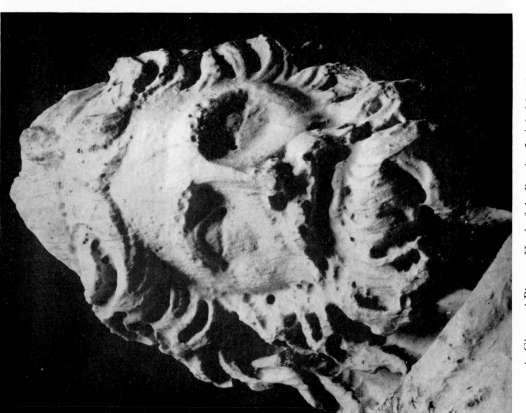

4. Giovanni Pisano: *Head of the Prophet Isaiah.* Marble.
Siena, Museo dell'Opera del Duomo

6. Giovanni Pisano: *The Prophet Haggai*.
Marble. London, Victoria and Albert Museum

7. Giovanni Pisano: *The Prophet Isaiah*. Marble.
Siena, Museo dell'Opera del Duomo

A model analysis of the façade statues by Keller has established that the figures flanking the central entrance, *David* and *Solomon*, and two of the figures on the south end, *Simeon* and *Mary of Moses*, were planned as pairs. The only extant figure from the left-hand entrance, the *Sibyl*, is so posed as to postulate some contact with the missing *Daniel* on the left of the same door. Similarly the new Prophet is shown in colloquy with a figure standing to the right. The statue with which it corresponds most closely is the *Isaiah* (Fig. 7) on the north face. This correspondence is both structural and technical. The figures face towards each other with their inner shoulders raised, and in both the axis of the chest counteracts the movement of the head. The drilled eyebrows (Figs. 4, 5) are common to both statues, as is the hair which recedes sharply from the temple. There is also a remarkable degree of uniformity in the cutting of the moustaches and of the beards, which curl in one case to the right and the other to the left. Arguing solely from these considerations, we might infer that the *Isaiah* and the Prophet formed a pair.

In order to establish that this is really so, it must be shown first that the statue which, till comparatively recently, stood to the left of the *Isaiah* had no right to that position, and second that the present figure stood in its place. During successive restorations many of the figures were removed from the façade, and some were wrongly replaced. Thus the *Habakkuk* usurped the position of the *Daniel*, the *Simeon* from the south end of the façade was installed in the upper register in a place intended for the statue of *St Matthew*, and the *Moses*, which was originally on the left side of the right-hand entrance, was substituted for the *St Mark*.[8] The original distribution of the statues can be established from the names incised behind them on the wall at shoulder height and from the inscriptions on their scrolls, whereby the individual figures can be identified. The name incised behind the statue of *Isaiah* has been renewed, and the name which formerly appeared behind the statue to the left has been eliminated. There is, however, a firm tradition that this, the first figure of the series, showed Haggai, and it has been universally assumed that Haggai is represented in the statue which occupied this place (Fig. 3).[9] The most gravely damaged of the statues, it has suffered from two restorations; in the later the head was sawn off and replaced by the Garibaldian head that we see now, and in the earlier metal clamps were inserted in the left arm, and the right arm and left hand were renewed. Probably the statue was already much mutilated at this time, for the scroll and its inscription were not reproduced and instead a rolled-up scroll was placed in the left hand. There is thus no basis, other than the

accident of its position, for identifying it as the *Haggai*. The statue with which it corresponds most nearly is the *Sibyl*, and on formal grounds it might more readily be looked upon as a companion to this figure than as a pair to the *Isaiah*.

On two statues, the *Solomon* and *Moses*, the scrolls have been recarved or replaced. The remaining inscriptions seem not to have been tampered with, and that of the *Sibyl* offers exact analogies for the E and T on the scroll held by the new Prophet. The epigraphy of the inscriptions is not uniform, and the height of the letters on the scrolls naturally varies in the ratio of the length of the inscription. In the *Habakkuk*, where the inscription is short, it measures 8.5 cm., while in the *Plato*, where the inscription is long, it measures 5.6 cm. The width of the letters is in turn proportionate to the height, so that in the vertical scroll held by the *Habakkuk* each line contains six letters, and in the vertical scroll held by the *Plato* each line contains eight. The height of the letters on the scroll held by the new Prophet is 4.2 cm., so it is likely that they were preceded by six other letters. Both Keller[10] and Lusini,[11] whose *Duomo di Siena* remains a fundamental source-book for the study of Sienese art and who seems to have had access to sources that are now untraced, record the inscriptions on the scrolls of the two missing figures. The legend of one was drawn from Daniel ix, 26, and read: '*Et post hebdomadas sexaginta duas occidetur Christus; non erit eius populus qui negaturus est.*' The legend of the other was drawn from Haggai ii, 8, and read: '*Et veniet desideratus cunctis gentibus; et implebo domum istam gloria.*' The first of these inscriptions cannot be reconciled with the scroll of the new Prophet, but the second conforms to the prescribed conditions and enables the figure to be identified confidently as *Haggai*.

One of the pairs of statues on the façade, the *Moses* and *Joshua*, consists of figures which were manifestly carved at different dates. Where the *Joshua* recalls the antecedent half-length figures on the Pisa baptistery, the *Moses* is a work in the same style as the *Isaiah*.[12] Two other pairs are homogeneous, the *Simeon* and *Mary of Moses*, which look forward to the style of the Pistoia pulpit and must belong to the last years of the sculptor's work on the façade and the *David* and *Solomon*, which belong conjecturally to a middle phase.[13] The *Haggai* and *Isaiah* are stylistically homogeneous in this sense, but the discrepancy in their conditions raises certain points which should be ventilated briefly here. With the *Isaiah*, as with so many damaged statues, the artist's intentions are debatable, but in the better-preserved *Haggai* they can be clearly read. They permit one general conclusion which is applicable to the cycle as a whole, that in accounts of the Siena statues undue emphasis

has been placed on analogies with Northern Gothic sculpture and insuffi-
cient weight as been attached to the influence of the antique. It has been
argued by Papini[14] that the relief style of the Pistoia and Pisa pulpits is
explicable only in the light of a careful study of sarcophagus reliefs. The
artistic intelligence behind them was undoubtedly different in kind from the
less elevated imitative faculty which dictated the reliefs of the pulpit in the
Pisa baptistery. This argument can be reinforced from the *Haggai*, where
the head in full-face (Fig. 5) reads like a thirteenth-century *Laocoön*. Where
Keller's apt comparison of the head of the *Isaiah* (Fig. 4) to an antique faun
may in the present condition of the statue appear fanciful, the Hellenistic
basis of the new figure is in no doubt. It is revealed in the rhythmical treat-
ment of the hair seen from the side (Fig. 6)—we need look no further than
the battle sarcophagus from the Vigna Amendola in the Capitoline Museum
to establish the kind of model that the sculptor must have known; it is
revealed in the treatment of the beard, where the drill holes are linked in
continuous incisions which have the character of brushstrokes in a painted
head—a figure on the extreme left of the marine sarcophagus in the Museo
dell'Opera del Duomo at Siena may have inspired this device; and it is
revealed above all in the human expressiveness of the whole countenance.
When all fourteen figures were in this condition, when the drilling in the
eyebrows was still fresh and the eyelids were still sharp, when the noses
were undamaged and the beards were still intact, any attempt to equate
them with the bland statuary of Rheims would have seemed inadmissible,
and it would have been abundantly apparent that their author was the first
sculptor to look at the antique with the eyes of a Renaissance artist.

Originally published in *The Burlington Magazine*, cv, December 1963.

New Works by Giovanni Pisano—II

IN the little group of Italian ivories shown in a wall-case in Room 22 of the Victoria and Albert Museum, one work is markedly more individual than the rest. It shows the Crucified Christ[1] (Fig. 8), and though it has been mutilated—the arms are missing and the legs have been broken just below the knees—it impresses us by virtue of its quite unusual emotional intensity. The powerful spell it exercises is due partly to its structure—the head is turned over the right shoulder and is balanced beneath by the contrary axis of the legs—partly to its technique—the tresses of hair are undercut and the loin-cloth falls away from the emaciated body in rich folds—and partly to the quality of imagination that is apparent in the closed eyes, the open lips and the smooth plane of the cheek.

Considering its merits, it is surprising that this figure has not been more generally discussed. It was bought for the Museum in 1867, for the small sum of £15, and nine years later it was described by Maskell, the great Victorian authority on medieval ivory carvings. 'The figure', observed Maskell,[2] 'is represented after death; but the still suffering expression of the drooping head, the strained muscles across the breast showing the ribs, and, as it were, the struggle of the legs contracted in the last agony, are admirably given. The eyes are closed, the forehead drawn with pain, the mouth open. The body is clothed with a garment crossed in white folds over the loins and falling to the knees. It is greatly to be regretted that this beautiful figure has been so mutilated. The conception of the artist is full of true feeling and devotion, and his treatment of the subject an excellent example of the right union of conventionality with enough of what is real.' Maskell's later volume, *Ivories*, includes a small reproduction of the figure, and in the text it is again singled out for praise.[3] In neither book is its source or date indicated. By the nineteen-twenties the Christ was regarded as Italian, and there is a perfunctory reference to it as an Italian work in Koechlin's *Ivoires Gothiques Français*.[4] It is described as Italian in Miss Margaret Longhurst's catalogue of the ivories in the Museum, with the gloss that 'a boxwood figure in the Kaiser Friedrich Museum at Berlin is closely similar in style; a larger wooden figure of the same period in the Opera del Duomo at Siena may also be compared'. There is no reference in the entry to the possibility that the Crucified Christ was carved at Pisa, but already in 1911

the boxwood in Berlin was classified as Style of Giovanni Pisano[5] and the connection of the Siena Crucifix (Fig. 9) with Giovanni Pisano was also generally recognised.[6]

What we know about Giovanni Pisano's treatment of the theme of the Crucified Christ derives from two marble Crucifixion reliefs, on the pulpits at Sant'Andrea at Pistoia (Fig. 11) and in Pisa Cathedral, and from two painted wooden Crucifixes, one in Sant'Andrea at Pistoia (Fig. 10) and the other in the Museo dell'Opera del Duomo at Siena.[7] In the Siena Crucifix the head and hair are disposed essentially in the same way as in the ivory. Whereas in the Pistoia Crucifix and in the relief on the Pistoia pulpit, the knees are turned in the same direction as the head, that is to the spectator's left, at Siena they are turned in the opposite direction, and in this respect too the Siena Crucifix links up with the ivory Christ. Presumably the two arms of the ivory were carved separately from the torso. The treatment of the arm-pits and of the musculature at the front and back shows that they were raised, but that the angle was less extreme than in either of the wooden Crucifixes. It is likely that the arms projected at roughly the same angle as those of the Christ in the Crucifixion relief on the Pistoia pulpit, and that the hands were originally somewhat above the level of the head. In any case, the type of Crucified Christ represented in the Pistoia and Siena Crucifixes is personal to Giovanni Pisano and seems not to have been imitated in other localities or by other artists,[8] and the ivory Christ closely conforms to it.

In some respects indeed the affinities that the ivory figure presents to Giovanni Pisano's authenticated marble sculptures are considerably closer than those presented by the two wood carvings. If, for example, we compare it with the male figure that serves as a support for one of the pillars of the Pistoia pulpit (Fig. 15), the resemblance is too marked to be easily dismissed. It is not merely a matter of articulation, though the angle and treatment of the head are strikingly similar in both, but extends to the conventions that are used to define the forms. In both cases the area of the forehead above the eye socket is carved essentially in the same fashion, and in both cases the point of juncture of the ribs is marked by a succession of short horizontal declivities. The delineation of the hair as a plastic mass faced with long furrows is uniform. In the marble figure the drapery across the waist hangs away from the figure in such a way as to establish what can only have been a conscious contrast between the emaciated body and the full forms of the folds, and in the Christ the section below the hips is treated in the same way.

Two of the most illuminating views of the ivory Christ are from the sides (Fig. 13). The neck protrudes from the body at an angle of forty-five degrees, so that the face is in a forward plane. In this it recalls the great figures from the façade of Siena Cathedral, where the same device is used, and we may guess despite the difference of scale that it was employed in the ivory Christ for the same reason, that the figure was intended to be looked at from below. At the sides the loin-cloth is resolved in heavy vertical folds, which are accompanied on the left side by a pattern of diagonal folds extending from hip to knee. This emphatic combination of vertical and diagonal folds recurs in another work by Giovanni Pisano, the marble statuette of the Virgin and Child which stands over the altar of the Cappella della Cintola of Prato Cathedral[9] (Fig. 12). There is only one nude male figure by Giovanni Pisano, the Hercules on the pulpit in Pisa Cathedral,[10] and its modelling is so singular that if the ivory were really by Giovanni Pisano, we might expect the same forms to be reproduced. In the Hercules the abdomen is represented as an arch on the front of the body, and the rib cage is so contracted that from the sides it reads almost as a triangle. At the back the spine is shown as a deep runnel with dents above the pelvis and below the shoulder blades (Fig. 16). In the ivory the form of the abdomen is exactly similar; in the view in left profile the rib cage is marked by parallel lines arranged triangularly, while on the back (Fig. 14) the vertical runnel down the spine and the declivities beneath the waist and shoulder blades occur again. Even were there no other evidence, it would seem highly unlikely that the bodies were carved by different hands. And the case becomes still stronger when it is recalled that Giovanni Pisano did on one occasion carve in ivory.

We know that he did so because in a document of June 1298 he was instructed by the Opera del Duomo in Pisa to complete a work in ivory ('opus eburneum') by the following Christmas on pain of a substantial fine.[11] The categorical terms in which the caution is couched and the scale of the fine leave no doubt that this was a work of considerable consequence. Its importance is confirmed by the inventories of the Cathedral. It is mentioned in 1369 as a 'tabulam unam eburneam ab altari maiori cum ymaginibus' (an ivory table with statuettes, from the high altar)[12] and is described in 1433.[13] According to the later entry it consisted of a number of pieces and had a tabernacle in the centre with the Virgin and Child with two Angels with metal wings. These three figures were carved in ivory. There were also two Passion scenes in ivory. The work was repaired at this time and again in 1452. At the end of the sixteenth century there was a fire in

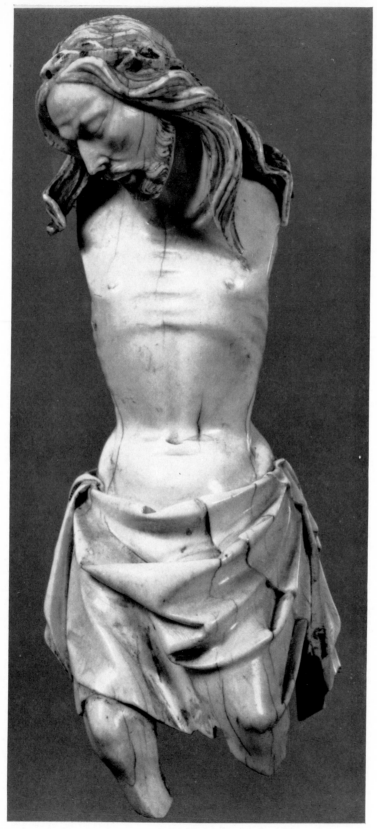

8. Giovanni Pisano: *Crucified Christ*. Ivory, height 15·2 cm.
London, Victoria and Albert Museum

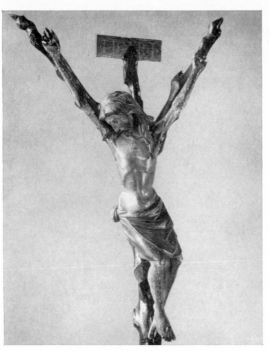

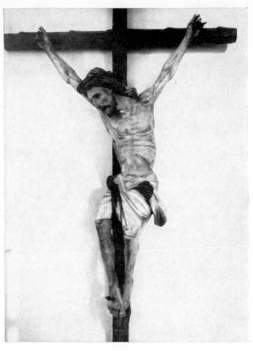

9. Giovanni Pisano: *Crucifix*. Pigmented wood. Siena, Museo dell'Opera del Duomo

10. Giovanni Pisano: *Crucifix*. Pigmented wood. Pistoia, Sant'Andrea

11. Giovanni Pisano: *Pulpit*. Marble. Pistoia, Sant'Andrea

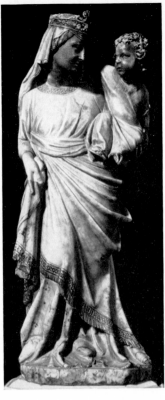

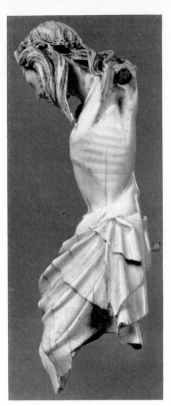

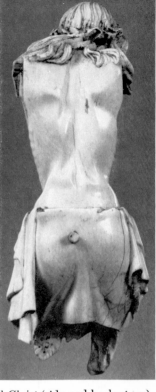

12. Giovanni Pisano: *Virgin and Child*. Marble. Prato, Duomo

13-14. Giovanni Pisano: *Crucified Christ* (side and back views). Ivory. London, Victoria and Albert Museum

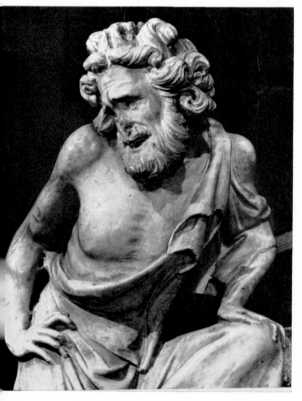

15. Giovanni Pisano: *Support of Pulpit*, Marble. Pistoia, Sant'Andrea

16. After Giovanni Pisano: Plaster cast of the figure of Hercules on the Pulpit in Pisa Cathedral

17. Giovanni Pisano: *Virgin and Child*. Ivory.
Pisa, Museo dell'Opera del Duomo

the Cathedral, but 'una Madonna d'avorio con dua figure simili guaste con tavola' (that is, the Virgin and Child with the two Angels but not the Passion scenes) seem to have survived, albeit in a mutilated state. Another reference, a few years later, describes the Virgin and Angels as broken, and in 1634 the Virgin and Child alone were repaired; the head and right arm and one foot of the Child were renewed, as well as the Virgin's right hand and part of the drapery.[14] In this form Giovanni Pisano's Virgin and Child survives in the Opera of the Cathedral today (Fig. 17).

Of course it does not follow that the ivory Virgin and Child and the ivory Christ were necessarily part of one commission. But the facts make it easier to believe that this was so than to believe the contrary. All the analogies for the figure in Giovanni Pisano's work can be localised at about the time of the carving of the Virgin and Child, that is, about 1300. Work on the Siena statues, which supply a parallel for the structure of the head, was suspended in 1296, the pulpit at Pistoia was completed in 1301, and the wooden Crucifix in the same church seems to have been carved at the same time. On general grounds, therefore, a dating about 1300 for the Crucified Christ is inescapable. So we must assume either that the Christ formed part of the ivory complex for the high altar of Pisa Cathedral or that it was an independent commission of about the same time.

The source of inspiration of the ivory Virgin and Child at Pisa, as of so much else in Giovanni Pisano's work, is French; it has been connected, quite correctly, with a statue of the Virgin in the north transept of Nôtre Dame.[15] But it is considerably larger (height 20½ in.) than the generality of French ivory statuettes. Indeed, of the statuettes that are reputedly of French origin, the seated Virgin at Villeneuve-lès-Avignon, a standing Virgin and Child in the Heugel collection and a similar group at Toledo are some of the few that are planned on the same scale.[16] One of the few cases in which a French ivory group is accompanied by ivory statuettes of angels is the Coronation of the Virgin in the Louvre, where the lateral angels are about half the size of the main figures.[17] It may well be that in the tabernacle on the high altar of Pisa Cathedral the same ratio between the figures was preserved. If this were so, their scale would have been approximately the same as that of the Crucified Christ. Several French ivory reliefs are known in which a Virgin and Child flanked by angels in the lower part is accompanied by a scene from the Crucifixion above,[18] and it is perfectly conceivable that the Christ was isolated above the tabernacle. But the inventory description of 1433 does not mention any such figure. On the other hand it refers specifically to two Passion scenes. Moreover, one figure from the

Passion scenes is said to have been missing, and from that we can deduce that they probably consisted not of reliefs but statuettes. One of the best known French Gothic ivories is a group of three statuettes in the Louvre, which originally formed part of a Deposition scene.[19] So it is possible that one of the Passion scenes from the Pisa tabernacle represented the Crucifixion, and that the Crucified Christ is the only piece from it to survive. But all this is, and is likely to remain, mere speculation, and it must be distinguished clearly from the area of fact, that in this richly imaginative figure we have the second ivory carving by Giovanni Pisano.

Originally published in the *Bulletin of the Victoria and Albert Museum, I,* July, 1965

The Arca of St Dominic: A Hypothesis

OUTSTANDING among the examples of Italian Gothic sculpture in the Victoria and Albert Museum are two figures of the *Archangels Michael*[1] and *Gabriel*[2] (Figs. 18 and 20), which were acquired for the Museum in 1859. The figures were bought in Florence, along with two groups representing the *Writers of the Canonical Epistles*[3] and the *Symbols of the Evangelists*.[4] At the time of purchase it was presumed that all four pieces formed part of a single pulpit, and Robinson,[5] writing in 1862, records the tradition that 'these fragments came from a church in the neighbourhood of Pisa, and the original position, in work, of the three angle-piers may be seen from a photograph, placed near them, of the celebrated pulpit by Nicola Pisano in the baptistery of the cathedral at Pisa, corresponding details of which they closely resemble'. The view that all four pieces originated from a single pulpit remained unchallenged till 1911, when Graber[6] pointed out that discrepancies in handling and differences in the marble used in the two sets of figures were such as to rule out this hypothesis. The form of the figures was also difficult to reconcile with the view that they came from a single pulpit, since in each case one piece (the *Archangel Gabriel* and the *Writers of the Canonical Epistles*) clearly filled an angle of the complex, while the other (the *Archangel Michael* and the *Symbols of the Evangelists*) seemed to have been set flat, and must have occupied a central position. When, therefore, in 1932, a new catalogue was issued of the sculpture at South Kensington,[7] it was assumed that the fragments originated from two separate pulpits, one of them an orthodox rectangular pulpit of the type of that in San Giovanni Fuorcivitas at Pistoia, in which the *Symbols of the Evangelists* would have occupied a central, and the *Writers of the Canonical Epistles* a corner place, and the other a similar pulpit, in which the *Archangels Michael* and *Gabriel* would have been set in exactly the same way. In so far as the two groups were concerned, this explanation was satisfactory, the more so that they were manifestly related to, and were probably executed by, the author of the pulpit at Pistoia, Fra Guglielmo. What indeed could be more plausible than the theory that there had existed in 'a church in the neighbourhood of Pisa' a small rectangular pulpit, of secondary quality, of which these groups formed part? But in so

11

far as it applied to the *Michael* and *Gabriel,* the explanation raised more difficulties than it solved.

These difficulties were part qualitative and part iconographical. In the first place there is no precedent in any Pisan pulpit for the introduction of archangels in substitution for the customary figures of the evangelists and writers of the Epistles. Were we dealing with a single figure of St Michael, it might be argued that iconographical precedent was set aside, on account of the dedication of the church in which the pulpit stood or for some other cause. But if, as is likely, the corresponding corner to that occupied by the Archangel Gabriel was filled by a figure of the Archangel Raphael, we must assume the existence of a pulpit in which the imagery was totally discordant with the purpose for which the pulpit was designed. Moreover, the treatment of the figures alone renders the theory that they formed part of a pulpit improbable. A passage in the Pseudo-Dionysius associates the priestly form of the angel with its role as a participant in the divine vision,[8] and the practice of representing angels and archangels in priestly costume is not uncommon in the thirteenth and early fourteenth centuries; it is met with, *inter alia*, in the angel symbolising Faith on the Pisa pulpit of Nicola Pisano, and in the angels holding the instruments of the Passion on the Siena pulpit. In painting (for example in the polyptych from the workshop of Giotto at Bologna) St Michael is also sometimes represented in this way. But the impression remains that the presence of three vested figures of archangels, holding objects identified as chainless censers in the current Museum catalogue,[9] would be unusual, and might by itself be indicative of a hieratic context of a rather different kind.

Passing to the qualitative considerations that must ultimately govern our analysis, it can be claimed that whereas the two pulpit groups are of comparatively little interest and may well originate from some dismembered minor work, the two *Archangels* are on a level with the most distinguished sculpture of their time. It is inherently unlikely that works of such high quality derive from some secondary complex of which no other trace survives. The style of the *Archangels* has been referred, initially by Graber,[10] and later by Swarzenski[11] and Maclagan and Longhurst,[12] to the author of the base with three figures of clerics, at one time wrongly connected with a holy-water basin, in the Museo Nazionale at Florence, and this in turn has been ascribed, notably by Swarzenski[13] and Nicco Fasola,[14] to Arnolfo di Cambio, with whom the two figures of *Archangels* have also been tentatively associated.[15] More recently it has been proved, with a fair measure of certainty, by Gnudi[16] that the base in the Bargello and a corresponding

base at Boston, published by Swarzenski,[17] formed two of the supports of the Arca of St Dominic in San Domenico Maggiore at Bologna. The problem of the authorship of the supports is thus inseparable from the problem of the authorship of the sarcophagus.

Let us re-examine the style of the *Archangels* in the light of Gnudi's persuasive analysis. The first fact that emerges clearly from a study of the figures is that they are executed by two different hands. This is apparent in details of execution, as well as in the conception of the heads and drapery. The *St Michael* has the character less of a free-standing figure than of a relief; the figure is restricted to a single plane, the robe is resolved in a number of shallow vertical incisions, and even the feet, resting on the dragon, are flat and decorative. In the *Archangel Gabriel*, on the other hand, the pose of the figure, with left knee and right forearm advanced, is that, not of a relief, but of a statuette; the figure rests firmly on its base, and the cloak is enriched by heavy horizontal folds which lend it a new plasticity. There are corresponding differences in the treatment of the eyes, mouths, and hair of the two figures. When we compare the figures with the attributable sections of the Arca, these differences are explained. Whereas the *St Michael* corresponds closely with the parts of the Arca attributed to Lapo, not only in the flattening of the head, but in mannerisms like the lines incised round the nostrils, the *Archangel Gabriel* is directly related to those parts of the Arca now believed to have been executed by Arnolfo. If, for example, we juxtapose the figure with the Virgin and Child from the centre of the Arca, there can be very little doubt that one sculptor was responsible for the two works, a conclusion that may be endorsed by comparing the head of the *Archangel* with the heads in *The Raising of Napoleone Orsini* and *St Dominic and his Brethren fed by Angels* for which Arnolfo seems to have been responsible. So close is the connection of both figures with the upper section of the Arca that we have clearly to ask ourselves whether they may not be identified as two of the missing caryatids which originally supported the sarcophagus.

The evidence relating to the caryatids is scanty and confused, and the chapter dealing with them is the weakest in Gnudi's otherwise admirable book. One of the presumed bases, that at Boston,[18] comes from Bologna, and in this case arguments from style may be reinforced by arguments from provenance. Nothing is known of the provenance of the Bargello base prior to its appearance with Bardini at the beginning of this century.[19] An examination of surviving Pisan monuments seems to show that the form of these supports, in which the figures are grouped round a central stem,

was invariably employed in the interior, and not on the periphery, of the complexes for which they were designed; the most obvious instance is the central support of the pulpit at Siena, where the figures of the Liberal Arts are conceived as gazing out on all sides of the monument. The contention implied in Gnudi's volume that the Boston and Bargello bases formed the outer supports of the Arca is for this reason most improbable,[20] and the balance of likelihood is in favour of the view that they served as the interior supports of the sarcophagus. What, then, of the outer caryatids? Here our sole source of information is a sentence in the *Uomini illustri domenicani* of Piò,[21] who in 1620 recorded the presence of the caryatids of the Arca in the Capella delle Reliquie in San Domenico. According to this source, the caryatids comprised *dodici Angeli, tre per ogni quadro.* Gnudi,[22] arguing from the analogy of the Arca di San Eustorgio and other monuments, points out correctly that the interval between the figures in the upper section of the Arca was almost certainly repeated below, and that the phrase *tre per ogni quadro* in all probability refers to the presence of three caryatids along the front and back of the monument. If we assume, with Gnudi, that two of these six caryatids were the bases in Florence and Boston, the number twelve and the reference to angels in Piò's description are unintelligible, and the description must be dismissed, in Gnudi's words, as *molto incerta e imprecisa.*[23] But is there not a possibility that Piò's description was literally correct? Replacing the two existing bases beneath the sarcophagus (Fig. 21) and postulating three caryatids along the longer sides, we reach a total of twelve figures. And if, beneath the front, we introduce the two *Archangels* in London and the lost *Raphael*, may it not be that the term *Angeli* employed by Piò was also absolutely accurate?

The hypothesis that the two *Archangels* were designed to serve as caryatids for the Arca explains both the treatment of the figures and the programme of the lower part of the sarcophagus. For St Gregory the archangels mediate between God and man—*qui minima nuntiant, angeli; qui vero summa, archangeli*—and for St Thomas they are *quasi principes angeli, quia respectu Angelorum sunt principes, respectu vero Principatuum sunt angeli.* It is reasonable to suppose that the corresponding caryatids from the back of the Arca were three further figures representing Faith, Hope, and Charity, and that the figure of Faith, no doubt an angel vested like that on the pulpit in the Baptistery at Pisa, would have carried the missal or volume of the gospels, the absence of which is noted by Gnudi from the liturgical implements shown on the inner supports. By a fortunate coincidence there is, in the Louvre, an Angel holding a book (Fig. 19),[24] which

Swarzenski alone has had the good sense to link firmly with the London figures.[25] Supposed in the catalogue to have decorated *l'angle d'un édicule, peut-être d'une chaire,*[26] and regarded by Toesca as the *frammento forse di un pergamo,*[27] this angel must originally have served as one of the corner caryatids at the back of the sarcophagus. How much more noble, how much more appropriate a scheme was this than the *sacra processione ... completata da frati domenicani ploranti, nell'abito dell'ordine, non partecipanti al rito,* postulated in Gnudi's book.[28]

Deductions from style and iconography are valueless if they are not corroborated by the evidence of size and form. Regarding the latter, it may be noted that the base of the *Archangel Gabriel* is similar in shape to the corners of the base of the sarcophagus. Regarding the former, dimensions speak for themselves; the Bargello support the *St Michael,* the *Archangel Gabriel,* and the Louvre *Faith* are respectively 98, 97, 97.5, and 95 centimetres high.

Originally published in *The Burlington Magazine,* xciii, November 1951.

Notes on a Florentine Tomb-front

THE relief illustrated in Fig. 22 was acquired in Florence by Sir J. C. Robinson during the spring of 1882.[1] Composed of eight cusped arches, of which two on the left and three on the right are filled with naturalistic foliage, it carries on the upper border above the spandrels the inscription in Leonine hexameters: VITA PRECLARA. REFVLGEnS NOMInE CLARA. NORMA RECLV-SARm. SPECVLVm SINe TurBInE CLARVm. mCLITA CVnCTARVm xRisti JACET HIC FAMVLARUM. A manuscript list of purchases made by Robinson at this time records it in the following terms:

There can be little doubt that this is the original front of the shrine of Santa Chiara (Saint Clara) which was at the same time the high altar of the church dedicated to the saint at Assisi. The church in question, which still exists, was built in 1253 by Fra Filippo di Campello, and not improbably the frontal is his work. The building has been much modernised, and most likely the present marble frontal was done away with at a comparatively recent period to make room for a more ornate shrine for the body of the saint, which still remains under the present high altar of the church.

This account of the origin of the relief, no doubt based on statements by the vendor eked out by Robinson's own observations, is repeated in the printed inventory of the Museum acquisitions for 1882, where the fanciful attribution to Fra Fillippo da Campello is omitted,[2] and forms the basis of an entry in the catalogue of 1932.[3]

Apparently the front of the original altar of the saint from her church (built in 1257) at Assisi. The unsymmetrical disposition of the arches on each side of the central seraph with the symbol of St Luke omitted) is curious; the seraph may have been emphasised in allusion to the vision of St Francis. Some of the books held by the angels in the spandrels are marked S. The relief probably dates from soon after the death (1253) of St Clare; if it formed part of the high altar—'altare majus sub quo S. Clara requiescent'of her church, that altar was consecrated by Pope Clement IV in 1265. The ornate shrine in the crypt where the saint's body (re-discovered in 1850 deep below the church) is now displayed dates from the middle of the nineteenth century.

The tone of scepticism in which the later of the two entries is couched is justified by the discovery in the *Notizie Istoriche delle Chiese Fiorentine*

of Richa of a description of the relief not at Assisi, but in the Florentine convent of Monticelli, where it formed part of the sarcophagus not of St Clare, but of a less familiar figure, the Beata Chiara Ubaldini. Richa's description[4] runs as follows:

Prima però debbo qui arrogere alle date notizie delle Reliquie una visita da me fatta con licenza de' Superiori al bellissimo Coro delle Monache, che è, per vero dire, un teatro stupendo della più tenera divozione di queste nobili Suore, ed un luogo adorabile per la maravigliosa disposizione delle insigni Reliquie.... Dirò pure quanto fosse per me felice quel giorno, nel quale posi indegnamente il piede in questo Ven. Monastero; posciachè desiderando io da gran tempo di vedere il Sepolcro della B. Chiara Ubaldini, benchè voto e spogliato di si prezioso Corpo, qui ebbi la consolazione di attentamente osservarlo, veggendosi il dinnanzi, che è tutto di marmo bianchissimo, istoriato con bassi rilievi rappresentanti un Tempio, o sivvero un loggiato con colonne, ed in aria Angioli, volatili, ed appie alberi, Lioni, e Uomini, e Donne vestiti in abito di penitenza, e nell'orlo del sepolcro leggonsi i seguenti versi leonini

> Vita preclara refulgens nomine Clara
> Norma reclusarum Speculum sine turbine clarum
> Inclyta cunctarum Crti iacet hic famularum.

The Arca must originally have been rectangular in form, and it may be presumed that the carving ran round the sides. The reasons for this assumption are, first that the surviving frontal section contains the symbols of only two of the evangelists (the attempt of the 1932 catalogue to identify the six-winged seraph as the symbol of St Matthew is clearly incorrect), and secondly that Richa mentions *Uomini, e Donne vestiti in abito di penitenza*, who do not appear on the front of the sarcophagus. There is no evidence of carving on the back of the Arca. Though due allowance must be made for the inexactitude of Richa's observation—the symbol of St Mark, for example, is wrongly referred to in the plural—the figure carving to which he alludes cannot have been a figment of his imagination, since it is also mentioned by Follini-Rastrelli in a note on the sarcophagus in the *Firenze Antica, e Moderna illustrata* of 1794:[5]

Il Sepolcro della Beata chiara Ubaldini viene altresi conservato da queste Religiose con molto divozione: questa cassa è di marmo bianchissimo, e nel davanti istoriata con bassi rilievi, rappresentanti un Tempio con colonne, intorno degli alberi, e figure vestite in abiti di penitenza, veggendovisi in aria degli Angeli.

The quotation ends with a transcription of the verse on the front of the sarcophagus reported by Richa. The probability, therefore, is either that

the figures which originally filled the vacant arcades beside the seraph have been erased, or that the arcading continued round the ends of the sarcophagus, and that the sides showed the symbols of SS. Luke and Matthew with *Angioli volatili* and kneeling Franciscan friars and nuns.

Established on Bellosguardo in March 1218, the community of Poor Clares of S. Maria di Monticelli was formally constituted by a bull of Honorius III in December of the following year. According to tradition, the first superior of the community was a sister of St Clare, the Beata Agnese, who was succeeded in 1253 by the Beata Chiara Ubaldini. The earliest printed account of the Beata Chiara's life is contained in the *Vite dei Santi e Beati Toscani* of Razzi, based on a manuscript history of the Ubaldini family, on *la Serafica del Padre Tossignano*, and on *altri approvati autori.*[6] One of Razzi's approved authors appears to have been an early sixteenth-century priest, Fra Mariano di Ognissanti, who compiled (no doubt from local records) a series of biographies of the abbesses and nuns of Monticelli, which are quoted in Richa's *Notizie Istoriche delle Chiese Fiorentine,*[7] and were also drawn on in the *Annales Minorum* of Wadding.[8] The stories recorded by Fra Mariano di Ognissanti, Razzi, Richa, and Wadding, though differing in detail, follow the same broad lines. These tell how at some time before the death of St Clare in 1253, the community at Monticelli received a new recruit in the person of Avegnente, the daughter of Azo Ubaldini and aunt of Cardinal Ottaviano Ubaldini, protector of the congregations of Vallombrosa and Camaldoli. Avegnente Ubaldini's husband, a Pisan, Galluria de' Visconti, had died some years earlier, leaving her with two sons. *Una nocte*, continues Fra Mariano di Ognissanti's narrative,[9] *riposandosi nel mezo de dua figliuoli, li quali quando luno et quando laltro piangevano, la madre vincta dal tedio di quale inquietudine, cominciò a meditare la quiete del servire a Dio, el grande fervore delle Suore di Monticegli, et infiammata dal divino amore, lasciò li figliuoli, et andossene al predecto Monastero, dove dalla beata Agnesa et dall'altre Suore con grande gaudio fu ricevuta et vestita dello habito.*

In 1253 the Beata Agnese was called to the death-bed of St Clare and entrusted with the charge of the Poor Clares at Assisi, and tradition records that Suor Chiara, as Avegnente Ubaldini had now become, was appointed her successor at Monticelli. Under the regime of the Beata Chiara, the community transferred to new premises outside the Porta San Piero Gattolini, in a procession headed by the Cardinal and attended by miraculous manifestations which are recounted by Padre Tossignano.[10] A year later, according to Wadding in 1261,[11] the Beata Chiara died. *Et immediate che fu*

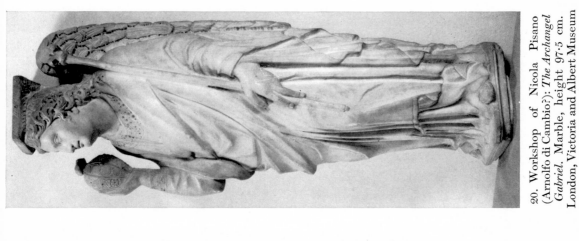

20. Workshop of Nicola Pisano (Arnolfo di Cambio?): *The Archangel Gabriel*. Marble, height 97·5 cm. London, Victoria and Albert Museum

19. Workshop of Nicola Pisano (?Lapo): *Faith*. Marble, height 95 cm. Paris, Louvre

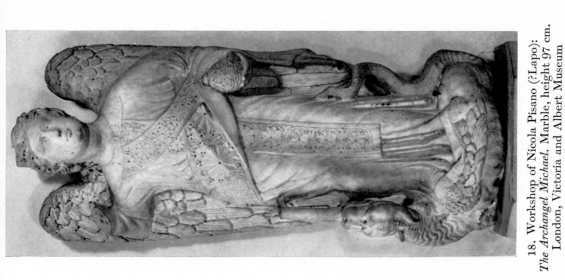

18. Workshop of Nicola Pisano (?Lapo): *The Archangel Michael*. Marble, height 97 cm. London, Victoria and Albert Museum

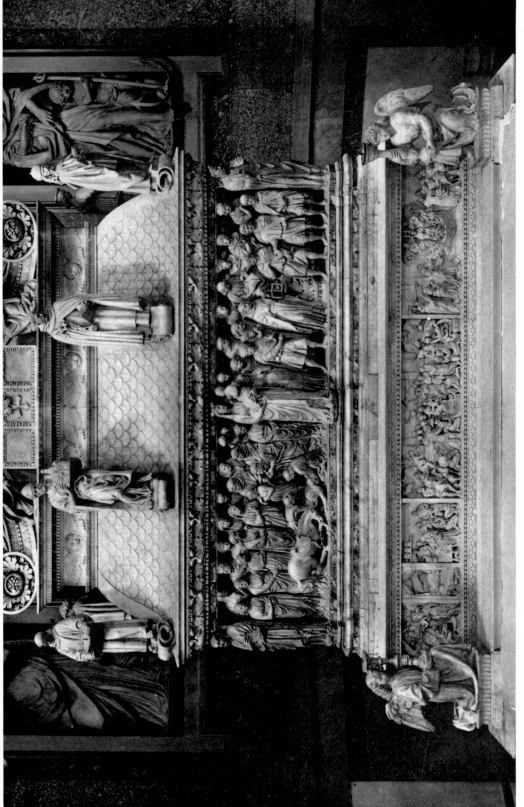

21. Workshop of Nicola Pisano: *Arca of St. Dominic.* Bologna, S. Domenico

22. *Sarcophagus of the Beata Chiara Ubaldini.* 86 by 211 cm. London, Victoria and Albert Museum

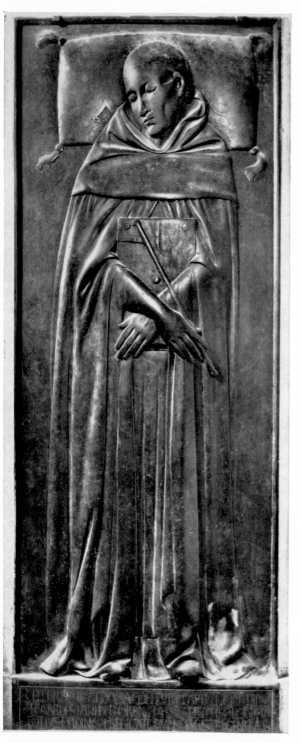

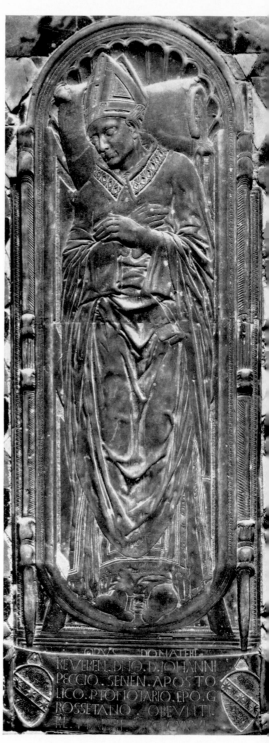

23. Lorenzo Ghiberti: *Tomb-slab of Leonardo Dati.*
Bronze. Florence, Santa Maria Novella

24. Donatello: *Tomb-slab of Giovanni Pecci.*
Bronze. Siena, Duomo

passata al celeste Sposo, writes Fra Mariano,[12] *cominciò con li miracoli a mostrare la sua santità. Et volendo le suore sepelirla, li Operai dela Chiesa Cathedrale di Firenze, da loro medesimi mandorno al Monastero una Archa di marmo dicendo che quivi sepellissino quel corpo beato, Et eravi sculpito questo epitaphio, Vita preclara refulgens nomine Clara Norma reclusarum Speculum sine turbine clarum, Inclyta cunctarum Christi iacet hic famularum.* Twelve years after the Beata Chiara's death, one of her nieces followed her to the grave, and it was thought appropriate that her body should be placed in the Arca of the Beata Chiara.[13] When the Arca was opened, the Beata's body was found fresh and incorrupt, and was removed from the choir and exposed for a time in the outer church. In 1459, when the choir of the church was extended, the Arca was opened yet again, and the body, *tutti tractabile come fussi viva*, was once more displayed for three days in the church, the sarcophagus in which it was replaced being subsequently *collocato ... in luogo più alto e honorevole.*[14] The phrase *collocato in luogo più alto* suggests that, like the Falconieri monument in the cloister of the Annunziata, the Arca may have been set on stone supports high on the wall.

At this point we return from the sphere of legend to the world of fact. In 1527 the nuns of Monticelli were evicted from their premises and instructed (as part of a plan for the strengthening of the Florentine defences) to withdraw inside the town. Until 1534, when they took possession of new premises in the Via de' Malcontenti, the community was homeless, and advantage was taken of an offer from the Franciscan friars of S. Croce to provide asylum for the Arca of the Beata Chiara. But in 1534, when the Arca was returned to the new convent, the Beata's body was nowhere to be found. Whether it had been stolen by the friars of S. Croce and *nascosto segretamente in quell'ampo Convento*,[15] as was popularly thought, or whether it was the object of a secular theft, was never ascertained, and from this time on the nuns of Monticelli had to content themselves with the possession of an empty monument. In 1808, the convent of Monticelli was suppressed, and its contents were distributed.[16] But as late as the middle of the century the memory of the Beata Chiara survived, and a Florentine calendar of 1847 records the feast of the Beata Chiara (February 27) and of her nieces, the Beate Giovanna and Lucia Ubaldini (May 30).[17]

The pedigree of the Ubaldini family is fraught with problems, and in 1588 was the subject of a notorious forgery by Giovambattista Ubaldini,[18] and this as much as any other factor must have caused the legend of the Beata Chiara to be called in question by Davidsohn,[19] who pointed out

that Avegnente, the first abbess of Monticelli, was mentioned as early as 1219, that there was no documentary confirmation of the existence of an Abbess Chiara Ubaldini in the third quarter of the century, and that the story reported by Razzi and other hagiographers was, therefore, *ganz phantastisch und schon aus chronologischen Gründen widersinnig.* Since, however, a number of *consaguineæ* of Cardinal Ubaldini were members of the community, it was conjectured by Davidsohn that the Beata Chiara might be a natural daughter or other relation of the Cardinal, who at a later date came to be identified with the historical abbess Avegnente. A Suor Chiara, whose surname is not recorded, was abbess of the convent in December 1327.[20]

Though it contains certain archaic features (of which the seated angels in the spandrels and the asymmetrical placing of the central seraph are the most notable), the style of the Arca, and particularly the naturalistic foliage in the five outer arcades, can hardly be reconciled with an origin in Florence in the third quarter of the thirteenth century. If the legend of the Beata Chiara is incorrect, there is *a fortiori* no reason to accept the statement that the Arca was supplied to Monticelli by *gli Operai della Chiesa Cathedrale di Firenze,* the less so that its handling cannot be directly referred to any decorative carving in the Cathedral or the Opera del Duomo. On the other hand, general analogies for the style of the reliefs are to be found where we might expect to find them, in a group of monuments executed for the Franciscan church of Santa Croce at the end of the first and the beginning of the second quarter of the fourteenth century. This group includes the Baroncelli monument of Giovanni di Balduccio, which was begun in 1327 and completed before 1338, the Bardi monument, probably begun in 1337, and the roughly contemporary Bardi di Vernio monument.[21] All three monuments are distinguished by the freedom of their naturalistic ornament. *Tutta la gioia delle forme della natura,* notes Bodmer in his analysis of the style of the Baroncelli monument,[22] *si manifesta però nell'ornamento di acanto della cornice della finestra, trattato con sorprendente delicatezza, in cui un motivo della prima scultura romanico del Duomo pisano acquista nuova bellezza nel linguaggio gotico più elegante e più lieve.* And the motifs of the naturalistic foliage on the Baroncelli monument are in fact closely related to those employed on the Arca. Here, on the inner edges of the supports beneath the lateral columns, there recurs a widely spaced design of flowers and fruit joined to a central stem set in a vase, while the strip of carving above the window in the monument provides a parallel for the free, deep-cut foliage, with leaves turned back over a

writhing stem, which we see in the second arcade from the left of the sarcophagus. The latter feature occurs again in a more constricted form in the lower part of the Bardi monument. There is no warrant for claiming that the Arca was carved in the same workshop as the decorative sections of Giovanni di Balduccio's monument, nor that the year 1327 is necessarily a *terminus post quem* for its execution.[23] But in the absence of earlier Florentine examples of carving of this type, the Baroncelli monument affords a valid indication of the probable date and likely style context of the sarcophagus. The tomb front thus takes its place among the earliest Florentine examples of the Gothic naturalism, which at the end of the century was to produce the decorative borders of the Porta della Mandorla and the Porta dei Canonici, and was to reach its climax in the foliage of Ghiberti's first bronze door.

Originally published in *The Burlington Magazine*, xci, April, 1949.

The Fifth Centenary of Donatello

DONATELLO died in Florence five hundred years ago today. He was eighty, and behind him lay sixty years in which the flow of original invention was never halted and vision after vision was realised in marble or in bronze. In a worldly sense his life had been no more than a qualified success. In his youth he was one of the founding fathers of Florentine art, and he reached the climax of his popularity in Florence in the fourteen-thirties when a success, great commission after great commission fell into his hands. For a decade he retired to Padua (where the Gattamelata and a bronze Crucifix were, at the time he died, the only visible proof of ten years of activity), and finally for thirteen years he lived in Florence in seclusion, occupied in the main with works for one faithful and percipient patron, Cosimo de' Medici. From the fourteen-thirties on he seems to have been looked on as a heterodox artist, whose style ran counter to the trend of taste.

Almost from the first it was recognised that his creative procedures were unlike those of other sculptors. That was acknowledged by Vasari, who declared that Donatello invested his figures with a power of movement and a vivacity and liveliness that enabled them to stand beside antique sculptures and works of the High Renaissance. It is a common experience today, in front of Donatello's works, to feel that this is an artist in our modern sense, a sculptor whose emotions are our emotions and whose work results from reconstructible thought processes. The subject on which I want to talk this evening is what, for want of any better term, I shall call Donatello's creative machinery. But I must first say a preliminary word about the study of the sculptor's work and how it has evolved.

When the fifth centenary of the artist's birth was celebrated, in 1886, his personality was much less apprehensible than it is now. The authentic, documented works were interwoven with works by other hands, and the books published then and for some decades afterwards remind us of the painted parable by Brueghel of *The Blind leading the Blind*. The Donatello concept was indeed so vague that almost any work in any medium could be ascribed to him. When a bronze figure by Vecchietta was purchased for Berlin, it travelled under Donatello's name, and when a Mantuan bronze mirror was bought for London, its passport was again made out to Donatello. With each misattribution the concept of the artist's style became more

blurred, and the message of those works which were authentic became more inaudible.

A great deal of the responsibility for that rests on the shoulders of Vasari, for Vasari's life is, by his own standards, ill informed. It begins with descriptions of the *Cavalcanti Annunciation*, the work through which, according to Vasari, Donatello's reputation was established, and it continues topographically, with the works in the Baptistery, the sculptures for the Duomo and Or San Michele, the bronze *Judith* and *David*, sculptures in the Palazzo Medici and other private palaces, Padua and Venice, Rome, Siena, and finally the works in San Lorenzo. In most of Vasari's quattrocento lives there is a considered framework of chronology, but in the life of Donatello there is none. None the less in 1886, quite a number of responsible scholars pinned their colours to Vasari's mast. When you open the book on Donatello by Cavallucci, the first plate you come to is of the *Annunciation* in Santa Croce, and in Schmarsow's monograph of the same year—its subtitle describes it as dealing with Donatello's development and the 'Reihenfolge seiner Werke'—the *Annunciation* is again used as a lead-in to the statues on Or San Michele. Schmarsow was capable of believing almost anything, but the fact that anybody, even in 1886, could suppose that representation in the quattrocento developed in this fashion still seems extremely odd.

Everything to do with the sculptures carved for the Cathedral and the Campanile was shrouded in uncertainty. They were, of course, looked upon as portraits. Semper, in 1875, devotes some eloquent pages to the 'Seelenleben' of these effigies, and I shall return to that point later, because I think there is more in it than is now supposed to meet the eye. Often in the writings of the time it is very difficult to make out exactly which statue is meant. How puzzling is Semper's reference to the smiling mouth and simple drapery of Donatello's *St John the Evangelist* until we realise that his words actually relate to the statue by Nanni di Banco of *St Luke*. That and a number of other mistakes were corrected in the only wholly responsible study inspired by the centenary, an article by Hugo von Tschudi in the *Rivista Storica Italiana*, where an attempt was made to reach the facts behind the myth. But the facts were not reached easily. Even Tschudi believed, for example, that the relief of the *Entombment* from the Padua altar was modelled in terracotta and not carved in stone, and the reason for that was that in the Santo it was set high over a door.

Vasari's delinquencies were not restricted to chronology; they affected attribution too. For it was he, not speculators in the nineteenth century, who propagated the belief that Florentine palaces were stuffed with

Donatellos, and who recorded, if he did not invent, the legend of Donatello's connection with the Martelli. There is no evidence to support it, but in 1886 and for long afterwards it was assumed, because of the special relationship Vasari postulated, that sculptures in the Palazzo Martelli, the Martelli Mirror in London, and the *Martelli David* which is now in Washington, and the *Martelli Baptist* which is now in the Bargello, must be by Donatello. The Martelli Mirror was questioned from quite an early time, but the attribution of the statues is still treated as though it rests on responsible tradition and is something that has to be explained away. Probably if a vote were taken, quite a number of people would argue now that Donatello was the sculptor of the *David* and a majority of scholars might support his authorship of the *St John*. At all events the *David* and *St John* are both ensconced in the standard Donatello catalogue. In the nineteenth century they were surrounded by a shoal of secondary works.

Not till the mid-nineteen-thirties was the catalogue of Donatello's works, for the first time in five hundred years, subjected to rational analysis. The agent was a Hungarian scholar, Jenö Lanyi, who, in a working life that proved pathetically short, reformed the study of quattrocento sculpture. One looks forward to the time when his articles are required reading for all students of art history. He changed its method by recognising frankly what no scholar had previously confessed, that students of Renaissance sculpture were bogged down in uncertainty because their method derived from the study of Italian painting. No results, he argued, could be more than superficial, if a critical method designed for works in two dimensions were wilfully applied to works in three. What was required was to establish how the sculptures were constructed, and not simply to compare one sculpture morphologically with another on the flat surface of a photograph. I stress that point because when I am told today that the *Martelli David* in Washington and the *Martelli Baptist* in Florence are really works by Donatello or that Donatello modelled the bronze bust of a youth in the Bargello, it seems to me that the significance of Lanyi's teaching has not been understood.

Lanyi's approach was through the eye, but it was also possible to approach Donatello historically through study of the world in which he moved and of his iconography. That task was attempted, also in the nineteen-thirties, by Professor Kauffmann in a short and learned book. The corpus of works accepted in it was traditional—that is to say roughly a third of them were not by Donatello—but for the first time it attempted a systematic survey of the typology of Donatello's work—the place of the *Judith* in the traditional

iconography of Judith, the David in the traditional iconography of David, and all the rest. Typological study is applicable mainly to medieval art, when images were really handed on, like batons in a relay race, from one artist to the next. It is concerned with antecedents, and for this reason there emerged from Kauffmann's book a picture of Donatello as a quasi-medieval artist. Just how little light the study of typology can throw on Donatello was illustrated some years ago in an article on the pulpits in San Lorenzo which proved, with an enviable wealth of footnotes, either that the writer had failed to identify the sources of the pulpits or that they had none. Finally the year 1957 witnessed the publication of what is, and will remain, the standard book on Donatello, Professor Janson's catalogue, where the two tributaries meet. In the plates we see the sculptures with the probing eye of Lanyi, the originator of the enterprise, and in the text the factual material is sifted with admirable pertinacity and honest-mindedness. The catalogue is comprehensive and its tone is argumentative. In reading it, one is indeed sometimes reminded of Donatello's own reliefs of the disputing Apostles in the Old Sacristy. If problems could be solved by argument, they would all be solved here. This is a valuable book, and thanks to it we are for the first time in possession of the facts from which Donatello's working processes can be deduced. And it is that that leads me this evening to ask the question, 'What kind of artist was Donatello?'

The first thing we observe about him is that visual preconceptions played almost no part in his work. He was concerned with creating an optical illusion and with enriching it by data gleaned from what the eye perceived. When Ghiberti, in 1425, designed the tomb-slab of Leonardo Dati (Fig. 23), he refined an accepted monumental type. The figure was framed by verticals at the sides, and the habit was resolved in mellifluous, non-naturalistic folds. Along the base there ran a classicising epitaph. When Donatello, in 1426, designed the Pecci tomb-slab at Siena (Fig. 24), the physical properties of the relief were virtually the same, but its optical character was different. The epitaph is on a scroll which falls loose in the centre, so that half of the artist's signature, on the plane behind it, is disclosed. The body rests on a concave bier, whose height is established by supports protruding at the foot; the feet are depicted illusionistically from on top; and the chasuble is rumpled so that the volume of the body can be clearly seen. Over the ankles the alb is drawn on the surface of the bronze.

I suppose that in the mind of almost everyone today the word 'realism' carries unpleasant overtones. It suggests an art that operates in the prosaic limits of daily life. Donatello's realism was of a different kind. It was not

the content that was realistic, only the language in which it was expressed. The real world does not lend itself readily to imitation by a sculptor, and one is constantly astonished by the resource that Donatello shows in establishing in sculpture effects analogous to those which we experience through the eye or through the touch. The feet of the *St Mark* press into the surface of a fictive cushion, and the same device is later developed in the *Judith*, where the weight of the two figures leaves its impress on the seemingly soft surface of the bronze.

This tactile impulse was present almost from the start. It occurs in the marble *David*, not in the simplified main figure but in the head of Goliath at his feet (Fig. 25), where we come upon one of those effects with which Donatello so often startles us, the heavy stone lodged naturalistically in the skull. When the statue was moved to Palazzo della Signoria in 1416, it was reworked, and the part which was recarved was evidently the Goliath head, which would have been illegible high on the Cathedral, and not, as is supposed today, the leg above. That can be confirmed from the God the Father over the niche containing the *St George* (Fig. 26), which was carved at precisely the same time. By the mid-fourteen-thirties no texture was too soft, no form too complex, for Donatello to render it in stone. He took a virtuoso's pleasure in distinguishing the surface of the dress from the stiff cuffs or collar under which it flowed, and in works designed to be seen from far below, like the Cantoria of the Cathedral, he could divide the feathery fabric of the wings from the firm flesh, and the flesh from the form-revealing draperies. In the latest of the Campanile statues, the *Zuccone*, with a precision which time has now all but effaced, he differentiates the scalp from the sparse hair and depicts the long tendons of the neck and the sagging skin over the cheek. When Vasari said that no sculptor of his own day could compare with Donatello, he spoke in this respect the simple truth.

In sculpture physical description can be perfected only by an additive technique, since the descriptive possibilities of modelled sculpture are greater than those of sculpture which is carved. Hence the transfer of Donatello's sympathies to bronze, and the obsession with modelled sculpture that must, in the last resort, have been accountable for his move in 1443 to Padua. The portent is the reliquary bust of San Rossore, where the contraction of the eyebrows is rendered with a truthfulness that surpasses even the *Zuccone*, and the incised stubble on the cheek is contrasted with the boldly modelled beard and hair. A decade or more later Donatello's fascination with the textural potentialities of bronze gives rise to the

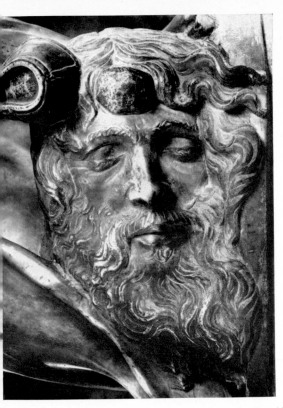

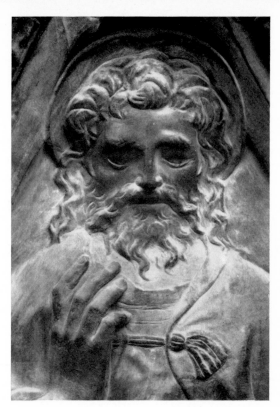

25. Donatello: *Head of Goliath*, detail of marble *David*. Florence, Museo Nazionale

26. Donatello: *God the Father*, detail from niche of the Arte dei Corazzai. Marble. Florence, Orsanmichele

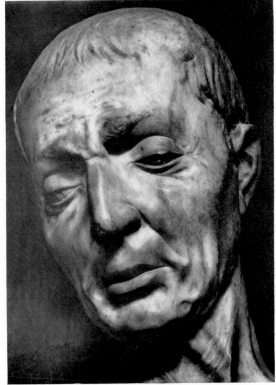

27. Donatello: *Head of Jeremiah*. Marble. Florence, Museo dell'Opera del Duomo

28. After Donatello: *Head of Joshua*. Marble. Florence, Duomo

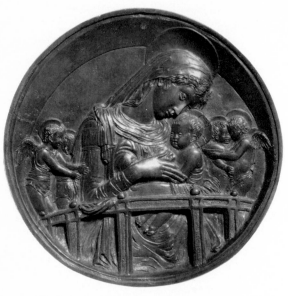

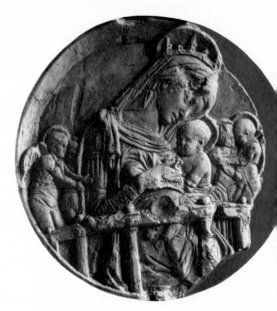

29. Workshop of Donatello (Bertoldo?): *Virgin and Child with Angels*. Bronze. Washington, National Gallery of Art (Kress Collection)

30. After Donatello: *Virgin and Child with Angel* Stucco. Verona, Museo di Castelvecchio

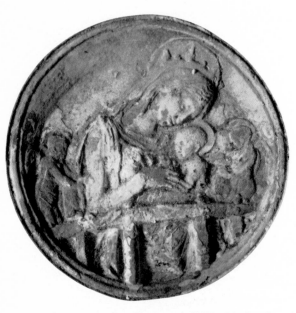

31. After Donatello: *Virgin and Child with Angels*. Stucco. Vicchio di Rimaggio

32. Sherwin after Donatello: *Virgin and Child with Angels*. Etching. London, British Museum

Amor-Atys from the Palazzo Doni, in which a woven belt is worn round the naked waist, and to the bronze *David*, where the unruly hair falls on the shoulder blades and the wing on the helmet of Goliath strokes the inside of the thigh. I suspect there are few visitors to the Bargello who are totally immune to the technique of physical communication of which Donatello disposes in these statues. Yet I was shocked to read in the *Daily Telegraph* last Friday that the *David* was 'the most kinky and most homosexual masterpiece in the whole of European sculpture'. The *David* is not only a great masterpiece, but a work of consummate sobriety and seriousness.

The descriptive technique that Donatello uses here he took with him to Padua, and he deployed it there not on the altar of the Santo (where, however, there are details like the diaphanous veil held by St Daniel that evoke the same physical sensations as the earlier works), but in the *Gatta-melata*. It is less apparent than it once was in the blotchy statue we see today, but the muzzle of the horse and the fringes of the armour and the saddle-cloth are sufficient to suggest the character of what must, in addition to its other merits, have been the most meticulous repertory of description since antiquity. Back in Florence, a climax is reached with the *Judith*, the most elevated of his statues, and at the same time the most literal. The sculptor would surely have been gratified by that involuntary indrawing of the breath that overcomes us each time we look at the left hand of Judith clenched round Holofernes' hair or at the bare foot set on his wrist. In this case, moreover, there is evidence from technical examination of the importance he attached to these effects. The drapery was modelled on real cloth—this technique must have been inculcated by Donatello in the members of his Paduan studio; at all events it is used again by Riccio in the beautiful male bust in the Museo Correr in Venice—and it has been claimed that the legs of Holofernes were based upon life casts. That claim has been contested, on the grounds that the legs of Holofernes are very similar to those of the *Baptist* in Siena, but the explanation of the similarity is that the legs of the Siena statue are based on life casts too. Something of the kind must have been suspected in the sixteenth century. Vasari in 1550 implies that at that time the body of the bronze *David* seemed to artists to have been moulded from the life.

Realistic detail will create an illusion of reality only if the work to which it is applied is realistic too. From the first Donatello's aim was the creation of a race of marble and bronze beings with human potentialities of movement and a human capacity for thought. For that reason his early works in marble reveal a consistent and deliberate effort to emancipate the

figure from the block. With the *St Luke* of Nanni di Banco the confining presence of the marble block is firmly felt; the two knees rest on the front plane and the sides of the block determine the shape of the two sides. With the *St John the Evangelist* of Donatello the opposite occurs. By turning knees sideways, the effect of the block has been annulled. The figure of *St George* is set diagonally on its base, with the left foot protruding boldly across the edge, hence the vivacity, *prontezza*, that was so much admired in the sixteenth century. From quite an early stage, Donatello was engaged in making modelled sculptures. He was paid in 1410 for a gigantic terracotta *Joshua* for the Cathedral, and the fruit of this experience can be read in the free carving of the earlier of the Prophets on the Campanile. Before the later Prophets there intervenes the bronze *St Louis of Toulouse*, and thereafter the *Zuccone* and the *Jeremiah* achieve a freedom that was not attained by any other quattrocento marble sculptor. These experiments must have excited special interest in the sixteenth century, when the dominance of the marble block was accepted as a principle of sculpture by all artists, even by Michelangelo.

The Prophets on the Campanile are shown in implied movement; they are represented not in motion, but as though about to move. By the time he carved them, Donatello's mastery of movement was complete. Nowadays we know the Cantoria only in the clinical setting of the Opera del Duomo, where a hard top light exaggerates the roughness of its execution and detracts from its illusionism. But if it could be seen again in the ambiguous half-light of the Cathedral, we should read its film-strip of boisterous figures in a very different way. No later sculptor, not Bernini, nor Rodin nor Carpeaux, has created an illusion of movement so impetuous, so all-embracing and so secure. Movement is the quality that is singled out in Vasari's beautiful account of the *Cavalcanti Annunciation*. The movement, he writes, convinces, because the naked forms beneath the drapery have been understood. The principle of movement which is established in these works was extended after 1443 at Padua.

Thanks to an excellent analysis of the Paduan documents by Fiocco, we now know that at the time he left Padua in 1453 Donatello's altar was not assembled, and when it was set up, more than two decades later, there is no guarantee that it was set up precisely in the form he planned. So at Padua, to a greater extent than is recognised in any book on Donatello, we are dealing with impalpables. The size and form of the altar can be established with some confidence, but its intended content must be deduced from the pieces that survive. Four of the seven figures—the Virgin rising from

her seat and three of the accompanying Saints—are represented moving or in arrested movement, and admit only of one inference, that Donatello conceived the statues as a dynamic group with a common animating impulse, and treated the floor space of the altar, like the tabernacle of the *Annunciation*, as a kind of stage. What we see today are the members of the cast and not the play.

In all our minds, however, the aspects of Donatello's statues I have been describing are secondary to their sharply individualised character. How exactly was it that at a time when a great artist like Ghiberti could achieve no more than the noble generalities of the *St Matthew* and the bland head of the *St Stephen*, Donatello could characterise his *St Mark* with such precision and could supply the firm focus of the head of the *St George*? Vasari had no doubt of the answer; he recorded a tradition, from the early source book known as the *Libro di Antonio Billi*, that the heads of the Prophets on the Campanile were designed as portraits. That has been contested, and the names he gave may well be wrong, but there can be no doubt that Donatello, from a very early time, imposed upon his heads the individualising processes of portraiture. Whereas in the Brancacci frescoes Masaccio's heads are generic forms some of which are invested with the semblance of individuality, the heads of Donatello were specific from the start. If they did not originate as studies from the life, how could the heads of the *Jeremiah* (Fig. 27) and *Zuccone* conceivably have been produced? Admittedly it is not till Padua that Donatello presents himself as an avowed portraitist, but the practice of studying the living head must have been part of his equipment from a very early time. Alberti in the *Treatise on Sculpture*, which seems to have been written before 1435 and not at the much later date that was at one time postulated, advocates that statues should be individualised, and individualise them Donatello did—hence what would otherwise be the peculiar fact that in some of the statues for the Duomo the head is carved separately from the body and attached. I believe everybody would agree with me if I said that behind the heads of the *Jeremiah* and *Zuccone* we must postulate clay models, and we must do so also in the most controversial of these cases, the so-called *Joshua* or *Poggio Bracciolini* (Fig. 28). The problem of this head cannot be solved by the dialectical device of arguing that it either is or is not by Donatello. The model was undoubtedly by Donatello—there was no other sculptor in Florence in 1418 who could possibly have modelled it—but it was transcribed to marble by another, less accomplished hand. A sceptical position is the easiest one to take up on almost anything, and I must confess that

having regard to the way in which the statues were produced (as well as to the part played by the portrait in Florentine society at the time) I find it much more credible that the Duomo and Campanile figures portray notable men than that they do not.

If Donatello's heads were simply lifelike, that would in 1430 have been remarkable enough. But they are expressive, and expressive in a rather special way. No one who visits the Brancacci Chapel can doubt the narrative intentions of Masaccio. In head after head they are made manifest. But the emotions are not stated; they are implied through inflections in what is fundamentally an inexpressive style. It is a strange experience now, and must have been a far stranger experience then, to pass from this generalised language of emotion to the precise expressive syntax of Donatello. This surely is an important factor in assessing the significance of Donatello for his contemporaries. At the time that he left Florence for Padua, he was the exponent of a realistic style which was totally opposed to the idealising current in the painting of the time. And when we look at the works that he produced in his last years—at the features of the *Judith*, stamped with disgust at the task that she is called on to perform, or at the *Magdalen's* inward-looking head—we may wonder whether any artist was ever further in advance of his own day than he.

One of the areas where Donatello's interest in psychology pays the highest dividend is the *Madonna* relief. The standard Donatello catalogue omits all the *Madonna* reliefs save two in marble, but to my mind that restrictive view is wrong. It is wrong in the case of the terracotta *Madonna* in the Louvre, where the Child gazes to the left and the Virgin, with a look that can only be construed as apprehension, follows his glance. It is wrong in the case of the terracotta *Madonna* in Berlin, where the Virgin is shown in prayer with the Child enclosed in her protective arm. It is wrong in the case of the *Verona Madonna*, where the Virgin shields the frightened Child with her left hand and the features reflect the experience of the *Judith* on which Donatello must have been working at about this time. There is contemporary evidence indeed that after he returned from Padua, in 1453, he made something of a speciality of terracotta sculptures. The source is his doctor Giovanni Chellini, who cured him of a serious illness at this time and for whom he made a bronze relief. Modern scholars tell us that Chellini's statement is not worth the paper it is written on, but I am bound to say it seems to me a trifle arrogant to dismiss the testimony of contemporaries, particularly when the works themselves survive.

When these Madonnas were transferred to other mediums, they were

sometimes weakened by studio execution, like the beautiful *Madonna* on Siena Cathedral, where the types both of the Virgin and the Child presuppose a model by Donatello of the date of the Verona composition, but the execution is comparatively coarse. Yet even in this work Donatello speaks. He speaks indeed not simply in the figures, but in the architectural surround, for the device whereby the frame takes on a spatial character is essentially the same that he employed in Florence in the great stained glass window of the *Coronation of the Virgin* in the Cathedral. In books on Donatello the window, too, is generally ignored, but it is by far the most majestic and inventive of the windows in Brunelleschi's cupola, and it is planned with a confidence and a sophistication that put the other artists who were employed there—among them Castagno and Uccello—to shame.

In some ways the most appealing of these *Madonnas*, because the smallest and most intimate, was the little circular relief of which a record survives in Washington (Fig. 29). I put it in that way because the composition of the Washington relief was obviously due to Donatello. I think that no one who examines its figurative content or its space structure—with that tell-tale bulging balustrade—could conceivably deny that that was so. It is not, however, like the marble *Madonna* at Siena a work designed by Donatello and executed in his studio; it is a version of a lost relief by Donatello. We know that because two stucco reproductions of the lost original survive. One of them is in a fragmentary condition at Verona (Fig. 30)—it has the same diameter as the relief in Washington, twenty-six centimetres— and it shows the Virgin wearing a crown as well as certain differences in the drapery and in the balustrade. The second stucco reproduction is in the church at Vicchio di Rimaggio (Fig. 31), and though it is blunter than the version at Verona, it is more complete. There is a third version in London, in the Soane Museum, in white plaster, dating it seems from the late eighteenth or early nineteenth century. The presence of this version in the Soane Museum might suggest that the relief was at some time in this country, and so it was, for in the eighteenth century it was engraved. It was engraved (Fig. 32) as the work of Donatello, and the owner was Lord Rockingham. The engraving, by Sherwin, seems to date from the seventeen-seventies; at all events it was made before the death of Lord Rockingham in 1782. As can be seen from the engraving, the relief was surrounded with an imitation Cufic border which is not reproduced in the stucco replicas or in the relief in Washington. Where, one wonders, is the relief now? All these reliefs were produced in the very middle of the century —the last of them, the *Madonna* at Siena, dates from 1457—and if we

compare them with the Virgins of Filippo Lippi or Domenico Veneziano, we shall find that the expressive language is more eloquent and the level of interpretation more profound.

The interest in emotion that lends them their special force also determined Donatello's attitude to the antique. Masaccio, at the time of the Brancacci frescoes, and Donatello, at the time of the *Ascension* in this Museum, were undoubtedly familiar with Roman processional reliefs. Masaccio deduced from them the static pictorial language of the *Tribute Money*. But Donatello, in the *Ascension*, treats them differently. The interval that he preserves is classical, and so, in its summary fashion, is the rendering of the forms, but the heads are individualised, and each of the Apostles reacts in his own fashion to the central scene. Through some unprecedented act of the imagination, the sculptor projects himself into the mind of every figure he portrays in the relief. In the *Miracle of the Wrathful Son* at Padua the central group is again based on an antique model, but once more the model served simply to spark off the imagination of the sculptor and left almost no stamp on the work of art that he produced. At the extreme end of his life Donatello is thought to have adapted a figure from a classical relief of the *Death of Meleager* for the Christ in the *Resurrection*, but this time the connection is so vague that we cannot be absolutely certain whether he really had the classical relief in mind or no. This pragmatical, casual, rather disrespectful attitude to the antique is the same that led him to carve the stupendous heads on the Parte Guelfa niche and to achieve the grotesque perversion of classical ornament on the Cantoria.

People who write on the reliefs of Donatello sometimes discuss them as though the constructional devices that are used in them were the reason why they were produced. The perspective devices are important; as early as 1416 in the relief under the *St George* they testify to Donatello's intellectual accomplishment. But the technique of space projection was only one of the expedients he employed. In the *St George* relief the space illusion is established by the figures in the foreground and by the lightly drawn impressionistic landscape at the back, and the area of perspective on the right is parenthetical; it contributes to a space illusion that is established by other means. In his last cycle of reliefs, on the pulpits in San Lorenzo, projected space, in the *Martyrdom of St Lawrence*, and constructed space, in the *Christ in Limbo*, likewise exist side by side. Donatello was an empiricist. In the *Ascension* perspective is the means by which the design is organised and the space structure is defined. But it is reinforced by optical effects—on the undulating surface of the marble the trees merge into nothing-

ness, and the putti are no more than partly visible among the clouds. In the *Assumption* the same effects are used again; perspective is present, but it is confined to the foreshortened seat, and the illusion is established by the hands and bodies of the supporting figures which protrude mysteriously from the mist.

Donatello was a supreme literary artist. Reaching maturity in the decade that saw the production of the Brancacci frescoes and of Masaccio's *Trinity*, he remained faithful for forty years to the same precepts, to the belief in a religious iconography that sprang from and was related to the world he knew. The sculptor who conceived the aged Virgin of the *Ascension*, where the essence of Masaccio is compressed into a figure a few centimetres high, is the same sculptor who conceived the suffering Christ of the last bronze reliefs. His bias was towards instantaneous images. The relief of the *Ascension* is relieved by adventitious movement on the part of the Apostles and of the angels in the sky, the Virgin of the *Assumption* is propelled to heaven by the physical endeavours of the figures who support the mandorla in its ascent, and the *Entombment* in St Peter's is presented as a transitory episode which the closing of a curtain may suddenly conceal from view. In the relief on the Siena Font not only is the action presented at its climactic point, but use is made for the first time of one expedient that bulks large in Donatello's later work, the severing of the figures at the sides in such a way as to suggest that the area we see is no more than one section of a world beyond the confines of the frame. Under the *Judith* this expedient is employed again with figures that are cut in an arbitrary fashion at the sides, and at San Lorenzo, by a logical extension of that principle, the scene of the *Lamentation over the Dead Christ* is cut not at the sides only but at the top as well, where the frame severs the legs of the foremost thief with an audacity for which there is no parallel in the whole fifteenth century.

When he was over fifty, in the Sagrestia Vecchia, Donatello portrays his Saints as participants in a spiritual dialogue, and in the twenty panels of the bronze doors beneath he explores, with a remorseless urgency of which no other artist in the fifteenth century was capable, the full range of this reciprocal relationship. At Padua the central groups of the four scenes from the legend of St Anthony likewise derive their sanction from the eye. How truly miraculous is the portrayal of the broken leg cured by the Saint's healing touch. And though the reliefs in San Lorenzo are less lifelike—in the sense that the proportions of the figures are more mannered—they are stamped with the same resolute humanity. What other artist could have

conceived the scene in which the recently alighted angel explains to the mourning women the mystery of the empty tomb?

Vasari describes Donatello as an artist who worked with great rapidity. Looking at the reliefs, the modelled not the carved reliefs, we can well believe that that was so. There was a long act of cogitation while the setting was planned—those complex perspective projections that we find in the Old Sacristy and at Padua—but once that phase was accomplished, impulse seems to have taken charge, and the figurative groups poured pell-mell from Donatello's head. In stucco they have the character of spontaneous sketch-models in which faulty articulation is redeemed by the emotional involvement of the figure in the scene, and in bronze, while more worked over, they preserve the same sense of spontaneity. The wax models for the bronze reliefs at Padua must have had the same character as the stuccos in the Old Sacristy, and the expressive refinements in the heads were in the main achieved by chiselling after the cast was made.

The very richness of Donatello's imagination, the wealth of his invention, compelled him to rely, more extensively than any other great sculptor of the fifteenth century, on help from the members of his shop. But both in marble and in bronze his handling is so highly individual that there is room for scarcely the least doubt as to the works he carried out himself and those that were carried out from his designs by studio hands. The first evidence of large-scale studio intervention occurs in Florence in the fourteen-thirties in the Prato pulpit, where the pattern of collaboration is reasonably clear. Autograph models seem to have been made by Donatello, and were translated into marble by three separate studio hands, and the reliefs in marble were then in part reworked by Donatello. The marble *Pieta* in London is in the same case; the model is Donatello's, but the Christ is the only part of the relief he carved. With bronze, on the other hand, the pattern of collaboration is rather different, since it was in the laborious work of chasing that assistants were called upon for help. Half a century ago it was generally supposed that the reliefs of Angels on the Padua altar were modelled by different members of Donatello's shop. Today it would be generally agreed that all the Angels were modelled by Donatello, and that the differences between them lie in the working-up.

Finish was something by which Donatello set comparatively little store. Faced with the question, 'Is uniformity of finish desirable?', he answered (and he was the only fifteenth-century artist to do so) in the negative. The consequences of that view can be read in marble on the Cantoria and in bronze at Padua, but are most clearly evident in his last works, the pulpits

34. Donatello and Bellano: Detail from *Pentecost*. Bronze. Florence, San Lorenzo

33. Donatello: Detail from the *Lamentation over the Dead Christ*. Bronze. Florence, San Lorenzo

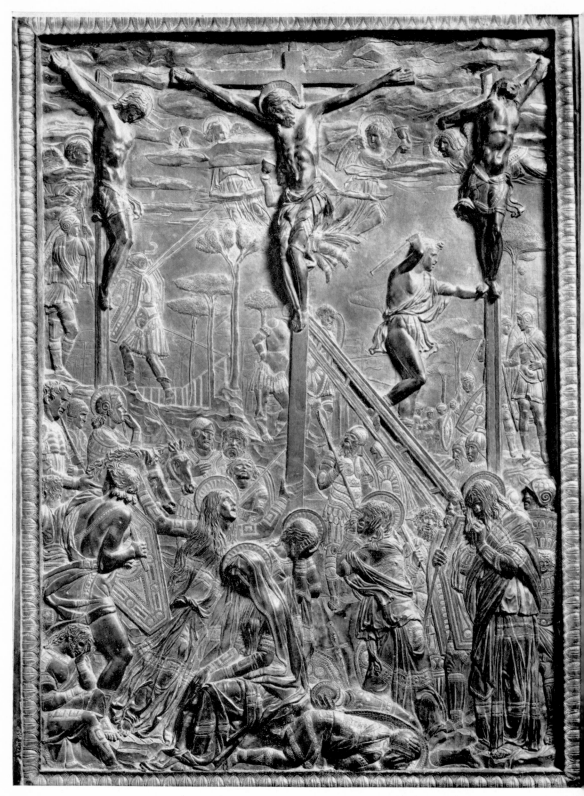

35. Donatello (assisted): *Crucifixion*. Bronze. Florence, Museo Nazionale

in San Lorenzo. In the *Christ before Caiaphas* the foreground figures are fully chased, but the figures in the middle distance are rendered with conscious ambiguity. The significance of this device escaped one of his assistants on the pulpits, Bellano, in the *Crucifixion*, where all the heads are treated with the same degree of emphasis. Almost a century later it eluded Bandinelli, who in a letter to Cosimo I ascribes the practice to the failing eyesight of old age. In the *Lamentation over the Dead Christ*, which was wholly chased by Donatello, the incisions are confined to the bare minimum necessary to define the forms, whereas Bertoldo, in the *Entombment*, has recourse to a multiplicity of parallel incisions which give the figures a flattened graphic character. In the wholly autograph reliefs in San Lorenzo some of the space relationships are undefined. The riding figures in the background of the *Lamentation*, for example, are not integrated rationally in the scene (Fig. 33). When these floating elements were rationalised, by members of the workshop, as they were in the *Crucifixion* relief in the Bargello (Fig. 35), the result is so anomalous that Donatello's authorship of the design has been denied. Certainly no other artist than Donatello can have been responsible for the model from which this extraordinary relief was cast. The contrast between the technical capacity of Donatello and that of the members of his studio is specially pointed in the last dated relief, the *Martyrdom of St Lawrence* of 1465, where the body of the Saint consumed by fire is treated with a fierce veracity that is fortunately unimpaired, while the chasing of the figures on the left is nerveless and mechanical. What an image might not have resulted in the *Pentecost* had Donatello, not Bellano, chased the flaming aura of the Paraclete (Fig. 34). *5385*

I think at this point I should sum up. One of the enigmas people who study art have constantly to face is that some of the very greatest artists are those for whom aesthetic calculation was not significant. Donatello, like Rembrandt, is an artist of that type. He was gifted from the first with physical awareness of a very special kind and with a moral earnestness, an apostolic zeal, that stamped itself on all the works that he produced. He was an instinctive not a conscious artist, and the aspirations which drove him forward arose directly from a revolutionary conception of the relation between life and art. Thanks to that conception he broke through the natural limits of every form and every medium he employed. In the sixteenth century he was commonly compared with Michelangelo, but historically the comparison is meaningless. The Albertian distinction between sculpture and modelling, to which Michelangelo adhered, was alien to Donatello, and when he carved he consciously invested the statues and reliefs he made

with the pictorial properties of modelled sculpture. Indeed the reason why we are celebrating his centenary is that he is not comparable with any other artist, that he distilled, from the force of his own genius, images which are as valid now as on the day when they were coined, and which are, in the most literal sense, unique.

Lecture delivered at the Victoria and Albert Museum on December 13th, 1966.

Donatello's Relief of the Ascension

'T HE Museum at South Kensington', announced the *Athenaeum* on 2nd February, 1861, 'has recently acquired some rather important examples of mediaeval art; in all, adding about a hundred new works to the national collection.' The examples purchased included two works by Donatello, of which one was 'a long frieze or predella, in extremely low relief— the subject, Our Saviour surrounded by the Apostles, giving the keys to Peter'. Since its acquisition this relief (No. 7629–1861. Marble: 41 × 114.5 cm.) of the *Ascension with Christ giving the Keys to St Peter* (Fig. 36) has come to be regarded as the most important example on exhibition outside Italy of the work of the greatest fifteenth-century Italian sculptor.

The scene of Donatello's *Ascension* is the summit of a hill. In the centre, beyond the lightly indicated foliage of the foreground, three distant trees placed on a lower plane than the main group establish the recession of the hillside. To the right the ground slopes away through a pattern of receding trees, while on the left the eye travels over undulating, tree-crowned hills to the distant city of Jerusalem. Across the middle distance flattened tree-tops, rising from a hidden spur of hills, stand out against the cloudy sky. In the centre, his head contiguous to the upper edge of the relief, is Christ supported by four putti on a throne of clouds. Seated frontally, he turns to the figure of St Peter to the right below, raising his right hand in benediction and proffering in his left the keys of heaven. To the left of this group kneels the Virgin, the fingers of her hand extended in vehement gesticulation and her tired face turned towards the ascending Christ. Behind St Peter are four apostles, one with arm outstretched engaging the attention of another on the right, and two in profile with hands raised in astonishment; the head of a fifth, delineated in the lowest possible relief, appears to the left of this group. Behind the Virgin the figures of five further apostles are ranged in a receding line. The first stands immobile, his head in profile and his gaze fixed on the keys; the second, his head turned slighly towards the front, raises his hand as though shielding his eyes from the radiance of Christ; and the third, his head in three-quarter face, expostulates with his right hand. The faces of the fourth and fifth figures are concealed. From the extreme left two embracing angels look on with rapt attention at the scene.

Donatello, to whom the *Ascension* is universally assigned, was born in Florence in 1386. As a boy he was apprenticed to a painter, Lorenzo di Bicci, but by the age of seventeen he had found his vocation in the workshop of the sculptor Ghiberti. By 1406 he was engaged on independent commissions for the Florentine Cathedral, and in his first important statue, the marble *David*, completed in 1408, it is the influence of the monumental marble sculptors employed on the statuary of the cathedral that dominates his work. In the ensuing eighteen years Donatello was engaged principally upon large-scale sculpture, and the masterpieces of these years, the *St John Evangelist* for the Cathedral, the *St Mark* and *St George* for the Florentine guild oratory of Or San Michele (1411–16) and the bald-headed prophet known as the *Zuccone* for the campanile of the Cathedral (about 1423–6), take on a progressively more classical and more naturalistic character. In the transition from the generalised Gothic forms of the *David* to the naturalism of the campanile figures Renaissance sculpture is born. The *Zuccone*, however, marks no more than the middle term in a development unparalleled among Renaissance artists, for in the works of Donatello's old age, executed before his death in 1466, the *St Mary Magdalen* in Florence (about 1455) and the *St John Baptist* at Siena (1457), the realism of his middle period gives way to an emotional and subjective style, equivalents for which must be sought in the late work of a Rembrandt or a Titian rather than in that of artists of the fifteenth century.

We know no fully authenticated relief by Donatello earlier than the *St George and the Dragon* on the socle of the Or San Michele statue of St George (Fig. 37), of which a partial replica in stucco is owned by the Museum. But in this relief Donatello's treatment of small forms already has a breadth and amplitude born of his experience in monumental sculpture, and as we follow his reliefs down through the bronze *Feast of Herod* on the Siena font (1423–6), the marble *Assumption of the Virgin* on the Brancacci monument in Naples (1427), the marble *Entombment of Christ* in St Peter's in Rome (1432), and the stucco tondi in the old sacristy of San Lorenzo in Florence (about 1435–40), to the bronze *Scenes from the Legend of St Anthony* at Padua (1445–50), we become aware not only of his progressively greater facility in the handling of each medium, but of the growth of a narrative imagination which has few rivals in Western art.

Outstanding among Donatello's marble reliefs are the so-called *rilievi stiacciati* or flattened reliefs, of which the *Ascension with Christ giving the Keys to St Peter* is an example. The main characteristics of this type of relief are described by Donatello's biographer Vasari, who, after referring to

the traditional techniques of *mezzo rilievo* (middle or high relief) and *basso rilievo* (low relief), goes on: 'The third type are called low or flattened reliefs. These consist of nothing else than the representation of the figure in dented and flattened relief. They present special difficulties, since they necessitate great skill in drawing and invention. . . . In this type of relief, too, Donato surpassed all other sculptors in skill, invention and design.' The most exacting, the most intimate, and the most subtle narrative technique used by Renaissance sculptors, *rilievo stiacciato* first makes its appearance on the socle of the *St George*. Thereafter it occurs regularly in Donatello's work, and is employed conspicuously for the Brancacci *Assumption*, the *Entombment* in St Peter's, and the Lille *Banquet of Herod*, a relief produced at about the same time as the tondi in the sacristy of San Lorenzo. It is generally agreed that on grounds both of style and of technique the *Ascension* must intervene between the Brancacci *Assumption* and the *Entombment*, and that in all probability it was produced in Florence after Donatello's return from Pisa in 1427 and before his departure for Rome in 1432.

A glance at the *Ascension* reveals the nature of the technical problems peculiar to this class of work. The relief is carved from a slab of white marble, thirty-six millimetres thick, pitted, particularly on the left, with a number of light brown flaws and intersected on the right by two diagonal grey veins. Along the inner edge of the tree-trunk in the right foreground of the scene the cutting reaches a depth of two millimetres, while the emphatically modelled central figures stand out a mere eight millimetres from the ground. To create within these rigid limits the illusion of space and distance, to define the distinction between forward and rear planes, and to establish the sense of the figures represented as three-dimensional bodies with an exact formal relationship to one another was a feat demanding the utmost virtuosity, and it was perhaps the very difficulty of the task that commended it both to Donatello and to the artist who, after Donatello, was its greatest Florentine exponent, Desiderio da Settignano. The modelling depends for its effect on slight, almost incommensurable differences in depth, on small declivities made in the surface of the marble (hence Vasari's term *ammaccato*, or dented), and on superficial chiselling, the *disegno*, or draughtsmanship, on which Vasari lays stress. So important is this last feature that in the lowest parts the execution has more in common with the silverpoint drawings of quattrocento painters than with marble statuary.

It is not known for what purpose the relief was made. Acquired for the

Museum from the Gigli-Campana collection in 1860, it figures in the 1858 catalogue of the Museo Campana, and seems to have been purchased by the Marchese Campana about the middle of the nineteenth century. There is no record of the source from which Campana obtained it, but it is certainly identical with a '*quadro di marmo di mano di Donatello di basso rilieuo: doue è effigiato, quando da le Chiaui Cristo a S. Pietro*', listed in the 1677 edition of Bocchi's *Le Bellezze della Città di Fiorenza* as in possession of the Salviati family in Florence. From an earlier edition of this book we learn that the relief was already the property of the Salviati in 1591. The fact that the Salviati were connections of the Medici through the marriage of Jacopo Salviati with Lucrezia, the daughter of Lorenzo il Magnifico, makes it almost certain that the relief is that listed in an inventory of the possessions of Lorenzo de' Medici, drawn up after the latter's death in 1492, as '*un quadro di marmo, chornicie di legname atorno, entrovi di mezo rilievo, una Accensione di mano di Donato*'. The wooden frame in which the relief was hung in the late fifteenth century may well be that in which it is exhibited today.

Before 1492 all is surmise. We know that at a relatively early stage in his career Donatello attracted the attention of Cosimo de' Medici, who was instrumental in financing the Brancacci monument in Naples, in which Donatello's relief of the *Assumption* was incorporated. In these circumstances it would be unwise to preclude the possibility that the relief was commissioned from Donatello by Cosimo de' Medici. An independent pictorial relief of this type would, however, have been an anomaly in the early fifteenth century, and for this reason writers on Donatello have tended to assume that the *Ascension* formed part of a larger whole. Ruling out the more fanciful of the theories put forward (that the relief was designed for the tomb of Donatello's mother, who died at about this time, a view based on the supposed relation of the figure of the Virgin to a portrait type; that the relief was executed for St Peter's in Rome, a view based on the fact that it contains a figure of St Peter), we find that speculation has followed two main lines. The first hypothesis connects the relief with Or San Michele, where it would have occupied, or been designed to occupy, a position on the socle of the statue of St Peter similar to that of Donatello's *St George and the Dragon* beneath his St George. When, however, we compare the two reliefs, we find that the *St George and the Dragon* is at once simpler in design and bolder in execution than the *Ascension*, which would have been no more than partially intelligible had it been displayed at the same distance from the ground. There is a further difficulty in that

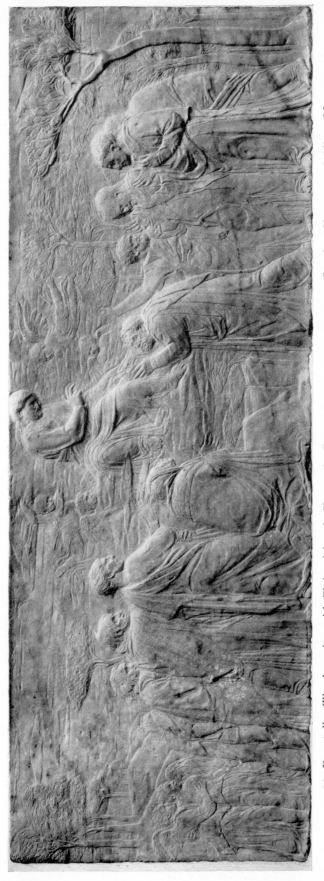

36. Donatello: *The Ascension, with Christ giving the Keys to St. Peter*. Marble, 41 by 114·5 cm. London, Victoria and Albert Museum

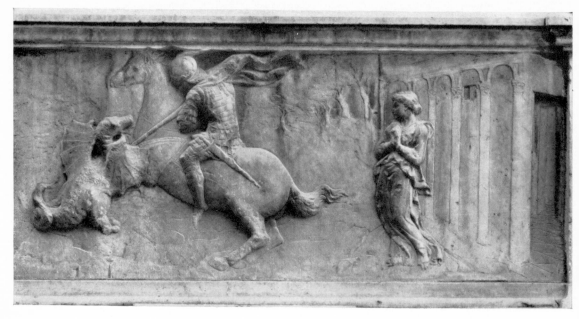

37. Donatello: Detail of *St. George and the Dragon*. Marble. Florence, Or San Michele

38. Ghiberti: *St. Luke*. Bronze.
Florence, Baptistry

39. Detail of Fig. 36

0. Detail from an Aretine Krater.
London, British Museum

41. Detail of Fig. 36

42. *Processional relief*, Roman, second century A.D. Marble. Rome, Lateran Museum

44. Detail from Fig. 36

43. Attributed to Lorenzo di Bicci: *Christ in Majesty with SS. Peter and Paul.* Florence, Uffizi

the statue of St Peter is probably the work of an inferior sculptor, Ciuffagni, and not of Donatello. The second hypothesis is that the relief was carved for the altar of St Peter in the Florentine Duomo in 1439, and formed part of a predella of which the outer panels, by Luca della Robbia, are now in the Bargello. The height of Luca della Robbia's reliefs, considerably greater than that of the *Ascension*, their deep cutting, and above all the absence of any particle of evidence that Donatello was involved in the construction of this altar, militate against acceptance of this view. At the same time the thesis that the *Ascension* formed the central section of a predella or part of a tabernacle has a certain inherent plausibility, since the relief was apparently designed for inspection at eye-level and the context is one in which low relief was not infrequently employed.

What light does the relief itself throw on this problem? We note at once that it combines two scenes which in the gospels are dissociated. The first and earlier of these is Christ's charge to Peter. 'When Jesus came into the coasts of Caesarea Philippi', so runs St Matthew's account of the event, 'he asked his disciples, saying, Whom do men say that I the Son of man am? . . . And Simon Peter answered and said, Thou art the Christ, the Son of the living God. And Jesus answered and said unto him, Blessed art thou, Simon Barjona: for flesh and blood hath not revealed it unto thee, but my Father which is in heaven. And I say also unto thee, That thou art Peter and upon this rock I will build my church; and the gates of hell shall not prevail against it. And I will give unto thee the keys of the kingdom of heaven: and whatsoever thou shalt bind on earth shall be bound in heaven: and whatsoever thou shalt loose on earth shall be loosed in heaven.' The second, and much the later, of the scenes is the Ascension. 'And he led them out as far as to Bethany', writes St Luke, 'and he lifted up his hands, and blessed them. And it came to pass, while he blessed them, he was parted from them and carried up into heaven. And they worshipped him, and returned to Jerusalem with great joy.' From very early times the Ascension played an important part in Western Christian iconography. But the subject of Christ's charge to Peter is comparatively rare. In the fourteenth and early fifteenth centuries it is represented symbolically by means of a formula which may best be seen in a drawing (Fig. 43) attributed to Donatello's supposed master, Lorenzo di Bicci, while later it is portrayed historically in terms consonant with the gospel narrative. Donatello, on the other hand, embodies one scene integrally in the other, and as if to emphasise that the charge to Peter is more than a detail in an otherwise conventional Ascension, shows the gaze of the spectators focused on the keys, and not on the ascending

Christ, and the gesture of benediction directed to St Peter, and not to the apostles as a whole. Any interpretation which regards the charge to Peter as incidental to the main theme of the relief runs counter to the whole character of the design.

At this point aid comes from an unexpected quarter in the person of Abraham, Bishop of Souzdal, who visited Italy in 1439 and left in a manuscript known as the *Itinerario* an account of what he saw there. It happens that Abraham of Souzdal was in Florence for the feast of the Ascension, and that on Ascension eve, 14th May, he was taken by his hosts to a performance of the Ascension play presented annually at this time in the Carmine. On his arrival in the church he found a stage disguised as a hill, the Mount of Olives. Below to the left, on the far side of a partition, was a castellated structure, the city of Jerusalem, and above, fifty or more feet from the ground, was a platform concealed by a blue curtain painted with sun, moon and stars. When all of the spectators were assembled, there appeared on the main stage four youths dressed as angels leading an actor representing Christ towards Jerusalem. After a brief interval these figures re-entered from the city, bringing with them the Virgin Mary and St Mary Magdalen. Returning once again to the castellated structure, the actor representing Christ fetched from it the apostles, headed by St Peter, whom he led up the stairs to the main stage. Arrived at the Mount of Olives, the Virgin Mary moved to Christ's right, St Peter to his left, and the apostles, 'barefoot, some beardless, some with beards, just as they were in life', ranged themselves on either side of the main group. After a brief dialogue, in which Christ conferred on each of the apostles his peculiar gifts, he climbed to the summit of the hill, speaking the words: 'Since all that was prophesied concerning me is now accomplished, I go to my Father, who is also your Father, and to my God, who is also your God.' The apostles turned to one another in consternation, exclaiming, 'O Lord, do not abandon us, for without Thee we are as orphans,' to which Christ replied: 'Cease weeping, for I do not leave you orphans. I go to my Father, and I will beseech him to send the spirit of consolation and truth upon you, which will teach you all things. If I do not depart, the Paraclete will not descend upon you.' At this point a clap of thunder resounded through the church, and a cradle, masked by painted clouds, descended on pulleys from an aperture above the stage. During its descent, the actor representing Christ took up two golden keys, and blessing St Peter handed them to him with the words: 'Thou art Peter, and upon this rock I will build my church.' Thereupon Christ took his place on the cradle, and with the aid of seven ropes was slowly hoisted out of sight, leav-

ing the apostles bathed in tears below. 'A marvellous performance', notes Abraham of Souzdal, 'and without equal anywhere.'

Now the Carmine play of the Ascension and Donatello's *Ascension with Christ giving the Keys to Peter* have a number of points in common. In the first place both the play and the relief combine two historically discrete scenes. In the second place the details of the two representations are in general conformity; the Christ seated as though on a cloud surrounded by flying putti, the St Peter to Christ's left rising from his knees to accept the keys, the lamenting Virgin to His right, the youthful angels, even the city of Jerusalem, all have their place in Donatello's scheme. And in the third place the spirit which animates the relief, inspires its passionate gestures and invests it with an overwhelming actuality is the spirit that flickers through the pages of Abraham of Souzdal. Inevitably artists were associated with the staging of religious dramas; in the 1430's, for example, Brunelleschi devised machinery for the play of the Annunciation performed annually in San Felice, and in the twenties, at the instance of the Carmine, Masolino repainted the cloud-covered platform on which Christ made his annual ascent to heaven. Though there is no evidence of Donatello's personal participation in such work, he would certainly have been familiar with the Carmine play of the Ascension, and we may conclude that he made this the source of his relief.

Let us pass at this point from iconography to style. For Vasari *rilievi stiacciati* were reminiscent of the Roman pottery ornamented with designs in low relief produced in Italy in the first century A.D. Later critics have tended to accept the suggestion implicit in Vasari's note that this pottery, the Aretine ware lauded by Martial and Pliny, formed a point of departure for the new technique. Not only is a classical origin for this class of relief, whether in pottery or marble, consistent with the study of classical antiquity pursued by Donatello in Rome in the early 1420's, but it serves also to explain the classical motifs which are so prominent a feature of the *Ascension*. Foremost among these we may note the sharply drawn profiles of two of the Apostles, precedents for which occur both in Roman reliefs and in Aretine moulds (Figs. 40–42). The handling of the drapery throughout the relief is also inspired by classical procedure, and it is instructive to compare the Christ, in which, following the Roman practice, the drapery is used naturalistically to define the forms, with the similarly posed St Luke on the first of the bronze doors of Ghiberti, where the forms are hidden beneath conventional Gothic folds (Figs. 38–39).

But if the style of Donatello's figures is classical, there is nothing classical

about the system on which they are deployed. Indeed it would be difficult to overstate the contrast between the simple, frieze-like structure of a Roman bas-relief and the complex organisation of the *Ascension*, for Donatello's design is based on the Renaissance doctrine of linear perspective, the law governing the depiction of bodies in receding space. In the history of optics the discovery of linear perspective occupies the place of the discovery of the law of gravity in physics or of the circulation of the blood in medicine; it effected a revolution in representation the results of which have lasted till today. The implications of linear perspective were not immediately appreciated. In 1424, a decade or more after Brunelleschi's earliest researches into the mathematics of space representation, Masaccio initiated the first fresco cycle in which linear perspective is extensively employed; in the 1430's the theory of perspective was codified in the *Della Pittura* of the architect Alberti; and in the 1440's its practice was carried to new heights of ingenuity by Paolo Uccello in the frescoes in the Chiostro Verde and in Donatello's bronze reliefs at Padua.

Initially linear perspective was accepted as a means of representing the real world in a more faithful way. It enabled the artist to invest figures, details of landscape, architectural forms, distributed over a multiplicity of planes, with a convincing three-dimensional existence, regardless of their distance from the foreground of the painting. The rapture with which artists greeted this illusionistic aspect of the new technique may be gauged in the *Ascension* from such features as the five apostles to the left arranged in a receding line and the receding diagonal of the trees behind them. But linear perspective had a second and ultimately a more important function as a system which permitted the artist to organise his composition as an aesthetic whole; through application of new structural principles the scene to be depicted was correlated with an elaborate linear scheme. By the protagonists of Florentine perspectivism, and notably by the painter Masaccio, it was recognised that these geometrical expedients were not ends in themselves, but means of securing greater clarity of structure and heightened expressiveness. It is in this spirit that they are employed in the *Ascension*, where the Christ is seated at the apex of a triangle, the side of which is completed by the left arm and right leg of St Peter, while the Virgin in dramatic isolation kneels at the left lower corner of the base. In this central episode, and in the subordinate features which direct the eye towards it, pictorial science is placed at the service of an overpowering dramatic sense.

For artists of the first half of the fifteenth century the *rilievo stiacciato* was a no-man's land between painting and sculpture in which the sculptor

could glean the fruits of pictorial research. As early as 1427 Donatello was in contact with the leading Florentine painter of his generation, Masaccio, This lends colour to the theory that in the *Ascension* the disposition of the figures was to some extent determined by the frescoes which Masaccio was engaged in painting between 1424 and 1428 in the Brancacci Chapel in the Carmine, and particularly by Masaccio's *Tribute Money*. Despite the basic disparity of scale the organisation of both compositions across an oblong field is generally similar; in both there is the same relation between the figures and their distant background; in both the apostles to the right of Christ are grouped in a half-circle, and those to his left are arranged on a diagonal; and in one case a figure from the *Tribute Money*, the St Peter, has been transferred bodily with minor modifications of pose to the right background of the *Ascension*. In face of these analogies it can hardly be doubted that at the time the *Ascension* was conceived Masaccio's frescoes in the Carmine were in the forefront of Donatello's mind.

Thus study of the style of the relief leads us back to the same point as study of its iconography, the church of the Carmine in Florence. And what an enticing vista opens before us when we allow speculation to take charge. Can it be, we ask ourselves, that the relief was actually designed for the Brancacci Chapel? That the execution of an altar or a tabernacle was interrupted, when the predella alone had been completed, by Donatello's Roman journey, and was discontinued when the Brancacci were exiled by Cosimo de' Medici in 1434? That the cycle of scenes from the life of St Peter painted in the chapel by Masaccio and Masolino omitted the central incident of the presentation of the keys precisely because this was to be shown elsewhere? To all these questions we can answer only that we do not know. But whether or not it was commissioned for the Carmine, the *Ascension* was certainly produced in close association with the artists employed upon the decoration of the church, and is imbued with the same classic gravity that inspired the work of these great pioneers.

The relief is also, in a profound sense, personal to Donatello. The more closely we analyse great works of art, the deeper is the respect we feel for the mysterious process by which old elements are translated into new; and study of its sources should not cause us to forget that for the early fifteenth century Donatello's relief style was one of revolutionary novelty. No artist in any medium had previously evolved a language so free, so human and so intimate. Today, when the freshness of Donatello's idiom is no longer immediately evident, these three qualities of freedom, intimacy and humanity endure. The *Ascension* still astonishes us by the movement of its broken,

highly activated surface, by its intimations of atmosphere and distance, by its suggestions of colour and light. The exquisitely subtle handling creates an illusion of momentary inspiration, and fosters a sense that we have been admitted to creative recesses of the artist's mind. And the subject, the founding of the Christian church, is interpreted in terms of universal emotions, which irrespective of our belief or incredulity, retain their vividness and their validity. An understanding of the relief presupposes knowledge of its place in the history of art and of the intentions with which it was produced. But the *Ascension* is at the same time the repository of a living message, which can only be fully apprehended when we lay textbooks and photographs aside and ourselves make ready for communion with Donatello's masterpiece.

Originally published as a Victoria and Albert Museum monograph in 1949.

Some Donatello Problems

THE AREZZO FONT RELIEF

THE low relief of the *Baptism of Christ* (Fig. 45) on the baptismal font in the Cathedral of Arezzo is mentioned by Vasari as a work of Donatello's brother Simone: 'Per lo battesimo similmente del vescovado d'Arezzo lavorò, in alcune storie di bassorilievo, un Cristo battezzato da San Giovanni.'[1] By the nineteenth century this attribution had become traditional and the relief figures under Simone's name throughout the local literature of Arezzo. Thus in the anonymous *Memorie istoriche per servire di guida al forestiero in Arezzo* of 1819, it is recorded in the form: 'Il Fonte battesimale che ha de' Bassirilievi esprimenti alcuni fatti della vita di nostro Signore, è pregiato lavoro di Simone, Fratello di Donatello che lo eseguì nel 1339.'[2] It appears, however, to have attracted little notice until it was mentioned by Bode and Fabriczy in the revised edition of the *Cicerone*: 'Der einfache sechseckig prismatische Taufstein im Dom, von Vasari dem Simone di Nanni Ferrucci (geb. 1402) zugeschrieben, ist nur wegen des Reliefs der Taufe Christi beachtenswert, das den engsten Anschluss an Donatello verrät.'[3] In 1908 the relief was the subject of a further footnote by Fabriczy, who observed that it was 'entschieden Donatellesk, in der einfach würdigen Komposition und dem Stiacciato den engen Anschluss an den Meister bekundend',[4] and a year later, for the first and only time, it was ascribed directly to Donatello. This ascription was due to Schottmüller, who noted that the quality recalled that of the Quincy Shaw *Madonna* and the St Peter's *Entombment*, but that the relief was somewhat earlier, and occupied a position midway between the *St George and the Dragon* in Or San Michele and the London *Ascension*.[5] In Schottmüller's view the date attached to the font probably depended from a lost inscription in which MCCCCXXIX has been misread as MCCCXXXIX. Based on these slender arguments, the attribution made no headway, and has been tacitly or explicitly denied by all later writers on the artist.

The Arezzo font is a six-sided structure containing on the three rear sides the stemme of the Popolo, the Commune and Opera of the Cathedral, and on the front the *Baptism of Christ* flanked by the two scenes of the *Baptism*

of St Donatus by the Monk Hilarion and *St Donatus baptising* (Figs. 46–47). It is known to have been moved on a number of occasions; in 1613 it was dismantled, in 1620 it was re-erected in the Cappella dei Morti on the right side of the church, and in 1796 it was again transferred and set up in its present position in the new bapistery.[6] In the course of these changes of position, it was considerably modified. Information available to Pasqui indicates that five of the six pilasters at the corners were replaced in 1568, and that other changes were made in the early seventeenth century. This chequered history is reflected not only in the architectural sections of the font, but in the three narrative reliefs. All of these rest on moulded bases, and the two lateral scenes terminate above in a frieze with a suspended garland carved in one with the relief. In the *Baptism of Christ* the upper garland is an addition, evidently inspired by the friezes on the companion scenes, and a section has been added on the right, apparently with the intention of equalising the width of the relief with that of the two lateral scenes. On the left part of the original moulding of the *Baptism of Christ* is preserved, and this was presumably repeated on the right. Despite these discrepancies, it cannot be doubted that the three reliefs were from the first intended for this complex, though their styles are strikingly dissimilar. In the absence of an inscription, the only evidence for the date of the font is the intrinsic character of the reliefs.

None of the available accounts of the *Baptism of Christ* nor any of the published photographs gives an adequate impression of its singularity. In the foreground slightly to the left of centre stands the Christ, with arms crossed on his breast and head in virtual profile to the right. The weight of his body is borne by the left leg, and his ankles and feet are visible beneath the water which runs across the whole front of the scene. St John, with head bowed and right arm raised, stands on the right on a slight eminence. His hair shirt is covered by a toga-like cloak which he holds up with a sharply foreshortened left hand. Behind him is an angel in left profile, wearing a long robe resolved at the bottom in smooth folds. The head of a second angel appears to the left of this figure. On the left of the relief are three more angels, one kneeling with Christ's robe across his wrists, and two standing, one with arms crossed on his breast and the other with hands clasped in prayer. These clandestine onlookers are partially concealed behind three leafy trees which separate them from the Christ and which seem to be opposed to a fourth barren tree on the extreme right. The trunk and branches of this latter tree are rendered in an extraordinarily ambitious fashion, as are the gnarled roots of the tree in the foreground on

the left. Another feature worthy of notice is the clump of bulrushes in the centre on the river bank, which closes the foreground of the scene. On the left between the foreground trees a distant tree is represented, and through the centre and right side of the relief is a panorama composed of folds of hills with upwards of ten receding trees. This part of the relief has been much abraded, and some details seem to have been effaced. In the sky above, on an intermediate plane, is an apparition of God the Father, apparently represented horizontally on a floating mattress of cloud, with head and halo foreshortened and the right hand raised. A diminutive dove with seven rays plunges down above Christ's head.

No more than a cursory glance is needed to see that the *Baptism of Christ* cannot, as Schottmüller supposed, be a work of Donatello carved in the mid-twenties between the St George relief and the *Ascension* in London. To take two points alone, the distant trees are relatively stiff and tentative, while in the St George relief they are rendered with marvellous impressionistic skill. At the same time the drapery forms of the St John and of the angel at his back have nothing in common either with the fluid drapery forms of the Princess on Or San Michele, or with the robes of the apostles in London. Yet these points also speak against the conclusion that the relief is a pastiche of these two carvings.[7] If then we ascribe the *Baptism of Christ* to a Donatello imitator, we must define him as a highly individual artist, responsive to some but not to other aspects of Donatello's work, who combined Donatellesque motifs with strongly classical though in some respects archaic drapery forms. No similar carving survives.

One of the most disconcerting facts about this explanation is the overpowering strength of the realistic impulse which is felt behind the whole relief. How strange that an artist who disdained to follow Donatello's drapery style should have inserted in the sky a little God the Father which has no source in Donatello's work, yet in handling and conception is so typical of Donatello. How strange that the trees if based on those of the *Ascension* should be treated so vigorously and in much greater depth. How strange that the whole iconography of the *Baptism of Christ* should be reinterpreted, by this unknown minor master, in classicising terms. The feet visible through the water, the mysterious bulrushes, the symbolism of the trees, the carefully meditated drapery, all of these seem to reveal an original, albeit a still inexperienced, mind. Above all, the central figures perform their roles with rapt concentration and solemnnity which prompt us to ask once again whether the relief cannot after all be a work of Donatello.

When, however, we resume the search for analogies for the main figures

in Donatello's work, we are led not to reliefs carved in the mid-twenties but to some of Donatello's earliest statues. The stance of the Christ finds a natural parallel in the marble *David* of 1408–9, where the weight is distributed between the legs in precisely the same way. The drapery of St John, caught up against the legs and falling in a single uninterrupted fold on the left thigh, is also reminiscent of this statue. In the angel behind St John the pure classical profile and free hair might be a tiny sketch for the St George, and the long vertical lines of robe could be regarded as a foretaste of the first of the prophets on the Campanile. Is there then a possibility that the Baptism is not an imitation of Donatello's mature work, but the earliest of his stiacciato carvings?

Without exception writers on Donatello have subscribed unquestioningly to the view that the scene of *St George and the Dragon* is Donatello's first relief. Yet when it was carved the sculptor was in his early thirties, and had behind him a long series of statues on a monumental scale. Are we then to believe that the interest in relief, which proved such a compelling force throughout his later work, developed only in middle life? Certainly the style of the St George relief would seem to imply the contrary, for though the space projection in this scene is still tentative, its technique is so assured that it can only be interpreted as the outcome of a series of earlier experiments. Those trees that are lightly yet precisely indicated in the background—surely they must have been preceded by countless trees of a less subtle and less expert kind? And the ground—how smoothly it recedes and how easy are the transitions between one plane and the next. Surely Donatello must have carved earlier reliefs in which the recession was less easy and the transitions were more abrupt? The figures, too—how effortlessly movement is rendered and volume is communicated. Surely there were earlier carvings composed of static figures, in which the artist's grasp of volume could be sensed only through the veil of an empirical but still inadequate technique? Obviously in reconstructing the putative style of these lost carvings, the statues Donatello executed at this time would have to be taken into full account, and when that was done we would arrive at a visual image remarkably like the Arezzo *Baptism of Christ*.

But there remains one piece of external evidence for the date of the Arezzo carving, and that is the style of the companion scenes. Assuming, as we are bound to do, that the three reliefs were executed for one complex in the same term of years, can the scenes of *Hilarion baptising St Donatus* and *St. Donatus baptising* be reconciled with a dating about 1410–12? The view of Schottmüller was that in these scenes 'die Architektur entspricht

der Zeit um 1430, den Anfängen der Renaissance, und gleiches gilt ja für die Taufe Christi'.[8] If the reliefs were planned for the same complex as the *Baptism*, Schottmüller seems to have argued, they must be the work of an assistant of Donatello, and what candidature could be stronger than that of Donatello's documented partner Michelozzo? Now not only have the carvings nothing in common with Michelozzo's authenticated reliefs, but they manifestly are the work of an artist of an older generation, incapable of more than a limited reaction to the new language of the early fifteenth century. In the scene of *St Donatus baptising* the hexagonal font is still formulated much as it had been by Orcagna in the *Presentation in the Temple* in Or San Michele, while in the *Baptism of St Donatus* the spandrels are filled with foliated decoration that in its modest manner recalls the Porta dei Canonici, as do the putto heads in this and the companion scene. The ramshackle space construction is less systematic than Orcagna's, and would be unthinkable in Tuscany in the second quarter of the fifteenth century, while the figures have the worried faces and pursed mouths, the loose articulation and ambling drapery that we associate with the work of Niccolò di Pietro Lamberti and other sculptors working for the Cathedral in Florence at the extreme end of the fourteenth and the very beginning of the fifteenth century. When account is taken of all these factors, it becomes clear that no date later than 1410–15 would be consonant with the style of these reliefs, and that they accordingly corroborate, and do not controvert, the date proposed for the *Baptism of Christ*. If this early dating is correct, however, the relationship between the scenes presumed by Schottmüller must be reversed, for instead of a complex designed by Donatello and completed by an assistant, we have here a unit planned by an unknown artist, to which Donatello contributed a single scene. Not only therefore are we present in the *Baptism of Christ* at the birth of stiacciato carving, but already at this early time the technique is used, as it was later in the St Peter's tabernacle and on the Brancacci monument, to provide a focus of narrative and aesthetic interest.

II

THE MARBLE LAMENTATION IN LONDON

One of the most notable of the fifteenth-century Italian sculptures in the Victoria and Albert Museum is a marble relief of the *Dead Christ tended by*

Angels (Fig. 48), which has figured intermittently in books on Donatello.[9]
Despite its long bibliography, it has not received the detailed consideration
it deserves. Nothing is known of the history of the relief before its appear-
ance in the Gigli-Campana collection.[10] It was accepted by Robinson, in
his catalogue of 1862, as a work of Donatello,[11] with the observation
that the torso of the central figure was 'so similar in style to that of the
Christ in the Pieta of Michelangelo, in St Peter's, that it is not unreasonable
to suppose Michelangelo to have been acquainted with it'. The relief
appears in Bode's *Denkmäler*,[12] and remained unquestioned in the spate
of books on Donatello that were published in the late nineteenth century.
In 1904, however, a note of doubt was sounded by Schottmüller,[13] in
1908 Lord Balcarres suggested that the relief was carved by Donatello
in collaboration with Michelozzo,[14] and in the same year Venturi, in the
Storia,[15] observed that 'dovette essere eseguito da un discepolo di Donato,
come fanno pensare particolarmente quegli angioli del fondo, due dei quali
portano la destra al capo, ed hanno sopracciglio ad angolo circonflesso'. In
1930 the attribution to Donatello was once more reiterated by Maclagan
and Longhurst,[16] and in 1935 it was taken up again by Kauffmann.[17] Ten
years later, in the more sceptical climate that resulted from the work of
Lanyi, it was omitted from the Donatello monograph of Planiscig.[18] More
recently an attribution to Donatello and Michelozzo has been revived by
Martinelli.[19] A survey of this literature leaves the general sense that those
students who looked seriously at Donatello's work, and were not, like
Bode, prepared to give every relief the benefit of every doubt, were one and
all concerned at the presence of features which could not be reconciled
with a direct ascription to Donatello. Yet attempts to explain away the style
of the relief by reference to Michelozzo (Balcarres, Martinelli) or the
young Desiderio (Schottmüller) have proved unconvincing, and are indeed
demonstrably false. Where then is a solution to be sought?

With the *Dead Christ tended by Angels*, more than with most Italian
sculptures of the kind, the gulf between the conception and the execution
is very great. Presumably intended (like the comparable carvings by Desi-
derio in S. Lorenzo in Florence and Giovanni da Majano in Prato Cathe-
dral) as a dossal or antependium relief, the carving shows the dead Christ
supported by two angels on the edge of the sarcophagus. Behind are three
lamenting angels disposed as a frieze in low relief. The relief is surrounded
by a decorated moulding which cuts off the lower part of the right hand of
Christ, the elbows of the outer angels in the background and the upper
parts of the haloes of two of the three foreground figures. This device

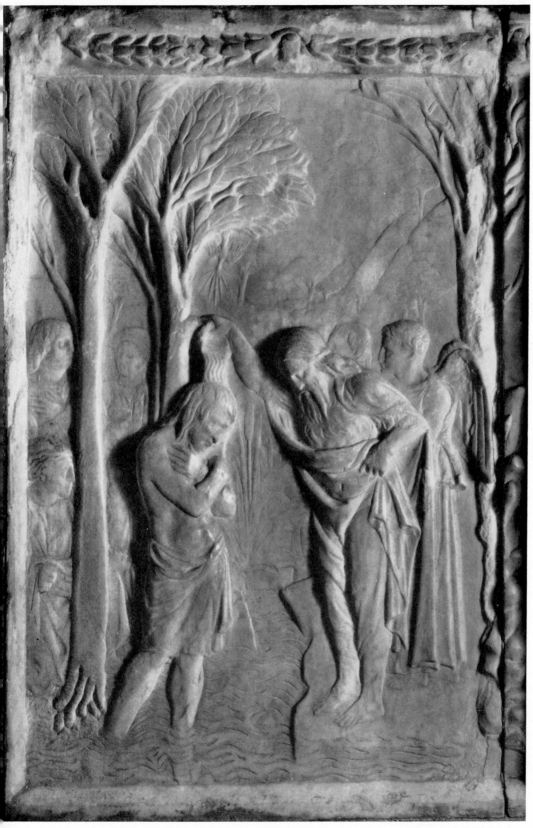

45. Donatello: *The Baptism of Christ*. Marble. Arezzo, Duomo

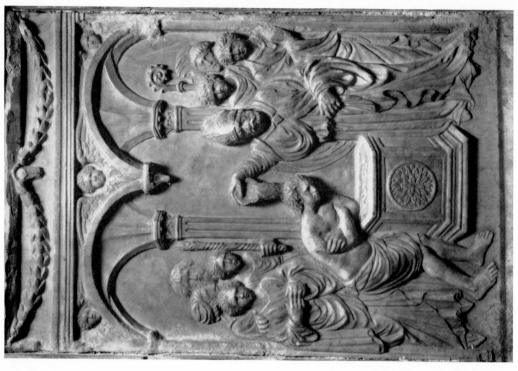

46-47. Florentine School: *The Baptism of St. Donatus by the Monk Hilarion, St. Donatus Baptizing. Marble. Arezzo, Duomo*

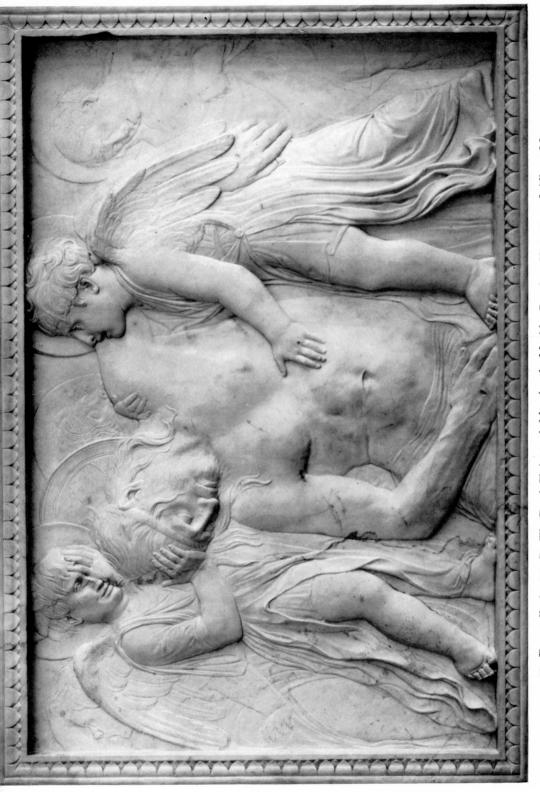

48. Donatello (assisted): *The Dead Christ tended by Angels*. Marble. London, Victoria and Albert Museum

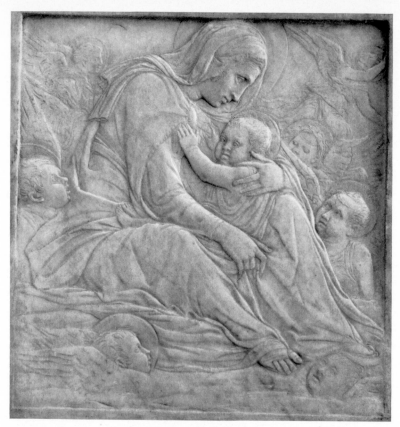

49. Donatello (assisted): *The Madonna of the Clouds*. Marble.
Boston, Museum of Fine Arts

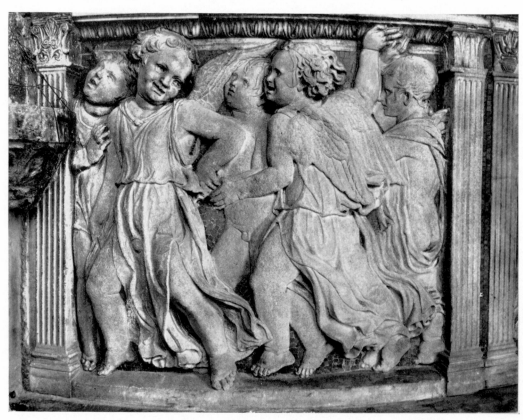

50. Donatello (assisted): *Pulpit relief*. Marble. Prato, Duomo

has the effect of emphasizing the main figures, and the central figure of Christ, precariously supported in an upright pose by the angel on the right, is conceived with a depth of human feeling that gives it a unique position in the sculpture and painting of its time. Not till after 1475 indeed do we encounter, in Giovanni Bellini's great *Pieta* at Rimini, a work in which the form and content are directly comparable to those of this relief.

Turning to the execution, we find, on the other hand, as Venturi noted and as countless other students must tacitly have observed, that the figures in low relief are drawn in a fashion which would be unthinkable in Donatello or in any other major artist. In that on the right the head rests loosely on the neck, like a flower which is too heavy for its stem, and the left hand and wrist are treated as flat areas of marble, with scarcely the least attempt to render the receding planes of the fingers and the hand. These same peculiarities recur in the figure on the left, where the foreshortened hand is reduced to a primitive formula and the thigh and lower leg are shapeless and schematised. The eyes of all three of the rear figures assume a roughly triangular form, with the lids looped up to a point at the top. The foreground angels suggest that the sculptor possessed a greater command of middle than of low relief, though even here the relation of the limbs to the bodies is uncertain and the sense of scale is insecure—there is, for example, a disconcerting difference in size between the rear hand pressed to the face of the angel on the left and the forward hand of the corresponding angel on the right. The insecure articulation of the angels is found again in the raised shoulder of the Christ, and both the upper and lower surfaces of the raised arm and the line of the body beneath it are reduced to a flat incision in which all sense of rotundity is lost. By contrast, the forward arm and the body on the left side are rendered with greater vigour, so that with the body the forms seem to recede through the relief surface, while with the arm the modelling achieves a high level of expressiveness. The rendering of the loin-cloth reveals the thigh beneath, and the almost impressionistic treatment of this part of the surface is manifestly different from the prosaic drapery forms employed elsewhere. From a qualitative standpoint the carving reaches its climax in the head of Christ, where the beard is treated with a delicacy that recalls the stiacciato reliefs of Donatello, and the problems of the ear, rendered with slight foreshortening, and of the further eye, are treated in a masterly fashion that is in marked contrast to the rest of the relief. If this analysis is correct, we are forced back on the view that the relief depends from a sketch-model by Donatello and was in large part

carved by a studio assistant, but that the head and the left side and arm of Christ were worked up or retouched by Donatello.

Perhaps in discussing the handling of the relief it would be well to begin with the putti in low relief at the back, since the forms here are especially mannered and there is at least one work in which they occur again. This is the *Madonna of the Clouds* in Boston (Fig. 49).[20] where we find on the right of the Virgin's knee an upturned cherub head that corresponds in all particulars with the head of the angel on the right in the *Lamentation* relief, and behind the Virgin's back a second cherub head which agrees, in reverse, with the head of the open-mouthed angel on the left. If the study of morphology is meaningful, it is inconceivable that the heads in the London and Boston reliefs were executed by two different hands. In judging the heads in the background of the *Lamentation* we are handicapped by the fact that no low reliefs by Donatello on a comparable scale are known. The cherub heads at Boston, on the other hand, are directly comparable with similar heads in the Naples *Assumption* and the *Ascension* in London, and when these are juxtaposed the possibility that one sculptor was responsible for carving them must clearly be ruled out. With the *Madonna of the Clouds* the conception once again is on an altogether higher level than the execution of the subsidiary parts, and once more there is a discrepancy in handling, this time between the flaccid, rather crudely rendered figure of the Child and the Virgin's noble and expressive head. Given the disparity of scale, it would be hazardous to argue that the heads of the Boston Virgin and the London Christ or the veil of the former and the loin-cloth of the latter were necessarily by the same hand, but it can be claimed with a fair measure of confidence that the smaller relief offers a precise parallel to the larger, in so far as its design is Donatello's, part of the execution may also be his, and the remainder is by the same studio hand. The passage dealing with the *Dead Christ tended by Angels* in Venturi's *Storia* contains a second pertinent suggestion, that the relief should be ascribed to the period of the Prato pulpit.[21] Of later writers Kauffmann also accepts the view that 'gewiss auch in zeitlicher Nachbarschaft der Pratokanzel offenbart sich das Londoner Relief als überlegenes Werk'.[22] So far as concerns composition, the reliefs of the Prato pulpit certainly provide the closest analogy for the *Lamentation*, first in the employment of a shallow platform on which the forward feet of the foreground figures rest, second in the relation between the height of the foreground figures and the total height of the relief, and thirdly in the use at the extremities of figures cut off at right and left in such a way as to suggest that the surface represents no more than one segment of a larger whole. But

whereas the figures in London rise from a flat marble ground, those at Prato are set against mosaic, and even the flattest of them are for this reason invested with some adventitious tactility. If therefore we wish to analyse the relation of the London to the Prato carvings, we must imagine the pulpit reliefs as they would have looked if they had rested on a neutral ground.

We know practically nothing of the methods of work employed in Donatello's studio. It has, however, long been recognised that the hands of a number of assistants are apparent in the Prato carvings, and a recent analysis[23] has even led to the conclusion that Donatello himself worked extensively only on one of the reliefs, the fourth from the left in the centre of the pulpit, that the third from the left is by Maso di Bartolommeo, and the sixth by a classicising artist related to Michelozzo and Pagno di Lapo Portigiani. How far this subdivision of the reliefs should be accepted is debatable, since there are countless instances throughout the pulpit where some passage of unexpected liveliness or enhanced tactility seems to argue the intervention of Donatello's hand. From the visual evidence of the pulpit carvings it can only be inferred that the procedure adopted in this case was remarkably close to that postulated for the *Dead Christ tended by Angels* and the *Madonna of the Clouds*. The connection is indeed an even more specific one, for in the pulpit the first (Fig. 50) and second reliefs on the left are manifestly in large part by one sculptor, and these provide the closest possible analogies for the London and Boston reliefs. In the centre of the background of the first relief, for instance, is a child in low relief whose head is little more than an enlargement of the head on the right of the *Madonna of the Clouds*, while on the extreme left of the second relief is a broken-necked child like the broken-necked angel on the right of the *Lamentation* relief. So intimate is the relation between the angel holding up the arm of Christ and the dancing putto in the right foreground of the first of the Prato carvings, that this seems to be a single figure in which an access of childlike grief has succeeded an outburst of childlike joy.

What lastly is the date of the marble *Lamentation*? It has been shown by Janson that the two relevant panels of the Prato pulpit were almost certainly among those executed between 1434 and 1436.[24] This would not in itself rule out the suggestion of Martinelli that the relief formed the front of the Altar of the Sacrament in the Vatican over which he presumes the St Peter's tabernacle to have been set.[25] This proposal is, however, unlikely on other grounds since the style of the relief is totally unrelated to that of the tabernacle, and it is difficult to associate a large relief of the *Dead Christ tended by Angels* with a complex of which a small relief of the

Entombment also formed part. This surely would have been a unique case of iconographical redundancy. The presumption therefore is that the relief was executed in the late fourteen thirties. In view of the close compositional connection with Giovanni Bellini, however, the possibility cannot be precluded that it was commissioned for or carved in Padua, perhaps concurrently with the much weathered tufo or Istrian stone relief of the *Precious Blood* at Mantua, which makes use of the same decorative pattern in the frame and which is most readily explained as a transcription of a design of Donatello's by a member of his Paduan studio.[26]

III

THE TORRITA LUNETTE

There is one work which has received even more perfunctory treatment from writers on Donatello than the Arezzo font relief. This is a lunette in the vestibule of the Ospedale Maestri at Torrita (Fig. 51), which was published many years ago by Bode as an autograph work of Donatello.[27] It represents the suffering Christ in a mandorla surrounded by seven angels, one of whom holds up a chalice to catch the blood pouring from the Saviour's side. To right and left are standing angels, and two busts which seem to represent the Virgin and St John (and not, as Bode supposed, a young husband and wife). The surface of the relief is considerably weathered, since it was exposed for many years over the entrance to the chapel of the Madonna della Neve adjacent to the hospital, and its effect is not wholly consonant with that of the only photograph available. In reproduction it seems that the angels are scrambling over boulders rather than flying through the sky, but in the original the treatment of the clouds is more sensitive and atmospheric than it appears in photograph, though the modelling, above all in the body of Christ, is somewhat less confident.

Granted that there is no trace of Donatello's hand in the lunette, the fact remains that its conception is remarkably original, and that the moving central Christ seems to depend from a sketch-model by Donatello. The scheme finds its closest point of reference in the *Assumption of the Virgin* on the Brancacci monument, and can hardly have been evolved before this time, but the drapery of the lateral angels is more closely connected with the putti on the Prato pulpit than with the relief at Naples, and would tend to suggest that Donatello's model was made at a somewhat later date

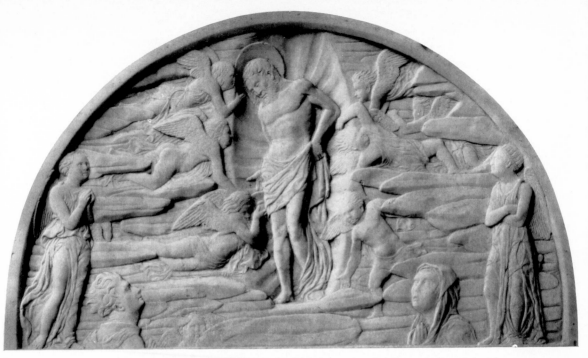

51. Workshop of Donatello: *The Blood of the Redeemer*. Marble. Torrita, Ospedale Maestri

52. Donatello: *Tabernacle*. Marble. Rome, St. Peter's

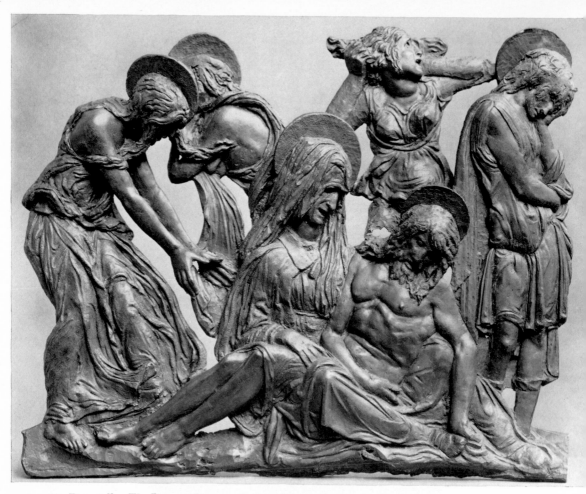

53. Donatello: *The Lamentation over the Dead Christ*. Bronze. London, Victoria and Albert Museum

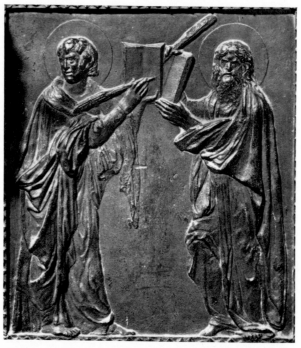

54. Donatello: Detail of Bronze door. Florence, San Lorenzo

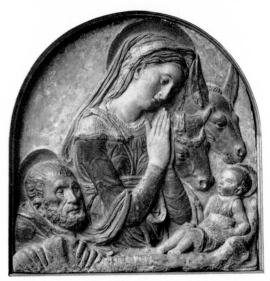

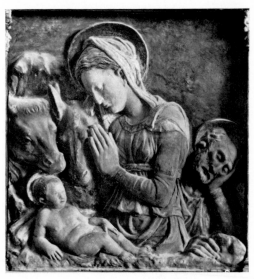

55. Urbano da Cortona: *The Holy Family*. Stucco.
Berlin, Staatliche Museen

56. Urbano da Cortona: *The Holy Family*. Stucco.
Florence, Museo Bardini

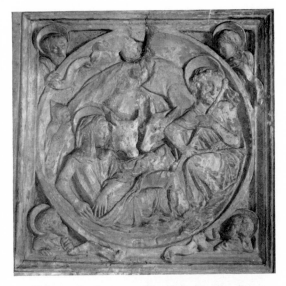

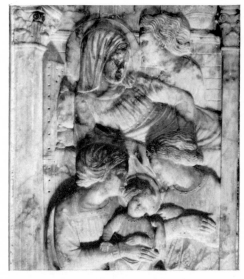

57. Urbano da Cortona: *The Holy Family*. Stucco.
London, Victoria and Albert Museum

58. Urbano da Cortona: *The Birth of the
Virgin*. Marble. Detail. Siena, Duomo

59. Donatello: *Virgin and Child*. Gilded terracotta.
London, Victoria and Albert Museum

60. Workshop of Donatello: *Virgin and Child*. Stucco. Berlin, Staatliche Museen

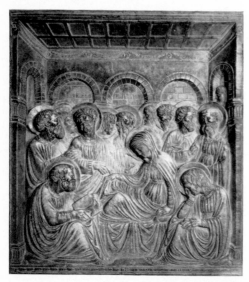

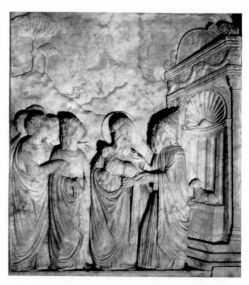

61. Urbano da Cortona: *The Apostles taking leave of the Virgin*. Marble. Siena, Duomo

62. Urbano da Cortona: *Joachim expelled from the Temple*. Marble. Siena, Duomo

than the *Assumption*, in the first half of the fourteen thirties. If the lunette was executed by an assistant, it was probably destined for a relatively high position, above eye level, in a complex of which Donatello may have carved the lower part. The subject of the relief has a Eucharistic significance, and this, in conjunction with its comparatively narrow width, warrants the supposition that the complex was a tabernacle. If, however, it were the upper part of a Donatello tabernacle, we would expect its iconography to be reflected in other works. In Florence no such works exist. When, for example, we turn to the S. Ambrogio tabernacle of Mino da Fiesole, we find that its Eucharistic symbol, the Child standing on the chalice, depends from Desiderio da Settignano's Altar of the Sacrament. When, however, we pass to Rome, to the tabernacle signed 'Opus Mini' in Santa Maria in Trastevere, we encounter above the tabernacle aperture the Eucharistic symbol of the Risen Christ pressing blood into a chalice in much the same form as in the Torrita relief. In isolation none of these fragile inferences would be valid, but together they build up a conjectural picture of the Torrita lunette as the upper part of a tabernacle probably carved in Donatello's studio in Rome about 1433. Was the relief then part of a second tabernacle carved in Rome, or was it the upper part of the St Peter's tabernacle?

Let it be said at once that the upper part of the St Peter's tabernacle (Fig. 52) (and not the lower part, as presumed by Martinelli[28]) is manifestly incomplete. The sense of discomfort we experience in looking at it in its sacristy today arises mainly from the emphatic moulding at the top, which must originally have been intended to support some form of superstructure. The reason for supposing this is that an analogous frieze with a closely similar decorative motif appears in the Cavalcanti *Annunciation*, where it serves as the platform for a lunette. In the Cavalcanti *Annunciation* the lunette is surrounded by a heavy moulding, which terminates in scrolls set directly above the lateral capitals. In the tabernacle the scrolls (if they existed) would presumably have rested on the protruding sections of the cornice, and the width of the surface area of the lunette would thus have been somewhat less than that of the *Entombment* relief beneath (77 cm. excluding lateral framing) while its height might have been roughly equal to that of the lower scene (41 cm.). The Torrita relief exactly fulfils these conditions, since its height (with moulding) is approximately equal to that of the *Entombment* (39.8 cm.) and its width (with moulding) is ten centimetres less (67 cm.). The sanction of dimensions is in this case supported first by the fact that the lateral angels in the lunette are manifestly by the same hand as the lower angels on the tabernacle, and secondly by the

coincidence between the type of the Torrita Christ and that of the Christ in the *Entombment*. The Torrita carving is no substitute for the relief which Donatello might himself have executed, and is something less than a great work of art, but it can at least be claimed that without it the relevance of the *Entombment* to the tabernacle as a whole cannot be understood.

IV

THE BRONZE LAMENTATION IN LONDON

The bronze relief of the *Lamentation over the Dead Christ* in London (Fig. 53)[29] was first published by Fortnum, who suggested that 'this admirable work of the master's earlier manner, was probably designed or modeled by Donatello and executed by one of his pupils'.[30] A direct ascription to Donatello is accepted by all writers on Donatello save Planiscig and Lanyi, by whom the relief was not discussed. It is indeed one of those rare undocumented works the attribution of which is not open to serious doubt. When, however, we proceed beyond this point, problems crop up on every side. Is this an early work, as Fortnum claimed? Or a Paduan work, as Schottmüller supposed?[31] Or a post-Paduan work, as Bode thought?[32] And if the latter, what evidence is there to support the view of Kauffmann[33] (followed by Middeldorf[34] and, in greater detail, by Janson[35]) that the relief is a trial cast made in connection with the doors of the Duomo in Siena in 1458? Perhaps it would be well to deal with this last question first. In the first place there is evidence that models for the bronze doors were made, for in 1467 there appears an inventory reference to 'duo quadri per disegmo delle porti del Duomo face Donatello con ficure suvi di ciera, una cierata et una no', and in 1639 we hear of 'un pezzo di bronzo a cornice doppia, fatta far per mostra delle porti del Dumo, di tre quarti di braccio'. This latter entry suggests that the area of the trial casting, including the moulded frame, was approximately the same size as the present relief. It is, however, highly unlikely that the *Lamentation* was intended as a trial relief, because the background (as has been established by Middeldorf[36]) was chiselled away after casting, presumably on account of casting flaws, and it would therefore have been useless for demonstration purposes. It is uncertain whether the excision was effected in Donatello's studio or at some later time; a stucco of uncertain date in the Museo Bardini appears to have been made from the present relief after the background was excised.[37] If,

therefore, in view of these manifold doubts, we are to accept the relief as a cast made in connection with the doors, it must be demonstrated that the composition belongs stylistically to this and not to any earlier period.

Let us at this point re-examine the relief. It consists of two parts, the seated Virgin and Christ on the ground in front and the four standing figures at the back. Both groups are swayed by strong emotion, but both are schematised. In front the legs of the Virgin are balanced by those of Christ, and the upper parts of the two bodies are turned slighly towards the spectator, so that the effect is one of flatness rather than of recession into depth. The forms unite in a triangular block on the front plane of the relief. The rear figures are arranged in pairs. On the right is the St John, facing outwards in a pose that recalls the corresponding figure in the *Entombment* on the St Peter's tabernacle, but with the left hand and not the right pressed to his face. To his left is one of the Marys, again turned in profile to the right, as is the corresponding figure in the tabernacle. In the bronze relief, how-ever, this mourning woman has the same maenad-like character as the adjacent woman with arms outstretched in the *Entombment*. When we move to the left side of the bronze relief, we find a figure of the Magdalen which is once more in a loose sense a synthesis of motifs used in St Peter's, this time of the male figures bending down to support Christ's shoulders and the distraught woman to his left. Moreover, here the union of the women who gaze in despair at one another in the marble is transferred from a psychological to a physical plane by the expedient of allowing the halo of St Mary Magdalen to cover the second woman's head. With Donatello's post-Paduan reliefs, none of these compositional analogies present them-selves. Neither in the Bargello *Crucifixion* nor in the S. Lorenzo *Lamentation* is there the least trace of the geometrical construction or the paired figures of the London relief, and in both the tendency to align the figures with the relief plane is replaced by a system of sharp recession, whereby in the *Lamentation* the bodies of Christ and the Virgin are shown in profile and in the *Crucifixion* the standing figures of the Marys and St John and the seated figure of the Virgin are represented at right angles to the plane of the relief. Moreover, the drapery forms in the relief in London are less rigid and more fluent than those used throughout the pulpit reliefs.

In all these circumstances we might deduce, from style alone, that the *Lamentation* did not belong with Donatello's latest works, but represented a further evolution of motifs sketched out in the St Peter's tabernacle and was therefore probably produced in the late thirties or early forties, shortly before or immediately after the transfer of Donatello's studio to Padua. But

the proof of this must inevitably rest in the relationship between the *Lamentation* and the doors in the Sagrestia Vecchia, which were almost certainly completed before 1443. When we enter the sacristy, we are immediately faced with parallels of a thoroughly conclusive kind. If, for example, we compare the lower part of the dress of the Magdalen in the *Lamentation* with the robe of the outer Apostle in the central panel on the right in the Apostle door, we shall find that in both essentially the same drapery forms are employed. In the San Lorenzo doors, and there alone, are convincing analogies to be discovered for the figure of St John, turned resolutely outwards from the main focus of the scene, for the full modelling of the flesh and hands, and for the surface treatment of the hair. Above all, the doors offer us, in the outer figure of the central panel of the Martyr door (Fig. 54), an exact analogy for the Christ in the London *Lamentation*, with its wide forehead and heavy beard and hair. This type, so characteristic of Donatello's work about 1440, undergoes its first change in the bronze *Lamentation* on the Padua Altar, and is finally transmuted in the late fifties or sixties into the spare, tense type that is employed throughout the pulpit reliefs. To sum up, then, the evidence of style is decisively in favour of the view that the bronze *Lamentation* was produced about 1440–3, in close proximity with the San Lorenzo doors, and the dating about 1458 postulated by Kauffmann is inconsistent with the character of the relief.

V

THREE STUCCO RELIEFS

The miscellaneous sculptures which have been ascribed to Donatello include three well-known reliefs of the Holy Family. The first (of which a good stucco version existed in the Kaiser Friedrich Museum in Berlin (Fig. 55)[38] and another is in the Museo Bardini[39]) shows the Virgin in half-length turned three-quarters to the right, with hands clasped in prayer and eyes fixed on the Child in the right foreground of the scene. In the corresponding position on the left is St Joseph whose head protrudes above the manger, which he clasps with large coarse hands. Behind the Child are the heads of the ox and ass. The second relief also has an arched top, though versions formerly in Berlin[40] and in the Museo Bardini (Fig. 56) are made up to rectangles. Other examples occur in the Musée Jacquemart-André[41] and elsewhere.[42] In this relief the scheme is an inversion of the first com-

position; the Virgin is turned to the left, the Child (on this occasion represented nude) is shown in the left foreground, the St Joseph, with head resting on his hand and the right hand once more clasping the manger, is on the right, while in the left background are the ox (based on the same cartoon as in the first relief) and the ass, this time in full face. The third relief is circular. A cartapesta of this composition in Berlin has been destroyed,[43] but a stucco exists in the Louvre and a somewhat superior version, forming a rectangle with heads of Prophets in the spandrels, is in London (Fig. 57).[44] In this scene the Virgin reclines in full-length on the left, the St Joseph is seated on the right with his head supported on his staff, and between them on a rear plane is the manger with a diminutive Child Christ watched over by the ox (whose head is shown in much the same position as in the other scenes) and the ass, turned this time to the left. At the back is a rocky cave, round which there peers the tiny figure of a shepherd clutching the rock with his right hand.

It was assumed by Bode[45] that all three reliefs had an explicit relationship to Donatello, the first and second being based, 'wohl von zwei verschiedene Künstlern', on a common Donatello original, and the third representing a similar and contemporary composition by the master. Schottmüller in her revision of the Berlin catalogue[46] modified this view, and postulated a direct connection with Donatello only for the third relief, which she presumed to have been executed from a Donatello sketch by the sculptor responsible for the Via Pietra Piana Madonna and the reliefs in the courtyard of the Palazzo Medici. Maclagan and Longhurst[47] (who were concerned only with the third relief) concurred in the view that this was 'closely related to Donatello's Madonnas and may be derived from a sketch from his own hand, probably dating from about 1450 or earlier'. Manifestly all three reliefs are connected with the work of Donatello, since the Virgin which is represented in the first and inverted in the second depends from a well-known Donatello Madonna of which the original, in gilded terracotta, is in London (Fig. 59),[48] and variants in pigmented stucco produced in the Donatello workshop are at Berlin (Fig. 60)[49] and in the Museo Bardini and elsewhere. But if we eliminate the Virgin, it is impossible, from the other figurative elements common to the three reliefs, to reconstitute a prototype which would pass muster as a Donatello. Not only are the mannered forms at variance with what we know of Donatello's work, but the space construction is also deeply un-Donatellesque. Schottmüller observes of the second relief that 'die Unklarheit der Raumanlage spricht gegen Donatello selbst'.[50] The truth is rather that the reliefs are without space; in the first

and second the heads of St Joseph and of the ox and ass are grouped in an arbitrary fashion round the Virgin and Child, and in the third the diminutive head of the shepherd on the left is introduced into what is otherwise a spaceless scheme. In view of this, the hypothesis that the interrelationship of the three scenes is attributable to a common prototype must be abandoned, in favour of the theory that the reliefs are original designs by one and the same artist. If we examine them morphologically from this point of view, we find abundant evidence of identity of authorship, above all in the hands, which are uniform through all three scenes. With none of the reliefs does it seem reasonable to presume the existence of a marble prototype, and to judge from their rough facture all three must have been moulded from modelled terracotta originals.

The terracotta *Madonna* by Donatello in London and its stucco derivatives are evidently post-Paduan works—not only the types of the two figures but the form of the seat which protrudes forwards from the plane of the relief argue in favour of this view—and the three reliefs under discussion can, therefore, scarcely have been produced before the late fifties. Moreover, their coarse quality and lack of compositional sophistication might be held to favour a provincial origin. Could they then have been the fruit of Donatello's years of residence in Siena? For analytical purposes the most serviceable of the reliefs is the third, the London stucco, since this contains, in addition to the main figures, four heads of prophets in the spandrels, which enlarge our picture of the figurative repertoire of the unknown artist; and we have only to isolate the six heads in this relief to discover that all of them recur in the documented reliefs by Urbano da Cortona from the chapel of the Madonna delle Grazie in Siena Cathedral.[51] The head of the Virgin in the London relief has an exact parallel in the head of St Anne in the relief of the *Birth of the Virgin* in Siena (Fig. 58); the head of St Joseph is an inversion of the head of an apostle in the *Apostles taking leave of the Virgin* (Fig. 61); and the head of the upper prophet on the right corresponds with that of the seated St John in the foreground of this scene. In none of these cases can there be the least doubt of identity of authorship. Moreover, when the search is extended to cover the two remaining stuccos, it becomes clear that the head of St Joseph in the first stands in the closest possible relationship to the head of Joachim in the *Joachim expelled from the Temple* (Fig. 62), and that the head of St Joseph in the second is intimately related to another documented work by Urbano da Cortona, the terracotta figure of S. Bernardino at the Osservanza.[52]

Before the dating of the three stuccos can be discussed it will be necessary

to say something about the chronology of Urbano da Cortona. Born in 1426, he was a member of Donatello's Paduan studio in 1447, when he was engaged in work on the *Symbol of St Luke* for the Padua Altar and on certain other tasks. Despite the efforts of Schubring,[53] there is no means of reconstructing this phase of his activity, and if his later work can be used as a criterion of quality, he must have been employed at Padua not in an individual capacity but as an operative in Donatello's studio.

After 1447 he is presumed to have returned to Central Italy, and to have executed the Baglioni monument in the Duomo at Perugia and a relief from the Bartolini monument in the Magna Aula of the University. Thereafter he moved to Siena, where, in October 1451, he received jointly with his brother Bartolommeo the contract for the Chapel of the Madonna delle Grazie in the Cathedral, which was to be completed by January 1455. From this complex thirteen narrative reliefs and one relief with the *Symbol of St Matthew* from the architrave survive. The latter depends from the corresponding relief by Donatello at Padua, but the style of the narrative scenes is not directly Donatellesque. On 16 July, 1451, two statues were commissioned from Urbano for the tabernacles on the Loggia di San Paolo; only one of these was executed, and this seems to have been set up in the loggia, from which it was removed in 1463 on the completion of Vecchietta's St Peter and placed on the Duomo façade. Two years later (5 May, 1453) there are references to a block of marble for a statue of S. Bernardino (presumably the same contract which was transferred in 1458 to Donatello), and a payment for a terracotta figure of S. Bernardino, which was presented in 1456 to the Osservanza. The latter was apparently designed as a model for the marble statue, and its pose and handling recall those of Donatello's SS. Anthony and Francis at Padua. A stone bench in the Casino de' Nobili in Siena belongs to the year 1462, and thereafter Urbano was almost certainly engaged on the Cristoforo Felici monument in S. Francesco, which bears the date MCCCCLXII ... (probably 1463). A concluding payment for the tomb dates from 10 February, 1487, but the monument was executed at a considerably earlier time.[54] In 1470–2 Urbano was involved in the decoration of the Palazzo Piccolomini; an arbitration between the sculptor and Caterina di Silvio Piccolomini of 27 January, 1472, mentions *inter alia* two Madonnas the price of which was under dispute. A payment of 17 March, 1470, 'per una sancta Chaterina di marmo a capo la porta con due agnoletti' refers to a relief over the entrance of the Oratory of St Catherine of Siena. Urbano died in Siena on 8 May, 1504.

If we disregard Urbano's designs for the pavement of Siena Cathedral,

which have no relevance to his sculptural activity, and those documents which relate to commissions of an architectural or decorative character, we find that the only valid basis for a reconstruction of his work is provided by the Madonna delle Grazie reliefs, the terracotta S. Bernardino of 1453, the Felici monument of (?) 1463, and the S. Caterina relief of 1470. Of the four Madonna reliefs which have been attributed to Urbano, three are inconsistent with his documented works. These include the problematical half-length Madonna behind the altar in the Sagrestia Vecchia of S. Lorenzo in Florence (attribution of Schubring[55]), and a Madonna formerly in the Satterwhite collection (attribution of Ragghianti)[56] which was shown as Federighi at Detroit in 1938. Though the ascription of this relief to Federighi is mistaken, there is a third relief attributed to Urbano da Cortona which is undoubtedly by Federighi; this is the marble relief at the entrance to the Seminario di S. Francesco in Siena, which shows the Virgin crowned with head in near profile to the right bent over the suckling Child.[57] The fourth of the Madonnas ascribed to Urbano is a hexagonal relief in the Palazzo Chigi-Saraceni in Siena, which shows the Virgin with the standing Child surrounded by six cherub heads.[58] Here for the first time are present all of the characteristics of the Madonna delle Grazie reliefs, both in the types of the Virgin and the Child and in the long rigid lines of drapery. No more than the Madonna delle Grazie reliefs can this work be connected with Donatello. The three stuccos, on the other hand, are strongly Donatellesque, and can be explained only as a fruit of the renewed contact between the two sculptors that must have taken place after Donatello's arrival in Siena. If this interpretation is correct, they would have been produced about 1460 to assuage the thirst for Donatellesque sculpture which had been promoted in Siena by the great Madonna, designed by Donatello and carved in his workshop, over the Porta del Perdono of the Cathedral. Analogies with painting seem also to support this view, for the practice of respresenting the ancillary figures in panels of the Virgin and Child by symbolic heads introduced behind or beside the central group only becomes common after 1460, and is associated mainly with the half-length Madonnas of Matteo di Giovanni.[59] Certainly the reliefs were executed before Urbano's style had become stratified in 1470 into the dry, constricted forms of the St Catherine lunette, where only the malformed, match-stick hands bear a recognisable relationship to the three stucco reliefs.

Originally published in *Studies in the History of Art dedicated to William E. Suida on his eightieth birthday*, 1959.

The Martelli *David*

O F the many works by Donatello whose authorship has been contested in recent years, the most remarkable is the unfinished statue of *David* in the Widener Collection of the National Gallery of Art in Washington (Figs. 63, 64, 67). Included in the Donatello monograph of Kauffmann,[1] it was omitted by Planiscig[2] (for somewhat inconclusive reasons stated in an independent article[3]), but has once more reappeared in Professor Janson's *The Sculptures of Donatello*,[4] where it is represented by a number of admirable detail photographs which proclaim, as unequivocally as the work in the original, that this is an interloper in the Donatello catalogue. The publication of Professor Janson's book has led me to turn up some notes which I made about the statue when I studied it three years ago in Washington. Confirmed by subsequent examination, these form the basis of the present article.

The facts about the history of the Martelli *David* (as distinct from the hypotheses which have been stitched into them) may be summarised as follows. A figure of David by Donatello in the Palazzo Martelli is mentioned by Vasari in the first edition of the *Vite*:[5] '*Sono nelle case dei Martelli di molto storie di marmo e di bronzo; e infra gli altri, un David di braccia tre, e molte altre cose di lui.*' The statue in Washington was acquired in 1916 for the Widener Collection from the Palazzo Martelli, and is certainly identical with the statue described by Vasari, since it is shown in the background of Bronzino's portrait of Ugolino Martelli in Berlin. Bronzino's painting dates from about 1540, and we can therefore be confident that in the middle of the sixteenth century the statue was owned by the Martelli and was regarded as a work by Donatello. There is contributory evidence of the importance which was attached to it, in the first place in a passage in the *Riposo* of Borghini,[6] and in the second in a number of bronze statuettes deriving from the statue. Examples of these are in the Louvre, the Kaiser Friedrich Museum in Berlin (Fig. 68) and the collection of Sir Kenneth Clark. The bronzes have been ascribed to Donatello (Bode,[7] Bange,[8] Kauffmann[9]), have been given to 'minor masters of the final third of the fifteenth century' (Janson),[10] and have been dated about 1500 (Weinberger).[11] Nothing is known of the earlier history of the statue, though it has been stated (Seymour)[12] that it was owned by Ruberto Martelli and suggested

(Kennedy)[18] that it was purchased by Ugolino Martelli shortly before the painting of Bronzino's portrait. The historical evidence for its ascription to Donatello is therefore in the highest degree inconclusive, and its authorship can be determined through examination of its style alone.

At the outset we are confronted by the central difficulty that the statue is unfinished. Unfinished quattrocento sculptures are extremely rare—the unfinished portrait of a lady in the National Gallery of Art in Washington is one of the few examples that come to mind—and it is essential to distinguish very clearly between the rough surface of the statue, which is a concomitant of its unfinished state, and the potential figure which lies beneath. If, to take an extreme instance, we imagined the svelte *St John the Baptist* of Benedetto da Majano in the Sala dei Gigli of the Palazzo Vecchio in the same unfinished state as the Martelli *David*, we should have to reconstitute an image in which the superficial ruggedness of the marble surface belied the nature of the intended forms. In order to identify the sculptor of the *David*, therefore, we must first gain an impression of the work he intended to produce.

The figure rises from a platform with a clearly demarcated frontal plane. The head of Goliath between its feet is aligned with the front of the base, and the right foot is set axially to the front plane. The left leg is withdrawn and is bent slightly at the knee. Across the hips the body conforms roughly to the plane of the base, but above the waist it is turned, so that the left shoulder and left arm project from the main plane and the right shoulder is drawn back. This movement is counteracted in the head, which is turned slightly to the left. When we move round the figure, we find that this rather indecisive pose is accompanied by a still more indecisive profile view (Fig. 64), in which a timid system of projection and recession is employed once more. The statue has in effect no more than a single frontal view, and its relief-like character is accentuated by a tree-trunk at the back which redresses its otherwise defective stability. This is the more puzzling in that the figure was apparently intended to be fully finished off behind. Perhaps the clearest proof of its deficiencies is provided by the bronze derivatives (Fig. 68), where the pose is elaborated and the stresses are heightened in such a way as to turn it in fact as well as name into a freestanding statue. In these the pose has been revised in the light of the style concepts of the second quarter of the sixteenth century, and there is no justification for supposing that any of the bronzes deriving from the marble date from before this time. What then is the relation of the statue to Donatello? It is true that when we dissect it limb by limb a number of motifs

prove to be derived from Donatello's sculptures. The right hand pressed against the thigh may, for example, be a reminiscence of the *St George*, and the placing of the right hand, as well as the protruding knee and elbow, may well depend from the bronze *David*. But these similarities are insignificant beside the fundamental incompatibility of the whole composition, the profiles as well as the front view, with those employed in Donatello's authenticated works. The proposition that the artist of the marble *David* and of the *St Mark*, of the *St George* and the Prophets on the Campanile, could have produced the weak and loosely planned Martelli *David* cannot be seriously maintained. Not only is the statue not by Donatello, but it proceeds from a different tradition and is by a sculptor of altogether different proclivities.

Two of its most un-Donatellesque features are the inorganic attachment of the limbs and the attention devoted by the unknown sculptor to trivial illusionistic detail. If we concentrate upon the tell-tale points of juncture at the shoulders, knees, and neck, it becomes clear that the artist possessed a far less lively sense for the structure of the human body than Donatello's. The limbs are, as it were, suspended from the frame. At the same time the front of the tree is elaborated with foliage; the right leg is shown with a torn stocking beneath which the knee is visible; beside the left foot is a slackly rendered sling and stone, and behind, held in position by a strap across the body, is the scrip in which, in the Bible narrative, David places the stones picked up from the brook. The rhythmic patterns of the drapery, like the pose itself, are tentative. Between the thighs, however, the vertical line of the tunic terminates in a group of decorative folds, which are repeated with minor variations above the waist. These must, therefore, be among the hall-marks of the unknown sculptor. In the literature of the *David* there are repeated references to a process called recutting. To cite only the two most recent scholars to commit themselves about the statue, it has been suggested (Janson and Kennedy) that work on the figure was undertaken at three separate periods of Donatello's life, the 'anecdotal detail' of the torn trouser-leg and tree-trunk being introduced 'at a later point by a hand other than Donatello's', and (Seymour) that 'the recutting evident in the *David* may have resulted from a decision to bring its proportions closer to those of the [Martelli] *St John*'. On these comments it must be observed, first that recutting, even on a scale far greater than that presumed by writers on the figure, could not have deprived a statue by Donatello of the whole of its essential character, and secondly that there is not a shadow of evidence in the surface execution that the statue was

worked on by more than one hand. The concept of recutting seems to owe its origin to the fact that the detail and the slender proportions projected for the limbs are incompatible with an ascription to Donatello. If we had to guess, from the body alone, at the objective towards which the sculptor felt his way, we should be bound to imagine a relief-like figure with a single view, with small, elegantly modelled limbs, elaborated with pictorial detail and covered with smooth, highly finished drapery.

The difficulties in the way of accepting the Martelli *David* as a work of Donatello increase immeasurably when we pass from the body to the head (Fig. 67). The face is soft and round, with a dimple or crease above the chin, and the wide mouth is shown with what apparently were to be parted lips. In profile the upper lip protrudes further than that below, and the relation between them might alone indicate a dating in the third quarter of the fifteenth century. The point of comparison cited most frequently from Donatello's authenticated works is the Virgin in the Cavalcanti *Annunciation*, but comparison between the heads serves only to prove how different in structure and technique they are. Perhaps the distinction transpires most clearly from the eyes of the Martelli *David*, where the sockets and brows differ radically from those of the Virgin Annunciate and the lids are like little rubber rings stuck on to the face. The relation of the neck to the shoulders on the one hand and the head on the other is more lifeless than in any sculpture by Donatello, while the preparatory work above the forehead suggests that the artist's aim was not the boldly rendered, rippling hair of the Cavalcanti Virgin, but locks refined by drilling and rendered in a far tamer and more static way. The hair is held back by a circlet, and at the back ends in a chignon, which, had it been completed, would perhaps have been transformed into a cluster of close curls. For the Goliath head beneath the feet a criterion is afforded by the Goliath head on Donatello's marble *David*, but by no stretch of the imagination can it be supposed that Donatello's Goliath head in a half finished state can have resembled that of the Martelli statue, where the precise neat forms recall rather the Goliath head on the bronze *David* of Verrocchio. It has been observed (Seymour) that 'these broad chisel strokes could hardly be refined without loss of vitality', and this is of course true, but refinement is precisely what the head of the Goliath in its present state seems to imply.

The use of these uncomplimentary epithets is unavoidable if the Martelli *David* is judged by the uniquely high standard of Donatello, but on its less exalted plane it is a work of great distinction, and is indeed one of the finest quattrocento sculptures outside Italy. And once it is transferred in time

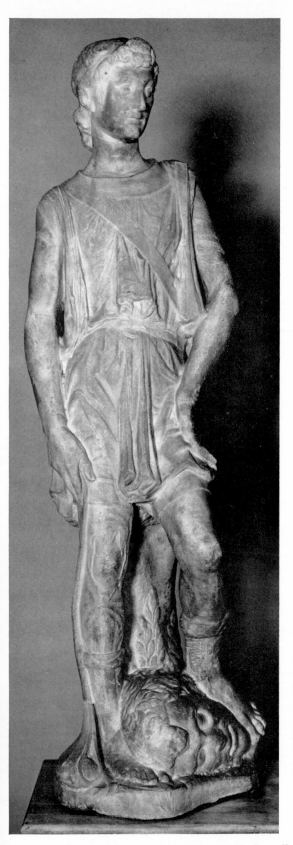
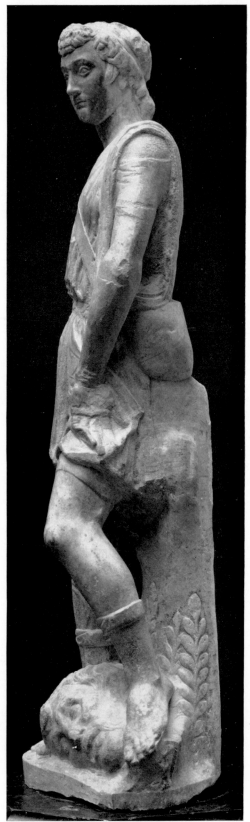

63-64. Here attributed to Antonio Rossellino: *David*. Marble, height 164·6 cm.
Washington, National Gallery of Art, Widener Collection

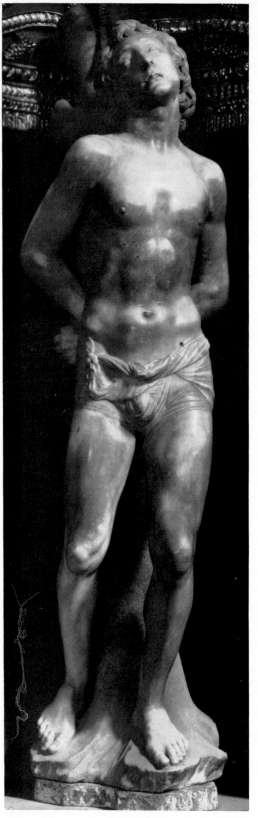

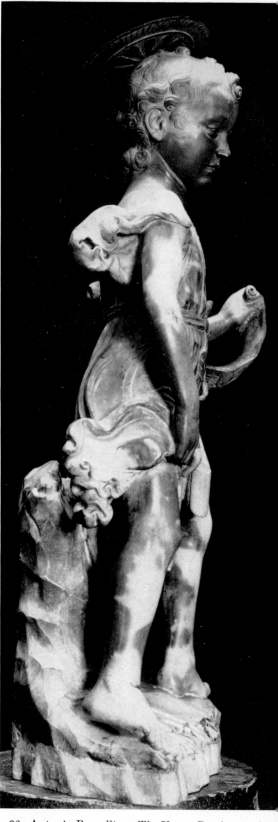

65. Antonio Rossellino: *St Sebastian*. Marble.
Empoli, Galleria della Collegiata

66. Antonio Rossellino: *The Young Baptist entering the Wilderness*. Marble. Florence, Museo Nazionale

68. After Rossellino: *David.* Bronze. Berlin, Staatliche Museen

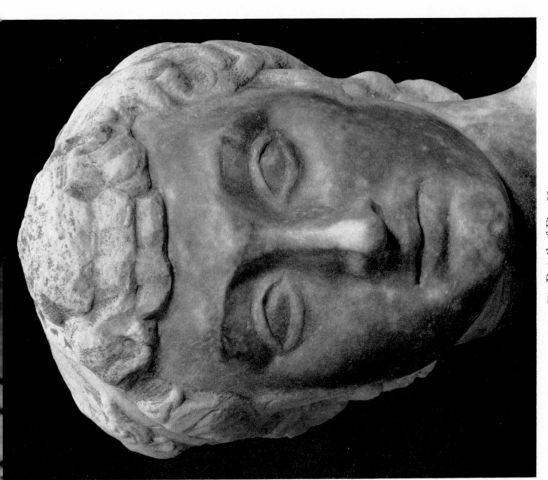

67. Detail of Fig. 63

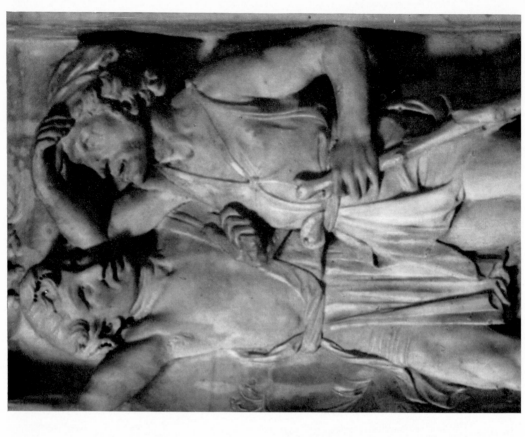

70. Antonio Rossellino: Detail of Shepherds in the relief of the *Nativity*. Marble. Naples, S. Anna dei Lombardi

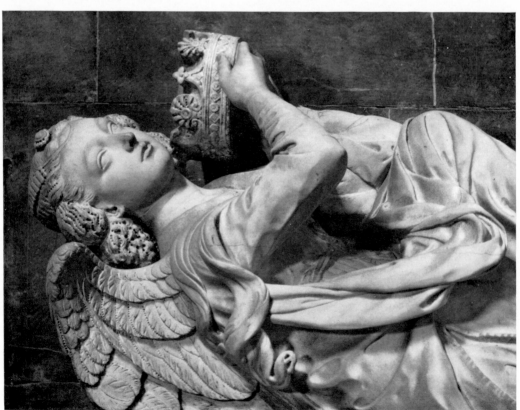

69. Antonio Rossellino: Detail of Angel on the Monument of the Cardinal of Portugal. Marble. Florence, S. Miniato al Monte

from the dates that have been assigned to it (1412, Janson; 1434–40, Seymour) to its correct date in the third quarter of the fifteenth century, its authorship is scarcely open to dispute, for in everything but its unfinished state it is a typical work by Antonio Rossellino. Rossellino's only independent full-size statue, the *St Sebastian* at Empoli (Fig. 65), is posed in the same ambivalent fashion as the *David*, with the hips parallel to the front of the base and the body slightly turned above the waist. In the *St Sebastian*, however, it is the right shoulder, not the left, that is advanced and the weight rests on the left, not the right leg. The attachment of the limbs has the same inorganic character as in the *David*, and the neck is once more represented as a kind of plinth on which to support the head. The relief system of the front view, though less emphatic in the *David* than in the *St Sebastian*, is essentially the same, and the two sensitive, yet indecisive profile views can only be the work of one and the same mind. When we turn to the *Young Baptist entering the Wilderness* in the Bargello, further analogies present themselves, for the *Young Baptist* is also relatively weak seen from the sides (Fig. 66), and it is no accident that in this figure too (as well as in the *St Sebastian* where it was justified by iconography) Antonio Rossellino was compelled to provide additional support, for which there was no narrative sanction and which was warranted on structural grounds alone. The *St Sebastian* and the *Young Baptist* were intended to be seen only from the front, the former in a painted niche, and the latter over the entrance to the Opera di San Giovanni, but both are fully finished off behind. In the Martelli *David* the back is worked up to the same state of finish as the front and would no doubt have been completed, even if the figure, like the *Young Baptist* and the *St Sebastian*, had been destined for a niche.

The relationship of the Martelli *David* to the work of Antonio Rossellino is apparent not only on the plane of structure, but in morphology and in technique. The ridged eyelids, which are one of the most individual features of the head, occur not only in the *Young Baptist* and the *St Sebastian*, but in the monument of the Cardinal of Portugal, most notably in the two putti seated in front of the sarcophagus. The treatment of the hair also has close analogies with that of the left angel on this tomb (detail, Fig. 69). Even the two incisions on the right side of the neck are exactly repeated on the right side of the neck of the *Young Baptist*, as is the profile of the upper and the lower lips. The pattern of the loin-cloth of the *St Sebastian* is predominantly horizontal, and is not therefore directly related to the vertical drapery of the *David*. The two groups of folds on the front of the tunic, however, recur once more in the dress of one of the two shepherds on the right of the

Nativity relief in Naples (detail, Fig. 70), which also contains parallels for the genre motifs of the scrip and sling used in the statue.

If then the Martelli *David* is a work by Antonio Rossellino—and this is, I suggest, scarcely open to dispute—when was it produced? The *St Sebastian* is not documented, but the delicate handling of its loin-cloth and the sharply rendered features have their closest point of reference in the Chellini bust in London, which is dated 1456. There is thus a presumption that this statue dates not from shortly after 1470 as was assumed by Planiscig, but from shortly before 1461 when work on the tomb of the Cardinal of Portugal was begun. Though the formal affinities of the Martelli *David* are with this statue, its technical affinities are with considerably later works, the Naples altar which was produced in the mid-seventies, and the *Young Baptist* which dates from 1477. The sculptor died between 1478 and 1481. Work on the figure would have been discontinued when the extent of the disfiguring brown vein across the face was first revealed, and it may have been this, and not the artist's death, which brought to an early close his efforts to work the arms down to the slender proportions of those of the *Young Baptist entering the Wilderness.* The most probable view, therefore, is that the Martelli *David* was begun and abandoned in the half-decade 1470–5. In 1476 the Operai of the Palazzo della Signoria purchased from Lorenzo and Giuliano de' Medici the bronze *David* of Verrocchio, in which an attempt is also made to adapt the David iconography of the earlier Renaissance to the stylistic preconceptions of the later quattrocento. The brash pose of Donatello's marble *David* and the stalwart youth depicted by Verrocchio were alike outside Rossellino's scope, and he fell back instead on a relaxed David, standing loosely against a tree-trunk, the sling held in a flaccid hand and the face transfigured with a look of rapture that he had caught once before in the *St Sebastian* at Empoli.

That the figure should have been regarded as a Donatello in the sixteenth century is less surprising than that it should be ascribed to Donatello now. To take an analogy from painting, it is as though a Ghirlandaio altar-piece passed muster as a painting by Masaccio. About 1540, on the other hand, despite Donatello's ever-growing reputation, quattrocento sculpture had coalesced into a unit whose chronology and stylistic deviations were increasingly unclear, and it is perfectly intelligible that Vasari should in good faith have accepted the Martelli *David* and the Martelli *Baptist* as works by Donatello. Why the *David* rather than the *Baptist* was chosen for inclusion in Bronzino's portrait can be surmised, for in the second quarter of the sixteenth century the vogue of the unfinished sculpture, fostered

by such works as the Pitti and Taddei tondi of Michelangelo, was at its height. How natural that Ugolino Martelli should have chosen for inclusion in his portrait not the *Baptist*—which was highly finished and must for that reason have appeared archaic and dry—but the *David*, in which the legendary author of the *David* statues in the Palazzo della Signoria was, it seemed, caught in the creative act in a work that so closely resembled the unfinished sculptures of the sixteenth century.

Originally published in *The Burlington Magazine*, CI, April, 1959.

The Virgin with the Laughing Child

IN 1858 the Victoria and Albert Museum acquired in Paris a statuette in terracotta which has since taken its place with the acknowledged master-pieces of the Renaissance. Some nineteen inches high, the *Virgin with the Laughing Child* (Figs. 71, 87) shows the seated Virgin supporting the Child Christ on her right knee (No. 4495–1858. Height: 48.5 cm. The front of the hood and the toe of the right foot are broken, and the nose and upper lip have been broken and repaired. There is some make-up in the drapery on the left side). The Virgin wears the loose, high-waisted robe, known as a *gamurra*, which we see in paintings of the time. Conforming to current fashion, the dress is caught up above the waist by an embroid-ered belt tied in a knot. From a cord round the Virgin's neck hangs a rectangular scapulary, edged with a fringe and ornamented with two tassels. On the forehead her veil is fastened by a jewel in the shape of a winged cherub's head, which must also have served to keep her hood in place. A cloak falling from the shoulders covers the right arm and wrist, is turned back on the left, and forms two heavy folds over the knees. The folds of drapery follow the legs until the fringed line of the cloak comes to rest in the centre of the base between the Virgin's sandalled feet (Fig. 80). In the later quattrocento the depiction of drapery, with its interplay of light and shadow and its infinite variety of form, was the constant concern of artists, and a well-known group of drapery studies, made about 1470 by Leonardo da Vinci while in the studio of the painter-sculptor Verrocchio, conforms closely to the spirit of our statuette.

Many small statuettes were made during the fifteenth century, and a number of examples are owned by the Museum, among them a terracotta statuette of the *Madonna* in the style, perhaps from the studio, of the sculptor Ghiberti (Fig. 72), and a statuette in stucco ascribed to Antonio Rossellino (Fig. 83). But the *Virgin with the Laughing Child* is distinguished from both these statuettes by the freedom and delicacy of its handling and by the intimacy of its sentiment.

For the painters and sculptors of the quattrocento representations of the Virgin and Child posed a problem not merely of form but of interpretative emphasis. It was not enough that the *Madonna* should show old iconography in a new guise; it must become the vehicle of a fresh and individual appre-

hension of the age-old relationship between the prescient Virgin and the unreflecting Child. With the new awareness of human values that sprang up after the middle of the century there emerged works of art, among them Leonardo's *Madonna of the Rocks* and Botticelli's *Madonna of the Magnificat*, the beauty of whose sentiment has endeared them to thousands blind to the perfection of their form. To these works we may add the present statuette, where the Child sits upright against the Virgin's right arm, his eyes wrinkled and his tongue twisted between his laughing lips as he holds in either hand the two ends of his loosened swaddling bands (Fig. 85), and the Virgin, with one hand on the Child's right thigh and the other on the loosened band, looks down at his curly head with a smile of compassion and serenity.

Made during the 1420's, the terracotta group ascribed to Ghiberti marks the first stage in a humanising process that culminates in the *Virgin with the Laughing Child*. In place of the conventional relationship common in Florence throughout the trecento we have a scheme in which the Child with arms thrown round the Virgin's neck, presses his head against her cheek. Yet even here the group has a symbolical rather than a sharply individualised character, and it is not until the 1430's, in early works by Luca della Robbia, that the Virgin and Child are set firmly on the human plane they occupy for the remainder of the century. In most of Luca's glazed *Madonnas* (Fig. 73) the spectator is brought into direct contact with the relief as the focus on which the Virgin directs her gaze or to which the Child's gesture of benediction is addressed. This practice is preserved in the *Virgin with the Laughing Child*, where the Child's attention is aroused not by the Virgin but by some imaginary onlooker. The significance of the conception may be gauged from a verse inscribed on a contemporary painting of the *Virgin with the Sleeping Child*:

> Sviglia el tuo Figlio, dolce Maria pia,
> Per far infin felice l'anima mia.
>
> (Wake thy Child, sweet Mary, to fill my
> heart at last with happiness.)

a behest obeyed by the author of our statuette.

Confronted with a group so subtle and so personal, we inevitably ask ourselves by what artist it was made and in what larger context it should be placed. With certain works of art study is furthered by the adventitious aids of long pedigrees and old inventory references, but we know absolutely nothing of the history of the *Virgin with the Laughing Child* before

the middle of the nineteenth century, and we have no other method than analysis of style for determining when and by whom it was produced. Speculation on its authorship has followed three main lines. The first regards it as a work produced in the studio of Verrocchio, by an artist who is perhaps to be identified with the young Leonardo. The second connects it with Verrocchio's older and shorter-lived contemporary, Desiderio da Settignano, while the third ascribes it to one of the most prominent Florentine sculptors of the second half of the fifteenth century, Antonio Rossellino. The attribution to Leonardo presupposes a dating between 1469 and 1476; that to Desiderio a dating before 1464, when the young sculptor died; and that to Rossellino a dating before the artist's death in 1479. It is thus generally agreed that the statuette, by whatever artist it was executed, was made within a bracket of fifteen or twenty years.

There are a number of reasons why the *Virgin with the Laughing Child* can hardly be Leonardo's, and since these tell us something positive about the statuette, it is worth while to examine them. One of the factors present in Leonardo's style is an instinctive sense of volume, a feeling for protuberant, rounded forms, which is already to be met with in the Virgin of the Uffizi *Annunciation* of about 1472, and is clearly apparent in one of the earliest of his paintings of the Virgin and Child, the *Benois Madonna* of 1478 at Leningrad. It is reasonable to assume that this same sense of volume would have been manifested in Leonardo's sculpture, of which no example is known, and in the 'heads in terracotta of women smiling', which Vasari tells us that Leonardo executed during his apprenticeship. The forms in the *Virgin with the Laughing Child*, however, are the exact antithesis of the forms in Leonardo's early paintings; in particular the left wrist and forearm, devoid as they are of all suggestion of a third dimension, and the robe above the waist, treated as it is as a flat decorative surface, are incompatible with Leonardo's pictorial style. Moreover, if we turn to the drapery study by Leonardo in which the pose is most closely related to that of the statuette (Fig. 79), a brush study on linen in the Louvre, we find that though the general disposition is similar, the detail is handled in a different way. Throughout the folds are rounder than in the statuette (Fig. 80), and, as in many works produced in the Verrocchio studio, the vertical lines of the drapery are broken by a multiplicity of small horizontal folds intended to enrich their plastic quality. The last and most compelling reason why the statuette cannot be Leonardo's is that we know two other works almost certainly by the same hand, neither of which, by any stretch of the imagination, could be ascribed to Leonardo.

One of these is a terracotta relief in the Kaiser Friedrich Museum at Berlin (Fig. 74), showing the Virgin with her head bent in three-quarter face over the Child, who is seated on a cushion with hands clasped, eyes lowered and mouth closed. When we set our statuette at the same angle as the relief (Fig. 75), the close relationship between the two is inescapable. Allowing for disparity in scale, the type of the Virgin, with her domed forehead, her raised eyebrows and her smiling lips, is the same. Above the girdle the treatment of the dress in the relief, as in the statuette, is flat and decorative, below it runs forward in a fluid line, while the left wrist is characterised by the same flatness and the hand by the same attenuated fingers as in the statuette. The other work is a relief, again in terracotta and also in Berlin (Fig. 76), in which the Virgin's head, posed frontally, is closely related to that in the statuette (Fig. 77), and where the Child's right arm repeats the gesture of the laughing Child. The two reliefs have been correctly linked with a sheet of pen studies in the Uffizi, Florence, containing two studies for a Virgin and Child, one of which is loosely associable with the London group (Fig. 78).

Like the *Virgin with the Laughing Child*, the Uffizi drawing has been ascribed to Desiderio da Settignano. When we recall the lightness, elegance and animation of Desiderio's marble reliefs, we can understand only too well how his name came to be attached to the two representations, for in the middle of the century Desiderio was an exponent of the graceful style in which they were devised. But when we refer them to the work which is supposed to confirm Desiderio's authorship of the statuette, the frieze of cherub heads carved between 1455 and 1460 for the Cappella Pazzi, it becomes clear that we are dealing not with Desiderio but with an independent personality operating within Desiderio's orbit at about this time. And as we pursue our investigation the conviction grows that this artist is none other than Antonio Rossellino, to whom the *Virgin with the Laughing Child* was initially attributed.

Antonio Gambarelli, known as Rossellino, was the youngest of the five sons of a stonemason of Settignano. 'By all who knew him', declares Vasari, who counted him the greatest sculptor of the generation after Donatello's, 'he was regarded as more than a man, and reverenced almost as a saint for the very great gifts which were united to his virtues.' Like Desiderio da Settignano, Rossellino matured at Florence while Donatello was in Padua; he was responsive neither to the heroic qualities of Donatello's statuary nor to the expressionism of his reliefs, and his style, as it emerged during the 1450's, reveals a talent unruffled by passion and intent on

finality of form. Trained in the family studio by his eldest brother Bernardo, a sculptor and architect eighteen years older than himself, he is first met with in Florence in 1449 as a youth of twenty-two engaged with another of his brothers on decorative work in Brunelleschi's church of San Lorenzo. The decisive influence upon him at this time, however, was not his brother's but that of Luca della Robbia, whose glazed terracotta roundel of the Virgin and Child on Or San Michele (about 1455) is recalled by our statuette (Fig. 73). By 1456, when he completed his earliest dated work, the bust of the doctor Giovanni Chellini in the Victoria and Albert Museum, Antonio Rossellino was already one of the most sensitive and most accomplished marble sculptors of the Renaissance. Two years later we find him employed, along with Bernardo Rossellino and his brother Giovanni, on the sarcophagus of the Blessed Marcolino of the Forlì, and in 1461 this is followed by his masterpiece, the monument to the Cardinal of Portugal in San Miniato al Monte outside Florence, on which he was engaged till 1466. It is in the exquisitely elegant details of this monument that we see for the first time an evident connection with our statuette and the two reliefs in terracotta. This connection would be unmistakable were the circular *Madonna* which crowns the monument our only basis of comparison (Fig. 81), for here we encounter once again the flat arm and wrist and the excessively long fingers of the statuette and the rather narrow face of the reliefs. But in practice the ascription of the group to Rossellino is clinched by a free-standing figure, the kneeling angel designed to carry the palm of chastity on the right upper corner of the monument (Fig. 82), whose left hand supports a cloak resolved in precisely the same transverse folds as the London terracotta. Since this type of drapery does not recur in any later work by Rossellino, we may conclude not only that the *Virgin with the Laughing Child* is Rossellino's, but that it was made at about the same time as the monument, that is about 1465.

What function was the statuette intended to fulfil? On the one hand, the free handling, which commends it to our taste today, would not have been acceptable in a completed work made in a period that set such store by finish as the Renaissance. On the other the statuette is too elaborate to have been designed for reproduction, like the frequently encountered full-length stucco from the Rossellino studio in the Museum (Fig. 83), which employs the simplified, rather degenerate forms of the artist's last work, the *Nori Madonna* of 1478 (Fig. 84). Our statuette may, however, have been intended as a model for a larger figure. Clay and terracotta models were often used in the last half of the fifteenth century in the development of marble

71. Antonio Rossellino: *The Virgin with the laughing Child*. Terracotta, height 48·5 cm.
London, Victoria and Albert Museum

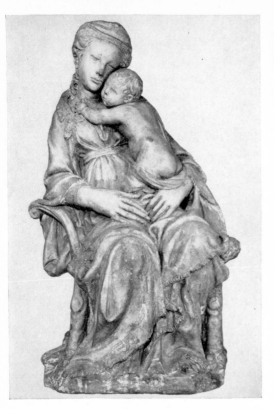

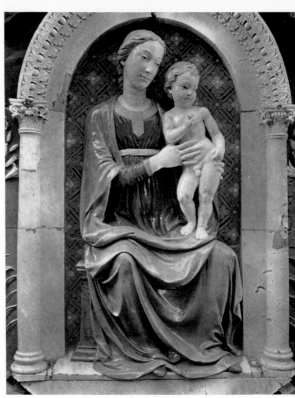

72. Florentine, about 1425: *Madonna and Child.*
Terracotta.
London, Victoria and Albert Museum

73. Luca della Robbia: *Madonna and Child.*
Enamelled terracotta. (Detail.) Florence, Or San Miche

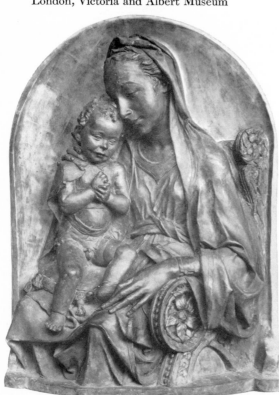

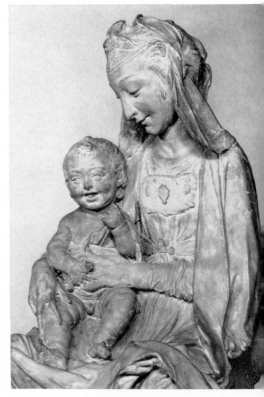

74. Antonio Rossellino: *Madonna and Child.* Terracotta.
East Berlin, Staatliche Museen (Bode-Museum)

75. Detail of Fig. 71

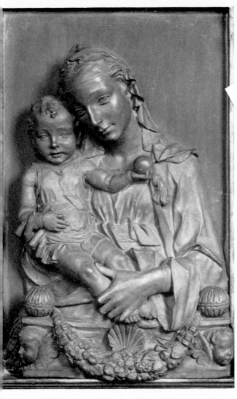

76. Antonio Rossellino: *Madonna and Child.*
Terracotta. East Berlin, Staatliche Museen
(Bode-Museum)

77. Detail of Fig. 71

78. Antonio Rossellino: *Studies for a Virgin and Child.* Florence, Uffizi

79. Leonardo da Vinci: *Drapery Study*. Paris, Louvre

80. Detail of Fig. 71

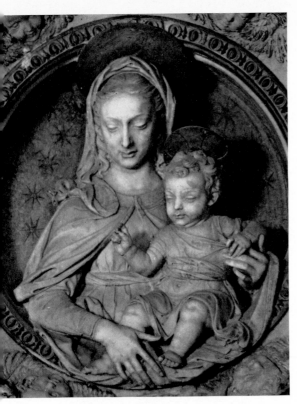

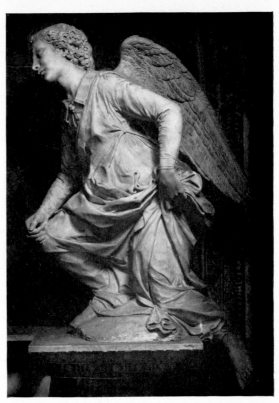

81. Antonio Rossellino: *Madonna and Child*. Marble. Florence, S. Miniato al Monte

82. Antonio Rossellino: *An Angel*. Marble. Florence, S. Miniato al Monte

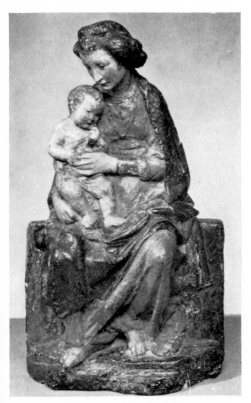

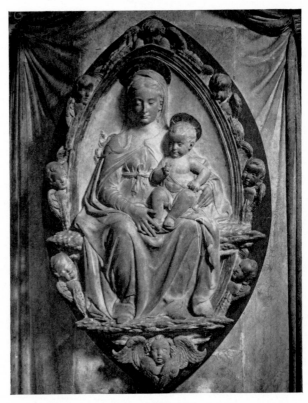

83. After Antonio Rossellino: *Madonna and Child*. Stucco, height 48·6 cm. London, Victoria and Albert Museum

84. Antonio Rossellino: *Madonna and Child*. Marble. Florence, Santa Croce

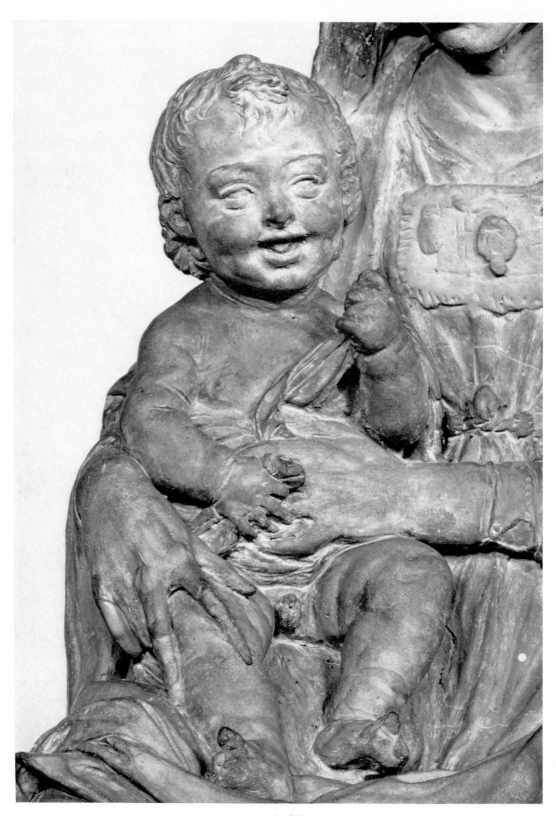

85. Detail of Fig. 71

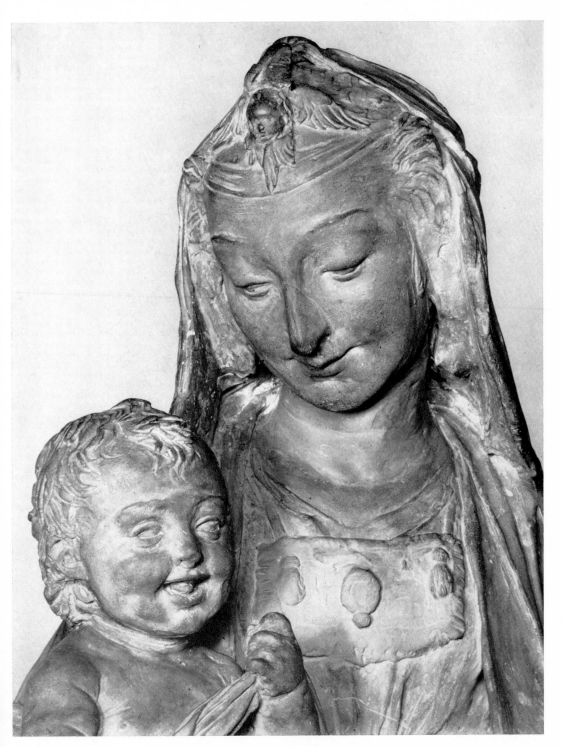

86. Detail of Fig. 71

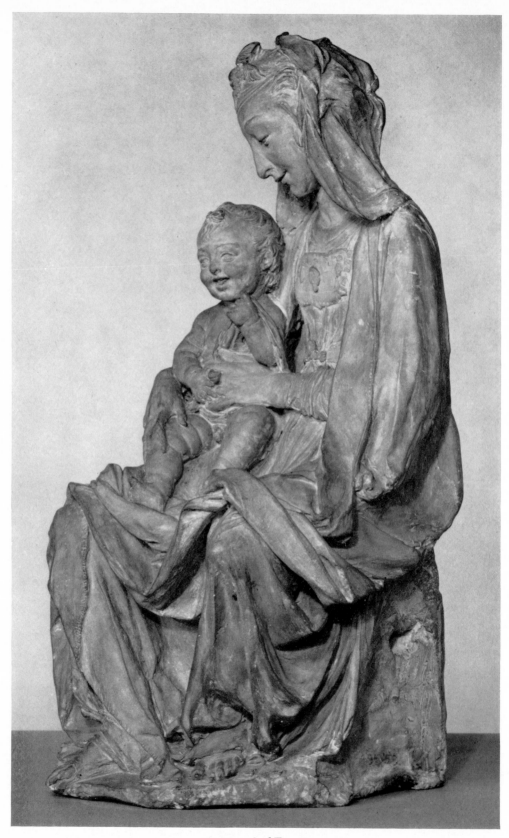

87. Detail of Fig. 71

sculpture—examples in the Museum collection include terracotta sketches for three of the reliefs in Benedetto da Majano's pulpit in Sante Croce—and though the bulk of those which have survived come from the studios of Verrocchio and Benedetto da Majano, there is a strong presumption that Desiderio and Antonio Rossellino also had recourse to them. Indeed we may imagine that the preliminary models which the artist must have made for the angels in San Miniato would closely have resembled our statuette. Whatever the intention with which it was made, the fascination of the statuette is inseparable from its sketch-like character. Were it preserved in its completed state, the core of natural observation round which it is built would be less evident, and the relationship between the figures would be colder and more constrained. But in the form in which it has come down to us the *Virgin with the Laughing Child* retains its early spontaneity and warmth, and possesses what Pater terms 'expression carried to its highest intensity of degree, that characteristic ... rare in poetry, rarer still in art, rarest of all in the abstract art of sculpture, yet at bottom perhaps ... the characteristic which alone makes works in the imaginative and moral order really worth having at all'.

Originally published as a Victoria and Albert Museum monograph in 1949.

A Relief by Agostino di Duccio

THE relief by Agostino di Duccio that forms the subject of this essay was bought for the Victoria and Albert Museum from the collection of Lord St. Oswald in 1926. It seems to have been brought from Italy in the late eighteenth or early nineteenth century, and was first identified in 1912 as the original of a composition known through a replica in painted stucco in the Kaiser Friedrich Museum in Berlin (Fig. 89). It shows a half-length Virgin and Child with five angels, two of them standing on each side and the fifth in front of the main group holding in place a scroll, the ends of which are secured by strings running under the Child's foot and tied round the neck of a vase placed on the right. Behind the figures is a decorated niche, and in front of them is an arched window which frames the scene within (Fig. 88).

A description in these terms might apply to many reliefs made in Florence in the middle of the fifteenth century. Yet Agostino di Duccio's *Virgin and Child* is strikingly dissimilar to every other relief in the Museum. Let us compare it for a moment with a marble relief of the *Virgin and Child* (Fig. 90) shown on an adjacent wall. In this second relief the group of the Virgin and Child is once again contained within a window frame, and the Child's foot once more rests on the parapet. But behind the two figures is a room, represented by a ceiling of intersecting beams drawn in perspective and by two receding walls, which convince us, within the limits of the medium, that the Virgin and the Child are real figures standing at the window of an actual room. In Agostino di Duccio's relief, on the other hand, there is no intimation of space behind the window frame, and the Virgin, the Child and the five angels seem, at first sight, to be represented on a single plane. This difference is carried through into the treatment of the figures themselves. In the second relief the Virgin's dress is represented by means of small naturalistic folds, which accentuate the forms beneath, and the hair over the temple is rendered in greater detail than that behind. Agostino di Duccio's relief, on the contrary, is executed with absolute evenness of emphasis; there is, for instance, no variation in depth between the carving of the vase in the foreground and the niche in the background of the scene. Moreover, the drapery tends not to accentuate but to conceal the forms; it enhances the visual pattern established by the figures, but not

their physical validity. These differences between the two reliefs reflect two different attitudes to sculpture. For the author of one relief sculpture is an illusionistic art, with its roots set firmly in visible reality; for the author of the other it is non-illusionistic, and the problem of composition in relief is that of merging the figures in a single linear scheme. Whereas the first attitude is common to Donatello, Luca della Robbia and almost all the sculptors who worked in Florence throughout the fifteenth century, the second is peculiar to Agostino di Duccio, and we cannot understand it without knowing something of the artist's other works.

One of the ten children of a weaver, Agostino di Duccio was born in Florence in 1418. The living conditions of his family, in a house in the Via de' Fossi, appear to have been difficult, and in 1433, after his father's death, he enlisted in the service of a mercenary soldier, Giovanni da Tolentino, and with him left Florence. He seems not to have returned there till after 1442 when he had executed his first independent work, an altar in Modena Cathedral carved with scenes from the legend of San Gimignano. Four reliefs from this altar prove what we might also deduce from documents, that Agostino di Duccio can hardly have been trained in Florence. With their figures carved in relatively deep relief against a lightly indicated ground, they most closely recall some of the reliefs by the Sienese sculptor Jacopo della Quercia on the façade of San Petronio at Bologna. Jacopo della Quercia was engaged on the portal of San Petronio between 1425 and his death in 1438, and there is no difficulty in supposing that, as a youth, Agostino di Duccio worked on this, one of the largest sculptural projects of the time. Though his mature work has no direct resemblance to that of Quercia, it is Quercia's reliefs that first state the principle on which this is based, that of the treatment of the relief surface as a linear unity.

The Modena altar completed, Agostino di Duccio returned to Florence, but by 1446 he had once more left the city, this time for Venice whither he had fled with his younger brother Cosimo, charged with the theft of silver vessels from the church of the Annunziata. The fact that Agostino could be charged with a theft from the Annunziata suggests that he was employed in the church, and in this event he would probably have worked under the general direction of the architect and sculptor Michelozzo. Another artist to whom he must have been indebted in these years is Luca della Robbia, whose cantoria in the Cathedral had been completed in 1438. In its employment of that symbol of Renaissance art the putto, playful, unfettered, innocent, the cantoria provides a precedent for Agostino's most important work, the reliefs of the Tempio Malatestiano at Rimini.

The Tempio Malatestiano owes its existence to Sigismondo Pandolfo Malatesta, Lord of Rimini, soldier, scholar and poet (Fig. 96), who in 1447 decided to reconstruct a chapel in the Gothic church of San Francesco in honour of his patron Saint, St Sigismund. A year later work was begun on a second chapel, destined to contain the monument of Sigismondo Malatesta's mistress, Isotta degli Atti. In 1450 it was decided to reconstruct the outside of the church, and in 1451 to transform its whole interior. The work of reconstruction was entrusted to the great architect Alberti, and was carried out under the direction of Matteo de' Pasti the medallist. Our only references to Agostino di Duccio's presence at Rimini date from the year 1454, but since he was responsible for a large part of the sculptured decoration of the church, he was probably at work at Rimini by 1450, and seems to have remained there till 1457.

Gifted and licentious, Sigismondo Malatesta filled the double role of condottiere and devotee of learning, and his court at Rimini rapidly became notorious for its scepticism and its amorality. 'He has built a church at Rimini in honour of St. Francis', declared his life-long opponent Pope Pius II, 'but he has filled it with antique images, so that it seems a temple for the worship not of Christ but of the pagan gods; and in it he has built a tomb for his concubine, beautiful as to material and craftsmanship, but with an inscription in the pagan style that reads: SACRED TO THE DIVINE ISOTTA.' The interior of the Tempio, with its exaltation of the twin divinities of Sigismondo and his mistress, is an expression of studied paganism. Outside it are set the monuments of the humanists who adorned the Malatesta court, Giusto de' Conti, remembered for a cycle of Petrarchan poems on his mistress's hand, *La Bella Mano*, Basinio Basini, author of a poem dedicated to Sigismondo, the *Esperidi*, Roberto Valturio, 'omnium scientiarum doctor et monarcha', whose historical treatise on the art of war enjoyed well-justified celebrity, and many more. Alberti, when he designed the outside of the Tempio, was imbued with the spirit of Roman architecture. This is reflected in the use of the motif of a triumphal arch on the façade and in the classical arcades which run along the flanks. In the interior the Gothic chapels were retained but rectangular piers were introduced to support the arches, and it was to the marble reliefs decorating these that Agostino di Duccio devoted a large part of his work. 'Internally', writes Symonds in a well-known description of the Tempio, 'the beauty of the church is wholly due to its exquisite wall ornaments. These consist for the most part of low reliefs in a soft white stone. . . . Allegorical figures designed with the purity of outline we admire in Botticelli, draperies that Burne-Jones might copy,

troops of singing boys in the manner of Donatello, great angels traced upon the stone so delicately that they seem to be drawn rather than sculptured, statuettes in niches, personifications of all arts and sciences alternating with half-bestial shapes of satyrs and sea-children—such are the forms which fill the spaces of the chapel walls, and climb the pilasters, and fret the arches in such abundance that had the whole church been finished as it was designed, it would have presented one splendid though bizarre effect of incrustation.' The relation between sculptured decoration and architectural forms was one with which Florentine artists were much concerned. In the case of the Sagrestia Vecchia in San Lorenzo in Florence, it was claimed by Brunelleschi, the architect of the sacristy, that the reliefs added by Donatello a decade or more after the completion of the building impaired the architectural scheme. With Alberti it was a point of principle that the part should be subordinated to the whole, and the few letters which relate to the building of the Tempio prove that here as elsewhere he was preoccupied with the detail as well as with the total effect of the interior. With the exception of one group of carvings, all of the sculptures in the Tempio are in low relief, and avoid the deep cutting and emphatic shadows which might prejudice the architectural effect.

As we might expect in the humanist atmosphere of Rimini, the mainspring of this style is the sculpture of antiquity. But whereas Florentine Renaissance sculpture depends mainly from Roman prototypes, the sculpture of the Tempio is orientated upon Greece, whence Sigismondo Malatesta transported the remains of the Neo-Platonist Gemistos Plethon for internment in the church, and whither Matteo de' Pasti was despatched in 1461 to the court of Mahomet II. The exact sources from which it derived can no longer be identified. But it would not be surprising if the sculptor of the Chapel of the Liberal Arts at Rimini proved to have been familiar, in the original or in reproduction, with the carvings on columnar sarcophagi of the type of the Mourning Women sarcophagus from Sidon, now at Constantinople, and if the sculptor of the Chapel of the Planets was acquainted with Neo-Attic carvings like the figures of Maenads in Madrid. To our eyes the idiom of these carvings seems strikingly unclassical. Contemporaries, however, saw them in a different light, and Valturio, speaking in the *De Re Militari* of the Tempio and its decorations, affirms that of all the sights of Rimini 'none is more worth inspection, none is more antique'.

Though it was a product of the Rimini commission, the style of these reliefs persisted long after the sculptured decoration of the Tempio was complete. When Agostino di Duccio left Rimini in 1457, he carried it with

him to Perugia, where he was engaged on the façade of the oratory of San Bernardino, and in 1462, when this commission came to an end, to Bologna, where he was employed on a design for the façade of San Petronio. A year later he returned to Florence, where he matriculated in the Guild of Stone-masons and Woodcarvers, and remained there till 1473, engaged on a terra-cotta relief of the Resurrection for the church of the Annunziata, and on other works. But after a decade of residence in his native town, he went back once more to Perugia, tempted by new commissions, and there in 1481 he died. In the polychrome façade of San Bernardino at Perugia the archi-tectural structure is weaker than at Rimini and the figures are less well related to the area they fill, but the flying maenads which surround the figure of the Saint have a fascination of their own, and it is interesting to speculate how the majestic front of San Petronio would have looked, if it had been completed in this decorative style. In the works of Agostino di Duccio's last years at Perugia degeneration is more marked, and in old age the genius who had reached his zenith in the Tempio Malatestiano becomes a dry provincial artist.

In addition to these large-scale works, we have four marble reliefs of the Virgin and Child by Agostino di Duccio, two in the Louvre, one in Washing-ton (Fig. 91), and one in the Museo Nazionale in Florence (Fig. 92). Two of these, the Washington *Madonna* and the *Auvilliers Madonna* in the Louvre, are closely related in handling to the angels surrounding the figure of the Saint on the façade of San Bernardino, and were probably produced soon after 1463, when Agostino di Duccio returned to Florence and would have become familiar with the reliefs of Desiderio da Settignano that seem to have inspired the Child in the relief in Washington. The *Madonna* in the Museo Nazionale may have been carved in Florence some years afterwards and reflects the influence of Antonio Rossellino. The latest of the reliefs, the *Rothschild Madonna* in the Louvre, shows the Child standing stiffly with the right arm raised in benediction, and probably depends from a com-position designed by Verrocchio about 1470. It goes without saying that all of the works executed by an artist with the pronounced idiosyncrasies of Agostino di Duccio have a certain fundamental similarity. But when we come to compare the relief in the Museum with Agostino di Duccio's other reliefs of the Virgin and Child, it is apparent that these have more in com-mon with each other than any of them has with our relief. In the first place the cutting in the relief in London is shallower than in the other four reliefs. In the second place the forms in the London relief are not rendered natural-istically but are reduced to their nearest geometrical equivalent; the heads

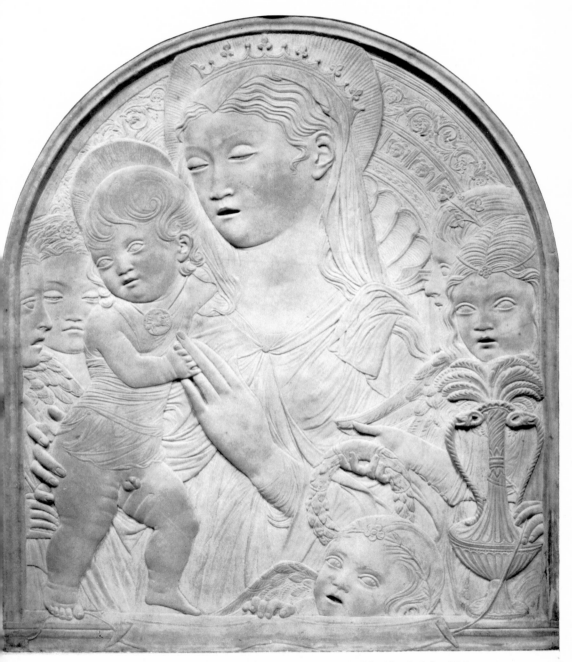

88. Agostino di Duccio: *Virgin and Child with Angels*. Marble, height 55·9 cm.
London, Victoria and Albert Museum

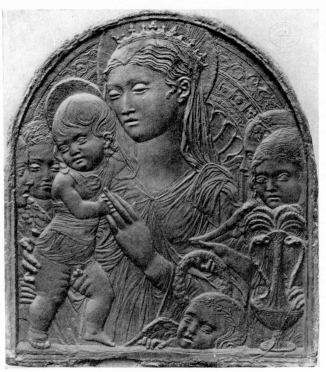

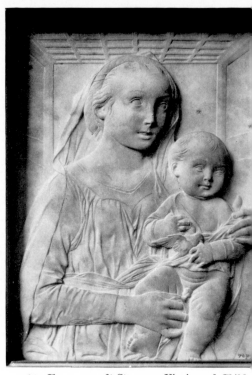

89. After Agostino di Duccio: *Virgin and Child with Angels.*
Stucco. Berlin, Staatliche Museen

90. Francesco di Simone: *Virgin and Child.*
Marble. London, Victoria and Albert Museum

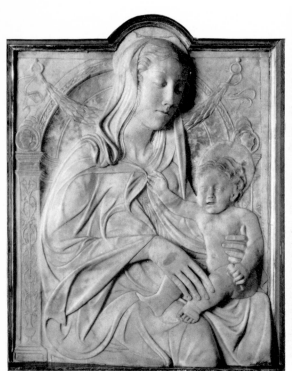

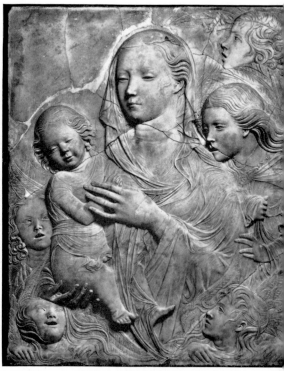

91. Agostino di Duccio: *Virgin and Child.* Marble.
Washington, National Gallery of Art
(Mellon Collection)

92. Agostino di Duccio: *Virgin and Child with five Angels.*
Marble. Florence, Museo Nazionale

93. Detail of Fig. 88

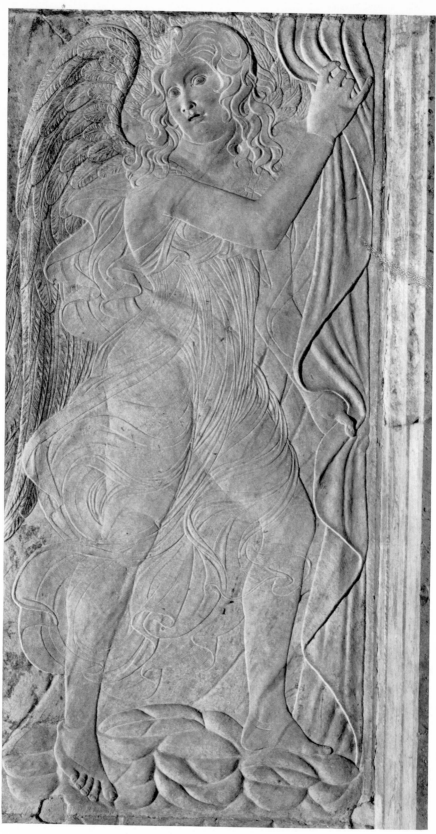

94. Agostino di Duccio: *Angel drawing a curtain*. Marble. Rimini, Tempio Malatestiano

95. Agostino di Duccio: *The Temple of Minerva*. Marble. Rimini, Tempio Malatestiano

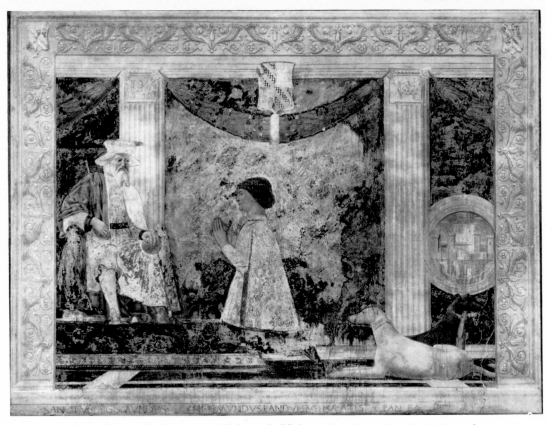

96. Piero della Francesca: *Sigismondo Malatesta kneeling before St. Sigismund.*
Rimini, Tempio Malatestiano

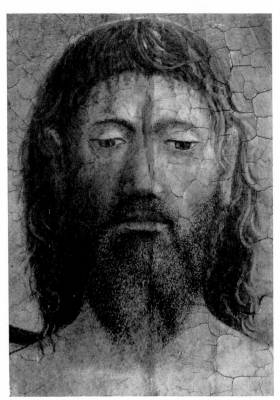

98. *Nike driving a Quadriga.*
Reverse of a silver coin of Hiero II. Enlarged.
London, British Museum

97. Piero della Francesca: *The Baptism of Christ*
(detail). London, National Gallery

99. Detail of Fig. 88

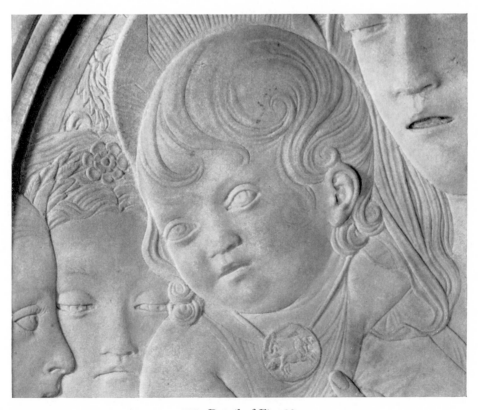

100. Detail of Fig. 88

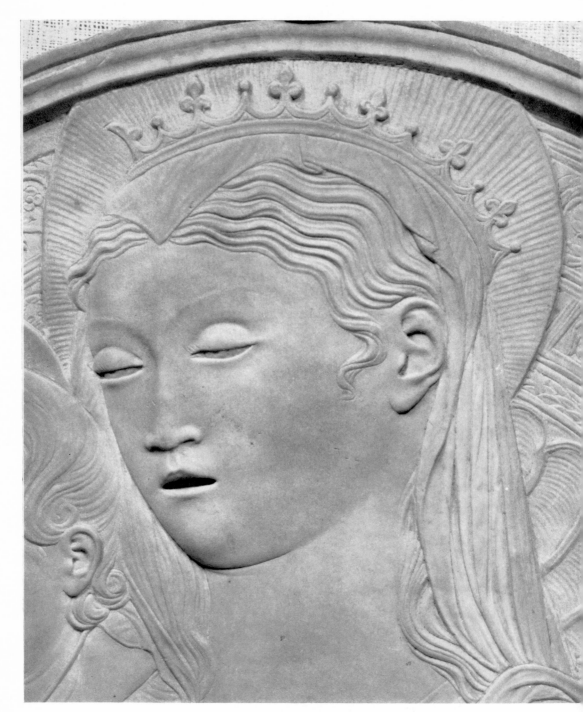

101. Detail of Fig. 88

of the Child and of the putto in the foreground (Figs. 99, 100), for example, like so many of the heads in the carvings at Rimini, are circular. In the third place there is not the slightest trace in the relief in London of the Florentine influences that went to the making of the other panels. From this we may deduce that the relief is earlier in date than the other *Madonna* reliefs of Agostino di Duccio, and was almost certainly produced at Rimini.

This view receives strong support from the sculptures in the Tempio. Thus the action of the Child, with the left knee advanced, the left arm outstretched, and the head turned back over the right shoulder, recurs in one of the two putti who support the scroll beneath the monument of Isotta degli Atti. In the same way the head of the putto in the foreground corresponds closely with that of a putto riding a dolphin in the Chapel of the Infant Games, and the pleated drapery of the Virgin's robe is met with once more in the dress of an angel in the chapel of St Sigismund (Fig. 94). The closest points of contact are, however, to be found in the relief of *The Temple of Minerva* (Fig. 95) on the sarcophagus dedicated by Sigismondo Malatesta to his predecessors and descendants. Here, behind the standing figure of Minerva, is a shell niche cut with the same striated lines as the niche in the relief in London, and supported by fluted pilasters and a fluted wall. Here, in the frieze above, are the diminutive cherub heads which run round the arch behind the Virgin and Child. And here, in the spandrels of the arches, occurs a pattern of foliage with the four-petalled Malatesta rose, which is strikingly like the outer strip of carving in our relief. Since these features are found together only in the *Temple of Minerva* and in the relief in London, they offer some reason for supposing that the two works were executed in close proximity. The Arca degli Antenati is one of the few pieces of carving in the Tempio that can be dated with absolute precision; a letter written to Sigismondo Malatesta on 18 December, 1454, tells us that at this time work on the Arca was complete save for the cover, and that Agostino di Duccio would finish this forthwith. There is a strong presumption that the London relief, too, dates from about 1454–5, that is from the last years of Agostino di Duccio's residence at Rimini.

When we replace it in its context at Rimini, certain features which would otherwise be puzzling are explained. One of these is the head of the angel in full-face on the left, with its curved eyes, flat nose and wide mouth. The nearest analogy for this head occurs not in sculpture, but in the paintings of Piero della Francesca. So close is the analogy with, for example, the head of Christ in Piero della Francesca's *Baptism* in the National Gallery (Fig. 97), that in the absence of contributory evidence we might assume one artist

to have been dependent on the other. If the relief were produced at Rimini, the relationship between the sculptor and the painter would be greatly clarified, for in 1451 Piero della Francesca completed at Rimini his great fresco of *Sigismondo Malatesta before St Sigismund* (Fig. 96). While he was employed upon this fresco, the two artists must frequently have met, and it is easy enough to understand how Agostino, in this relief, came to adopt Piero's forms. Significantly enough, the paintings which offer the clearest parallel for our relief are the impassive, mannered images executed under Piero's influence by Cosimo Tura at Ferrara for the Este court. Another feature is the wreaths with which the angels' heads are crowned; each of these bears in the centre a heraldic rose, the best known of the many emblems of the Malatesta family. A third is the laurel wreath proffered to the Child by an angel on the right. The Malatesta rose apart, no motif occurs at Rimini with greater frequency; on the outside of the Tempio we find it employed to frame the monogram of Sigismondo and the Malatesta arms which form a frieze beneath the funerary monuments; within, it surrounds the portrait reliefs of Sigismondo Malatesta and his monogram. By an extension of this symbolism, a laurel wreath, Roman symbol of triumph, Greek symbol of atonement, is here held out to the Child Christ. A fourth is the vase (Fig. 93), containing two sprays of palm leaves, perhaps employed as a symbol of the Word made flesh. That the vase and wreath are more than casual interpolations in the composition and were intended to carry a specific meaning, is suggested by a fifth feature, the pendant suspended by a chain round the Child's neck (Fig. 100). This shows a figure in a chariot drawn by a team of horses, and is based on a Greek coin from Syracuse, probably of the third century B.C., with the design of a quadriga driven by a winged male figure, probably a Nike or Victory (Fig. 98). If the subject of the coin was identified correctly in the fifteenth century, it must relate to the victory of Christ, and the wreath must be the victor's crown. On the other hand, a related design of *Apollo driving the Chariot of the Sun* appears above the arch in the Chapel of the Planets in the Tempio Malatestiano, and the imagery of the coin may have been interpreted in this sense. The inscription painted on the cartellino, now erased, would have clarified this imagery.

The court art of the Italian Renaissance was an art designed for small circles of cultivated men. Of its very nature it was recondite, literate and sophisticated. The humanist conceptions embodied in the carvings in the Tempio Malatestiano are said by Valturio to have 'won the admiration of those who have experience of letters and are far removed from the vulgar

throng'. It is very possible that the programme of the relief in London was devised by Sigismondo Malatesta or a member of his entourage, and here, as in the Tempio, this finds its counterpart in an etiolated style which, of its very nature, can have exercised no more than a limited appeal. Like the carvings in the Tempio Malatestiano, it seems at first sight to be lacking in humanity and naturalness. The Virgin with her downcast eyes, the Child gazing over his shoulder, and four of the five angels intent upon the central group, make no overt appeal to the spectator, and direct contact can be established only with the putto whose head appears over the parapet. Yet, on an aesthetic plane, this is a more rewarding work than many more immediately engaging reliefs. Remote though they may seem, its figures are instinct with life, and the parted lips of the Virgin and the Child give the scene the same quivering intimacy, the same sense of arrested movement, as the open-mouthed choir of angels in Piero della Francesca's *Nativity* in the National Gallery. Beneath the apparently flat surface lies an infinite variety of subtle modelling, most clearly evident on the Virgin's neck and throat, where the grey veining of the marble lends the forms an added emphasis. Reduced to its constituent parts, it presents a series of details of the highest quality, and some of these—the hand of the Child clasping the Virgin's finger, for example, and the wrist of the angel proffering the wreath —have the same finality, the same chiselled perfection, as comparable passages in Piero's paintings. Above all, it speaks to us through its use of line, sometimes in calm accents like those of the contours of the Virgin's neck and hand, sometimes in the gayer tones of the drapery that ripples downwards from her throat. With a style and imagery alike revivified by contact with antiquity, the relief is eloquent of the ambition to reconcile the worlds of Christianity and paganism, which inspired so many of the masterpieces of Renaissance art.

Originally published as a Victoria and Albert Museum monograph in 1952.

Two Paduan Bronzes

In 1906 attention was drawn by Bode to two Paduan bronzes in the Figdor Collection in Vienna, representing the *Mountain of Hell*.[1] One of these two bronzes[2] showed the gate of Hell, with the three Furies gesticulating above it, and a prostrate male figure, probably Tityus, at one side. To the right, on a smaller scale, was a gateway and bridge leading to a castle with a machicolated wall. Adjacent to the gateway was a male figure embedded in the rock, and above three more male figures protruded from the cliff, two of them looking upwards and one down. The second bronze[3] also showed the gate of Hell, guarded this time by Cerberus. To the left was Ixion on the wheel, and to the right Tityus accompanied by a bird of prey. Still further to the right appeared two women—perhaps the Danaids filling their bottomless cask. The second model differed from the first in the absence of the gateway, bridge, and castle, but, above, the giants appeared again, this time with small male figures at their sides, proffering indecipherable objects, perhaps fruit. One of the giants may have represented Tantalus. A harpy sat at the apex of the bronze. Throughout the two bronzes the imagery derived from the celebrated passage in the *Metamorphoses* (iv, 447–63) describing Juno's visit to the underworld:

Thither, leaving her abode in heaven, Saturnian Juno endured to go; so much did she grant to her hate and wrath. When she made her entrance there, and the threshold groaned beneath the weight of her sacred form, Cerberus reared up his threefold head, and uttered his threefold baying. The goddess summoned the Furies, sisters born of Night, divinities deadly and implacable. Before hell's closed gates of adamant they sat combing the while black locks from their hair . . . This place is called the Accursed Place. Here Tityus offered his vitals to be torn, lying stretched out over nine broad acres. Thy lips can catch no water, Tantalus, and the tree that overhangs ever eludes thee. Thou, Sisyphus, dost either push or chase the rock that must always be rolling down the hill again. There whirls Ixion on his wheel, both following himself and fleeing all in one; and the Belides, for daring to work destruction on their cousin-husbands, with unremitting toil seek again and again the waters, only to lose them.

Any doubt that this (not the *Inferno*, as supposed by Planiscig) was the source of the representation is resolved by a woodcut of *Juno in the Under-*

world in the Venice edition of the *Metamorphoses* of 1477, which shows Tityus, the Danaids, and Ixion precisely as they are represented on the two bronze groups.[4] Possibly a figure of Juno was originally included in the second Figdor model.

Subsequently two further bronzes of the *Mountain of Hell* were published by Planiscig.[5] These were variants of a single model, one in the Stiftmuseum at Heiligenkreuz[6] and the other in the H. W. Cook Collection (Fig. 104).[7] In the Cook bronze the gate of Hell, as we see it on the Figdor groups, is replaced by a cave, from which there steps out a female figure with left arm outstretched. Above the cave are the Furies, gesticulating at a missing figure on the right, and beside it is Cerberus chained to the rock and the Tityus figure of the second Figdor bronze reversed. At the back stands a small figure of Sisyphus. Three bearded figures peer out from between the rocks, and at the top is a harpy, also related to that in the second Figdor model. The Heiligenkreuz bronze is considerably coarser, and is of interest only because it includes the missing figure beside the cave, a Hercules. From the prominence given to this and to the female figure it is evident that the model represents Hercules rescuing Alcestis, and that its theme is the discomfiture of the infernal powers by Hercules.

The two Figdor bronzes were given by Bode to Bellano[8] and by Planiscig to the young Riccio;[9] the latter attribution is that most widely accepted today. It was not unnaturally assumed by Planiscig that the Heiligenkreuz and Cook bronzes in turn depended from a lost original by Riccio. '*Es mag für uns gleichgültig sein*', he observes of the former,[10] '*zu erforschen, wann der Höllenberg des Museums von Heiligenkreuz entstanden ist. Sicher ist er keine eigenhändige Arbeit Riccios, und die flaue, summarische Art der Behandlung schliesst auch die unmittelbare Werkstatt dieses Künstlers aus. Wir werden nicht irren, wenn wir annehmen, dass er eine Kopie oder ein Nachguss nach einem verlorenen oder verschollenen Original ist, nach einem Werke, das in seiner ursprünglichen Form gewiss die ausserordentlichen Qualitäten der zwei Höllenberge der Sammlung Figdor aufwies.*' The designation '*nach Riccio*' appears under the illustrations of the Heiligenkreuz and Cook bronzes in Planiscig's monograph. There would seem every reason to believe that the bronze reproduced on Fig. 102, which has recently been acquired (along with the Cook version) for the Victoria and Albert Museum, is the missing original the existence of which was inferred by Planiscig.[11] The bronze is incomplete; the harpy has lost its head, one of the three heads of Cerberus is missing, and, more important, all of the three free-standing figures, the Alcestis, Hercules and Sisyphus,

have disappeared. It cannot be assumed that the placing of these figures
was necessarily the same as in the Cook and Heiligenkreuz versions. That
there were differences between the groups is clear from the posing of the
Furies, who are turned slightly to the right and not represented in full face
as in the Cook example; and judging from holes in the base where the large
figures were originally set, we may conclude that the Hercules in this example
stood slightly to the right, and that the Sisyphus (one of whose feet
survives) faced inwards as though walking up the cliff. However that
may be, the correspondence between the other figures is close enough
to prove that Planiscig was right in regarding the two known bronzes as
derivatives from a superior original. Right, that is, in everything except
his guess as to its authorship, for the new bronze is by Bellano not by
Riccio.

 A criterion of style for the small bronzes ascribed to Bellano is provided
by the ten documented reliefs in the choir of the Santo. We do not know
the order in which these were executed, save that the *Samson destroying
the Temple* is the earliest of the scenes and was completed by November
1484.[12] An order was then placed for the nine remaining scenes (including
two, the *Story of Jonah* and the *Crossing of the Red Sea*, which had been
allocated a year earlier to Bertoldo). All of the scenes were finished by 1488.
For Vasari the Santo reliefs represented no more than an unsuccessful
effort to emulate the style of Donatello. '*E, per quanto si vede*', runs his
commentary,[13] '*ebbe questo artefice estremo desiderio d'arrivare al segno
di Donatello; ma non vi arrivò, perché si pose colui troppo alto in un'arte
difficilissima.*' In fact, Bellano's aspirations throughout the reliefs in the
Santo have almost nothing in common with Donatello's, and are rather a
reversion to the encyclopaedic naturalism of Gentile da Fabriano and Pisa-
nello. In Florence his memories of Donatello's reliefs on the altar of the
Santo must have been superseded by the far more assimilable Gothic
naturalism of Ghiberti; and in Rome recollections of the Porta del Paradiso
must have been coloured by the rude vigour of the bronze reliefs of Filarete.
As a result Bellano, when he returned to Padua, had moved away from
Donatello's conception of a relief field organised by means of linear
perspective as an aesthetic unity, and had replaced it with a system by
which space was represented intuitively and not by the use of an artistic
device. Hence the vast panoramas of the Santo bronzes ('*carte geografiche
in rilievo*', as Venturi calls them).[14] For Bellano linear perspective was an
impediment to naturalism, and the most remarkable of his inventions (for
example, the extraordinary group of figures crushed by falling masonry

above the Samson scene) would scarcely have been possible had his com-position assumed an artificial form.

The recourse to naturalistic settings in turn permitted a new naturalism in the treatment of the figures. In Padua, in Florence, in Rome even, Bellano's temperament insulated him from the antique. Throughout the Padua reliefs the carefully particularised figures depend for their effect not on calculated artistry but on sheer imaginative force. Seeking the vivid depiction of emotion and direct communication with the onlooker, Bellano evolved a bronze style which was the antithesis of Donatello's on the altar and set a premium on roughness and strength. Hence the often misquoted judgment of Pomponius Gauricus who, after mentioning Leo-nardo's sculptures, uses the words: '*Sed et Donatelli discipulus Bellanus tuus, Leonice, inter hos quoque nomen habebit, quamquam ineptus arti-fix.*'[15] These considerations are fundamental for an understanding of the newly acquired bronze. To those who are accustomed to the small bronzes of Riccio there will be something disconcerting in this squat model, devised with sublime disregard for the clasical canon or for aesthetic effect. Yet, set against the background of Bellano's other works, it becomes not merely a document of cardinal importance in the history of the Paduan bronze statuette, but a serious and impressive work of art. The figures have the same graphic quality as those in the Samson relief, and are modelled with an elemental vigour which derives in part from the overriding conviction of the sculptor and in part from the deliberate roughness of the cast. All of the forms are realised with great intensity, and the heads, especially the heads of the embedded giants (Figs. 107, 108), attain an astonishing level of expressiveness. The surface treatment in its essentials is that of Riccio, but it is bolder and more empirical; from a technical point of view some of the most fascinating passages occur in the Furies, where the hammering of the sagging breasts and sharply defined veins and ribs is particularly notable. Owing to its unorthodox form and varied subject-matter, the model offers a fuller illustration than any other small bronze by Bellano of the repertory of bronze technique from which the early style of Riccio springs.

The relation of the present version to the Figdor models cannot be ana-lysed in detail, since both these bronzes were destroyed in 1945.[16] In the first Figdor bronze the giant to the right of the gateway and bridge appar-ently derives from the uppermost of the giants on the new bronze, but the features are slightly modified and the proportions of the head have become more classical. These are the changes that we would expect had the young Riccio adapted Bellano's type. The two lower figures from the new model

recur, in somewhat different context, on the second Figdor bronze, and once more they are less expressive and more highly worked. If the bronze which has now come to light was executed by Bellano in the last decade of his life, there is nothing to preclude the view that the two Figdor bronzes were made by Riccio while he was still working with Bellano. They can hardly be of a later date than the three figures which were contributed by Riccio, after Bellano's death in 1496–7, to the Roccabonella monument.

Unlike the Figdor bronzes, the Cook version must have been commissioned as a copy of Bellano's prototype. A number of changes are introduced into the scheme; as has been noted, the three Furies are differently posed, the Sisyphus is shown walking round the mountain, and the left arms of the two giants are no longer extended downwards but are clasped round the rock. The head of the figure restraining Cerberus has taken on a San-sovinesque character, and would by itself scarcely admit of a dating before the middle of the sixteenth century. The bronze is rather yellower than the Bellano, and the cast is lighter;[17] the smooth treatment of the surface is also consistent with a later origin. Both form and technique are indicative of a Paduan artist of the generation of Desiderio da Firenze, but a direct ascription to this sculptor is not permissible.

For what purpose was Bellano's model made? It was suggested by Planiscig[18] that '*wir in den Höllenbergen Güsse nach Modellen für "macchine trionfali" vor uns haben; wir müssen sie uns auf Wagen aufgestellt denken, wahrscheinlich mit einem Mechanismus versehen, der die Figuren in Bewegung setzte: die Furien und die Hexen neigten die Köpfe und erhoben die Arme, das Rad des Ichtyon drehte sich, der Geier des Tityus schlug mit den Flügeln und die verschlossene Eisentür am Eingang der Unterwelt ging von Zeit zu Zeit auf, um irgend ein Ungetüm der Hölle zu zeigen. Die gewaltigen Dimensionen einer derartigen "macchina" können wir aber aus dem hölzernen Pferde im Salone zu Padua entnehmen, das für eine solche gedient zu haben scheint.*' Here Planiscig has clearly allowed an always active imagination to run away with him, since an explanation which would be unpersuasive enough if only one version survived is entirely untenable when there are five. If, as it is reasonable to presume, the proto-type was made during the 1490's, was adapted by Riccio, and half a century later was modified by another artist, it is obvious that we are dealing with an object which was either regarded as attractive in itself or had some practical function to perform. That the latter is the proper explanation of the model is proved by the fact that in the Cook bronze the mouths of the Giants, Cerberus, and the Furies, are bored and fitted with small tubes.

102. Bartolommeo Bellano: *The Mountain of Hell*. Bronze, height 26 cm.
London, Victoria and Albert Museum

104. Paduan, mid-sixteenth century: *The Mountain of Hell.*
Bronze, height 28 cm. London, Victoria and Albert Museum

103. Bartolommeo Bellano: *The Mountain of Hell.* Bronze, height 26 cm.
London, Victoria and Albert Museum

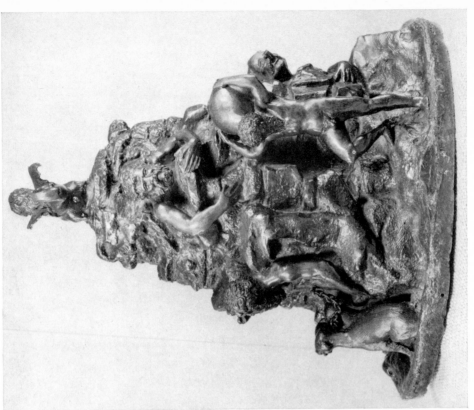

106. Paduan, mid-sixteenth century: *The Mountain of Hell.*
Bronze, height 28 cm. London, Victoria and Albert Museum

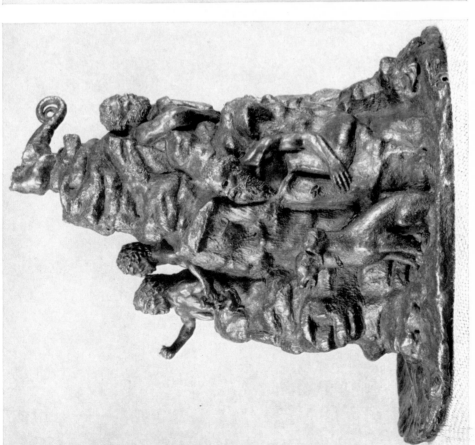

105. Bartolommeo Bellano: *The Mountain of Hell.* Bronze, height 26 cm.
London, Victoria and Albert Museum

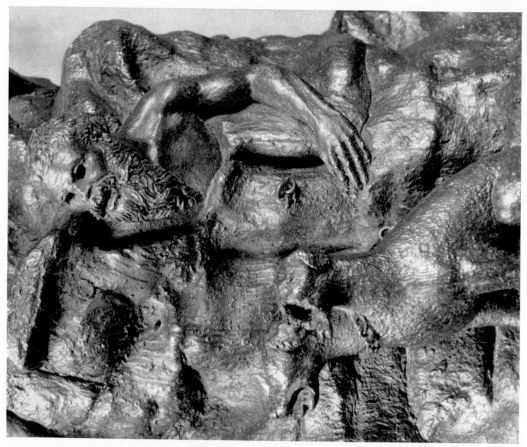

108. Detail of Fig. 106

107. Detail of Fig. 102

Bellano's prototype is not fitted with tubes, but in this case not only the mouths are bored, but the eyes as well. In addition there is a hole beneath the cavity from which Alcestis must have stepped. The base of both models has the form of a circular rim, and would be consistent with the view that the bronzes formed the upper part of some receptacle. Since the external tubes of the Cook bronze are not continued inside the model, this cannot have been a table fountain, and the emergence of streams of water from a bronze of the Inferno would in any case have been inapposite. If, on the contrary, the Bellano bronze formed the top of a brazier or perfume burner, the holes would have emitted smoke, and the verisimilitude of the model would have been much enhanced. Let us then substitute for Planiscig's triumphal car the picture of a smoking brazier crowned by a simulacrum (playful in intention, yet lifted by a great artist to a new expressive plane) of the defeated powers of Hell, and we shall understand why, in the humane climate of Padua, copies of the model were in demand.

Originally published in *The Burlington Magazine*, xcvi, January 1954.

Two Chimney-pieces from Padua

W HEN the catalogue of the Italian sculpture in the Victoria and Albert Museum was prepared during the nineteen twenties, it was laid down that decorative and architectural carvings should be omitted even where they were figurated. Among the casualties which resulted from this policy was a tufo chimney-piece[1] (Figs. 109–111), which has in consequence been overlooked by writers on Italian sculpture. Comparatively small in size, it is supported on two jambs with semi-detached balustre-shaped shafts in the form of classicising candelabra. The bases of the jambs are in the form of lion feet terminating in acanthus leaves, and beneath these are set two lion masks. Between the jambs and the upper section of the chimney-piece are consoles in the shape of tritons gazing across the intervening space. But the main interest of the chimney-piece centres on the frieze, which is filled with a continuous band of small figures and animals carved in such depth that many of them are virtually in the round. Working round it from left to right, we find on the left side a board attacked by hounds accompanied by huntsmen and naked putti. On the front appear three hunting scenes, a goat hunt, in which the hounds are goaded on by a nobleman and a lady riding side-saddle, a bear hunt, and a stag hunt in which a solitary boar has accidentally become involved. At each end of the front is a genre group, that on the left consisting of two peasants and a woman drinking from a flask, and that on the right composed of two more peasants and a woman carrying a basket (Figs. 115, 116). On the right side, corresponding to the boar hunt on the left, is a bull attacked by hounds. As might be expected in a tufo frieze so deeply cut, a number of the figures have been damaged, certain faces have been obliterated, and some heads have been broken off. Enough remains, however, to establish that the fire-place is an example of late fifteenth- or early sixteenth-century naturalistic carving of extraordinary vigour and inventiveness.

It so happens that one other chimney-piece from the same workshop survives. This is published by Planiscig in his catalogue of the Estensische Kunstsammlung in Vienna.[2] The reason for claiming that the two works come from a single studio is that the underside of the projecting section of the chimney-piece in London is carved with an extremely shallow band of hounds, hares and other animals (Fig. 112). A band of precisely the same

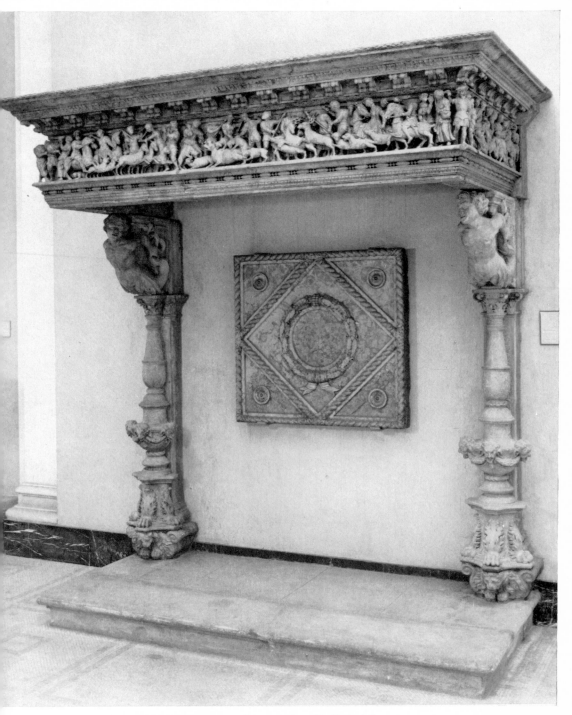

109. Workshop of Riccio: *Chimney-piece*. Tufó, height 231·8 cm.
London, Victoria and Albert Museum

110. Workshop of Riccio: *Chimney-piece* (left side). London, Victoria and Albert Museum

111. Workshop of Riccio: *Chimney-piece* (right side). London, Victoria and Albert Museum

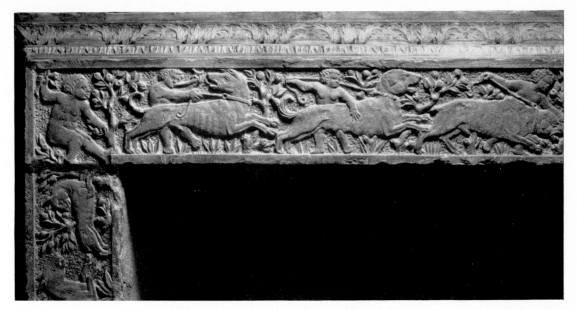

112. Workshop of Riccio: *Chimney-piece* (under side). London, Victoria and Albert Museum

113. Workshop of Riccio: *Chimney-piece* (under side). Vienna, Kunsthistorisches Museum

114. Workshop of Riccio: *Chimney-piece*. Vienna, Kunsthistorisches Museum

115-116. Workshop of Riccio: *Woman drinking from a flask; Woman with a basket.* London, Victoria and Albert Museum

character appears on the underside of the projecting section of the Vienna chimney-piece (Fig. 113). There can, indeed, be little doubt that the putti beneath the Vienna chimney-piece and the putti beneath the chimney-piece in London were carved not simply in a single studio but by one hand. The subject-matter of the frieze in the second fireplace (Fig. 114) is, however, rather different from that in the first. If we read round it once again from left to right, we find a series of foliated scrolls, peopled with birds and snakes and frogs, a child riding on a dragon, a satyr child playing with a griffin and a human child playing with an ape. On the front the same motifs continue —to the left of the central stemma there is an enchanting group in which a satyr child and a real child embrace—and the right side completes the left with a dragon ridden this time by a satyr child. The state of conservation of the Vienna chimney-piece is better than that in London, and the relief system is one of exceptional brilliance and variety.

From the style of the small figures alone, we would guess that the chimney-piece in London was carved in Padua, and this is indeed the case; it was bought for the Museum from the Soulages collection in 1865, and according to Robinson's catalogue of this collection,[3] had been procured originally 'from the palace of the Counts Petinelli at Padua'. Moreover, we come upon the traces of the chimney-piece again, in a pamphlet published in 1832[4] when it was still in the possession of the Conti Petinello, containing a description which is of interest only in so far as it reveals that the chimney-piece then comprised the same elements as now, and was already a good deal deteriorated. The sale of the chimney-piece to the Soulages collection seems to have taken place in 1841, and the house from which it was removed was No. 3779 (old numbering) in the via San Francesco al Soccorso.[5] The Vienna chimney-piece was secured for the Este collection from Catajo, and has the arms of Obizzi in the centre of the frieze. In spite of this clear indication of its Paduan origin, it was regarded by Planiscig as Florentine, and was ascribed by him to Benedetto da Rovezzano.[6]

This is the more puzzling in that the affinities of the two chimney-pieces are manifestly with an artist to whom Planiscig had given specially close thought. It is surely inconceivable that any student should have looked at the Obizzi stemma on the Vienna fireplace without being reminded of the larger, more imposing stemma under the Trombetta monument; that the running putti should not have evoked memories of the *Running Child* in the Lederer collection and the Liechtenstein *Running Child with arm raised*; and that the children seated on the dragon's back should not have brought to mind the beautiful door-knocker with Romulus and Remus in

the Hermitage. Even the figure of a satyr on the right, with back arched and left arm raised, might alone have rung a muffled bell. Suspicion in Vienna becomes certainty in London, for whereas the relationship of the Vienna figures is to Riccio's satyr bronzes and his putti, the London frieze spells out the name of Riccio the maker of naturalistic terracottas and bronze statuettes. Here a figure reminds us of the so-called *David* in Berlin, and here another reminds us of the *Wolf* in the Mayer collection. How wholly in the spirit of the *Spinario* in Berlin is the right side of the frieze (Fig. 111), where a kneeling man is shown struggling with a lion in precisely the same posture that is found again in Moderno's *Hercules and the Nemean Lion* plaquette, and an adjacent figure with ankles crossed also reflects a classical original. How true to the style of the *Resting Shepherd* in Vienna is the seated man playing a bagpipe immediately to the left of these two groups. And how typical of Riccio's imaginative processes are the groups of peasants on the front. Admittedly the forms throughout the London frieze are stiffer and less well articulated than is usual with Riccio's bronze statuettes, but in the two female figures, one drinking from a flask and the other carrying a basket, the whole character of Riccio's model, its sentiment and even the movement of its drapery, in some miraculous fashion is preserved.

The interest of the chimney-pieces need not be insisted on. Neither was carved by Riccio, but both certainly depend from models by this sculptor. Never will there appear more than a hundred new animal and figure bronzes ascribable to Riccio, yet here we have over a hundred figures—animals and human figures and figures in between—which are faithful reproductions of his designs. They extend our knowledge of the teeming world that lies below the crust of the classicism of the Paschal Candlestick, and they reveal the artist of the Della Torre monument in a new guise, as a domestic decorator of the first rank. Above all, they suggest that the problem of Riccio's work requires to be thought out afresh, not, as it was by Planiscig, from the standpoint of the modern collector of small bronzes, but historically as the carefully calculated vehicle whereby the conceptions of a circle of Paduan humanists found expression in church sculpture and in the artefacts of daily life.

Originally published in *Arte antica e moderna*, 1961.

A Relief by Sansovino

T HE relief reproduced in Fig. 117 was acquired by the Victoria and Albert Museum during the spring of 1958 with the assistance of a generous contribution from the National Art-Collections Fund.[1] Measuring 56.5 by 127.5 cm., it represents two scenes, neither of which can be readily identified, and its interest resides not in its subject-matter but in its authorship and its technique. On both counts it is entitled to a place among the great documents of High Renaissance art. The relief is modelled on two cypress boards joined at the back with vertical braces or supports. So far as can be judged its structure has not been modified since it was made, and the back is penetrated by a number of old nails, on whose heads the protruding sections of the figures seem to have been built up. The surface of the wood in front is covered with abraded dark blue paint. The seven figures are modelled in a form of coarse stucco or unbaked clay mixed with goat hair, and their dresses are constructed of linen covered with paint or size. Both trees and figures are painted in a greyish brown, and though there are slight traces of local colour on the lips of one of the two soldiers on the left, it seems that the raised areas were not pigmented naturalistically, but were coloured in a fashion which would, at a distance, create the illusion of a stone or bronze relief. Despite the fragility of its construction, the relief is well preserved, though the front of the right foot of the figure on the extreme left has disappeared and there are traces elsewhere of local repairs in stucco, possibly dating from the sixteenth century. So far as I am aware there is no analogy for the ramshackle technique of the relief in the early or High Renaissance, and the scene therefore represents a category of sculpture of which no other example has survived.

If the subject-matter is a conundrum, the authorship of the relief is not, for it is in every respect a typical work by the artist who was, after Michelangelo, the greatest sculptor of the sixteenth century. Only one indubitable sketch-model by Jacopo Sansovino has been preserved, a wax *Deposition*[2] which according to Vasari was prepared for the use of the painter Perugino and which was employed by Perugino in a fresco at Città della Pieve and by a Perugino pupil in a panel at Bassano.[3] Fortunately the *Deposition* is also owned by the Museum in which the new relief has come to rest, and direct comparison between the two leaves not the least doubt of identity of

authorship. Thus the modelling of the protruding head of the soldier in the new relief is identical with that of the figure at the apex of the *Deposition* (detail, Fig. 120), and the modelling of the arms of the two bearded figures on the right and the three forward figures on the left also finds the closest possible analogies in the wax relief. Sansovino's authorship of the new scene need not, however, rest on similarities to the wax model alone. If we turn to the marble statue of *St James* in the Duomo in Florence (Fig. 119), we find an exact equivalent in carving for the nervous ridges of the linen drapery, and if we turn to the monument in S. Marcello in Rome, we encounter in the *St Peter* in the left-hand niche (Fig. 118)[4] a first cousin to the bearded man on the right of the new scene (detail, Fig. 121). Also typical of Sansovino is the construction of the units which make up the relief. In that on the right (detail, Fig. 121) the legs of the three figures are disposed, with great boldness and ingenuity, as a triangle, in a pattern which at once recalls the pyramidal stance of the Child in the *Madonna del Parto* in S. Agostino, while in that on the left (detail, Fig. 122) the four figures form a rectangle, through which the kneeling man with left arm raised and right arm lowered marks an inspired diagonal. This Raphaelesque motif also falls within the repertory of Sansovino.

If, then, the relief is an unrecorded work by Sansovino, when was it produced? The most important factor in dating the relief is the presence of the two nude soldiers on the left, which depend from figures in the print of the *Massacre of the Innocents* of Marcantonio. Since the *Massacre of the Innocents* was designed by Raphael about 1509–10, the relief cannot have been made before this time. The wax *Deposition* is not exactly datable, though it was certainly conceived before 1517, the year of the fresco at Città della Pieve. If Vasari is correct in stating that it was made for Perugino's use in Rome, it must have been modelled in 1508 or 1510.[5] The *St James* in Florence was commissioned in 1511, was in course of execution in 1513, and was finished five years later.[6] In the same year (1518) work was begun on the *Madonna del Parto*, which was completed in 1519.[7] Concurrently Sansovino seems to have been engaged on the *St James* for S. Giacomo degli Spagnuoli (where the drapery forms are less closely related to the stucco relief than those in the *St James* in Florence).[8] The monument in S. Marcello (where the drapery forms are once more simpler, though the action remains uniform) is undocumented, but seems to have been planned about 1522.[9] The balance of evidence, therefore, is that the new relief was made about 1512–18.

There is one source of corroboratory evidence for the date of the relief,

and that is the work of Andrea del Sarto in the same term of years. Though Vasari[10] describes the inter-dependence of Andrea and the young Sansovino, little attention has been paid to this by writers on either artist, and for this reason it may be well to quote the passage here:

Giovò anco pur assai all'uno ed all'altro la pratica e l'amicizia, che nella loro fanciullezza, e poi nella gioventù ebbero insieme Andrea del Sarto ed Jacopo Sansovino, i quali, seguitando la maniera medesima nel disegno, ebbero la medesima grazia nel fare, l'uno nella pittura, l'altro nella scultura, perchè conferendo insieme i dubbi dell'arte, e facendo Iacopo per Andrea modelli di figure, s'aiutavano l'un l'altro sommamente.'

At a time when no early relief by Sansovino was known—no relief, that is, earlier than the lunette of the S. Marcello monument—the significance of this passage was uncertain, though most students of High Renaissance painting must have observed in silence that the child with upturned head on the left of the fresco of *Charity* of 1512–15 in the Chiostro dello Scalzo was loosely based on the Raphaelesque *Bacchus* carved by Sansovino for the garden at Gualfonda in 1512.[11] Similarly the triangular group on the right of the new relief has a direct relevance to the group on the right of the *Arrest of the Baptist* in the Chiostro dello Scalzo (Fig. 124). This fresco was painted in 1517.[12] Vasari may have been correct in supposing that both artists were spontaneously speaking the same language, but the contrast between the tight, resolute group of Sansovino and the weaker, more diffuse construction of Andrea would in itself suggest that Andrea at this point was working from a model by Sansovino. Possibly in the fresco of *St John Baptising*, which was completed in the same year, Sansovino prepared models for the remarkable nude figure with knee raised on the left and for the central figure of the Baptist, where the torsion is more extreme than is usual with Andrea at this time. Almost certainly Sansovino, with the glamour of his Roman years behind him, was the dominant partner in this relationship.

The new relief, moreover, proves that as a relief artist no less than as a full-scale sculptor Sansovino's was a remarkably consistent development. When, in 1535, he was called upon to complete the relief begun by Antonio Minelli in the Santo at Padua, he introduced into the centre a female figure which, in reverse, recalls the kneeling man with arms raised in the present scene; and when, in 1536, he was commissioned to execute a second relief for the church, he made use once more, in the left half of the carving, of the pose of the beardless figure on the right side of the new relief. In a more

general way the soldier from the new scene explains the genesis of the bearded man on the extreme left of the second Padua relief, where, by that magic of which only a great artist is capable, Raphael has been transmuted into Tintoretto. On its own terms the stucco is the supreme example of Raphaelesque style in relief sculpture, and adds a new chapter to the story of the only artist who spans the gulf between Perugino's ceiling in the Stanza dell'Incendio and the Villa Maser.

For what purpose was the relief made? In the sixteenth century Sansovino's sketch-models were highly prized; the model for the *St James* in Florence was, for example, owned by Bindo Altoviti.[13] What divides this figure so sharply from the work of Andrea Sansovino is its drapery forms which are commented on both by Vasari[14] and Borghini.[15] Possibly the drapery of the lost model was built up in linen as in the new relief. There is, however, one decisive reason against interpreting the new scene as a sketch-model, and this is the difficulty of determining the medium and function of the completed work. The scene could hardly have formed part of a predella, since the protruding heads of the kneeling man and forward soldier on the left are fully intelligible only when they are inspected from below. Moreover, the figures on the left, though not those on the right, are as a whole incompatible with marble sculpture. If then the relief was set relatively high, is it not possible that we are here dealing with a finished work? And if this be so, may the relief not prove to be the sole surviving fragment of the celebrated decorations which Sansovino executed for the entry of Pope Leo X into Florence in 1515?

The excitement of the month preceding the Pope's entry on 30th November is best described by Landucci:[16]

E nota ch'a far queste cose di legname fu necessario operare queste cose Santa Maria del Fiore, Santa Maria Novella, la chiesa e chiostri, Santo Spirito, la chiesa, chiostri e rifettori, Santa Felicita in Piazza, S. Jacopo Soprarno, Santa Croce, el Palagio del Podesta, lo Studio, San Michel Berteldi e molte altre stanze. Ed erano in modo occupate queste dette chiese, che bisognava dicessino l'ufficio per altre stanze. E di di festa e di feriali, di notte e di di, v'era maggiore rumore e fracasso, e basto piu d'un mese inanzi con piu migliaia diuomini. Non era in Firenze si da meno dupintorello, e d'ogni arte, che non fusse condotto in tale arte, diverse cose che bisognava.

For more than a month 2,000 men were employed in constructing the triumphal arches under which the procession was to pass and the reproductions of Roman monuments that lined the route. The most vivid des-

cription of the decorations is quoted from an unspecified source by Domenico Moreni in his edition of Paris de' Grassi's *De Ingressu summi pont. Leonis X Florentiam.*[17] Since this book is not generally available, the passage may be quoted here:

Entro la Santita di Leone X dalla Porta a San Gaggio, la quale trovo ornata di un bello, e vago arco fatto a similitudine di quelli degli antichi Romani, dipoi se ne venne a S. Felice in Piazza, dove trovo il secondo Arco, dove era l'immagine di Lorenzo suo Padre con un verse che diceva: *Hic est Filius meus dilectus*, il che da S.S. veduto, e letto fu visto alquanto lagrimare; dipoi addirizzatosi su per via Maggio arrivo al Ponte a S. Trinita, il quale trovo ornato di due bellissime macchine: una era all'entrare del Ponte in forma di arco, nella sommita della quale era scritto *Leoni X laborum victori*, e l'altra era di la dal Ponte di verso S. Trinita, e quest'era un'altissima Guglia. Passato il Ponte arrivo a S. Trinita, e dipoi sul canto, dove si abboccano le due strade una detta Parione, e l'altra Porta Rossa: qui vi era fatta un' altra Macchina in forma di un tondo Tempio, avanti al quale un Vestibolo in forma di luna, nel fregio del quale erano lettere, che in sostanza significavano esser questa Citta in protezione di due Leoni, e due Giovanni felicissimamente posarsi, intendendo per l'uno il celeste Batista, e per l'altro il terrestre de' Medici: dipoi addirizzandosi su per Porta Rossa, arrivato in Mercato Nuovo, quivi trovo un'altissima Colonna molto ben lavorata, dipoi per Vacchereccia arrivo in Piazza de' Signori, dove sotto gli archi della Loggia, che de' Tedeschi si chiama, era fatta una grandissima Statua di Ercole colla Clava in sulla spalla, dipoi torcendo verso il Leone, che e sul canto della Ringhiera, quivi trovo un altro arco bellissimo, il quale era diviso in quattro, e per il suo mezzo faceva due strade, posate su otto bianchissime Colonne scannellate, nella sommita del quale era scritto *Leoni X. P. Max. propter merita*; e cosi passanda al Sale, e da i Gondi arrivo al Palazzo della Podesta, dove era dirimpetto a Badia fatto un superbissimo arco, e allato alla Porta di detta Badia ve n'era fatta a similitudine di quella un'altra finta; e questo per non essere la detta Porta a dirittura nel giusto mezzo della via del Palagio a tale che la falsa dalla vera non si distingueva, e sopra quest'arco fu scritto: *Leoni X. Pont. Max. Fidei Cultori*; e seguendo la strada dal Canto de' Pazzi, e venendo da' Fondamenti quivi sul canto d'onde prima si scuopre la Cupola trovo un altro arco bellissimo, il quale sembrava tutto di rosseggiante Porfido, e per la sua mirabile struttura fu tenuta il piu bello di tutti gli altri, nella sommita della quale era scritto: *Spes eius in Domino Leo X Pont. Max.* e girando dietro a essi Fondamenti pervenne in sulla Piazza di S. Gio. dove la faccia di S. Maria del Fiore era tutto rifatta da terra fino alla cima del tetto, e mostrava con bellissima invenzione essere tutta di pallidi marmi, che per loro stessi denotassino per lunghezza del tempo, e per le continove

pioggie essersi dalla lor natural bianchezza nel colore dell' orientali perle trasformati.

After vesting in the Cathedral, the Pope again left the church, and

passando dal Canto alla Paglia arrivo al Canto de' Carnesecchi dove era fatto un vago e bellissimo Arco con 10 Ninfe, che cantavano, e trall'altre in un quadrato era un quadretto dipinto un Leone, che colla propria lingua curava le piaghe di un ferito corpo con un motto, che diceva: *Omne dulce in ore Leonis*. Dipoi arrivato in sulla nuova Piazza di S. M. Novella, nel mezzo della quale era fatto un bello e grandissimo Cavallo a similitudine di quei due, che sono in Roma a Monte Cavallo.

Thence, by way of the Via della Scala, the Pope proceeded to his lodgings. Some additional detail is provided by Landucci, who methodically counted the number of columns and pilasters in each arch and recorded some contemporary views on the relative success of each part of the decoration. From Landucci we learn that the copy of the Trajan Column, fifty *braccia* high '*fasciata di tela*', was '*piuttosto cosa sciocca*', and that the *Hercules* which the unlucky Bandinelli constructed in the Loggia dei Lanzi '*non fu molto stimato*'.

Sansovino's share in the decoration was confined to two points,[18] one of them the Piazza di Santa Maria Novella, where he was responsible for a gigantic reproduction of one of the two horse-tamers from the Quirinal on a brick base four *braccia* high,[19] and the other the Duomo façade. This last work seems to have been looked upon in the sixteenth century as the focal point of the entire scheme. The reason for this, if Landucci and Cambi are so to be trusted,[20] was that the wooden front constructed by Sansovino was popularly thought to be a model for a permanent façade. The arch is mentioned by Vasari on two occasions at considerable length. The first and more important of the two references occurs in the life of Sansovino:[21]

Il Sansovino non solo fece i disegni di molti, ma tolse in compagnia Andrea del Sarto a fare egli stesso la facciata di Santa Maria del Fiore tutta di legno, e con statue e con istorie ed ordine di architettura, nel modo appunto che sarebbe ben fatto ch'ella stesse, per torne via quello che vi è di componimento ed ordine tedesco. Perchè messovi mano, per non dire alcuna cosa della coperta di tela, che per San Giovanni ed altre feste solennissime soleva coprire la piazza di Santa Maria del Fiore e di esso San Giovanni, essendosi di ciò in altro luogo favellato a bastanza; dice, che sotto queste tende avea ordinato il Sansovino la detta facciata di lavoro corinto, e che fattola a guisa d'archo trionfale, aveva messa sopra un grandissimo imbasamento da ogni banda le colonne doppie, con certi nicchioni fra loro, piene

117. Jacopo Sansovino: *The Story of Susannah*. Stucco and linen on wood, 56·5 by 127·5 cm. London, Victoria and Albert Museum

118. Jacopo Sansovino: *St Peter*.
Marble. Rome, S. Marcello al Corso

119. Jacopo Sansovino: *St James*.
Marble. Florence, Duomo

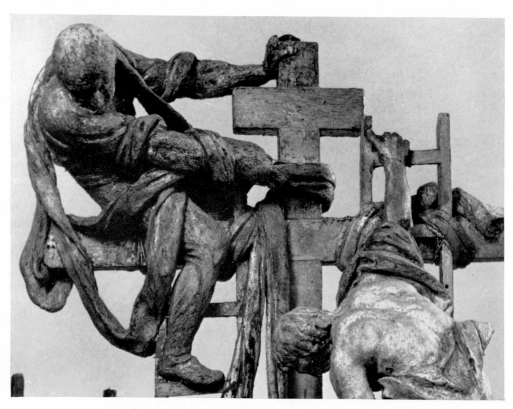

120. Jacopo Sansovino: Detail from *Deposition*. Gilded wax.
London, Victoria and Albert Museum

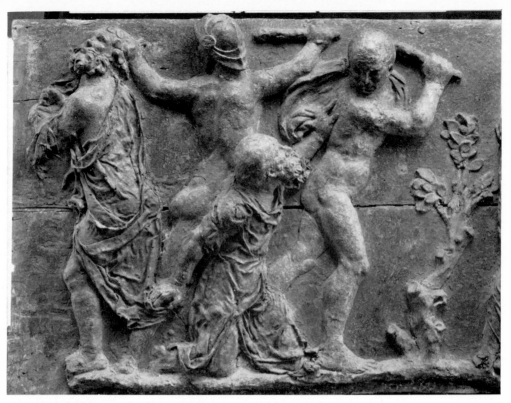

121. Jacopo Sansovino: Detail from *The Story of Susannah* reproduced in Fig. 117.
London, Victoria and Albert Museum

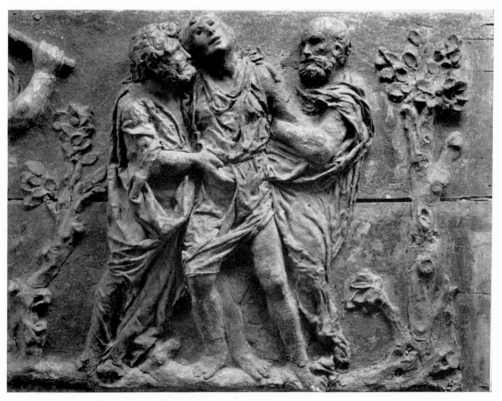

122. Jacopo Sansovino: Detail from *The Story of Susannah* reproduced in Fig. 117.
London, Victoria and Albert Museum

123. Pinturicchio: Detail from *Susannah and the Elders*.
Fresco. Vatican, Appartamento Borgia

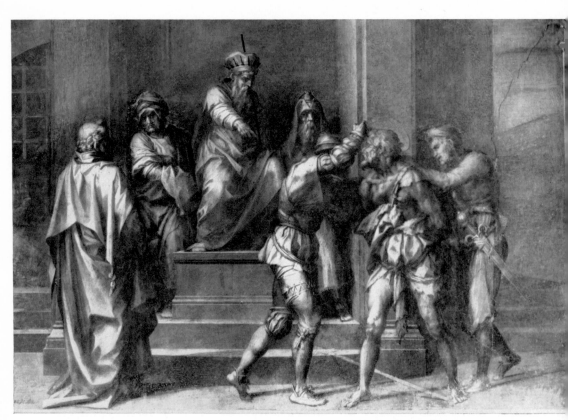

124. Andrea del Sarto: *The Arrest of the Baptist*. Fresco. Florence, Chiostro dello Scalzo

di figure tutte tonde che figuravano gli Apostoli: e sopra erano alcuni storie grandi, di mezzo rilievo, finte di bronzo, di cose del vecchio Testamento; alcune delle quali ancora si veggono lung'Arno in casa de' Lanfredini. Sopra seguitavano gli architravi, fregi e cornicioni che risaltavano; ed appresso, vari e bellissimi frontespizi. Negli angoli poi degli archi, nelle grossezze, e sotto, erano storie dipinte da chiaro scuro di mano d'Andrea del Sarto, e bellissime.

The second reference is found in the life of Andrea del Sarto:[22]

Ma quello che fu più di tutto stimato, fu la facciata di Santa Maria del Fiore fatta di legname, e lavorata in diverse storie di chiaroscuro dal nostro Andrea tante bene, che più non si sarebbe potuto desiderare. E perchè l'architettura di questa opera fu di Jacopo Sansovino, e similmente alcune storie di bassorilievo, e di scultura molte figure tonde, fu giudicato dal papa che non sarebbe potuto essere quell'edifizio più bello, quando fusse stato di marmo: e ciò da invenzione di Lorenzo de' Medici padre di quel papa; quando viveva.

Landucci[23] provides the further information that the façade included twelve simulated marble columns, larger than those in San Lorenzo, with triumphal arches over the three doorways, and that the structure reached 'presso a' primi occhi della Chiesa'. The fictive façade, therefore, covered the whole of the Arnolfan façade of the church, extending to the base of the circular window on the south side. As a compliment to the Pope (who had already been greeted by his father's portrait as he entered the via Maggio), the design prepared or approved for the façade by Lorenzo il Magnifico in 1491 was adopted as the basis of the scheme,[24] but was elaborated by Sansovino as a triple triumphal arch decorated with paintings, stucco statues of the apostles, and stucco reliefs. In 1515 San Giovanni dei Fiorentini lay in the future, and not a little of the interest caused by Sansovino's façade must have been due to the discovery that in him Florence possessed not merely a great sculptor, but an architect potentially of the first rank.

After the Pope left, the decorations were dismantled. A vast sum had been expended on what Landucci describes as 'queste cose non durabili che passarono com'un ombra'.[25] Especially regretted was the dismantling of the façade. 'S'aveva dispiacere', says Landucci, 'a vederlo disfare.' The only fragments of the decorations with which Vasari was acquainted were a painting of *Pallas* by Pontormo from the triumphal arch at the Badia,[26] and Sansovino's reliefs which survived in the Casa Lanfredini.[27] It has been suggested that four monochrome paintings on linen in the Gabinetto dei Disegni of the Uffizi, three in the style of Andrea del Sarto and one

in that of Pontormo, were also relics of this scheme.[28] The fact that at least two of the paintings are manifestly by a pupil of Andrea del Sarto, not by the master himself, is no argument against their supposed provenance, since much of the work on the triumphal decorations seems to have been sub-contracted. A number of stucco figures, presumably statues of apostles, were farmed out by Andrea del Sarto and Sansovino to Rustici.[29] Three of the paintings are of roughly the same dimensions as the stucco relief.[30]

There is, however, one obstacle in the way of the suggestion that the relief was made for the façade of the Cathedral in 1515. This is the fact that the subjects of the reliefs are specifically stated by Vasari to have been drawn from the Old Testament. There may have been other reliefs as well, scenes from the lives of the Apostles for example, but we have no evidence of this, and if the subject matter of the new scene proved to be drawn from the Acts of the Apostles or the New Testament, we would be bound to conclude that it formed part of an entirely different scheme. What precisely is represented in the relief? It shows two separate scenes, on the right two bearded figures seizing a youth or girl, and on the left the same bearded figures assaulted by two soldiers with clubs. The figurative language of the first quarter of the sixteenth century is often baffling, and my own competence in iconography is limited. For this reason, unable to read the relief myself, I consulted a number of authorities. It would be ungenerous if I were to detail all the explanations they advanced. This article would indeed have ended on a note of sceptical interrogation, had it not been for the insight of my friend Ulrich Middeldorf, who identified the scene correctly as an illustration of the story of Susannah in Daniel xiii, 62, showing on the right Susannah in the hands of the two elders and on the left the elders clubbed. The irrefutable proof of this lies in a fresco by Pinturicchio in the Appartamento Borgia (detail, Fig. 123) where Susannah is shown between the elders in a form so closely similar to that in the relief that the painted figures must have lain not far beneath the surface of the sculptor's consciousness when the relief was planned. A single exceptional feature is that the two elders on the left are not naked and are not bound together, as they are in the background of Pinturicchio's fresco and other quattrocento paintings, but this is no doubt to be explained by the introduction of the two nude soldiers from the Marcantonio print, who could not have been easily combined with the traditional motif. Certainly the scene of the *Judgement of Daniel* (presumably accompanied by its corollary, the *Judgement of Solomon*) would have found a natural place in a programme of biblical scenes designed for the Duomo façade. Thus the circumstantial evidence of

authorship, date of execution, style, medium, and subject all tend to support the view that after four centuries of hibernation one of the reliefs seen by Vasari in the Casa Lanfredini has come to light at last.

Certainly the relief, so impulsive yet so mellifluous, so noble yet so elegant, with its tacit profession of faith in the genius of Raphael, must have made an impression on the Pope. Though the 'modello per fare detta faciata di marmo' as it is called by Giovanni Cambi,[31] who watched the Pope's entry from a stand near the steps of the Badia, was never realised, it led in turn to the commissioning of another façade, that of San Lorenzo. The San Lorenzo façade was commissioned from Michelangelo, not from Sansovino, but we know that in connection with it Sansovino, presumably on the strength of the reliefs on the façade of the Cathedral, was promised by the Pope a contract for a set of bronze reliefs. This information comes from no less a source than the sculptor himself, who in 1517 wrote angrily to Michelangelo:[32]

E piu vi dicho, che el papa e'l cardinale e Jachopo Salviati sono uomini, che quando dicano uno si, e una carta e un contratto; con cio sia sono verilj e non sono, come voj dite . . . E sapiate che, el papa mi promesse le storie e Jachopo anchora e sono uominj, che me le manterano. E o fatto in verso di voj tanto quanto i'o potuto di cosa vi sia utile e onore e non mi ero avisto anchora, che voj non faciestj maj bene a nessuno.

In the pages of Thode[33] this letter is cited as proof of the senseless jealousy with which the great intellect of Michelangelo had to contend. Now, however, that we are aware of the relief style practised by Sansovino at this time, it becomes evident that the conflict was not primarily one of personalities, but of aesthetic principles, and that there must from the beginning have been a fatal element of compromise in the Pope's decision to provide San Lorenzo with a façade by Michelangelo decorated with Raphaelesque reliefs.

Originally published in *The Burlington Magazine*, CI, January 1959.

Michelangelo in his Letters

IN 1564, when news reached Florence that Michelangelo was on the point of death, his nephew, Lionardo Buonarroti, travelled post-haste to Rome. Before he left he called on Cosimo de' Medici, who declared that he wished the body to be brought to Florence 'with every imaginable pomp', and as soon as he arrived in Rome he was greeted with the welcome news that Michelangelo required his corpse 'to be taken to his noble country Florence, which he had always loved'. Since there was a risk of disturbances if it were known that the body was to be removed, it was 'secretly wrapped up like merchandise', and 'hurriedly but with caution' smuggled out of Rome.

Such a tumult ensued in Florence when it was known to have arrived that only with difficulty could it be taken to the sacristy of San Pier Maggiore, where it was to be unwrapped. Thereafter, in Santa Croce, the coffin was embellished with epigrams and poems, some of which were transcribed. One of them gives an account of Michelangelo's return to the celestial regions, whence he had briefly descended upon Florence. When the lid of the coffin was removed the body proved to be incorrupt. What was celebrated in the official obsequies that followed in the summer was more than the death of a great artist; it was the passing of a saint, whose God-given capacity had found an outlet in the visual arts.

This view of his career and personality was sedulously tended by Michelangelo. When the first edition of Vasari's *Lives* appeared in 1550, it included a uniformly flattering biography. But favourable as it was, this account conflicted with Michelangelo's vision of himself, and three years later, in 1553, it was corrected in an independent life by a pupil, Ascanio Condivi, which was certainly inspired and may in part have been dictated by Michelangelo. Condivi's life is that rare thing, auto-hagiography. According to it, Michelangelo, through his whole adult life, was a passive agent buffeted by fortune, at the mercy of popes and patrons, whose competing, often irrational, requests diverted him from one work to another in defiance of the natural instincts which he could more profitably have obeyed. It is an apology in which the divinely inspired artist, the universal genius explains how, despite the envy of fellow artists and the vacillation of his employers, he accomplished what he did.

104

Michelangelo, Condivi tells us, is personally abstemious, eating food 'more from necessity than pleasure', has given away many marketable sculptures, has praised all his contemporaries, even Raphael of Urbino, and has never been influenced by thought of gain. When the Florentine Academy planned his funeral in San Lorenzo this was the artist whom they honoured, and when Vasari, in 1568, rewrote his biography of eighteen years before this was the artist he described.

Not until 1875 was this image disturbed. The agent who dispelled it was a scholar, Gaetano Milanesi, and the vehicle was the comprehensive publication of the letters of Michelangelo. In his own lifetime Michelangelo was not distinguished for his reticence. In the 1540's, for example, he was perfectly prepared to authorise the publication of almost half his poems, among them some of the most intimate. Yet had he realised that posterity would gain access to his correspondence (or rather to that part of his correspondence which was by chance preserved), he would have been appalled at this violation of his privacy. For the picture presented by the letters, if they are read at their face value, is in total conflict with the self-portrait Michelangelo built up with such care.

'It is always a good idea to take care of oneself and of one's things', he writes to his brother Buonarroto in 1515 while working on the Julius tomb, and this is the subject of a large part of the correspondence. Did the Spedalingo of Santa Maria Nuova really absent himself deliberately when a farm deal was to be closed, and if so should Michelangelo invest elsewhere? Was the nun who wrote to him for alms truly his aunt and actually in need, or was he being duped? Have four hundred and sixty-three and a half ducats been credited to his Florentine account? Let the family of a Settignano stone-mason be given wheat, but 'I ask you not to give them anything else'. Need the little boy sent down to him from Florence, who was so anxious to learn that he 'wants to draw the whole night', have travelled 'respectably on muleback', costing him an extra ducat? 'Concerning the Montespertoli farm, I think it is dishonest that you should pay four hundred scudi more than it is worth.' When his tailor in Florence provides a tight-fitting coat, he wonders if the tailor, though he looks an honest man, did not take some of the cloth.

Jacopo Sansovino, in an angry letter, once complained that Michelangelo helped nobody, and his relations with his employees seem, from his correspondence, to have been queered by egotism of a particularly unattractive kind. At Bologna he dismisses one assistant, Lapo, and the

other, Lodvico, also leaves his service. 'Both of them together are not worth three soldi.' Lapo, it appears, 'never realised he was not the master until I fired him', and 'may have cheated me many times about which I know nothing'. All but two of the marble workers whom he takes to Serravezza desert him and return to Florence. 'What hurts me even more . . . is the fact that they give me and the marble quarries a bad name.' Another assistant, Sandro, 'through malice or ignorance has treated me very badly'. By 1519 he had 'already allocated the San Lorenzo marbles three times, and every time I was cheated'. 'No one ever had anything to do with me (I am referring to workmen)', says Michelangelo in 1524 apropos of difficulties with his assistant Stefano,

to whom I did not do good with all my heart. Then, because of some peculiarity of my temper or some madness, which they say is part of my nature and which hurts no one but myself, they begin slandering me. Such is the reward of all men who mean well.

The picture presented in the letters no doubt is true (though it has often been touched up and sentimentalised), but it is not the whole truth because the letters themselves are not fully representative. In the edition of Milanesi roughly two-thirds of the letters are addressed to members of the artist's family, and of the remaining third more than half are concerned with business matters. Though his brother on one occasion seems to have accused the artist of 'being more concerned with worldly goods than is becoming to me', the prose of daily life formed his sole link with relations to whom the world of the intellect was barred. 'You and the rest of the family have never known me', he writes in an exasperated letter to his brother in 1513, 'nor do you know me now. May God forgive you.'

Psychologically there is much of interest in this record of a Florentine *Long Day's Journey into Night*, but it is a thousand pities that through the whole period of gestation of the Sistine Ceiling Michelangelo's recorded thoughts should be so pedestrian and irrelevant. Forty years later it is no less disconcerting to remember that the perfunctory notes on cheese and cash and marriage prospects addressed to his nephew Lionardo come from the artist who was currently immersed in what Vittoria Colonna called 'sweet colloquy' with the figures in the Pauline Chapel.

Rather surprisingly 'these colourful letters' are presented for the first time in translation by a novelist, Mr Irving Stone. Nearly three-quarters of them, we are informed, 'had to be checked against all existing documents', a

number of them proved to be misdated, and the utmost care was taken to ensure that everything of even slightest interest or value should be preserved. The facts are a good deal less reassuring than this claim suggests. Omissions are nowhere indicated in the text, and comparatively few of the letters are printed complete. Sometimes the omissions are trivial, sometimes they are significant.

Thus we have the letter of July 2, 1508, in which Michelangelo asks his brother Buonarroto to arrange for a Spanish painter to have access to the battle cartoon, but not the furious postscript of July 31, when Michelangelo learnt that the Spaniard had not troubled to visit the Palazzo Vecchio. Also missing is the delightful account of Michelangelo's visit to the sculptor Ammanati, when he was working on the Del Monte tombs. Much of the point of the single surviving letter to the boy Febo is lost by the deletion of the second half of the first sentence, and there are some unfortunate excisions in the middle of the famous reply to the questionnaire of Benedetto Varchi. Even in the important letter to an unnamed Monsignore, in which Michelangelo in 1542 recounted the history of the Julius tomb, four separate passages are mutilated.

No less strange than these omissions are the occasions where two letters are conflated into one. This is the case with a letter to the artist's father printed under September 5, 1510. In a crucial letter to Fattucci of January 1524, a passage from the preliminary draft in the British Museum is introduced into the completed letter in the Archivio Buonarroti, and a letter to Lionardo Buonarroti (which Mr Stone dates April 19, 1549, though it incorporates the words: 'e oggi a di 25 d'aprile') is merged with a letter to the same recipient of May 2. In a letter written to Fattucci in 1550 two separate versions are also synthesised. The much-vaunted redating of the letters gives some cause for concern. The letter to Michelangelo's brother Buonarroto, which Mr Stone assigns to October 23, 1510, unfortunately has the superscription 'da Roma di febraio 1510', and was therefore written in February, 1511; the letter to Michelangelo's father assigned to September 15, 1510, was received in Florence on September 18, 1509; and the famous reference to the completion of the first part of the Sistine Ceiling is here dated 1509, though it has been correctly reassigned by Tolnay to the following year. Mr Stone follows Milanesi in printing the two surviving letters to Vittoria Colonna in the wrong sequence under the wrong date.

The translation of the letters is by Dr Charles Speroni, and in only a few instances will his versions lead the reader seriously astray. Sometimes he reads into the text more than is actually there. Michelangelo, for example,

in a letter to his father written during work on the Sistine Ceiling in 1510, refers to an impending payment 'per mettere mano nell'altra parte dell' opera' (not 'to put up the scaffolding and start the other section of the work'), and declares that the marbles for the version of the Julius tomb "n'andò male' (not 'were injured and pillaged').

Occasionally the sense of the Italian is entirely lost. This occurs with one of the great cruxes of Michelangelo criticism, the self-justificatory letter written to Fattucci. 'He saw to it', says the new volume, 'that I was given two thousand ducats Camera [*sic*], and the first thousand of the ducats for the marbles which they advanced me for the tomb.' What the letter really says is:

He [Bibbiena] arranged to give me two thousand ducati di Camera, and it is this sum, with the first thousand I received for the marble, that they charge me with receiving for the tomb.

The point here is that if the sum was a retrospective payment for the Sistine Ceiling, Michelangelo was at liberty to reinvest it, but that he could not do so if it were a payment on account for material for the tomb; hence the accusations of dishonesty levelled at him by the Della Rovere. The important concluding sentence of this letter has also been misunderstood. Michelangelo at Pietrasanta in 1518 was not attempting 'to make this town art-conscious', and in January 1548 he did not say that 'what Giovansimone left belongs to him (Gismondo) as well as to me', but that his brother's death 'tocca a lui come a me' (affects him as much as me).

Sometimes the sense fails to come across because the translation is insufficiently direct. Michelangelo wrote 'io fo una figura' (not 'I am sculpturing an image'), 'buttato via' (thrown away, not wasted), and in his letter to Pietro Aretino refers to 'la pittura che io facci' (not 'my work'). In many cases the inflections throughout the text, and those rhetorical exaggerations which are typical of Michelangelo's epistolary style, are not transcribed. Thus Michelangelo did not say of the lantern of the Medici Chapel that 'everyone likes it', but that 'piace universalmente a ogni uomo'; he did not promise to serve Febo 'as well as . . . any other friend', but 'quanto nessun altro amico'; and he did not complain that 'the uncertainty is wearing me down', but that 'mi consumo a star qui sospeso'. According to Mr Stone's preface, 'the editing and footnotes are the responsibility of Mrs Stone and myself'. The letters are interspersed with a few of Michelangelo's poems in the versions of Symonds, and are linked together by narrative passages which, for inaccuracy and vulgarity of statement, could hardly be surpassed.

All this would matter less were we not conscious of the presence, just out of reach, of another, infinitely more attractive Michelangelo. He commanded a vein of ironic humour which even today retains all its individuality. Evidence of it occurs in a letter written in October 1525, to Fattucci, describing a plan for a colossus in Piazza San Lorenzo, with a barber's shop installed in the base, a cornucopia serving as a chimney in the hand, and a dovecot in the head. He was capable of seductive charm. 'I pray to God', he writes to the boy Febo after a quarrel,

that he may open your eyes once more, so that you will recognise that he who desires your good more than his own health, knows how to love, and not to hate like an enemy.

'All your friends', he declares to the otherwise unknown Gherardo Perini at Pesaro,

and I among them, are overjoyed, and most of all those whom you know love you best, to hear of your health and contentment from your last letter ... I say only this, that we your friends are in the same state, that is well, and that we all recommend ourselves to you, and especially ser Giovanni Francesco and Piloto. Seeing that you will soon be here, I hope to reply more fully by word of mouth, and to satisfy myself as to every detail, because it matters to me.

In the present book the last two sentences of this letter appear in the form: 'We, your friends, are also well, and send you all our best.' This is the Michelangelo to whom a friend could write from Rome: 'Since you left, I feel like an orphan in this great Babylon, so much did I enjoy our talks.' In 1532 Michelangelo, in Rome, met Tommaso del Cavaliere, and the three letters which he sent him on his return to Florence attain an imaginative elevation which gives them a place apart. Perhaps other such letters were written and have been destroyed. But it may be suspected that after middle life, behind his armour of egotism, Michelangelo was a lonely man, who was capable of intimacy only when reason was temporarily in abeyance and a strong gust of emotion blew him from his course.

One of the abiding impressions left by Condivi's *Life* is that of an artist who reacted to the human predicament more deeply and more passionately than other men. This impression the letters confirm. In 1556, after the death of Urbino, we find him writing to Vasari:

You know that Urbino is dead. This has been a great grace from God, but a grave loss to me and a source of infinite sorrow. The grace is this that he who, when he

was alive, comforted me in life, has in his death taught me how to die, not with reluctance but with a wish for death. The greater part of me has gone with him, and for me there remains nothing but infinite wretchedness.

'I am old', he writes to another correspondent in 1549,

and death has stripped me of the thoughts of my youth; let him who does not know what old age is wait till it arrives, for he cannot know it before.

In these and a few other fragments of correspondence the resonant, human voice of the artist of the Medici Chapel can be heard.

In the aggregate Michelangelo's correspondence may be disappointing, but it provides the clearest of all illustrations of the handicaps and hazards with which genius must contend. What matters is not the rancour and meanness and self-pity, but the fact that Michelangelo, through character and concentration, could habitually rise so far above the level on which, in terms of temperament, he seemed condemned to live. There is a story (for which Michelangelo himself is our authority) that in Rome he complained to the painter Signorelli that he felt unwell and could not work. 'Do not worry', replied Signorelli, 'the angels will come down from heaven, they will hold your arms and help you.' And the angels did.

Originally published in *The Times Literary Supplement*, August 2, 1963.

Michelangelo's Cupid: the End of a Chapter

The Gigli-Campana collection of Italian sculpture, when it was acquired by the South Kensington Museum in 1861, contained one work which transcended all others in importance, the *Cupid* of Michelangelo. The *Cupid* was bought by Gigli from the Marchese Giuseppe Stiozzi in 1854,[1] and had been discovered not long before. According to Migliarini (one of the two persons present) it was found in the Gualfonda gardens,[2] according to the sculptor Santarelli (the second person present) in the Orti Oricellari.[3] Both gardens at this time belonged to the same owner, and no importance attaches to the discrepancy.[4] Fifteen years after the statue arrived in London, Wilson, in his volume on Michelangelo, printed an account of the discovery as it had been related by Santarelli:[5]

Some years ago the Professor Miliarini and the eminent sculptor the Cavaliere Santarelli visited the gardens of the Oricellari (in Florence) to look at some works of art, and to give an opinion of them to Signor Giglio, who purchased on account of the Marchese Campani. They were invited by the man in charge to see some figures in a cellar, where they found three by Andrea Pisano. The attention of Santarelli was attracted by another in a dark corner, and after peering at it in the uncertain light, he called to Miliarini and said 'look at that'. After an earnest and startled look, he said 'It is his' and the sculptor replied 'Certainly it is his'. This was the statue which is now the chief ornament of the South Kensington Museum. The left arm unhappily was wanting, broken off nearly across the deltoid, the right hand was also broken and obviously never had been finished. Signor Santarelli restored the left arm, as it is now seen; the right hand he did not touch.

Reference to Migliarini[6] shows that the 'three by Andrea Pisano' included the two *Doctors of the Church* from the façade of the Duomo in Florence, now in the Louvre (Nos. 578, 579). To make assurance doubly sure, the owner of the *Cupid* in the autumn of 1854 obtained two certificates that the statue was by Michelangelo, one from Santarelli (*'credo poter francamente dire esser quella statua un'opera del divino Michel Angelo Buonarroti, e credo ancora che difficilmente possa accadere di emettere un parere su tali cose con maggior convinzione di quello che faccio in quest'occasione'*) and the other from the sculptor Dupré (*'io non dubito possa essere questa*

111

opera del divino Michel Angelo; questo mio guidizio, per la tenuità del mio ingegno, puo essere tenuto più per un semplice parere che per una sentenza artistica; ma comunque si sia è però l'espressione della mia convinzione').[7] It was decided, moreover, that the new-found statue must be identical with Michelangelo's lost *Cupid,* and Santarelli, when he replaced the lost left arm, placed in the hand the handle of a bow. Not only did Santarelli restore the arm, but he set an additional layer of rock-work beneath the base. 'Why', asks Horne in a letter printed by Maclagan,[8] 'did Santarelli add that second base? How greatly the statue would gain if his additions could be removed.' This wish was realised in 1946, and the accompanying photographs show the figure without its raised left arm and base; the left arm has since been replaced.

The literary sources for the *Cupid* have often been transcribed, but since from the beginning the attitude of students towards the statue was dictated by their attitude towards the sources, it will be necessary to recapitulate them here. The earliest reference to the *Cupid* occurs in Condivi,[9] and reads as follows:

Volle anco detto messer Iacopo che'egli facesse un Cupidine; e l'una e l'altra di queste opere oggidi si veggono in casa di messer Giuliano e messer Paolo Galli, gentiluomini cortesi e da bene, coi quali Michelangelo ha sempre ritenuta intrinseca amicizia.

Vasari in the second edition of the *Vite* states that the *Cupid* was carved in marble and was life-size.[10] There are two further references to the figure. One of these is by Lomazzo,[11] who quotes four lines from Petrarch describing Cupid as a naked winged youth *'con arco in mano e con saette a' fianchi',* and adds the gloss:

ed in questa forma fu dipinto dal nostro Tiziano, appoggiato sopra la spalla di Venere ... siccome dal divin Michelangelo fu scolpito in marmo in Roma a Giacomo Galli.

The other occurs in 1550 in a list by Ulisse Aldrovandi, printed under the title *'Delle statue antiche, che per tutta Roma, in diversi luoghi & case si veggono'* in 1556 in Mauro's *Le antichità della città di Roma;*[12] in this Aldrovandi, after describing the *Bacchus* in the garden of the Casa Galli, continues:

In una camera più su presso la sala si trova ... uno Apollo intiero ignudo con la pharetra e saette a lato: & ha un vaso a piedi, è opera medesimamente di Michele Angelo.

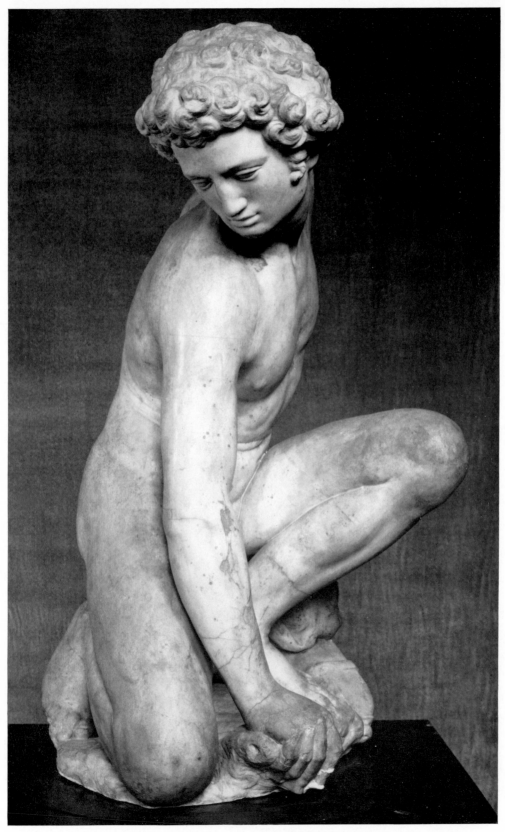

125. Here identified as a Renaissance restoration of an antique statue: *Narcissus*. Marble, height 110 cm. London, Victoria and Albert Museum

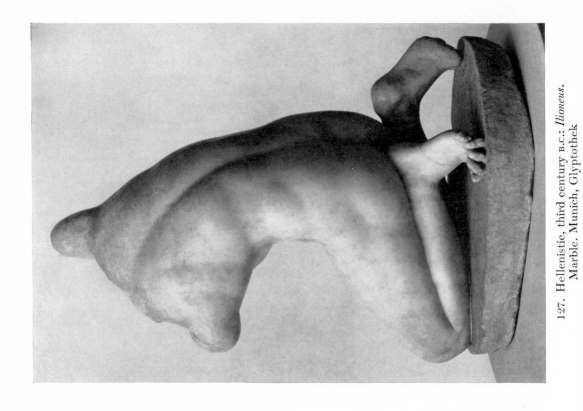

127. Hellenistic, third century B.C.: *Ilioneus.*
Marble. Munich, Glyptothek

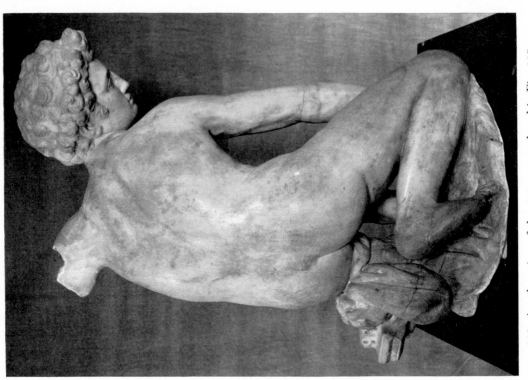

126. Another view of the statue reproduced in Fig. 125

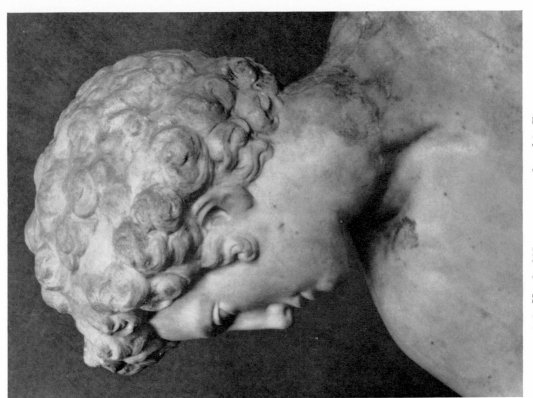

129. Head of Narcissus reproduced in Fig. 125

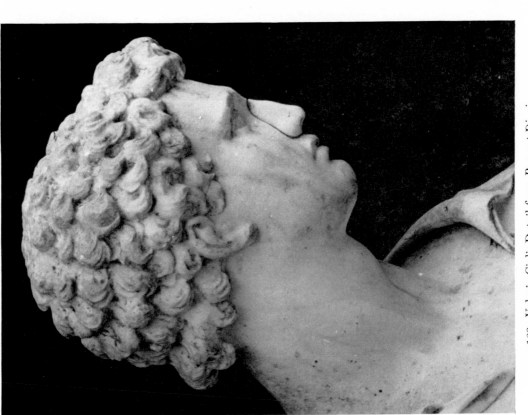

128. Valerio Cioli: Detail from *Peasant Digging*.
Marble. Florence, Boboli Gardens

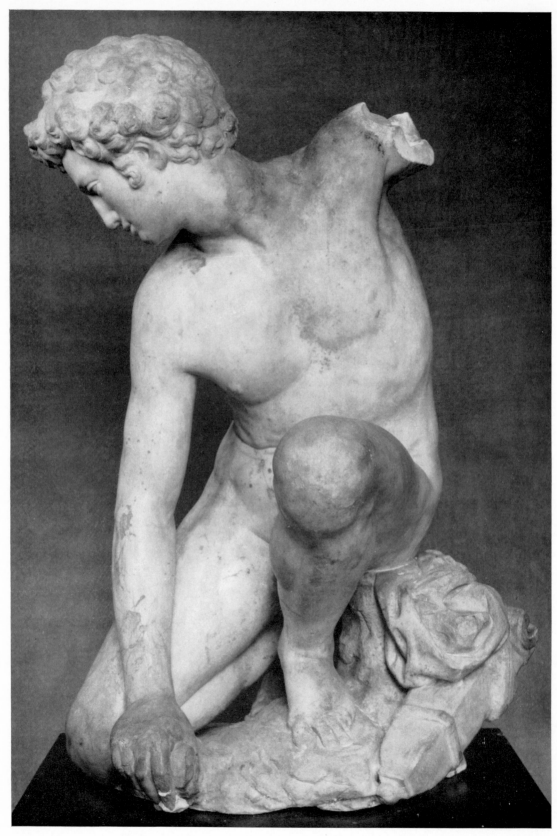

130. Another view of the statue reproduced in Fig. 125

The later history of the figure is confused. In a passage in the preface to the third volume of the *Museum Florentinum* of 1734, Gori states that the *Cupid* was brought to Florence with the Galli *Bacchus* by Ferdinando de' Medici;[13] this statement must be incorrect, since the *Bacchus* was actually bought by Francesco de' Medici in 1572 and the Galli *Apollo* (with which the *Cupid* is generally presumed to be identical) is recorded by Boissard in the *Romae urbis topographiae* of 1597–1602, and appears not to have reached Florence before 1662.[14]

At first the attempt to identify the statue with the missing *Cupid* was unopposed. Admittedly it did not look much like a Cupid, but Michelangelo's conception of Cupid, it was agreed, would certainly have been original. This was Migliarini's view:[15]

Un' Amore di Michelangelo doveva essere inquieto e pieno di fuoco, ed egli desiderava che il marmo lo dimostrasse, e moto e fuoco risvegliasse in ogni suo osservatore . . . Non curò di adornarlo con le ali perche questo attributo allorquando non è necessario, e bello il non produrlo in scultura.

'Michelangelo's Cupid', wrote Symonds,[16] in a still more romatic vein, 'is as original as his Bacchus . . . When quite an old man, rhyming those rough platonic sonnets, he always spoke of love as masterful and awful. For his austere and melancholy nature, Eros was no tender or light-winged youngling, but a masculine tyrant, the tamer of male spirits. Therefore this Cupid, adorable in the power and beauty of his vigorous manhood, may well remain for us the myth or symbol of love as Michelangelo imagined that emotion.' But in 1878 these poetic musings were interrupted by Michaelis, who, in a brief note in the *Zeitschrift für bildende Kunst*,[17] drew attention to Aldrovandi's description of the *Cupid-Apollo*, pointing out, perfectly correctly, that there were discrepancies between this and the statue at South Kensington. A work by Michelangelo the statue might well be, but it was not the *Cupid* carved for Jacopo Galli, and had no title to the place accorded to it among Michelangelo's authenticated works. At about the same time Grimm[18] noted that the iconography of the London statue was inconsistent with the description of Lomazzo, and opined that the statue must be an unrecorded work by Michelangelo. Michaelis convinced Springer,[19] who also noted the absence of the jar described by Aldrovandi, but not Wickhoff,[20] who preferred to think that Aldrovandi had mistaken the tree trunk for a vase. And as a Cupid so unorthodox that it might be mistaken for Apollo with a tree trunk that might be mistaken for a vase, the figure remained until 1914 when Horne (in a letter printed by Maclagan[21])

pointed out what should have been obvious from the beginning, that the statue, with its rapt, downward glance, had the characteristics of a Narcissus rather than of a Cupid or Apollo. Only one feature could Horne, by his own admission, not explain, the presence beside the kneeling youth of a quiver rather than of the spear appropriate to a Narcissus. This detail (though more significant than he supposed) was insufficiently substantial to discredit Horne's contention, and his interpretation of the subject of the statue was later endorsed by Kriegbaum.[22]

The pose had from the first been looked upon as puzzling, and one of a number of conjectural explanations of it was supplied by Migliarini:[23]

It seems to us it is intended to show that this Cupid, having emptied his quiver in vain, even his last arrow having glanced back to him through the insensibility of the object against which it was launched, he precipitately seizes it, and prepares to shoot it anew, too certain of his own power; in this violent movement he bends, but to raise himself again the more speedily. Daring is expressed in his countenance—and in the turn of his head.

Even a critic as responsible as Justi[24] interpreted the pose as an incident in an imaginary narrative, applying a concept of arrested motion familiar to nineteenth-century academism but alien to the Cinquecento:

Die Statue, wahrscheinlich für einen hohen Standort bestimmt, solte einen mythischen Bogenschützen darstellen. Am obern Rand eines mit Gestrüpp bewachsenen Hügels hatte er sich niedergelassen; eben ist er aber abgelenkt worden durch einen Vorgang, den er im Trhal unten bemerkt, er scheint nach seiner Waffe zu greifen; leider fehlt der linke Arm, der wohl mit dem Bogen beschäftigt war. Denn der Schütze hält den Bogen in der linken, während er mit der rechten die Sehne spannt und den Pfeil zielend auflegt . . . Am Boden der Wildnis, rastend oder zuwartend, ist er überrascht worden, denn der Köcher ist noch angebunden; diese Plötzlichkeit verrät die scharfe Wendung des Kopfes, der grade über der rechten Schulter sitzt . . . Er ist alarmiert, aber das erspähte Ziel fesselt seine Aufmerksamkeit so, dass er den Blick nicht von ihm abziehen kann, statt nach Köcher und Pfeilen zu sehen.

The most complex of these accounts was that of Frey,[25] who rejected the earlier reconstructions and instead (for reasons stated at a length of over four pages) placed a bronze bow in the right hand and a bronze bow-string in the left. 'Dieser missglückte Versuch einer Rekonstruktion' received short shrift from Thode,[26] who reverted instead to the original interpretation of Migliarini and Santarelli:

Eros hat geschossen: noch hält die linke (Hand) den Bogen, indem die Rechte auf schmaler Felsenhöhe dem Körper Halt giebt.

The only common ground between Frey and Thode was a determination to force the statue and the documents into conformity.

Never, it seems, did the contingency suggest itself to any of these writers that the so-called Cupid might, after all, not be by Michelangelo. True, there was some disagreement as to how to date the work. Not among lexicographers like Thode (who believed that '*etwas von Michelangelos eigener Physiognomie*' was reflected in the head, and for whom the figure '*eröffnet eine neue Welt, die über den versinkenden Zaubern des Alterthumes sich gestaltet*'),[27] but among students whose criteria were primarily visual. At the head of these we find Wölfflin[28] and Berenson,[29] both of whom saw very clearly that the statue could not be an early work by Michelangelo, and who related it instead to the Sistine Ceiling, and specifically to the slave to the right above the Prophet Ezekiel. Re-reading Wölfflin's open-minded account of the statue, with its frank admission of the morphological differences between this and the authenticated early works, it seems in retrospect rather surprising that he did not dismiss the figure out of hand. Perhaps he was misled by the ill-lit, retouched photographs which were then on sale.

All of these students, and a cohort of secondary writers, believed as an article of faith that the statue was carved by Michelangelo. But little by little the voice of scepticism made itself heard. Fabriczy rejected the statue, though he did so in the privacy of his own copy of the London sculpture catalogue,[30] and Reymond denounced it in print as '*un Michel-Ange qui aurait été retouché par un Canova ou un Thorwaldsen*'.[31] In the case of Reymond this might have been regarded as one aspect of a universal incredulity which dismissed objects which were, as well as those which were not, what they were supposed to be. Two of the writers who denounced the *Cupid* most firmly enjoyed no reputation as art historians, but had the advantage of knowing the figure intimately at first hand. These were Davies,[32] who thought it 'at best a copy of a work by him from a less able hand', and Holroyd,[33] who broke new ground by formulating a purely qualitative verdict:

The head is like a copy of the head of the David, the division between the pectoral muscles is weak, and their attachments to the breast bone are round, regular and without distinction, very different from either the naturalism of the Bacchus, the

delicate truth of the Pietà, or the dignified abstraction of the David . . . The statue is like the work of a poor imitator.

In 1908 the problem was discussed afresh by Mackowsky,[34] who, in the course of an excellent analysis, concluded (for reasons which are now self-evident and which need not be recapitulated here) that the statue must be omitted from the list of Michelangelo's works. Not only could it not be by Michelangelo, but it was, Mackowsky insisted, in certain respects profoundly un-Michelangelesque. There the matter rested till 1929, when the whole evidence was reviewed by Kriegbaum,[35] who removed the figure from its alleged date of origin and placed it firmly in the later cinquecento:

Die Analyse der Statue führt zu der Feststellung, dass es sich im einer Freiskulptur im wahren Sinne des Wortes handelt, eine Skulptur, die ihre Aufbaugesetze allein in sich trägt und die irgendeiner Gliederung oder Ordnung des sie umgebenden Raumes nicht mehr bedarf. Ihre Charakteristika sind die von einer Ebene in die andere hinüberführenden Linien, die sich schraubenförming abdrehenden, gleichsam entfliehenden Teile. Die dadurch bedingten Drehungsmomente, die ihrerseits den Beschauer zum Umschreiten veranlassen, sind aber nichts anderes als Eigenschaften jener Figura serpentinata, die in der Kunsttheorie des späteren Cinquecento eine so grosse Rolle gespielt hat und die für einen Teil der damaligen italienischen Bildhauer die ästhetische Hauptforderung bedeutete.

Though the 'overpowering arguments' in favour of the authenticity of the *Cupid* are restated in the 1932 catalogue of the Italian sculpture at South Kensington,[36] and though the figure makes a last fleeting appearance as Michelangelo in the *Storia* of Venturi,[37] Kriegbaum's case has come to be generally accepted and since 1945 the figure has been labelled 'formerly ascribed to Michelangelo'.

If the figure is not by Michelangelo, to whom is it to be attributed? Only one answer to this problem has been proposed, again by Kriegbaum, who ascribed it to Vincenzo Danti.[38] Kriegbaum's attribution (later taken over by Tolnay[39]) rested on '*endlose Analogien*' with the anatomy, proportions, surface treatment, and handling of detail in Danti's documented works. The attribution, moreover, was supported by a document, in the form of a reference in a letter of 1577 from Niccolò Gaddi, printed by Gaye,[40] to a '*figura a sedere*' made by Danti for the Grand-Duke. It is debatable whether the term '*figura a sedere*' could apply to the kneeling *Narcissus*, and the contingency can be ruled out if, passing to '*das Morellianische*', we disregard the allegedly unfinished areas and compare the weak, rather flaccid treatment of the knees with the far bolder, more vigorously carved

left leg of the *Honour* in the Museo Nazionale. Whoever carved the body of the London statue, this cannot possibly have been Vicenzo Danti.

At this point it may be well to redefine the problem by looking at the figure more attentively (Figs. 125, 130, 126). The head is well-preserved, whereas the body is pitted with small dents. According to the catalogue,[41] these dents were caused 'by pistol bullets aimed from a point almost directly opposite the left hand'. The story of these pistol bullets, 'which were wantonly fired at it whilst placed in the Riccardi Gardens in Florence', makes its début in the sober pages of Robinson,[42] and was presumably invented while the statue was still in Italy to explain the deteriorated lower part. One of the most severely weathered areas is the right forearm and hand. Part of the knuckles and the upper surface of the right hand are restored in plaster, but the now indecipherable object held in this hand is original. The figure is otherwise free of makeup save for a wedge-shaped area of plaster on the left shoulder, and a small patch of plaster at the back of the head immediately above the shoulder restoration. Between the head and body is a narrow collar of make-up reaching a depth of a quarter of an inch in front. This break has been explained by the assumption that the statue was damaged by 'a fall which jarred off the head',[43] but when we come to examine the rendering of the neck above and below the point of juncture, we find features which are not consistent with this view. At the throat is the base of the left sternomastoid with an indentation on either side. Above the break the sternomastoid continues (in defiance of anatomy) to a point some distance behind the ear. The throat muscles alone would imply a head turned slightly to the right and tilted up, whereas the present head is in profile and gazing down. There is only one possible explanation of these discrepancies, that the head and body are by two separate artists.

So far as concerns the torso, the weakness of the carving of the chest (to which attention is drawn by Holroyd alone),[44] and of the right arm and thigh should be sufficient to assure us that we are not here dealing with a major sculptor. The right thigh in particular is so inadequately rendered that the figure seems incapable of rising from the ground. But if major artists be ruled out, the generalized handling is still incompatible with the practice of Florentine cinquecento sculpture. On the other hand, it has countless parallels in Hellenistic sculpture, in such works as the copy of the *Aphrodite* of Doidalsas in the Louvre and the *Ilioneus* at Munich (Fig. 127). Wickhoff,[45] though he regarded the figure as '*unzweifelhaft von Michelangelo, ja geradezu eine seiner kühnsten Bildungen*', connected its pose with two statues reproduced by Clarac,[46] a kneeling male figure in

the Galleria Giustiniana and the statue of a *Phrygian* in the Vatican; Springer[47] related it to the *Knifegrinder* in the Uffizi; and Maclagan, as long ago as 1908, wrote the following pencil note in his copy of Robinson's catalogue:

Possible influence of the Ilioneus at Munich. The right leg and foot and part of the torso are remarkably like: the treatment of the knees, which Loeser objects to as un-Michelangelesque, almost identical. The surface is stylised in much the same way in both, with the simplified curves of a young and rather fleshy body omitting any insistence on anatomical details. The marbles are much more alike than photographs suggest.

There is something tantalising in the fact that almost fifty years ago Maclagan should have come so near to the solution of the riddle, that the torso is a Roman copy of a Hellenistic statue of the second or third century B.C. Once this is established (and it is scarcely open to dispute), much that would otherwise be puzzling becomes plain. Whereas the right forearm is severely weathered, the right upper arm has a smooth surface and is proportionately somewhat thinner, and must therefore have been recut. The area between the right shoulder and breast seems also to have been resurfaced, and the pectoral muscles on this side are treated more emphatically than on the left, where the original surface is preserved. Some difference in colour suggests that the incisions round the waist have also been recut, as have the outer face of the right buttock, the right ankle, and the line where the right calf meets the thigh. Examination of the statue under ultra-violet rays confirms this analysis in every particular, and indicates that the head and body were carved at different periods of time, that the head is the more recent and the body the older of the two sections, and that parts of the body were recut at roughly the same date as the carving of the head.

The head is undubitably by a Florentine sculptor of the later cinquecento. It is not unfinished (as Kriegbaum among others supposed),[48] but has been carried only to a state of relative completion which would conform to the condition of the lower part, and this fact must be borne in mind in determining its authorship. There is one sculptor whose candidature can be ruled out at once, and that is Vincenzo Danti, since neither the features nor the hair show any trace of the sharp, incisive handling of the *Honour overcoming Falsehood*, with which they have been compared. Where, then, should we search for the author of the head? Cellini,[49] when confronted with the torso which later was to become the *Ganymede*, made a contemptuous reference to professional restorers of antique statuary: '*Non si conviene*

amme il rattoppare le statue, perché ell'è arte da certi ciabattini, i quali la fanno assai malamente'. At a rather later date, two sculptors in particular specialised in this class of work. These were Valerio Cioli, who is said by Vasari[50] to have restored *'al giardino del cardinale di Ferrara a Monte-cavallo ... molte antiche statue di marmo, refacendo a chi braccia, a chi piede, e ad altra altre parti che mancavano; ed il simile ha fatto poi nel palazzo de' Pitti a molte statue che v'ha condotto per ornamento d'una gran sala il Duca'*, and Giovanni Caccini, who, according to Baldinucci,[51] became specially proficient *'nel restaurare l'antiche Sculture, tal che, fra la grande imitazione dell'antico, e l'esquisita maniera, che egli avea nel com-mettere insieme i pezzi, riducevale a signo, che paravano d'un sol pezzo, e quelle stesse, che gia negli antichissimi tempi erano uscite dalle stanze de' Romani, e Greci Maestri, onde molte, a molte di esse gli erano fatte restaurare dal Gran Duca Francesco, e molte ancora dal Cavalier Gaddi'*. Caccini's activity as a restorer can be reconstructed through documented works,[52] but the characteristics of Cioli's restorations are still uncertain. Weinberger credits Cioli with the restoration of the *Dying Meleager* relief in the Metro-politan Museum,[53] but this attribution is hypothetical, since there is no visual equation between the restored areas in the relief and Cioli's accepted works. On the other hand, there is a very real relationship between the soft head of the *Narcissus*, with its wide, rather sulky mouth and fleshy nose, and the head of Cioli's *Sculpture* on the monument of Michelangelo.[54] In Cioli's statues in the Boboli Gardens this becomes more actual still. The closest point of reference is provided by the *Peasant Digging*, in which the carving of the hair, despite its somewhat higher finish, directly recalls that of the *Narcissus*, and the rendering of the neck, with its haphazard structure and inorganic attachment to the shoulders, recalls the *Narcissus* as well (Figs. 128–129).

As Cagiano de Azavedo observes in his interesting little book on the factor of taste in the restoration of antiques, *'il gusto di "abbellire" non consisteva solo nell'integrare o sistemare piacevolmente le antichità, ma talvolta nel modificarle anche radicalmente coartandone l'aspetto e il significato per piegarle a rappresentare quello che si desiderava che fos-sero'*.[55] So Cellini determined to complete the torso shown him by the Grand-Duke with missing members and an eagle *'acciò che e'sia battezzato per un Ganimede'*,[56] and so Cioli adapted as a fountain figure of Narcissus the torso of a youthful warrior, the identity of which must have been clearly apparent in the sixteenth century since it was indicated by the quiver at his side. In order to fit the figure for its new role, it was necessary to violate the

movement of the body by adding a down-turned head. As it was completed, Narcissus was shown gazing down into a pool, so that the relation of the figure to the water was of the same ingenious and resolutely practical kind that we find in the *Morgante stilling the Waters*, the *Fontana del Tino*, and the *Woman washing a Child's Hair*.

The torso, like all classical figures of its type, has a single front view, in which the right hand occupies a place a little to the left of centre, and it is from this angle that the statue has usually been photographed (Fig. 130). But since the recutting is limited to the right arm and shoulder, the right leg and thigh, and the inner side of the left leg, and does not extend to the left arm and shoulder, the outside of the left leg or the back, we may infer that on the fountain the statue was seen from the right side, with the left side and back concealed and the head lowered in full face towards the pool (Fig. 125). So far from being a '*Freiskulptur im wahren Sinne des Wortes*', it was a statue with a single viewpoint, but a different viewpoint from that originally postulated. By this change it was reconciled with mannerist practice, as established in the lateral figures on the Michelangelo tomb, and was invested with a unifying rhythm, the '*wunderbare Bewegung*' which Wölfflin singled out for praise.[57] But mere recutting could not harmonise the ambivalent postures of the body and the head. Alone of earlier students, Horne noted the conflicting movement within the statue, and when it stood in its original position, it must have seemed that Narcissus was depicted shrinking back in apprehension from his image in the pool. Almost certainly this romantic effect was adventitious, but it goes far to explain why Kriegbaum related the figure to the *Pastor Fido*[58] and why today, among works of much superior quality, it continues to exhale a sense of mystery and to exert its old imaginative spell.

Originally published in *The Burlington Magazine*, xcviii, November 1956.

The Palestrina Pieta

I must make my position clear at once. I am briefed by the prosecution. I speak, that is, on behalf of the many people who believe that the Pieta from Palestrina (Fig. 131) is *not* by Michelangelo. I say 'many,' but at the outset it must be admitted that the number of believers far exceeds those who doubt. The group appears in every popular book on Michelangelo, and there is scarcely a casual visitor to Florence who is not brain-washed in the matter by some vociferous guide. But the list of students who support the attribution, though very long, includes only a few specialists on sculpture and only a few specialists on Michelangelo. My motive in re-examining the subject is not polemical; it is to discover whether, at long last, some measure of agreement cannot be reached.

The story starts one day in 1907 when a student at the French Academy in Rome, Grenier, visited the church of Santa Rosalia at Palestrina. He was accompanied by two friends, one of them an artist, and as they looked up at the altar their reaction was unanimous; the group behind it could only be by Michelangelo. That is a refrain that echoes through the literature of Michelangelo. 'It is he' Santarelli exclaimed when the Cupid in London first emerged from the Gualfonda gardens, 'It is he' declared Marangoni, only a few years ago, before the rough-hewn hulk of Vincenzo Danti's Venus at Boboli. Grenier committed his conclusion to an enthusiastic article in the *Gazette des Beaux-Arts*,[1] but his discovery was less original than he supposed. Eight years earlier the group had already found its way into art literature in a footnote in Wölfflin's *Klassische Kunst*.[2] The Pieta, said Wölfflin, should be tested—'wäre zu prüfen'—against the universally accepted Rondanini group. In the fourth edition of the book in 1908 he added a reference to Grenier's publication.[3] Italian translations of the *Klassische Kunst* render the footnote in a way which suggests that Wölfflin endorsed the attribution.[4] In fact his recorded attitude is one of strict neutrality.

In fairness to Grenier it must be admitted that there was a tradition which appeared to lend some colour to his view. It went back to 1756, when in Cecconi's not very discriminating history of Palestrina, the group was ascribed to Michelangelo.[5] I should add that two other near-by works were also given by Cecconi to Michelangelo, a roughed-out lion at Capranica and a statue of Aeolus incised with what purported to be a signature. Rather

more than a century later, in 1875, Cecconi's attributions were revived by Gori in an article.[6]

Once the Pieta was launched, it was borne forward on a mounting literary tide. Some writers were content to repeat what Grenier had said—like Vasnier in the *Chronique des Arts*[7]—some writers advanced further, more serious reasons for attributing the sculpture to Michelangelo—like Wallerstein in 1914 in the *Zeitschrift für Bildende Kunst*[8]—and some writers were frankly sceptical. One of them was Thode, who knew the work only from photographs: he commented adversely on the 'reliefartig' character of the carving and on the proportions of the Virgin's head.[9] Another was Steinmann, who had access to a cast which was shown in 1911 in the Castel Sant'Angelo. In an extremely acute note in the *Cicerone* he ascribed the group to a 'fremde Meissel' and refused to recognise anywhere in it the hand of the great artist. Whatever his relationship to Michelangelo, Steinmann declared, the sculptor did not lay bare 'die Psyche seiner Kunst'.[10] It must be recognised that the difficulties in the way of studying the work were very great. It was exhibited behind the altar in imperfect light and in conditions which precluded inspection from the side. For long the medium was not even identified as marble—reddish stone resembling marble was Wallerstein's description of it—and several writers supposed that it was carved from living rock. Everything published before it was removed from Palestrina in the late nineteen thirties must be read with that physical factor in mind. What the early writers were really doing was to compare the blurred image of a group walled up in Palestrina with blurred images of the unfinished Slaves which were still immured in their grotto at Boboli. Some students, like Mackowsky, were convinced by the original and thought it superior to the plaster cast,[11] others like Popp saw in it the work of a follower operating from a sketch by Michelangelo.[12] Symptomatic of the trend of criticism at this time is an account, published in *L'Arte* in 1931, of the struggle between body and soul manifest in the group.[13]

All that changed radically in 1937–38 when the Pieta was at last removed from Palestrina, was presented to the Italian State (according to a contemporary article in *Le Arti* by a donor who was anxious to conceal his name) and was shown first at a mineral exhibition in Rome and then where we see it now in Florence in the Accademia. At this point it was republished by Professor Toesca.[14] I yield to no one in my admiration of Professor Toesca's work, and I wish that it were possible to pass in silence over this aberrant article. But since it set the stamp on much that followed, I cannot avoid mentioning two aspects of his case. The first aspect is pedigree. The group

had no pedigree before 1756. But it was suggested by Toesca, albeit as a conjecture, that it might prove to be identical with a sculpture mentioned in 1652 as having been discovered in the house of Michelangelo. Something of the sort has been repeated in other books—in some cyclostyled lectures on Michelangelo I looked at recently it was even claimed that the group was purchased by the Barberini on the advice of Pietro da Cortona as a work of Michelangelo—and I seem to detect some hesitancy on the point even in the entry in Professor de Tolnay's book.[15] So I want to look for a moment at the source on which these assertions rest. The passage occurs in the *Trattato della Pittura* by Ottonelli and Berretini which appeared in 1652. It reads like this: 'I should not omit to mention what a great Professor told me about the celebrated Michelangelo, namely that in Rome he several times left works blocked out. Even though they might serve as examples to other masters, none the less they did not completely satisfy his aims.' And now come the crucial sentences: 'Such are the two Pieta groups, one of which was found buried in a ground-floor room, and is now on public view in a workshop in Rome; and the other is in the garden which belonged to Cardinal Bandini at Monte Cavallo.'[16] The second group is, of course, the Pieta in the Cathedral in Florence which was procured in Michelangelo's lifetime by Francesco Bandini, was installed by his son Pierantonio out of doors in the Bandini vigna, and was brought to Florence in 1674. So far as concerns the other sculpture, one Pieta group, and one only, is mentioned in the inventory of Michelangelo's house, and that is the Rondanini Pieta. By no conceivable possibility, therefore, can the sentence in the *Trattato* relate to the Pieta from Palestrina, even if we assume, as Toesca was prepared to do, that the word 'seppelito' should be read literally, and that the manifest imbalance of the group had caused it to fall forwards so that it was buried face down in the floor.

The other aspect of Toesca's article I must mention affects the way in which the group is carved. One of the best and best-known accounts of Michelangelo's working procedure is that given by Cellini, who describes how he attacked the marble block initially on the main face of the statue. The sentences are known to everybody in this room, and they need not be quoted here. The Pieta, argued Toesca, was carved on a single face, and therefore it must be by Michelangelo.[17] I do not want to anticipate one or two points I shall make later about the structure of the group. But it is, of course, the case that Michelangelo's other unfinished sculptures are multi-facial, and this is one of the great points of incompatibility between the authentic sculptures and the Palestrina group. By a perverse form of logic

Toesca transformed that feature of the group which was least Michelangelesque into the hall-mark of his authorship.

The band-wagon started to roll, but only one of the affirmative articles need be mentioned here, an analysis by Mariani, which stressed two features of the group, its pictorial charcter and its frontality.[18] I mention it because the article recognised that in both respects the Pieta was atypical, but concluded, rather illogically, that it therefore marked an extension of our knowledge of the sculptor's style. For the rest, sweetness continued to rise from sorrow, and spirit and matter remained locked in ceaseless strife. Nothing, it seemed, could dispel this fog of rhetoric, not the opposition of Wittkower[19] and Tolnay,[20] not the silence of Wilde or the expressed doubts of von Einem,[21] not the ambivalent position of Kriegbaum,[22] who included a plate with a non-committal note at this end of his book on Michelangelo but did not discuss the sculpture in his text.

That then is the position today. The group is undocumented, and has no pedigree beyond the eighteenth century. So if the attribution is to be maintained, four things must be demonstrated. It must be proved first that the actual chiselling really corresponds with the chiselling of Michelangelo's other unfinished works. Second that the forms in the finished as well as the unfinished parts have valid parallels elsewhere. Third that the methods by which the group is excavated are compatible with those employed in other sculptures. And fourth that Michelangelo was, or could have been, responsible for the design. I put the points in that order partly for reasons of method and partly because I hope it will remove if not the sting at least some of the emotion from the argument. So first the matter of manual technique.

What I have to say about it has been to some extent anticipated in a very clear-headed article in the paper *Il Ponte* earlier this summer.[23] The gist of the argument was this, that all of Michelangelo's unfinished works are characterised, in the unpolished parts, by a general uniformity of handling, a 'scrittura', and that this handwriting is conspicuously lacking on the Palestrina Pieta. To put that in concrete terms, we can all of us remember the fine filigree of chisel strokes on the naked figures in the *Battle of the Centaurs* and the coarser filigree of strokes that appears on the head of the Evening in the Medici Chapel. It is rather specially difficult to generalise about sculptural technique, but one point can be made, that however primitive the state of the sculpture the chiselling of Michelangelo follows the forms as he intended they should be. The chiselling changes direction with each change of plane and from the very first his aim is to define the figure and not simply to block it out. It is to this incomparable subtlety of

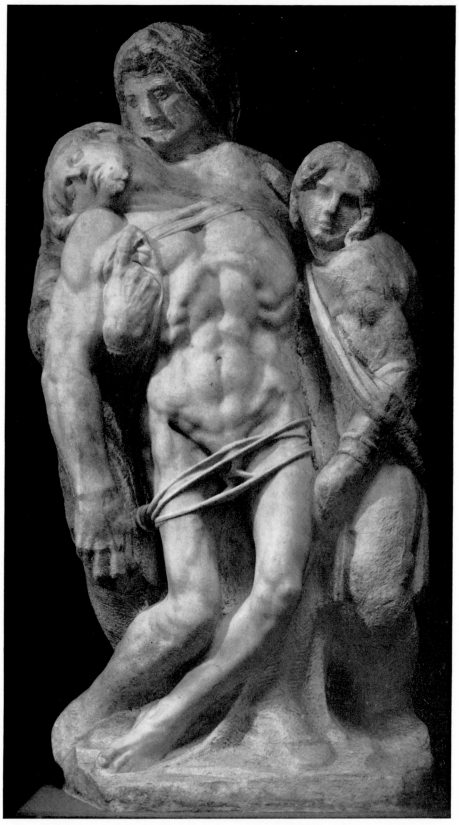

131. Attributed to Michelangelo: *The Palestrina Pieta*. Marble. Florence, Accademia

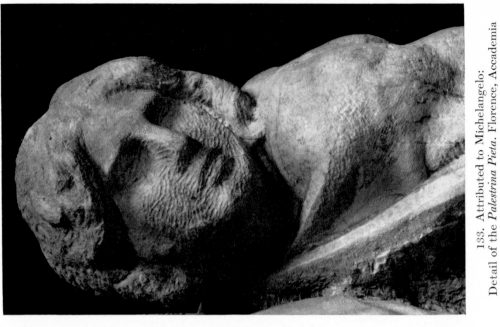

133. Attributed to Michelangelo:
Detail of the *Palestrina Pietà*. Florence, Accademia

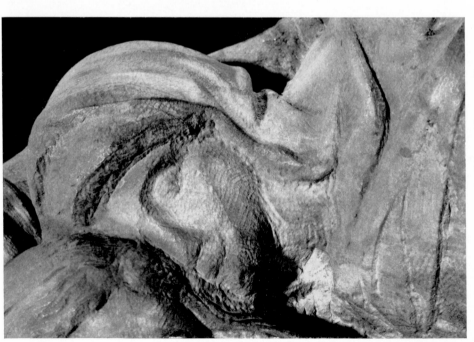

132. Michelangelo: Detail of *Pietà*. Florence, Duomo

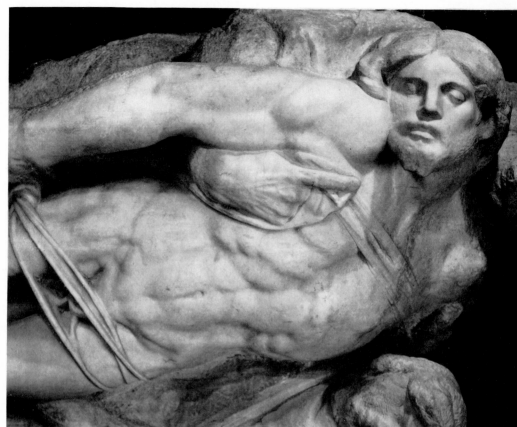

134. Attributed to Michelangelo: Detail of the *Palestrina Pietà*.
Florence, Accademia

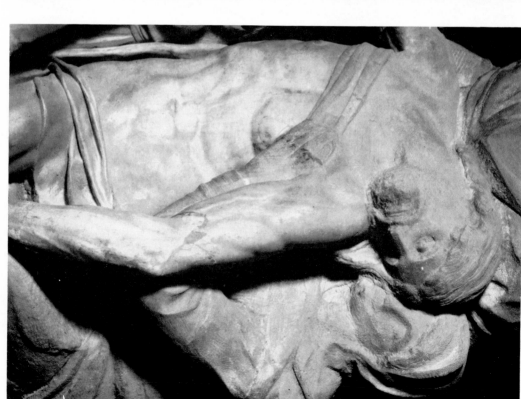

135. Michelangelo: Detail of *Pietà*. Florence, Duomo

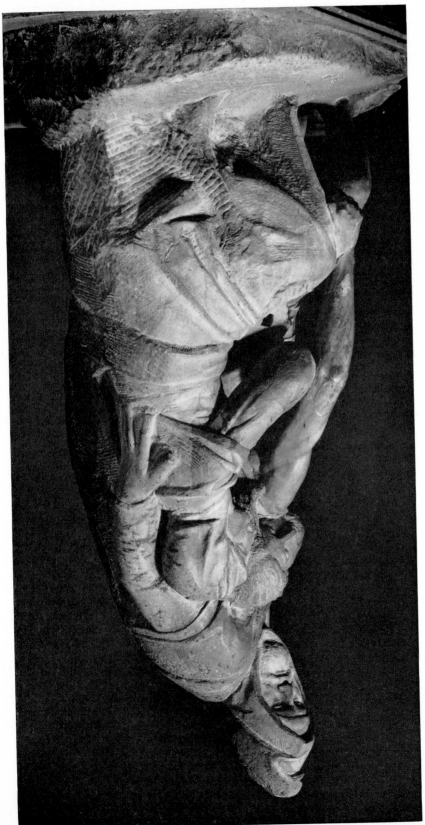

136. Michelangelo: *Pietà.* Marble. Florence, Duomo

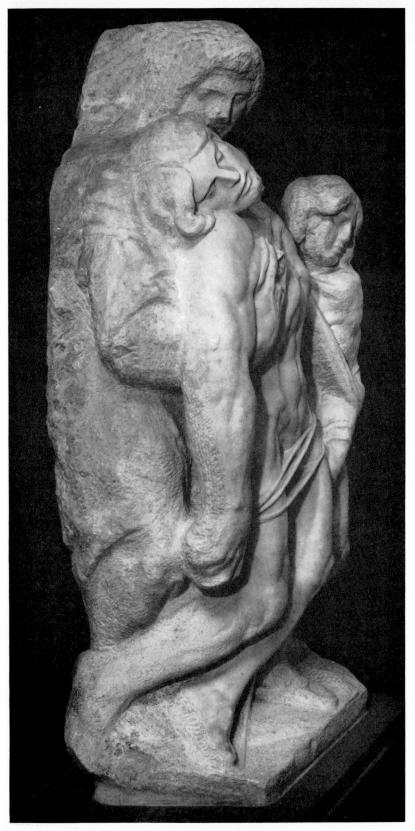

137. Attributed to Michelangelo: *The Palestrina Pieta.*
Florence, Accademia

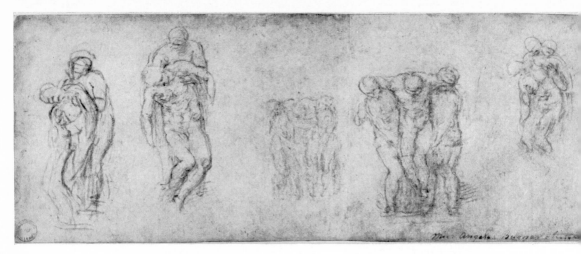

138. Michelangelo: *Studies for a Pieta*. Oxford, Ashmolean Museum

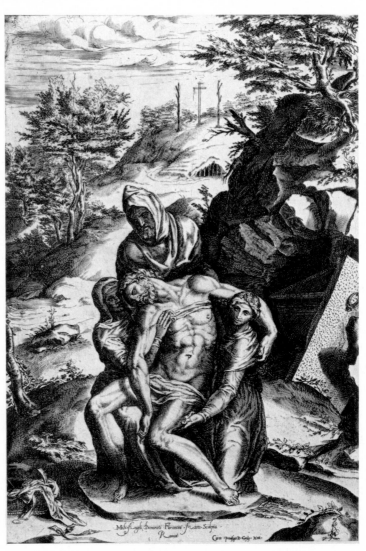

139. Cherubino Alberti: *Engraving after the Michelangelo Pieta*

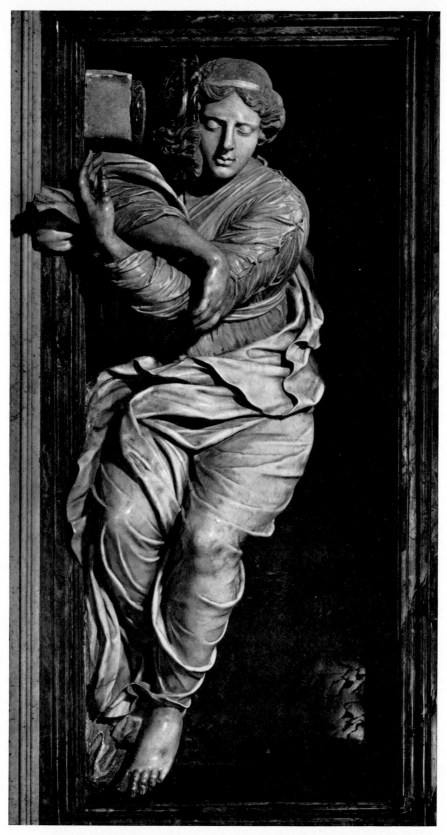

140. Menghini: *Santa Martina*. Marble. Rome, SS. Martina e Luca

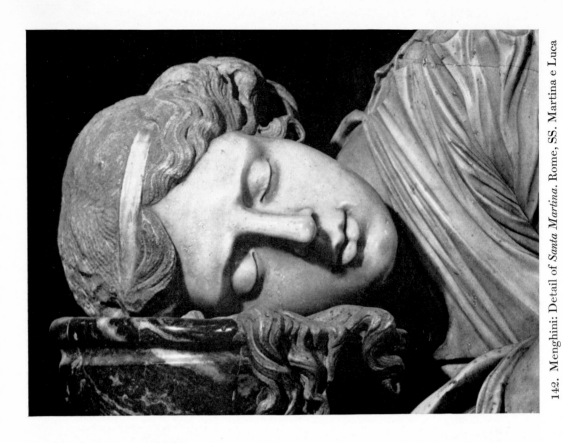

142. Menghini: Detail of *Santa Martina*. Rome, SS. Martina e Luca

141. Attributed to Michelangelo: Detail of the *Palestrina Pieta*.

handling that the quality of heads like that of the Virgin in the Pieta in the Duomo in Florence (Fig. 132) are in large part due; what could be more meticulously graduated than the chisel strokes that establish the shape of the eyelid and the surface of the cheek. Now this quality is absent from the Palestrina Pieta. In the head of the woman on the right (Fig. 133), for instance, the wavering chisel strokes run straight across the cheek and diagonally up the nose; of the act of definition as it was understood by Michelangelo there is not the smallest trace.

Of course, you may object that these two heads, so far as finish is concerned, are in two different states, so I will take another instance where the degree of finish is more closely comparable. One of the most beautiful and revealing texts for the study of Michelangelo's technique is the throat of the Victory, where the forms once more are rendered by means of an always functional mesh of lines. No other Renaissance sculptor had a technique as direct and precise and articulate as this. But when we turn to the head of Christ in the Pieta from Palestrina (Fig. 141) we find that the technique is different in kind. The nose and the right cheek, even the temple, are covered with a pattern of hesitant horizontal chisel strokes. It seems that some writers who support the attribution of the group to Michelangelo have actually been conscious of this distinction. Goldscheider, for example, declares that the group was begun by Michelangelo and finished by another hand,[24] and recently Dr Russoli, in a useful little book on Michelangelo, has presumed a maldexterous 'ripassatura' by some other sculptor at the time the group was installed at Palestrina, in the late seventeenth century that is.[25] I doubt if any resolution of the problem on those lines is possible. The simple truth is that the technique is un-Michelangelesque not only by Michelangelo's own elevated standards but by the standards of less expert artists who carved essentially in the same way. Two obvious instances are Cosini, in the trophies intended for the Medici Chapel, and Tribolo, in the Martyrdom of St Andrew in the Bargello. The technique of Tiberio Calcagni, as we see it in the head of the Magdalen in the Bandini Pieta, is likewise a weak imitation of Michelangelo's.

I come now to a second point, the morphology of the figures in the group. The wide, low head of the Virgin, where does a parallel for that occur in Michelangelo? Not in the Rachel and the Leah with which it is sometimes supposed to be contemporary, not in the Pieta in the Cathedral, not in the Rondanini Pieta, where the head, second version though it be, is shaped with such consummate artistry. And then the Virgin's grotesque hand (Fig. 134), where exactly does that find an equivalent? Not certainly in the

hand of the Virgin in the Duomo Pieta. And how to explain the flat pro-
tracted legs of Christ, with their thick ankles and tapering feet? Are these
really by the artist who carved the tense compact limbs of the Pieta in
Florence or the exquisitely sensitive legs of the Rondanini group? Moreover,
there are passages where the intentions of the artist are curiously ambiguous.
One of them is the forward shoulder of the figure on the right, which would
be expicable only if the sculptor were in doubt as to the effect that he
intended to produce. How different is this shapeless mass from the firm
shoulder of the Virgin in the Duomo Pieta (Fig. 135). But the decisive area,
which has led certain students to postulate the intervention of a second
hand, is, of course, the torso of the Christ. It is anatomically false, and has in
common with the torsos of Michelangelo only a certain nobbliness. Never
was he guilty of carving as inorganic or as weak as this.

Now you may feel that those adjectives introduce an element of pre-
judice. But my reason for employing them will transpire clearly enough
when we pass to the third point, the structure of the group. There has been
only one serious analysis of that since Thode, and it appears in the fifth
volume of Professor de Tolnay's *Michelangelo*.[26] From the beginning it was
recognised that the unknown sculptor, I shall call him the Palestrina Master
from this point on, conceived his group as a relief and carved it on a single
face. It has been argued that there were technical reasons for his doing so,
in that he was restricted by the block. I should mention here that in 1938,
when the group was moved, it proved to have been excavated from a Roman
architectural fragment which shows traces of acanthus at the back. (Blaise
de Vigenères,[27] in a passage which is related by von Einem to the Pieta
in Florence,[28] actually describes Michelangelo carving from a block of
rather the same kind.) Now it is, of course, true that the predetermined
dimensions of the block inhibited the carving of so large a group fully in
the round, but it did not condemn the sculptor to the course that he elected
to pursue; it did not, in other words, impose the solution of a group that was
entirely flat. The simplest way of establishing the difference is to compare
the side view of the Duomo Pieta (Fig. 136), which has those fully developed
secondary views that play so large a part in the work of Michelangelo, with
the side view of the Palestrina group (Fig. 137), which reveals an un-
sophisticated sculptor with a positive abhorrence of tridimensionality. How
could the sculptor of the Slaves and of the Pietas conceivably have been
responsible for this? Moreover, when we turn once more to the front view,
we find that even there the Palestrina Master was incurably addicted to dis-
posing forms across a single plane. In the Duomo Pieta Christ's shoulders

reach back diagonally through the group. The shoulders of Nicodemus are also placed on a diagonal, and the Virgin is similarly set across the corner of the block. There is nothing of all that in the other Pieta. The flat body of Christ is framed between the two emphatic verticals of the right arm and of the figure set in the same plane on the right side, and though the Virgin's head is turned towards Christ the placing of her body is actually determined by the flat back of the block. The differences are so great as in my view absolutely to preclude the possibility that one mind was responsible for the two groups.

There is indeed evidence that at one time, probably about 1555, Michelangelo did experiment briefly with the notion of a Pieta group where the Christ was supported by a single figure from behind, with his head on his right shoulder, and with the lower legs inclined towards the same side. It occurs in a tiny study on a famous sheet at Oxford (Fig. 138),[29] which comprises sketches for two separate groups. One, recorded in two drawings in the centre of the sheet, is developed from the Vittoria Colonna Pieta, in that it shows Christ with his head hanging forward and his upper arms extended horizontally. The subject on this occasion is the Entombment not the Pieta or Deposition, and the body is accompanied by two full-size male figures who transport it on their shoulders to the tomb. There are many miraculous inventions in Michelangelo's late work, but none is more astonishing than this, a three-figure sculptured group in which the central figure is supported with its feet free of the ground. The other scheme is for a Pieta, and the earliest version of it, as Professor de Tolnay has shown,[30] is the second drawing from the left, which is developed from the Duomo group. It contains two figures only, and they have repeatedly been cited as preparatory studies for the Palestrina Pieta. But the resemblance is less important than the differences—the shoulders of the Christ are, for example, set diagonally across the block—and the sketch is not a final study; it is a phase in a thought-process that led on first to the drawing on the extreme right, where the head and the right shoulder are pulled still further forward and the position of the two knees is reversed, and then to the drawing on the extreme left, where the revised pose of Christ is retained almost unchanged, but the figure of the Virgin is now slightly turned. It has been proved, I think in a conclusive fashion, that the group to which these last sketches lead up is the Rondanini Pieta (Fig. 139), I want to repeat once more, only one of these five little sketches has any relevance at all to the Pieta from Palestrina, and the connection is casual and not purposive.

I am compelled to interrupt the argument at this point to say something

of the datings that have been suggested for the Pieta. A good many of the people who believe it is by Michelangelo suppose that it is earlier than the Pieta in the Cathedral. That was Venturi's view—it was, he said, of the period of the unfinished Slaves.[31] Others have supposed that the two works are contemporary—Toesca, for instance, believed that work on the group was confined to the bracket 1547 to 1555. And then it has also been suggested that Michelangelo worked on it after the Duomo group, concurrently with the first version of the Rondanini Pieta. By some strange paradox the people who believe that it is not by Michelangelo adhere to rather the same view. One must think, said Thode, of some sculptor active in Michelangelo's workshop like Tiberio Calcagni or Daniele da Volterra. One must believe, said Steinmann, that the grandiose composition depends from drawings by the master. One must imagine, wrote Dr Popp, reviewing the *Klassiker der Kunst* Michelangelo volume in 1924, that the group was carved by a close follower of Michelangelo working from the master's designs for the Rondanini Pieta. Professor de Tolnay subscribes to the same fallacy. 'A terminus post quem ca. 1552', he says 'is given by the Oxford sheet with the Pieta drawings, the motifs of which were used by the sculptor of this work.'[32] I cannot help feeling that the attributional fate of the Palestrina Pieta might have been a little different if those arguments had been thought through more carefully. Two interrelated points are involved—when the Pieta was made and why.

I hope I have said enough already to convince at least some members of this audience that the technique and structure of the group differ so fundamentally from Michelangelo's that the possibility that it was carved by a sculptor who had so much as seen Michelangelo at work must necessarily be ruled out. The only scholar who has hit that particular nail squarely on the head is Professor Wittkower, with his blessed noun 'pastiche'. How then was the group produced? There are two lines of explanation of which I am frankly sceptical. One of them is that this enormous group was worked up, posthumously, from the autograph thumbnail sketch at Oxford. It is possible, of course, but to my way of thinking it is not particularly likely. One of the things that renders it improbable is the fact, on which Professor de Tolnay and many other scholars have commented, that the upper part of the group is—I quote—'a kind of paraphrase in reversed edition of the Florentine Pieta.' When one comes to think about it, this business of reversal is more than a little bit peculiar. The Palestrina Master may have looked at the group in the Bandini vigna, and said to himself, in a moment of self-exaltation, 'I will copy this, but back to front'. But as a creative process

that would be eccentric, and we are consequently bound to investigate whether there was not some prior stage, in which reversal had already taken place. Obviously the first area to dredge is that of engraving in which more often than not the image was reversed. A great many of Michelangelo's works were engraved in the sixteenth century, and some of them, the Vittoria Colonna Pieta for example, were always reproduced the right way round.[33] But with the Bandini Pieta the opposite occurred; it was reversed. And as soon as I put the engraving on the screen (Fig. 139), I think you will agree that some knowledge of the composition in this form must be postulated in the Palestrina group. The figure on the right is manifestly based on the figure on the right of the engraving; the proof of that resides not only in the head, but in the fact that a right-handed action, the cleaning of the corpse, is performed with the left hand. The group also follows the engraving in that the axis of the head of the rear figure is towards the left. The limited width of the block necessitated that the third figure, the kneeling Virgin, be left out, and it is to this that the change in the identity of the rear figure seems to be due. But by an unhappy compromise the hand of the missing figure was retained and was transferred to the figure standing at the back. And the engraving for the first time gives us a date. It was made probably by Cherubino Alberti, with the privilege of Pope Gregory XIII, that is between 1572 and 1585. So the group from Palestrina was not executed in the lifetime of Michelangelo. But the date is, of course, no more than a *terminus post quem*, for the changes that are introduced into the composition would be explicable only if the sculpture were carved at a much later time. First of all there is the change of scale; the figures in the Palestrina Pieta are almost double the size of those in the Cathedral, and their expansion represents one of the less happy consequences of the revolution initiated by Bernini. The relief-like carving is also Berninesque, and the resolution of the lower part, whereby the legs mirror the posture of the head, and the body is resolved on a continuous curve, is likewise a mature Baroque device.

Let it not be forgotten that on the part of sculptors interest in the Bandini Pieta was as great in the seventeenth century as it had been in the sixteenth. For example, we find Falconieri in 1674 writing to Florence to propose that it should be set up in the Medici Chapel at the altar end. 'What Bernini told me, I know is absolutely true,' says Falconieri,[34] 'that the Christ, which is almost completely finished, is an inestimable marvel . . . and that he (Bernini), when he grew to manhood and became a master . . . studied it continuously for months and months.'

All that, you may tell me, is a matter of opinion, but there is just one point that is not. It is that the hand of Christ is not shown, as it is in the engraving and in the Bandini Pieta, with open palm, but from the back, a change that in turn affects the whole posture of the arm. Why did that occur? Because the unknown master substituted for the arm of the Pieta in the Cathedral the suspended arm of the Rondanini group. That can be confirmed by reading up the arm of the Palestrina Christ: from hand to elbow there was a model by Michelangelo to follow, but above, the soft, rubbery shoulder reveals all the artist's doubts as to exactly how the arm should be attached. Now I want here to go back to the point from which I started, Pietro da Cortona's treatise of 1652. It mentions, you recall, two Pietas, the group in the Bandini vigna which had been continuously available for study since before the death of Michelangelo and which is indeed copied in quite a number of paintings in the later sixteenth century, and the Rondanini Pieta which was found buried in the studio of Michelangelo. That the Rondanini Pieta must really have been inaccessible is suggested by the fact that it was not copied in painting in the sixteenth century. If only we knew exactly when the group was disinterred—not long before the publication of the *Treatise*, in the second quarter of the seventeenth century perhaps. But of one thing it seems to me we can be sure: until it was installed in the Roman workshop where the *Treatise* describes it, the later Pieta could not have been produced.

So all this evidence—and I do not for a moment claim that it is watertight—all this evidence from technique and structure and style leads us inexorably towards one conclusion, that the group dates from some time in the seventeenth century. Now there are only three sculptors who are mentioned in connection with the palace and church at Palestrina. One is Michelangelo—and I think on that score I may already have said enough—and another is Bernini—and heaven forbid that we should hold Bernini responsible for this. But in 1655 Suaresius introduced a third name, that of Niccolò Menghini.[35] I must make it clear that Suaresius says nothing about a Pieta, and that the citation of Menghini is in connection with decorative sculptures of some unspecified kind. But Menghini's name lingered on in Palestrina. When, for example, Cametti's authorship of the two Barberini tombs there was forgotten, it was Menghini to whom they were ascribed.[36] So I thought in connection with this paper that it was just worth while to look once more at the statue of Santa Martina in SS. Martina e Luca (Fig. 140), which was carved by Menghini in 1635. Everybody here will remember it of course; Professor Wittkower qualifies it with the to my mind

generous epithet 'unsatisfactory'. Now it is notoriously difficult to compare reclining with standing figures and finished with unfinished works. But looking at the statue I am bound to say that it did make me think twice. I want to put the Palestrina Pieta once more on the screen, and then turn Menghini's figure so that it is erect. If that is done one can imagine that when the statue was first blocked out it could have looked just a little like the Magdalen in the Palestrina group. The difficulty is to translate that into more specific terms. Those mannered feet might be expected to recur, but the feet in the Palestrina Pieta are hardly carved at all. As for the hands, all that is plain is that Menghini and the Palestrina Master experienced the same trouble in keeping them in scale. We are left, therefore with the head. Here is the head of the Magdalen, and there is the head of Santa Martina (Fig. 142). I am bound to admit that physiognomically they do look to me more than a little alike. But the head of the Saint is not intended to be seen from this angle at all. It rests on the right cheek, and in the Pieta there is one head that rests on the right cheek too (Fig. 141). I shall put that on the screen once more as well. And this time surely there is no mistake. The two heads could really have been carved by one and the same hand.

Of course, more ample evidence would be required before a wholly convincing attribution could be evolved from that hypothesis. I am much more confident about the date of the group than I am about its authorship, but it is worth recording that Petrini, in his *Memoire Prenestine* of 1795, records under the year of dedication of Santa Rosalia, 1677, that the Pieta was then generally ascribed to Bernini or to Niccolò Menghini.[37] Anyway the important thing about the work is what it is not. I do not want to appear dogmatic in this matter, but I am convinced that a conception of Michelangelo which admits the inclusion of this group is a wrong conception of Michelangelo.

Originally delivered at the International Congress of Art History, Bonn, 1964, and published in *Stil und Überlieferung in der Kunst des Abendlandes*, ii, 1967.

Two Models for the Tomb of Michelangelo

ONE of the best-known Florentine terracotta models in the Victoria and Albert Museum is a seated female figure (Fig. 144) which has been associated, since the middle of the nineteenth century, with the statue of Architecture on the tomb of Michelangelo.[1] This connection was first claimed in 1854, when the model was described in the catalogue of the Gherardini Collection:[2] 'Model of the statue representing Architecture upon the monument of Michelangiolo, in the church of Santa Croce, sculptured either by Lorenzi or Giovanni dell' Opera, it is not certain which. However, it is by one of that school, the members of which vied with each other in honouring the memory of their master.' The documents relating to the monument published by Gaye[3] left some doubt whether Giovanni Bandini or Stoldo Lorenzi was the author of the Architecture, but Robinson, in his catalogue of 1862,[4] none the less ascribed the model to Bandini. The attribution to Bandini and the connection with the Architecture were accepted sixty years later by Brinckmann,[5] and were challenged only when Schottmüller[6] summarily dismissed the attribution of the figure to Bandini on account of its incompatibility with a model of Charity wrongly ascribed to Bandini in the Kaiser Friedrich Museum. In 1929 the model was restudied by Middeldorf,[7] who accepted the attribution to Bandini but pointed out that the pose was incompatible with that of the Architecture. He suggested, therefore, that the model might have been made for the figure of Architecture commissioned from Bandini for the catafalque of Michelangelo rather than for the statue on the tomb. Middeldorf's doubts are reflected in the cautious tone of the 1932 catalogue entry of Maclagan and Longhurst,[8] who comment that 'this finely modelled study shows considerable divergence from the statue (the upper part of the figure is more or less reversed), but there seems no reason to reject the traditional ascription'. These observations did not disturb Venturi,[9] who used the figure to point the contrast between Bandini's sketch-model, on which he impressed 'la macchia della figura, a steccate rapide, improvvise, benchè indistinte,' and the inanimate marble statue.

The model shows a female figure seated on a roughly indicated moulded plinth. The left foot is drawn back, and the right knee is consequently higher than the left. The left arm is severed just below the shoulder, and

132

Pensiere di Georgio Vasari per il sepolcro di M. Ang. Bonaroti nella
Chiesa di Sta: Croce

143. Vasari: *Study for the Michelangelo Monument*. Oxford, Christ Church

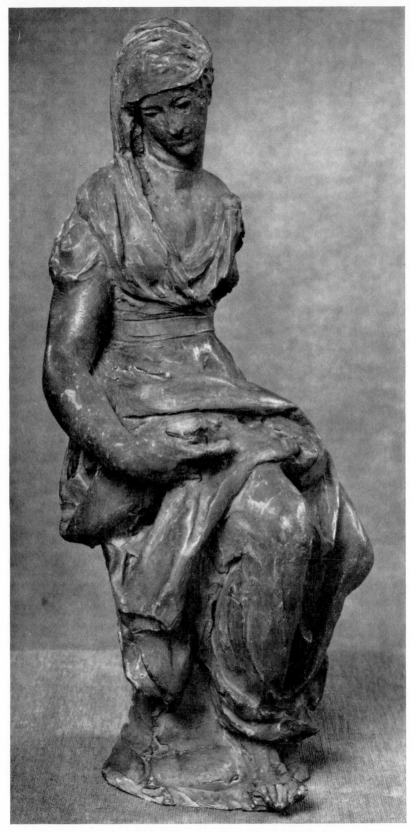

144. Battista Lorenzi: *Sketch-model for the statue of Sculpture on the Michelangelo Monument*. Terracotta, height 34·1 cm. London, Victoria and Albert Museum

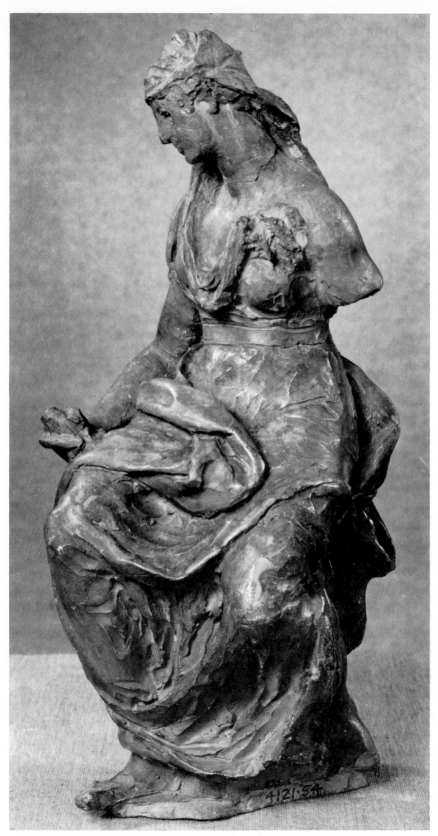

145. Battista Lorenzi: *Sketch-model for the statue of Sculpture on the Michelangelo Monument*. London, Victoria and Albert Museum

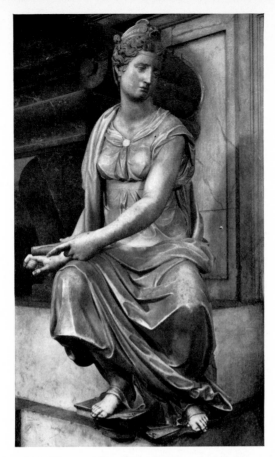

146. Giovanni Bandini: *Architecture*. Marble.
Florence, Santa Croce

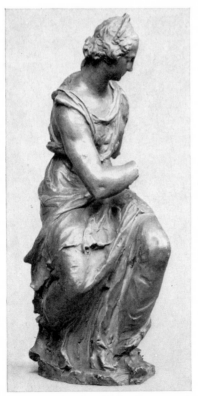

147-148. Giovanni Bandini: *Sketch-model for the statue of Architecture on
the Michelangelo Monument*. Terracotta, height 35·1 cm. London,
Sir John Soane's Museum

the right hand, which holds an indecipherable object, rests on the right thigh. A break in the drapery over the left breast indicates the original position of the missing hand. The plane of the shoulders recedes diagonally from that of the knees, and the resultant movement of the figure towards the spectator's left is accentuated by the head, which is downturned and appears in profile seen from the plane of the two knees. That the figure was conceived with the head turned to the left not to the right, can be corroborated from the relative finish of the two views, the side dominated by the right arm being markedly less highly worked than the side opposite (Fig. 145). Bandini's Architecture (Fig. 146) is set on the right-hand side of the sarcophagus, as a counterpart to Battista Lorenzi's Painting on the left-hand side, and there is no documentary warrant for supposing that it was ever destined for any other site. We are forced back, therefore, on two alternative hypotheses: either the model was made, as Middeldorf supposed, for the statue of Architecture on the catafalque (which, to judge from the summary description in the *Esequie*,[10] may have had a leftward axis) or the model was not made in connection with either of the figures of Architecture. No authenticated sketch-model by Bandini survives, and the attribution of the model to this sculptor is contingent solely on its supposed connection with the marble statue.

If this were all, we should be bound to return a negative verdict both as to the authorship and purpose of the model. But it so happens that there is another unrecognised term to the equation, in the form of a sketch-model in the Sir John Soane Museum (Fig. 147)[11] which was manifestly made for the same monument. It shows a female figure seated on a moulded plinth closely related to that of the so-called Architecture, but with the right knee drawn back, the position of the shoulders inverted and the head downturned to the spectator's right. Even more decisively than with the companion piece, the degree of finish differentiates the front of the model from the back (Fig. 148). The axis of the figure, therefore, corresponds with that of Bandini's Architecture, and though the position of the legs is different, the intervening drapery shows in embryo the strong diagonal fold which is one of the main features of the marble statue. The rigidly classicising type, with its long straight nose, corresponds exactly with the features of the Architecture, and on the head there is a diadem closely similar in form to that worn by the statue. We are bound, consequently, to suppose that the Soane figure is a sketch-model for the statue, and records an early stage in the design, when the legs were reversed and the arms were differently disposed.

The Michelangelo monument was designed by Vasari in the course of 1564, and by the first week of November of that year it had been agreed that the tomb should include three allegorical figure sculptures.[12] At this time it was proposed that the statues should be entrusted to Battista Lorenzi, Giovanni Bandini and a pupil of Ammanati, Battista. When at the end of December it transpired that the third of these sculptors would not be available for work on the tomb, the outstanding figure was allotted to Valerio Cioli, who was at the time engaged on other work.[13] The first of the statues to be completed, Bandini's Architecture, was paid for in 1568.[14] A final payment for the corresponding figure on the left was made to Battista Lorenzi in 1575.[15] In the *Riposo* of Borghini[16] the emblems held by the three figures are described. According to this source, the programme drawn up by Vincenzo Borghini provided for lateral figures of Sculpture and Architecture flanking a central figure of Painting. At the request of Leonardo Buonarroti, however, this scheme was modified, and the figures of Painting and Sculpture were transposed. This change was effected after one of the statues, that by Battista Lorenzi, had been begun, and for this reason the figure of Painting to the left of the sarcophagus holds a small torso which was originally intended as an attribute of sculpture. It can be established that Cioli's Sculpture was carved after the other figures, since a report made by Vicenzo Borghini on March 23, 1573[17] states that at that time Bandini's Architecture was finished, and was looked upon as satisfactory, Battista Lorenzi's Painting was regarded as unsatisfactory, and Cioli's Sculpture 'non è anchor fatta nè si fa'.

Interpreted in the light of these documents, the significance of the Victoria and Albert model is not open to serious doubt. If, as is evident, it is a counterpart to the model for the Architecture in the Soane Museum, it must have been destined for the left side of the sarcophagus, and it must consequently be the work of Battista Lorenzi, who was responsible *ab initio* for this figure. But the figure is not bare-headed like the statue on the tomb. Instead the head is covered with a veil which recalls that on the head of Cioli's Sculpture. Borghini's original proposals for the imagery of the tomb are not preserved, but we know from other cases that his views on iconography were inflexible and the veil on the head of the sketch-model can therefore be explained by the assumption that when it was prepared the figure represented Sculpture not Painting. The broken object held in the right hand may be an embryonic version of the bozzetto shown in the completed statue. Though the model conforms to the same idiom as Bandini's, it is manifestly by a different hand. Whereas in the Victoria and Albert

model the heavy folds of drapery tend to mask the forms, and are designed with a predominantly horizontal emphasis, in the Soane model the damp drapery clings tightly to the flesh, and the emphasis within it is diagonal or vertical. There is no documented sketch-model by Battista Lorenzi by which the attribution can be corroborated, but the distinction which contemporaries seem to have drawn between the quality of the completed statues—according to Borghini's *Riposo*,[18] Lorenzi's Painting was condemned as an 'opera sproporzionata', while Bandini's Architecture was looked upon as satisfactory—is faithfully reflected in the weaker, less organic treatment of Lorenzi's statuette.

In his letter of November 1564 Vincenzo Borghini promised Cosimo I that 'per più sicurtà della bontà et perfettione del opra, Mess. Giorgio, che ha fatto il disegno della sepoltura, ne terrà particular cura, et vedrà giorno per giorno i designi et modelli'.[19] The thinking behind the terracotta models seems to reflect an intermediate stage in Vasari's planning of the tomb. Initially, if the evidence of a drawing at Christ Church (Fig. 143) inscribed 'Pensier di Georgio Vasari per il sepolcro di M. Ang. Bonaroti nella chiesa di Sta: Croce' is to be trusted, the tomb was planned as a wall monument resting on consoles, in which the bust was set over the sarcophagus. In the receding faces at the sides were two allegorical figures, each of them standing before a rectangular niche. The placing of these figures clearly depends from Ammanati's Del Monte Chapel, with whose scheme Vasari had been associated. It seems that prototypes by Ammanati also determined the form of the two models, for not only are the moulded seats closely similar to those used for the seated Virtues on the Benavides monument, but the disposition of the feet in Lorenzi's statuette is imitated from the left-hand Virtue on the Benavides tomb, while the expansive movement of the right arm of Bandini's model is imitated from the corresponding Virtue on the right. This dependence does not result from plagiarism; Ammanati was the most prominent sculptor in Florence when the monument was planned, and though he withheld permission for his pupil to undertake one of the statues, it is scarcely conceivable that he was not consulted during the evolution of the tomb. The pity is that his influence did not predominate, and that under Vasari's guidance the harmonious and emotive figures recorded in the sketch-models were transformed into the sterile statues that are preserved today.

Originally published in *Studien zur Toskanischen Kunst. Festschrift für Ludwig Heinrich Heydenreich*, Munich, 1964.

A Small Bronze by Tribolo

THE bronze statuette known as *Aesop*[1] (Fig. 151) was acquired for the Victoria and Albert Museum in 1855, and is of interest not only for its unusually high quality, but for the widely divergent opinions to which it has given rise. Fortnum,[2] in his careful catalogue of the Museum bronzes, describes the statuette as Florentine and dates it in the sixteenth century. Bode,[3] on the other hand, seems to have felt doubtful as to its place of origin, but confident as to its date, which he placed *c.* 1520. This dating is accepted by Planiscig,[4] but not the prudent reservation as to the centre in which the bronze was cast. '*Die paduanisch-venezianische Herkunft unserer Bronzegruppe*', writes Planiscig with misplaced assurance, '*habe ich als selbstverständlich vorausgesetzt*'. Not only is this conclusion not self-evident, but it is wrong. Planiscig was, however, successful in associating the London bronze with a bronze figure of a dwarf mounted on a snail in the Louvre. The correctness of this surmise was eventually proved in 1957, when Dr Herbert Keutner[5] discovered, in the garden of the Medici villa at Careggi, two marble figures (Fig. 153) based on the two bronzes. Publishing these as an addendum to an admirable article on the Giovanni Bologna *Morgante* in the Museo Nazionale in Florence, Dr Keutner commented: '*Offensichtlich jedoch sind die Bronzen in Florenz und in der Nachfolge unserer Morgantegruppe um 1950 entstanden, und als ihren Schöpfer möchte ich Valerio Cioli vorschlagen, von dem man bisher nur Marmorarbeiten kennt, der uns aber auch also Bronzegiesser überliefert-ist. Die Marmogruppen in Careggi möchte ich als Werkstattarbeiten nach den Bronzevorbildern des Meisters ansehen, die vielleicht erst nach dessen Tode, im frühen 17. Jahrhundert, entstanden sein könnten.*' The two bronzes were thus returned to Florence, but at seventy years removed from the date proposed for them by Bode and Planiscig.

The marbles at Careggi provide our only secure point of reference for the bronze statuettes, and it may be well to open our enquiry at this point. Dr Keutner has been so good as to supply me with four unpublished documents which relate to the Careggi statues. The first[6] is a copy of a Supplica of July 31, 1599, in which Valerio Cioli acknowledges instructions from the Grand-Duke to proceed to Carrara '*a cavare marmi, de dua Nani e de dua contadini per accompagnare la lavacopo, che e di gia fatto, e Modelli di*

136

questi che gia V.A. gli aveva dato l'ordine'. Valerio died in the same year, and six years later a Supplica[7] relating to the figures was submitted by Giovanni Simone di Bernardo Cioli to the Grand-Duke. The operative sentences of this document read as follows:

Giovan simone di bern.do Cioli scultore con reverenzia espone come l'anno 1601 del mese d'Agosto fu per ordine di V.A.S. introdotto a lavorare di scultura dua nani alla piazza de' peruzzi dove gia lavorava Valerio Cioli suo zio serv.re di V.A.S. egli fu ordinato solamente per ogni giorno lavorativo L dua e promesso quando saranno finiti detti lavori sara pagato nel modo che da huomini della professione sara giudicato havendo adunque detto esponente dato lor' fine et amezato il Contadino che vendemia di br. quattro incircha come a visto V.A.S. la qual pregha e con maggior reverentia la supliza voglia ordinare che detti lavori gia finiti sieno visti e stimati conforme alla promessa fattali per valerci delle sue fatiche e darli animo maggiore di rilebarsi o veramente V.A. gli ordini provvisione come dava a Valerio suo zio.

The valuation of the two figures of dwarfs (*'le dua statue del Morgante e Margutte'*) took place on September 1, 1605. The following joint statement was signed by the assessors, Cristoforo Stati and Pietro Tacca:[8]

Essendo stato comesso a noi Cristofano stati e pietro tacha schultori del Mag.co S.r Cap.no Gio. bat. a cresci provv.re delle fortezze di S.A.S. di vedere et giudicare quello che vagliano dua figure di marmo di simone Cioli cioe un Morgante et un Marguttino abiamo stimato il tutto visto et benissimo considerato et connogni scarico di nostra coscientia giudichiamo il morgante valere scudi novantacinque el il margutino ottanta et in fede io pietro tacha sudetto ho fatto la presente di propria mano questo di in firenze. Io Cristofano stati scultore afermo quanto in questa si contiene e di tanto siamo dachordo questo di p.° di settembre 1605.

The valuation was formally confirmed on January 19, 1606,[9] when a note was made that the two animals on which they rested (*'li Animali dove essi posano'*) were to be bored for water by order of the Grand-Duke. From these documents we learn that the marble figures depending from the bronzes were commissioned from Valerio Cioli in 1599, that they were executed after his death by his nephew Simone Cioli, and that they represented the two dwarfs Morgante and Margutte.

The term 'depending from' implies the priority of the bronze statuette over the marble, and it is perhaps worth while to ask ourselves on what this assumption rests. Save in one respect (which will be mentioned later) the marble and the bronze are laid out in precisely the same fashion, with a

broom in the dwarf's right hand and an owl between his legs. The elbows are in both cases held free of the body, and the left leg in both cases is advanced. The effect of the marble is, however, flatter than that of the bronze. The owl's head is no longer turned against the dwarf's left thigh, but is represented frontally; the left shoulder is less sharply retracted; the chest and abdomen are correspondingly less tense; and at the back the formal implications of the bronze have not been fully understood. Not only does comparison demonstrate conclusively that the marble was conceived as a variant of the bronze, and not *vice versa*, but it provides strong reasons against ascribing it to the same artist. Admittedly we know that Cioli worked in bronze, and admittedly no bronze figures by Cioli survive. But when we relate the statuette to the marble by Simone Cioli on the one hand and to the authenticated marbles of Valerio Cioli on the other, it becomes plain, first that the statuette is far superior to the sculptures of either artist, and second that the method by which it is constructed argues an origin in the workshop of a more sophisticated artist at a rather earlier time. And it so happens that in the Bargello there is one statuette that was demonstrably modelled and worked up by the same hand.

The figure in the London bronze is set on a rectangular base cast in one with the remainder of the model. The legs of the dwarf are disposed diagonally across the square with the left foot in the forward left corner and the right foot in the right corner at the back. Above the thighs, however, the body is turned so that the plane of the hips is roughly aligned with the front plane of the base, and above, this movement is continued so that the shoulders counteract the movement of the feet. The right hand, which holds the broomstick, is thrust forwards, and the left elbow is thrust back, inverting the pattern at the base. The awkward gap between the forward and rear leg is filled by the owl, seated in a position corresponding to that of the dwarf's rear foot, but with its head pressed forward between his legs. The body is modelled with strong plastic emphasis and much vivacity, and below the protuberant collarbone the area of the ribs and stomach is rendered with great freedom and skill. One of the sculptor's strangest idiosyncrasies is seen on the right shoulder, where immediately above and below the point of juncture of the arm and body we find two depressions in the surface of the bronze. Behind, the channel between the shoulder blades is represented in unaccustomed depth, and the spine between the neck and buttocks is unified in one continuous line. Particularly striking is the rugged modelling of the head, with rounded indentations in the cheeks and the projecting eyebrows heightened by depressions in the forehead above.

149. Detail of head of *Dwarf* reproduced in Fig. 151

150. Niccolò Tribolo: *Pan*. Bronze, height 26 cm. Florence, Museo Nazionale

151. Here attributed to Niccolò Tribolo: *Dwarf*. Bronze, height 32·4 cm.
London, Victoria and Albert Museum

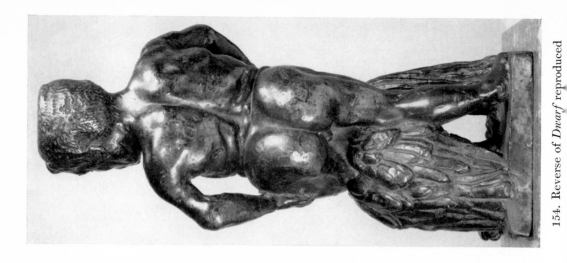

154. Reverse of *Dwarf* reproduced

153. Simone Cioli: *Morgante.* Marble.

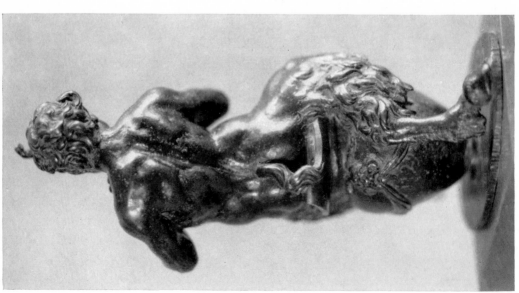

152. Reverse of *Pan* reproduced in Fig. 150

The bronze in the Bargello in which these mannerisms (if they can justly be described as such) occur again, is a small figure of *Pan* seated on a vase[10] (Fig. 150), in which we find not only the same system of modelling in the head, not only the same formation at the back (Fig. 152), not only the same rendering of the torso and the same treatment of the shoulder and upper arm, but a compositional scheme which is closely analogous to that in the London statuette. In this case the base is oval not rectangular, but once more the two legs are set diagonally, the left hoof forward and the right hoof back. Once more the movement is continued above the hips, and once more it reaches its climax in the inverted diagonal of the elbows and of the shoulders above. The relationship between the figures, therefore, is more than an external relationship of accidents of form; it is the fundamental relationship between works conceived by the same artist and guided by the same formal principles. Had this connection been established by Bode or Planiscig, the sculptor would doubtless have been known as the Master of the Dwarf or the Pan Master, and it might still have been maintained that he was active in Padua, not Florence, at the end of the first quarter of the sixteenth century. Fortunately, however, the sharp eye of James Holderbaum[11] has recently enabled the Pan statuette in the Bargello to be identified beyond the least possibility of doubt as a work by Tribolo, and to be assigned not to a hypothetical bracket of time but to the specific year of 1549. It follows that the London statuette is also by Tribolo, and was produced at about this time, thirty years later than was suggested by Bode and Planiscig and forty years earlier than Dr Keutner supposed.

At this point it must be mentioned that the bronze in London has one physical peculiarity, that the top of the head is flat and contains a large circular hole. On all of the earlier occasions on which it has been reproduced, it has been shown wearing a grotesque hat which is evidently of some age but in facture is completely different from the remainder of the figure. A hat or other headdress could have been cast easily enough in one with the main figure, and the sole function of the present hat (whenever it was made) must from the first have been to hide the hole bored in the skull. Is it then possible that the hole provides a clue to the purpose of the statuette? The vase beneath the *Pan* in the Bargello seems to have been designed as a receptacle for ink or sand, and the circular hole in the dwarf's head could well have been intended as the socket of a candlestick. If this were so (and the explanation is of course conjectural), the heavy base on which the figure rests would presumably have been designed to supply the complex with the necessary stability.

In republishing the bronze in the Bargello Mr Holderbaum made some large but well-justified claims for Tribolo as a bronze sculptor, and these may be amplified in the case of the London statuette, which reveals him once more as an artist of exceptional formal ingenuity. At the same time it discloses a new aspect of his personality, for where the *Pan* is conceived with remarkable imaginative impetus, the dwarf, for all its satirical intention, explores a deeper realm of feeling, and reveals in the head a nobility and a compassion which remind us that after 1534 the sculptor was working under the gigantic shadow of Michelangelo. There is indeed something truly Michelangelesque in the sense of strength of mind triumphant over disability which can so easily be read into the profile of the bronze. One small point suggests that this interpretation may be less fantastic than it at first appears. The marble figures at Careggi are designated in the documents as Morgante and Margutte, and one of them, that with the owl, closely reproduces the features and physique of Morgantino, while the other has a different head and is of slighter build. The statuette from which the marble was derived must also represent the dwarf Morgante,[12] but though the body agrees closely with Morgante's, the head (Fig. 149) differs radically both from the marble and from the other representations of the dwarf. Why was Morgante's body combined with this discrepant, seemingly intellectual head? Possibly it was this contrast that caused Fortnum,[13] when the statuette was purchased, to suggest that it showed the legendary Aesop of Maximus Planudes, 'Aesop as a hunchback dwarf holding a rod, and standing astride an owl'. The symbols of the owl and broom are of no great assistance, for as has recently been pointed out by Mrs Tietze-Conrat,[14] these are described by Ripa as attributes of '*Vulgo, overo ignobilità*'. They occur again in a painting by Bronzino of the dwarf Morgante in the Uffizi,[15] which seems to have been produced in close proximity to the bronze since it was already in Medici possession in 1553. While the identification of the bronze as Aesop must remain conjectural, comparison with Bronzino's portrait leaves little doubt that it is not a portrait in the true sense, but a figure used to illustrate a moral theorem. Whatever its significance, it is a work of applied art conceived, possibly as a Medici commission, by one of the most distinguished sculptors working at the Ducal court, in which the formal refinements of Florentine mannerist art are combined with a weight of meaning that Tribolo, alone of the contemporaries of Cellini, could communicate.

Originally published in *The Burlington Magazine*, CI, March, 1959.

A Sketch-model by Benvenuto Cellini

W HEN a sculpture without a pedigree is ascribed to Benvenuto Cellini, our suspicions inevitably are aroused. So many objects have been wrongly credited to Cellini in the past—in the Victoria and Albert Museum they include works as various as a little terracotta statuette which has been claimed as model for Cellini's marble *Narcissus* in the Bargello and a South German jewelled book-cover—that any sculpture which is not mentioned in his *Life* or in contemporary documents must be regarded with the utmost scepticism. None the less by good fortune the Museum has recently purchased a bronze (Fig. 155—13.8 cm.) which is not only an autograph sculpture by Cellini but was made as a sketch-model for the head of the Medusa in his masterpiece the *Perseus*.

At the outset perhaps it would be well to recapitulate what we know about the statue. It was commissioned in 1545 when Cellini, as a fugitive from France newly returned to his native town of Florence, paid his respects to the ruler of the city, Cosimo I de' Medici, who was in residence in the near-by villa of Poggio a Cajano. The Duke—and for this we are dependent on a passage in Cellini's *Life*—enquired whether Cellini was prepared to make a statue for the Piazza della Signoria, and Cellini, though his experience of large-scale, free-standing sculpture was at the time no more than theoretical, enthusiastically agreed to do so. The subject was designated by the Duke, who 'replied that, for a first essay, he would like me to produce a Perseus'. According to Cellini's own account, the model, a braccia high and made of yellow wax, was completed in a few weeks, and was then shown to the Duke. This model is now preserved in Florence in the Museo Nazionale. The only other preparatory models Cellini mentions in the *Life* were on the same scale as the statue, and were made in gesso and terracotta. The gesso model stood in his studio till his death in 1571, and though it no longer exists we can gain some impression of what it must have looked like from two full-scale gesso models in the Accademia, which were made later in the century by Giovanni Bologna for the *Rape of the Sabines* and the *Florence triumphant over Pisa*. The first wax model is so different in scheme from the finished statue that we must suppose a whole series of other models intervened between the two, and proof that that was so is supplied by a bronze model, also in Florence in the Museo Nazionale, which is not

141

documented (in the sense that it is not mentioned in the *Life* and does not appear in any inventory) but is traditionally given to Cellini and is accepted as Cellini's by every writer on his work. The bronze model also differs from the statue, but much less radically than the wax, and it is generally assumed to occupy an intermediate position between the two. It is perhaps worth mentioning here that work on the statue occupied Cellini for nine years—the group was not installed in its present position in the Loggia dei Lanzi till 1554—and that the lower part, the headless body of Medusa, was cast before the Perseus.

It follows that the new Medusa head can be accepted as Cellini's only if it conforms in handling to the bronze model in Florence and only if it can be shown to occupy an intermediate position either between the wax and the bronze models or between the bronze model and the finished statue. The scale is about four times that of the Medusa head in the Bargello model, but as soon as we compare the two we find the clearest evidence that they are by one hand. In the Bargello model (Fig. 156) the writhing snakes that crown the head are modelled like little sausages, and the snakes in the new model (Fig. 159) are depicted in precisely the same way. The form of Perseus' fingers and the modelling of the face, above all the tell-tale area of the eyebrows and the deep declivity beneath the lower lip, are also closely similar. The making of small-scale bronze models was, of course, unusual (though a bronze model was later made by Giovanni Bologna for the Fountain of Neptune at Bologna), and in Cellini's case it has been explained by the need to experiment with bronze casting in the unfamiliar conditions of Florence. Much trouble was evidently taken over the casting of the bronze model in Florence, above all with its patination which has a greenish surface like that of excavated Roman bronzes that is unique among small bronzes cast in Florence in the middle of the century. The reason for this is presumably that after 1546 Cellini was engaged in restoring a number of recently discovered Roman and Etruscan statuettes. By what is surely more than a coincidence the patination of the new model agrees exactly with that in Florence.

Now it would be quite possible for a modern forger to model and cast a pastiche of the head of the bronze model in Florence and to patinate it in the same fashion, and it is here that the second test is of significance. As soon as we compare the hand of Perseus in the bronze model in Florence with the hand of Perseus in the statue, we find that there are striking differences between the two. In the model (Fig. 158) the hand is held flat, whereas in the statue it is at an angle and the knuckles are sharply

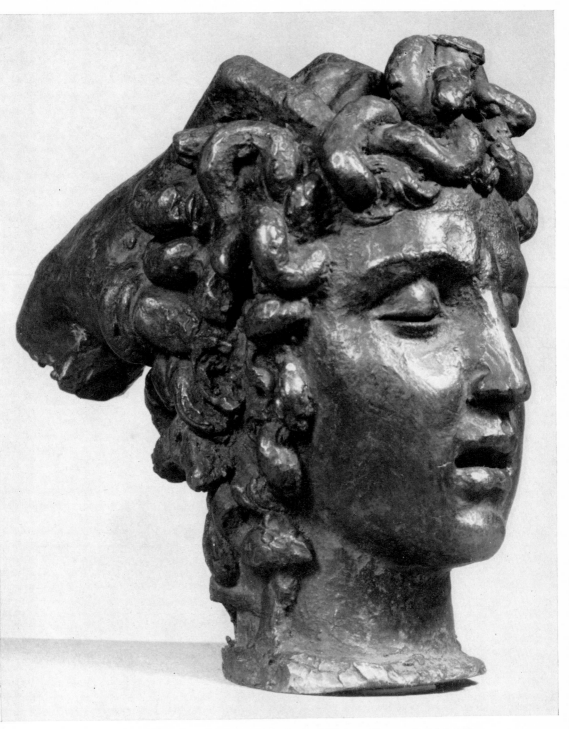

155. Benvenuto Cellini: *Sketch-model for the head of Medusa*. Bronze, height 13·8 cm.
London, Victoria and Albert Museum

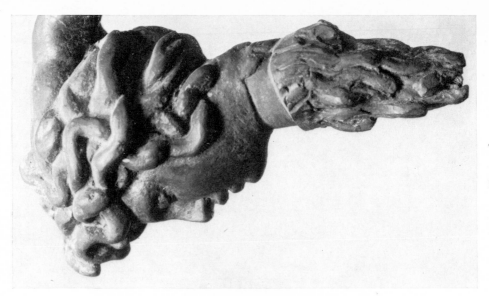

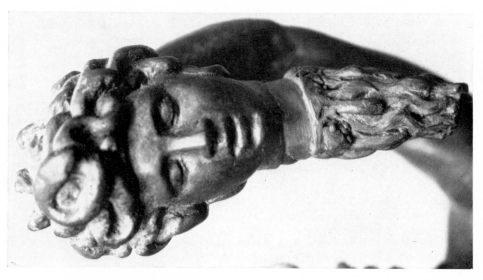

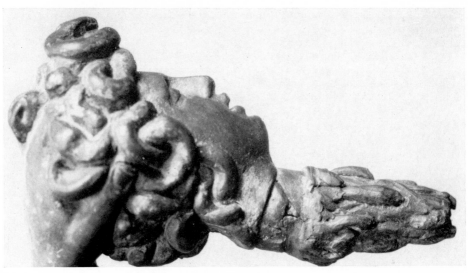

156-158. Benvenuto Cellini: *Head of Medusa from the bronze model for the Perseus.* Florence, Museo Nazionale

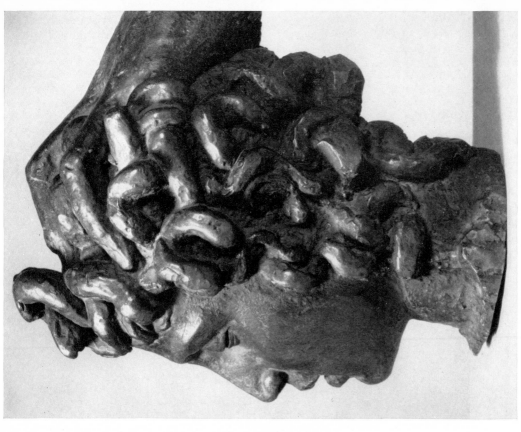

159-160. Benvenuto Cellini: *Sketch-model for the head of Medusa*. Bronze. London, Victoria and Albert Museum

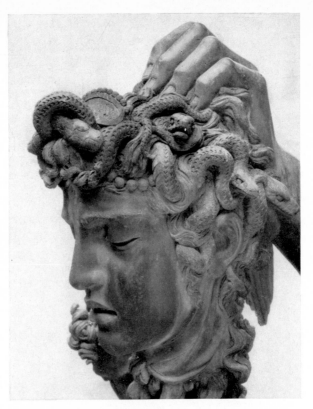

161. Benvenuto Cellini: *Head of Medusa from the Perseus*. Bronze. Florence, Loggia dei Lanzi

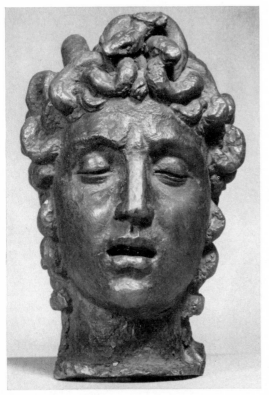

162. Benvenuto Cellini:
Sketch-model for the head of Medusa. Bronze.
London, Victoria and Albert Museum

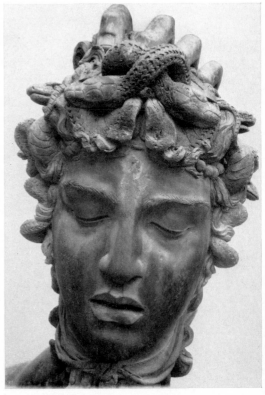

163. Benvenuto Cellini:
Head of Medusa from the Perseus. Bronze.
Florence, Loggia dei Lanzi

bent. The hand of Perseus in the new model (Fig. 160) still rests on the head, but the knuckles are raised so that they register from the front view, and at the sides the artist experiments with a motif that is present neither in the Florence model nor in the statue, two serpents twined like rings round the little finger and the thumb. In front of the left ear of the Medusa there appears for the first time the lock of hair that is also present in the full-scale head. When we look at the model in Florence and the Medusa on the statue from the front, another difference becomes apparent. In the bronze model (Fig. 157) the forehead is surmounted by a single snake centred above the nose. In the statue (Fig. 161) this is replaced by two snakes with heads facing outwards to right and left. The new model (Fig. 162) also shows two snakes, disposed in a less schematic manner than the snakes on the completed head and obviously evolved from the single snake on the earlier model. In face of all this evidence it is very difficult to contest the view that the new model represents an unrecorded stage in the development of the design and was made after the Bargello bronze and before the full-scale model for the statue.

It would, however, be quite wrong to suppose that the differences between the Medusa head in the bronze model in Florence and the Medusa of the statue are simply matters of design, for the principal distinction between them is in expressiveness. The head in the bronze model is impassive, whereas the head in the completed statue (Fig. 163), with its loose decadent lips and its rhythmical, rather supercilious eyelids, is one of the most sophisticated essays in expression in the whole sixteenth century. It is here that the function of the new model (Fig. 155) becomes evident. It marks not just a change in the formal structure of the head, but the first stage in an investigation of its expressive possibilities. One of its peculiarities is that the two sides of the face are in two different states. The right eye and right cheek of the Medusa are left practically in the rough, whereas the left eye and the left cheek, as well as the nose and lips and chin, are chased with the delicacy and precision for which Cellini was pre-eminent. The eye and mouth as a result take on for the first time the evil, languid character of the completed head, and—a detail that is omitted both from the earlier model and the statue—the teeth are visible between the parted lips. It would be hard to find a more convincing answer to the question, 'What exactly does the artist's surface working contribute to a bronze cast?' than is given here.

Though Cellini is the High Renaissance sculptor about whose psychology and creative procedure we are best informed, nothing about his work is ever quite as we expect. One of the peculiarities of the bronze model in Florence

is that it is fully finished: it was suggested by Plon, in his great book on Cellini, that though it was cast in the first instance as a model, it was then worked up by the sculptor as a statuette for the Duke's consort, Eleanor of Toledo. Of the new model this is also true; it lacks the blood which in the bronze model and the statue spurts out from the neck, and is finished off with a flat base so that it stands as an object in its own right. A bronze model for the Medusa head stood in Cellini's studio at his death—'una testa di Medusa, di bronzo', it is called in the inventory—and though we have no information about its size it is tempting to suppose that this and the new model may be identical.

Originally published in the *Bulletin of the Victoria and Albert Museum*, I, January, 1965.

Giovanni Bologna's Samson and a Philistine

I F at any time between 1600 and 1800, a person of taste had been asked who were the greatest sculptors since antiquity, he would have put forward two names, the first that of an Italian, Michelangelo, the second that of a Fleming, Giovanni Bologna. The popular view of Giovanni Bologna's sculpture is summarised in 1699 in Monier's *History of Painting, Sculpture, Architecture, Graving and of those who have excelled in them* in these terms:

It was this Famous *John Bologna*, who gained the most Honour of any to his Nation for Sculpture, by the Beauty which appeared in all his works, which have all of them the true Way and Gust of the Ancients, wherein he perfected himself in *Italy*, and particularly at *Florence*, where he resided, and held the first Place in that Art. He was there employed by the Princes *de Medicis* to make several Pieces of Sculpture: The fine Marble Statues, and the great Groups of Figures in Brass which adorn the Squares of *Florence*, of *Leghorn*, and of *Bologna* are very charming, and so many Proofs of his Excellence, and Monuments of his Glory.

Michelangelo's was a legendary reputation, since his works were scarcely to be met with outside Italy, but the sculptures of Giovanni Bologna were widely known, partly through bronze statuettes made by the artist himself and partly through bronze reductions from his best-known figure, the *Mercury*, and from his marble sculptures. All of Giovanni Bologna's most celebrated works in marble were carved for the Medici Grand-Dukes of Tuscany, and were, with one exception, jealously preserved in Florence. The exception was a group of Samson and a Philistine, which found its way from Florence to a house in Yorkshire, and in 1953 was purchased for the Victoria and Albert Museum with the assistance of the National Art Collections Fund (A. 7–1954. H. from the upper edge of the base to the top of the right hand of Samson 6 ft. 10¼ in. [209 cm.]. The marble group is set on a rectangular York stone base. The noses of both figures, the right foot and left foot and ankle of Samson, and the fingers of the Philistine's right hand have been broken and replaced, as has the jawbone in Samson's right hand.

The *Samson and a Philistine* (Figs. 179–184) illustrates the passage in the Book of Judges describing Samson's victory over the Philistines:

And when he came unto Lehi, the Philistines shouted against him: and the Spirit
of the Lord came mightily upon him, and the cords that were upon his arms
became as flax that was burnt with fire, and his bands loosed from off his hands.
And he found a new jawbone of an ass, and put forth his hand, and took it, and
slew a thousand men therewith. And Samson said, with the jawbone of an ass have
I slain a thousand men.

Carved in Carrara marble, it comprises two life-size figures. The Samson,
represented in action, is naked save for a cloak blown out behind him; his
right arm is raised above his head, its muscles tensed as he prepares to strike
the blow, and his left arm is thrust downwards on the forehead of his
adversary. The sense of superabounding physical vitality communicated by
this figure is enhanced by the crouching Philistine, who, with all the strength
at his command, grips the thigh of Samson with his left arm. On the strap
running across Samson's chest is the sculptor's signature, now reduced to the
letters IOAN BELGAE . . .

Giovanni Bologna was born at Douai in Flanders in 1529. According to
early biographers, he was apprenticed, about 1544, to the sculptor Jacques
Dubroeucq, then at work in Mons on the rood screen of Saint Waudru
(1535–48). Dubroeucq, a typical Flemish Mannerist sculptor of the second
quarter of the sixteenth century, worked, as was the custom in Flanders,
largely in alabaster, and his sculptures for the choir screen fall into two
classes, the first statuettes, conceived for the most part in a classicising style,
and the second reliefs, planned with strong linear feeling which reflects the
emotional preconceptions of Northern iconography. Both aspects of Du-
broeucq's work had their influence on Giovanni Bologna. More than
thirty years later, when he was commissioned to design a cycle of bronze
Passion reliefs for S. Francesco di Castelletto at Genoa, he adapted, for his
own *Ecce Homo* (Fig. 165), motifs from Dubroeucq's *Ecce Homo* in Saint
Waudru (Fig. 164). while the figure of Science which he prepared as part of
the same contract recalled in a general way the infinitely less sophisticated
Virtues of Dubroeucq at Mons. Of Giovanni Bologna's own work at Mons
we know nothing, though it has been conjectured, with a fair measure of
probability, that he was responsible for an alabaster figure of Faith, which
accompanies Dubroeucq's Hope and Charity. The Faith differs from its
companion figures in that its interest is not limited to a single frontal view,
but contains, in embryo, the elements of the free-standing figures which the
artist was later to evolve in Florence.

We have no certain information as to Giovanni Bologna's movements

until 1559, when he was already in Florence. A first-hand knowledge of Italian art was *de rigueur* for the Italianate Flemish artists of the middle of the century, and about 1555 he may have left Flanders for Italy, whither Cornelis Floris and so many of his contemporaries in Flanders had preceded him. For Northern sculptors, Italy in the sixteenth century had a double aspect. On the one hand, it was the home of Roman sculpture, and offered for study an incomparable wealth of antique monuments and works of art. On the other, it was the scene of the movement known as the Renaissance, in which sculptors, the earliest of them Donatello and the most famous Michelangelo, had evolved a style based on the antique yet marked by a new freedom and variety. To artists who had gazed at Michelangelo's *Madonna* on its altar in Notre Dame at Bruges, and who had pored over drawings and engravings of the antiquities of Rome, Italy was a promised land, a centre of enlightenment. Giovanni Bologna's first objective, like that of most Northern artists in Italy, was Rome, where, according to early biographers, he resided for two years, making clay studies from classical sculpture. Then, moving northwards once more on the first stage of his return to Flanders, he left Rome for Florence, where he seems to have arrived in 1557 and was destined to spend the remainder of his life.

In 1557 the artistic scene in Florence was dominated by the overpowering figure of Michelangelo, and the impression of Michelangelo's sculpture which the young artist must have formed in Flanders from the Bruges *Madonna* and in Rome from the *Bacchus* in the Casa Galli, the *Christ* in Santa Maria sopra Minerva and the *Pietà* in St Peter's, could be filled out with the sculpture of the Medici tombs and the *David* in the Piazza della Signoria. Benvenuto Cellini's statue of Perseus had been unveiled in the Loggia dei Lanzi three years before. Baccio Bandinelli, the unworthy competitor of Michelangelo, was reaching the end of his career, and had been superseded in the favour of the Duke, Cosimo I de' Medici, by a sculptor whose work Giovanni Bologna must have seen in Rome, Bartolomeo Ammanati. In the same year as Giovanni Bologna there also arrived in Florence a twenty-five year old Umbrian, Vincenzo Danti. Not only for these major artists but for a host of minor sculptors such as Domenico Poggini there was work and to spare, in churches like the Duomo where Bandinelli was constructing a new choir screen, or Santa Croce, which had been remodelled by Vasari, in the Palazzo Vecchio, where Cosimo I and his consort, Eleanora of Toledo, had established their rigid, autocratic court, in public squares like the Piazza della Signoria, the scene of a rapidly expanding exhibition of what we would now call sculpture in the open air, and in

gardens like those of the Medici villas at Pratolino and Castello. Seldom has any period been so fully memorialised in bronze and marble as the reign of the first Medici Grand-Duke.

The fact that an artist was of Flemish birth was no obstacle to success in Florence. Since 1544 the Medici tapestry works had served as a magnet for Flemish craftsmen and designers, and of the scenes from Florentine history and other subjects which it turned out, the majority were planned by Flemings. When he arrived in Florence, therefore, Giovanni Bologna would have found a small Flemish colony (headed by the painter Stradanus) established in the town, and before long he discovered a Florentine patron in the connoisseur Bernardo Vecchietti. According to Borghini, whose *Riposo*, named after Vecchietti's villa, was published in the sculptor's life-time, Vecchietti restrained the young sculptor from going back to Flanders by a promise to maintain him in his house. At this time Giovanni Bologna was engaged in making models in clay and wax. Many of these were collected by Vecchietti; Borghini records in his villa 'many figures by Giambologna in wax, clay and bronze in diverse attitudes, representing various persons such as prisoners, women, goddesses, rivers and famous men', and describes a room 'all surrounded with models by Giambologna'. For forty years Giovanni Bologna maintained a continuous output of small works. But by temperament he was not a small-scale artist, and before long (again according to Borghini) he begged Vecchietti for an opportunity to prove his worth in marble sculpture, carving a marble Venus, which brought him to the notice of the son of the Grand-Duke, Francesco de' Medici. From this point his name was made. In 1559 he undertook his first official commission, the carving of the Medici arms on the Palazzo di Parte Guelfa, and in 1560 he took part in the competition for the great fountain outside the Palazzo Vecchio in Florence, where his fellow competitors were Cellini, who had scored a notable success with the *Perseus* six years before, and Ammanati, to whom the commission was awarded and who planned the fountain as it exists today. We can gain some impression of the fountain Giovanni Bologna might have designed in the Piazza della Signoria from a fountain which he executed at Bologna not long afterwards (1563–7). Where Ammanati's Fountain of Neptune in Florence has the form of a large shallow basin edged with seated figures in bronze, with a colossal marble Neptune standing in the centre, Giovanni Bologna's Fountain of Neptune (Fig. 166) rises from a relatively small basin filled in large part with a rectangular plinth. Above this, two smaller elements, one decorated with seated putti, lead the eye up to the bronze Neptune above. The careful reasoning and the self-criticism

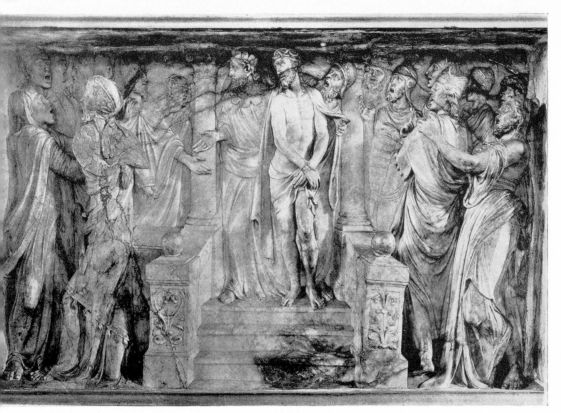

164. Jacques Dubroeucq: *Ecce Homo*. Alabaster. Mons, Saint Waudru

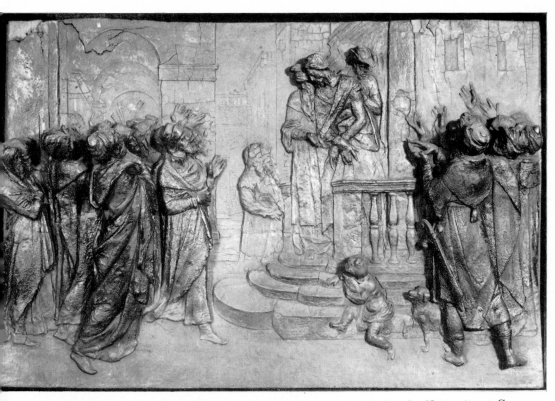

165. Giovanni Bologna: *Ecce Homo*. Wax sketch-model for a bronze relief in the University at Genoa.
London, Victoria and Albert Museum

169. Giovanni Bologna:
Florence Triumphant over Pisa. Wax.
London, Victoria and Albert Museum

168. Michelangelo: *The Genius
of Victory.* Marble.
Florence, Palazzo Vecchio

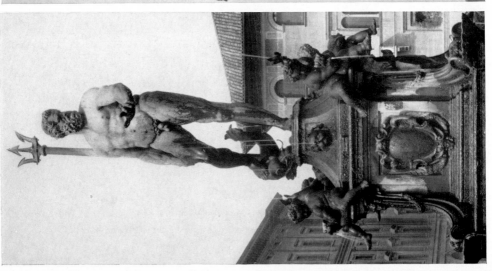

167. Giovanni Bologna: *Neptune.* Clay.
London, Victoria and Albert Museum

166. Giovanni Bologna: *The Fountain
of Neptune.* Bronze. Bologna

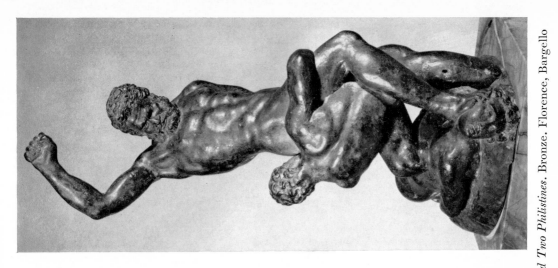

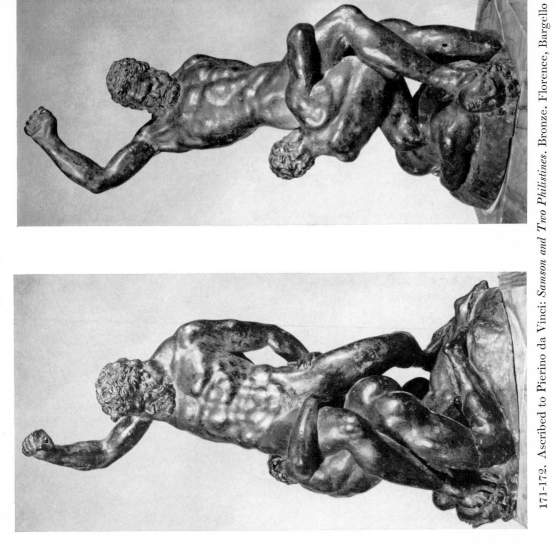

171-172. Ascribed to Pierino da Vinci: *Samson and Two Philistines*. Bronze. Florence, Bargello

170. After Michelangelo: *Hercules and Cacus* (?). Wax. London, Victoria and Albert Museum

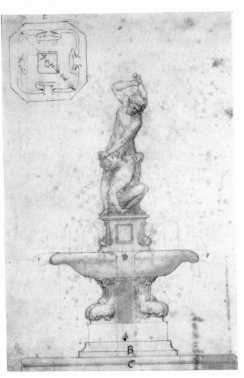

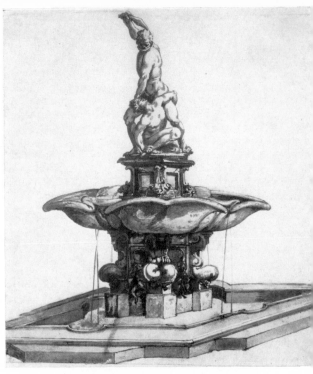

173. Drawing after Giovanni Bologna:
The Fountain of Samson. Florence, Uffizi

174. Drawing after Giovanni Bologna:
The Fountain of Samson. Florence, Uffizi

175. *Basin of the Fountain of Samson*. Aranjuez, Jardín de la Isla

176. Giovanni Bologna: *Head of an Ape*. Bronze.
London, Victoria and Albert Museum

177. Giovanni Bologna: *The Fountain of the Monkeys*. Florence, Boboli Gardens

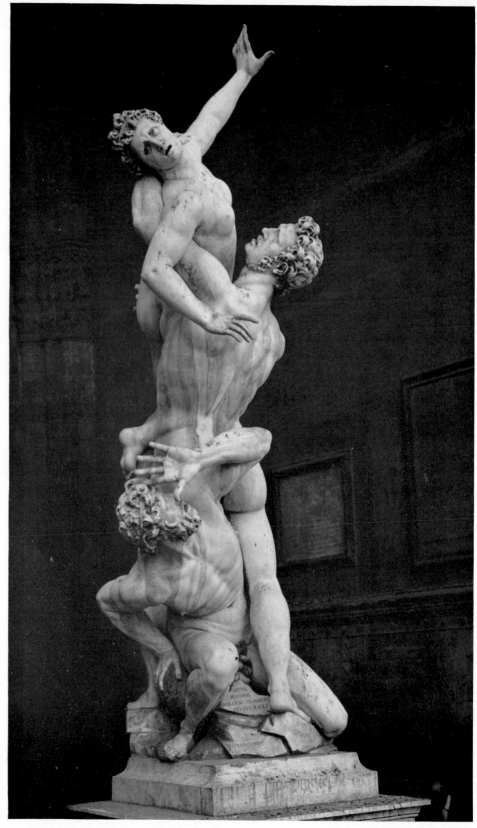

178. Giovanni Bologna: *The Rape of the Sabines*. Marble. Florence, Loggia dei Lanzi

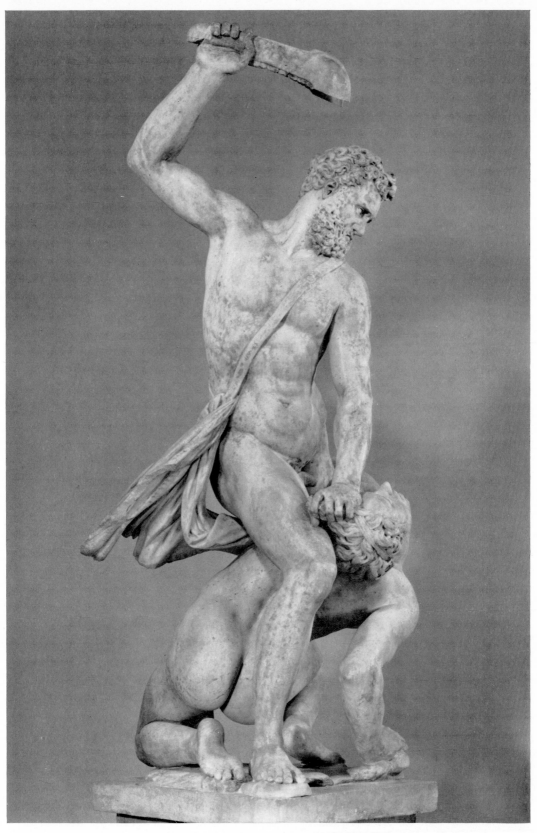

179. Giovanni Bologna: *Samson and a Philistine*. Marble, height 209·9 cm.
London, Victoria and Albert Museum

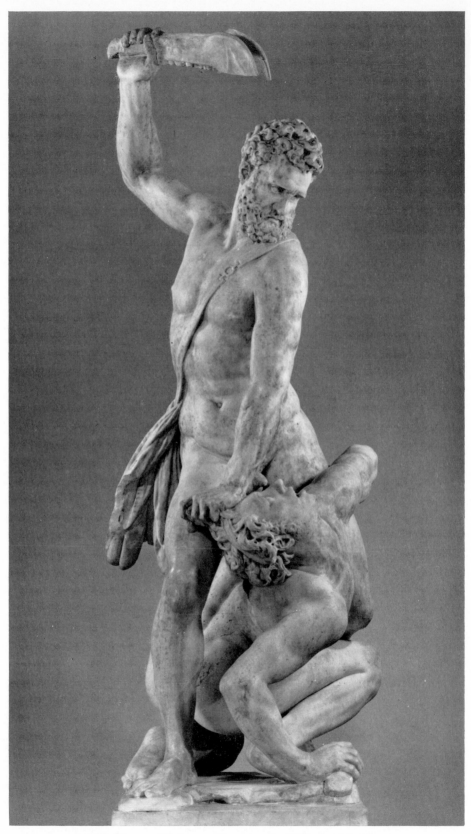

180. Giovanni Bologna: *Samson and a Philistine*. Marble.
London, Victoria and Albert Museum

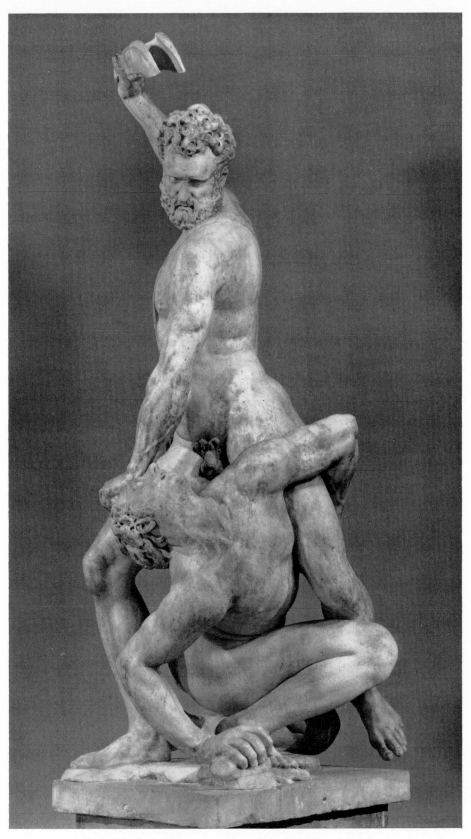

181. Giovanni Bologna: *Samson and a Philistine*. Marble.
London, Victoria and Albert Museum

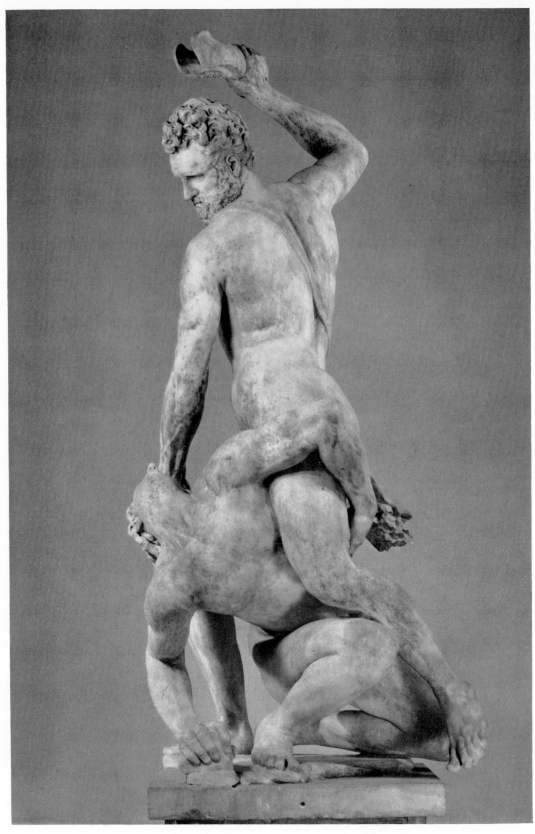

182. Giovanni Bologna: *Samson and a Philistine*. Marble. London, Victoria and Albert Museum

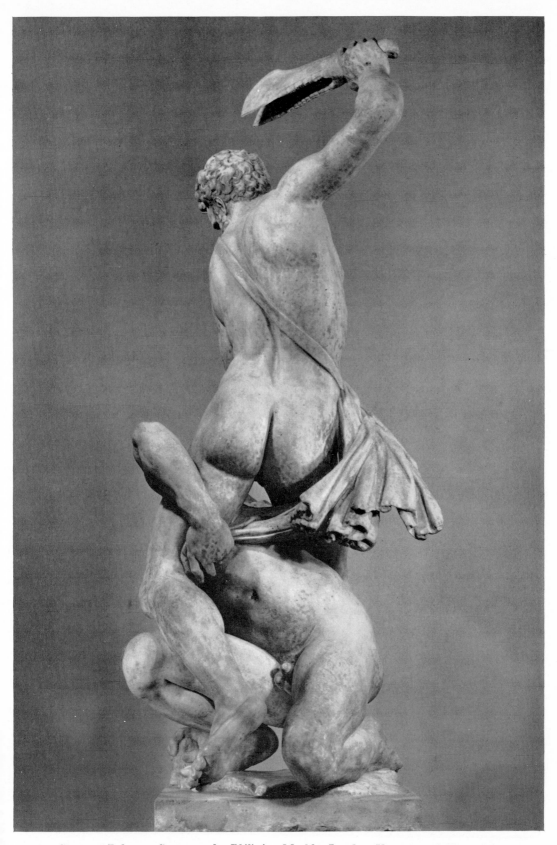

183. Giovanni Bologna: *Samson and a Philistine*. Marble. London, Victoria and Albert Museum

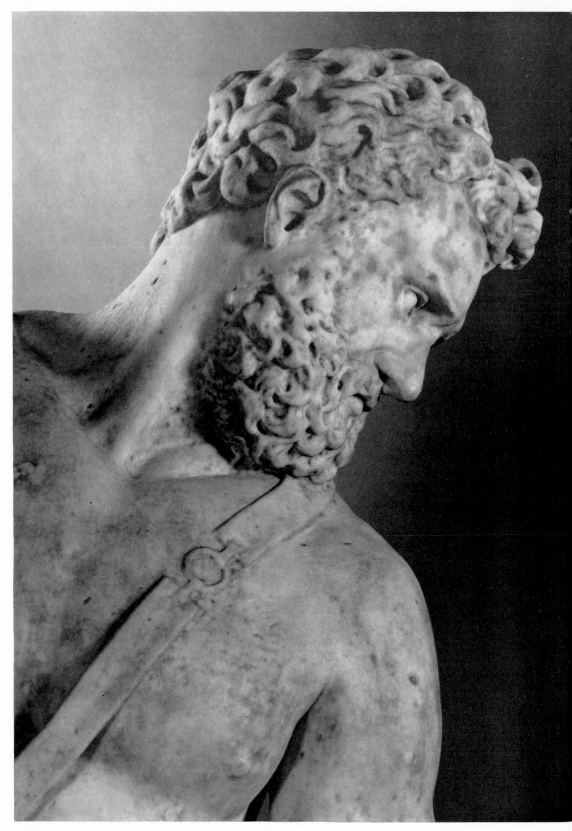

184. Giovanni Bologna: *Samson and a Philistine*. Marble. London, Victoria and Albert Museum

which went to the design of this highly concentrated scheme, may be judged from a clay statuette of Neptune in the Victoria and Albert Museum (Fig. 167), which was at one time connected with the sculptor's rejected design for the Fountain of Neptune in Florence, but seems actually to have been made as a study for the fountain at Bologna. It is typical of Giovanni Bologna's perfectionism that, unlike his contemporary Vittoria in Venice who tended to preserve the first fruits of his tempestuous invention, he should have introduced so many changes into his original design.

Returning to Florence in the spring of 1565 for the marriage festivities of Francesco de' Medici, Giovanni Bologna created the first of his great monumental groups, two figures described by contemporaries as *Florence triumphant over Pisa* and later denominated *Virtue triumphant over Vice*. A version in gesso (now in the Accademia in Florence) was shown in the Sala dei Cinquecento in the Palazzo Vecchio, probably in December 1565, and some four years later was carved in marble (Museo Nazionale, Florence). Since the genesis of this group has a direct bearing on the *Samson and a Philistine*, we must turn aside for a moment to examine the circumstances of the commission. Michelangelo had died, at the age of eighty-nine, in 1564. Universally acknowledged as the greatest artist of his age, he left behind him the memory of great projects but relatively few completed works. The most important of these projects had been the tomb of his patron Pope Julius II, which after countless vicissitudes, was erected by Michelangelo himself in 1542–5 in S. Pietro in Vincoli in Rome, in a form far smaller and less ambitious than had originally been planned. For the rejected versions of the tomb Michelangelo had carved a quantity of sculptures for which no place was found in the monument as executed; among them were two figures of Captives (now in the Louvre), four unfinished Slaves (now in the Accademia in Florence), and last and most important a group known as the *Genius of Victory* (Fig. 168). When Michelangelo died, the painter Vasari, who acted as *arbiter elegantiae* at the Medici court, was engaged in redecorating the interior of the Palazzo Vecchio. Vasari yielded to none in his admiration for Michelangelo and he at once demanded from the artist's heirs that the *Genius of Victory* should be presented to the Grand-Duke with a view to installing it in the vast Salone dei Cinquecento. Michelangelo's heirs concurred, and the group still occupies a place in the hall in which Vasari set it in December 1565. Giovanni Bologna's *Florence triumphant over Pisa* was planned as a companion group. In intention it is a visual counterpart of the *Victory*. It represents a crouching man subdued not by a naked youth but by a female figure with her right knee, not her left, set on

his back and her body above the hips turned to the left. Once more the Museum collections can illustrate one of the stages by which this design was reached, with a small wax statuette (Fig. 169), evidently a first thought for the commission, a trifle less rhythmical and less compact, but containing the main features of the group as it was executed.

This type of pyramidal composition was one in which Michelangelo had a special interest. Other evidence for this rests in a clay model in the Casa Buonarroti in Florence, here illustrated from a copy in wax in the Victoria and Albert Museum (Fig. 170). There is no certainty as to the purpose for which the original model was designed, and two main theories have been advanced, the first that it was made as a project for a companion figure to the *Genius of Victory* on the monument of Pope Julius II, the second that it was prepared as a study for a colossal group of Hercules and Cacus which Michelangelo was to have executed for the Piazza della Signoria. In either event it would have been made about 1525–28. The group in the Museum shows a nude male figure, headless and with the arms cut off below the shoulders, standing astride a crouching man, who grips the right leg of the standing figure with his left arm and the left leg with his own left leg. The story of the project for the *Hercules and Cacus* is a strange one, since the contract was at first awarded to Michelangelo's enemy Baccio Bandinelli, was later for a short period transferred to Michelangelo, and was subsequently restored to Bandinelli who executed the large group of Hercules and Cacus that stands in the Piazza della Signoria today. Vasari records it in the following terms:

After the departure of the Medici (1527), while the popular government was ruling in Florence, Michelangelo, who was then employed on the fortifications of the city, was shown the block of marble which Baccio (Bandinelli) had spoiled along with his model for the Hercules and Cacus. The intention was that if the marble was not too much spoiled, Michelangelo should take it over, and carve two figures of his own. When he had studied the block of marble, Michelangelo thought of another different plan; and abandoning Hercules and Cacus, took as his subject Samson holding down two Philistines whom he had subdued, one completely dead, and the other still alive, whom Samson, raising the jawbone of an ass, was endeavouring to slay.

Vasari's story that the *Hercules and Cacus* was transformed into a *Samson and two Philistines* is confirmed by a number of small bronze and terracotta statuettes representing Samson and two Philistines which were produced in Florence in the second quarter of the sixteenth century, and which depend

from a lost model of this subject by Michelangelo. These exist in the Bargello (Figs. 171–172), and elsewhere, and are sometimes ascribed to Pierino da Vinci (d.1555) on the strength of a story of Vasari that Pierino made models from a drawing of this subject by Michelangelo. They depart in scheme from Michelangelo's *Hercules and Cacus* model, first in that the right foot of Samson rests on the head of the dead Philistine, and secondly that the living Philistine is no longer in front of the standing figure but behind, grasping his right thigh with the right arm and his left thigh with the left. The pose of the standing figure itself remains essentially unchanged, though the axis of the movement is transferred from left to right.

All this is a matter of academic reconstruction today, but it was a living issue in the sixteenth century, and we can safely assume that the facts relating to Michelangelo's projects his models and their derivatives were present in the minds both of patron and artist when, about 1565, Francesco de' Medici commissioned a fountain of Samson and a Philistine from Giovanni Bologna. So far as the date of this commission is concerned, we are dependent upon inference. The earliest reference to Giovanni Bologna's *Samson and a Philistine* occurs in Vasari's life of the sculptor. It reads as follows:

This artist, apart from countless works in clay and terracotta, wax and other mediums, has made in marble a Venus of great beauty, and has almost completed for his lordship the Prince a life-size Samson, who fights on his feet with two Philistines.

The volume of Vasari's *Lives* in which this passage occurs was printed in 1567, so that the statue may well have been begun in 1566. It has been suggested that two letters written by Tommaso Inghirami to Francesco de' Medici in May and August 1569 refer to the base of the figure, and if this is so, it could hardly have been set in position before 1570. It was known to Borghini, who writes in the *Riposo* that Giovanni Bologna 'worked in the Casino of the Grand-Duke Francesco the very beautiful marble figure representing Samson with a Philistine beneath him, which is over the fountain in the cortile where the Semplici are'. The Casino, was built for Francesco de' Medici, during his father's lifetime, by Buontalenti, and stood in the garden opposite the convent of San Marco in Florence. In the following century the group is mentioned again rather more fully in the *Notizie* of Filippo Baldinucci:

Giovanni Bologna had a commission to carve, for the Casino of the Grand-Duke Francesco, the group of Samson with a Philistine beneath him. This was placed on

the fountain in the Cortile de' Semplici, where, in addition, he made a beautiful fantasy of sea monsters who supported the basin. It seems that Giovanni Bologna surpassed himself in this statue of Samson, in that he succeeded in avoiding a certain mannerism which many of his sculptures have, and, as a result, made it much more natural and life-like. A beautiful clay model of this work came into the hands of Giovanni Francesco Graziani, who was much interested in these arts. This fountain was later despatched by the Grand-Duke Francesco as a gift to the Duke of Lerma in Spain, along with another, on which was Samson, rending the lion's mouth, made by Cristoforo Stati of Bracciano.

The fountain by Stati of Samson and the Lion mentioned by Baldinucci was not executed till 1604–7, forty years after the fountain of Samson and a Philistine, and was despatched direct to Spain.

Before we go on to examine the *Samson and a Philistine* in detail, it is perhaps as well to follow through the romantic history, of which a foretaste is given in the final sentence of Baldinucci's note. In 1601, seven years before the death of Giovanni Bologna and eight years before the death of the Grand-Duke Ferdinando de' Medici, the fountain of Samson and a Philistine was presented by the Grand-Duke to the Duke of Lerma, Prime Minister of King Philip III of Spain, and shipped to Valladolid. Two drawings in the Uffizi show the complete fountain before it was dismantled. One of these (Fig. 173) is measured, and seems to have been made while the fountain was still under construction; the other (Fig. 174) is a free drawing in bistre wash, probably made for record purposes before it was despatched to Spain. A document of September 1601 (communicated by Mr James Holderbaum) describes the despatch to Leghorn of the marble basin, sawn up and packed in four cases, of the base and support beneath the basin, of the plinth on which the figure stood, and of eight bronze snails. The group remained in Spain only till 1623, when Charles I as Prince of Wales visited Spain, and received it as a gift from Philip IV. Charles, Prince of Wales, gave it to the Duke of Buckingham, on whose instructions it was moved to England: an entry in the Privy Purse accounts of 1623 reads:

Given by his Lordship's orders at Valladolid to Mr Gerbier towards the charge of bringing the great stone statue from thence to St. Andrews (Santander) £40.

The basin of the fountain remained in Spain, and was moved from Valladolid to the royal gardens at Aranjuez (Fig. 175), where it still is today.

The group of Samson and a Philistine is mentioned by Sir Thomas Wentworth in a letter of June 17, 1624:

'My Lord of Buckingham return'd to Court yesterday much discolour'd and lean with sickness. The dearness betwixt the Prince and him still continuing, and outwardly all appearing very serene towards him,—yea not so much as York House but goes on passing fast, another corner symmetrical now appearing answerable to that other raised before you went hence, besides a goodly statue of stones set up in the garden before the new building bigger than the life, of a Samson with a Philistine betwixt his legs, knocking his brains out with the jawbone of an ass.

Possibly the jawbone (which is now made up in wood) was already broken at this time, for when the group is mentioned again in or about 1633 in the *Compleat Gentleman* by Peacham, it has changed its identity. The garden of York House, writes Peacham:

will be renowned so long as John of Bologna's Cain and Abel stand erected there, a piece of wondrous art and workmanship. The King of Spain gave it to his Majesty at his being there, who bestowed it on the late Duke of Buckingham.

In the schedule to an indenture dated May 11, 1635, made on the marriage of Buckingham's widow to Lord Dunluce, occurs the entry:

On the mount in the garden: a rare piece of white marble of Cain and Abell.

The group also figures in a manuscript catalogue of Buckingham's collection made about 1650.

No. 8. Cain and Abel in marble, by John of Bologna, now in York-house garden, or at Chelsea.

It was then moved from York House to Buckingham House, apparently between 1703, when the house was rebuilt by John Sheffield, Duke of Buckingham, and 1714, when it is mentioned there in Macky's *Journey through England*:

The staircase is large and nobly painted; in the hall before you ascend the stairs is a very fine statue of Cain slaying Abel in Marble.

During the eighteenth century the group enjoyed great popularity and lead copies of it by Nost, Cheere and other sculptors, in every case described as representing Cain and Abel, exist at Chatsworth, Seaton Delaval, Southall and elsewhere. In consequence, for nearly a century and a half it was from the *Samson and a Philistine* as much as from the *Rape of the Sabines* in the Loggia dei Lanzi in Florence that the cultivated Englishman's mental image of Giovanni Bologna's style was formed.

Buckingham House was acquired by George III as a palace in 1762, and at some time after this date the group was presented by the King to Thomas Worsley, Surveyor General of His Majesty's Works. The first record of the presence of the group at Hovingham occurs in a manuscript catalogue of 1778:

<div align="center">The Vestibule.</div>

Samson slaying a Philistine, given as a parting gift by Philip King of Spain to our King Charles I, who gave it to Villiers Duke of Buckingham, was purchased with Buckingham House, and by the favour and grace of George III was sent to Hovingham.

Seeing the *Samson and a Philistine* on the plain rectangular plinth on which it is shown in the Museum, we shall find difficulty in visualising it in the setting for which it was designed. The fountain on which it was set (as can be seen from photographs of the Aranjuez fountain and from the drawings in Florence) had a basin with segments shaped like the curved lips of a shell. This irregular cylix was something of an innovation, and looks forward to the Baroque fountain basins of the following century. Water was fed into it from eight snails set at the angles of a support in the centre of the basin, and fell from the sides of the basin into a pool below. The angles of the base supporting the basin were richly carved in marble and between them, on the four flat faces, were niches filled with seated monkeys in bronze. The niches can still be seen on the base of the fountain at Aranjuez, but the monkeys have disappeared. It has been suggested that three of these monkeys are in fact the monkeys which now decorate the so-called Fountain of the Monkeys in the Boboli Gardens in Florence (Fig. 177); this is unlikely since the Boboli monkeys seem to have been designed to form a continuous circular movement which on the Fountain of Samson would have been quite out of place. Possibly the head of a monkey in the Museum (Fig. 176), which has been severed at the chest and must originally have been part of a full-length figure, is a fragment of one of the missing monkeys from the Aranjuez base. Certainly it enables us to form some impression of what the monkeys on the fountain were originally like, and the vivid naturalism, which it shares with the sculptor's bronze birds in the Bargello in Florence, represents the opposite pole of Giovanni Bologna's art to the austere, resolutely intellectual group above.

The square plinth on which the *Samson and a Philistine* was set in the centre of the basin is a squatter and somewhat simpler variant of the plinth of the *Neptune* at Bologna. Since the main group consisted of two figures in

violent action and not of a single figure in repose, its function was to supply a firm platform on which action could take place, and not to induce a sense of lightness and insubstantiality. So little was the group of Samson and a Philistine adapted to its function and so overpowering does it appear in drawings of the fountain, that we might even guess that it was planned as a free-standing statue and that the decision to place it on a fountain was in some sense an afterthought. As it was shown on the fountain, the base of the group stood between six and seven feet from the ground.

The clay model of the *Samson and a Philistine* which Baldinucci saw in the possession of Giovanni Francesco Graziani has disappeared, so that for an understanding of the creative processes behind the statue we are dependent on study of the statue itself. Its scheme results not from strict adherence to the scheme of the *Hercules and Cacus* or the *Samson and two Philistines*, but from an inspired combination of elements from both. The body of Samson recalls the *Hercules and Cacus* model, with the head turned over the left shoulder and the right arm striking forwards and not back. But as in the *Samson and two Philistines* the legs are shown astride the crouching figure, and the weight is thrown forward on to the right leg, not back on to the left. Like the Cacus, the Philistine is set in front of the main figure, not behind, but the body, like that of the living Philistine in the second group, is threaded through between the Samson's legs so that the two figures are, to borrow a phrase applied to Giovanni Bologna's work by Flaxman, 'harmoniously incatenated'. By comparison with the Cacus and the living Philistine, the pose of the crouching figure is greatly simplified. The head does not, like the head of the Cacus, protrude from the main rock, but is represented in profile on the same plane as the Samson's head and left arm; and the arms and legs are no longer disposed like tentacles round the Samson's thighs, but support the weight of the group with the left arm alone strained round the left thigh of the standing figure. This last motif was clearly suggested by the right arms of the Cacus and the Philistine in the statuettes. At the same time a new psychological relationship has been established between the Samson gazing downwards at his victim and the frightened Philistine looking upwards at his executioner. Another new feature is the cloak of Samson which billows out behind him and is caught up by the Philistine's left hand; this forms a counterbalance on the left to the Philistine's projecting elbow on the right, and allows the rear of the group to be strengthened and filled out.

The fact that the group can be said strictly to have a front and a back view is indicative of the place it occupies in Giovanni Bologna's career. In

1579, when he started work on the *Rape of the Sabines* (Fig. 178), the principle of the free group conceived as a continuous play of form without front, back or side views, was fully formulated. But at the time the *Samson* was designed, this existed only in embryo, and the scheme of the group stands midway between the old conception of the frontal figure, as it was developed in the quattrocento and continued in Bandinelli's *Hercules and Cacus*, Cellini's *Perseus* and Ammanati's *Neptune*, and the new conception which Giovanni Bologna imposed on Florentine, and through Florentine on European sculpture. Where the *Rape of the Sabines* looks forward to the *Pluto and Proserpine* of Bernini, the *Samson and a Philistine* looks back beyond Michelangelo to the group of *Abraham and Isaac* carved by Donatello and Nanni di Bartolo for the Campanile. There is abundant evidence of the interest felt in Florence in the middle of the sixteenth century for the sculpture of the first half of the quattrocento. The clearest testimony comes from a pamphlet by Francesco Bocchi (1571) dealing with Donatello's statue of St George on Or San Michele. In his preface Bocchi declares that he undertook this essay not merely at his own inclination but at the instance of men of letters, who, as connoisseurs of sculpture, felt a special admiration for Donatello's figure. For Bocchi the merits of the St George could be assessed under three headings, *Costume* (deportment), *Vivacità* (vivacity or lifelikeness) and *Bellezza* (beauty or harmony), since the statue must be an ideal embodiment of the action and emotions it was intended to represent, must have a lively movement in all its parts, and must reveal 'a certain unity, a calculated suitability, in which each part is pleasing both in itself and in relation to the whole'. It was precisely the idealised character, the virile yet particularised execution, and the lucid forms which were admired in quattrocento sculpture, that Giovanni Bologna in this early phase sought to revive.

At the same time, the sculptural conceptions embodied in the group are overwhelmingly original. Where the *Genius of Victory* and the *Hercules and Cacus* model are conceived as solid blocks of marble, the figures of Samson and the Philistine are segregated from each other in an open composition in which the apertures are so contrived that the forms nowhere coalesce. This principle was implicit in classical sculptures of the class of the *Laocoon*, but is here developed with such virtuosity that, in looking at the group, we cannot, with the eye alone, see where the main weight of the figure rests. Emancipated from the limitations of its medium, it is treated with the lightness and freedom we might expect in a bronze cast. To the marvellous technical facility, the sheer sleight of hand of which the *Samson*

and a Philistine offers the first evidence Giovanni Bologna owed his pre-eminence in his own day, and to it is due also his central place in the history of sculpture, for the style which is first manifested in the *Samson* and was developed in the *Rape of the Sabines* and the *Mercury*, points towards the future and heralds the achievements of Baroque and Rococo art.

Originally published as a Victoria and Albert Museum monograph in 1954.

Antonio Calcagni's Bust of Annibale Caro

IN Baldinucci's life of the sculptor Antonio Calcagni there is a well-known reference to a bust of Annibale Caro. 'In questo tempo,' writes Baldinucci,[1] 'si crede che già avesse fatta la statua di bronzo del virtuosissimo commendatore Annibal Caro, gloria della sua patria Civita Nova nella Marca d'Ancona. Questa figura, che è una testa col busto sopra un bel piedistallo, si conserva tuttavia, in memoria di tant'uomo, nella casa di sua famiglia in essa città.' The words 'in questo tempo' refer to the sculptor's marriage in 1572, and if the passage in Baldinucci is read literally the bust would thus have been executed before this year. A somewhat fuller account of the bust occurs in 1578 in an inventory, in which it is described in the library of Caro's house.[2] 'Una statua dal petto in su,' reads this account, 'con la testa di bronzo et il petto di marmo misto, con il piede di misto, sopra lo sgabello di legno con iscrizione *Annibal Carus.*' Nothing further is heard of the bust till 1834, when it is referred to once more by Ricci, in his *Memorie storiche delle arti e degli artisti della Marca di Ancona,*[3] this time in the past tense: 'ed uno de' primi fu il busto del Commendatore Annibal Caro allogatogli da quelli di sua famiglia, lavoro, che se si conservasse, direbbesi preziosissimo tanto pel merito artistico, come per essere un ritratto eseguito da un contemporaneo, che giova credere cogliesse nella vera imagine di si chiaro soggetto; ma Civitanova non conserva che la gloria di aver dato la culla a quest'uomo insigne.' Somewhat the same words are used in 1915 by Pauri in his volume on sculpture in Recanati[4]: 'Di questo busto, che se esistesse potrebbe esser un documento prezioso per giudicare del valore del Calcagni e nobil ricordo del letterato marchigiano, non ci è stato possibile aver notizia.' The bust was not, however, lost as Pauri supposed, but had been exported to France, where on May 12, 1886 it was sold at the Galerie Georges Petit with the Stein collection.[5] The description given at this time in the sale catalogue agrees closely with that in the Caro inventory: 'Buste d'Annibal Carvs, en bronze grandeur nature, avec chlamyde en marbre brèche de Sicile. Le piédouche de même matiere présente sur sa face principale une cartouche de noir antique portant le nom d'Annibal Carvs, gravé en creux.' At the Stein sale the bust was purchased by the Comtesse de Rochefort, and

thereafter once more disappeared, but its existence was none the less recorded in the Thieme *Künstlerlexikon*.[6]

On the basis of the material already known, it seems that Calcagni reached his apogee as a portrait sculptor in comparatively early works, and that thereafter the freshness of his handling and the intentness of his observation suffered some decline. What we know of his early portrait sculptures depends from the splendid bust of Monsignor Alberici in the Duomo at Recanati, which was commissioned in 1574 as part of the Alberici monument, from the statue of Gregory XIII at Ascoli Piceno, which was commissioned from Girolamo Lombardi and carried out after his death by Calcagni, and from the portrait reliefs in the Massilla Chapel in the basilica at Loreto, which were commissioned in 1577 and completed in 1582. His later portraits, the statue of Sixtus V at Loreto and the reliefs of Agostino Filago at Loreto and of Padre Dantini in S. Agostino at Recanati, are drier and more stereotyped. Assembling the data on the missing works, we might therefore imagine a bronze head still freer and more powerful than that of Alberici mounted on a breccia bust, which was in turn supported on a mistio pedestal with a black marble cartellino on the front. This picture would indeed correspond exactly with the recently discovered bust (Fig. 185).[8] The head is modelled with a richness and power which recalls the work of Guglielmo della Porta, the sumptuous body is formed of crimson breccia stained with white, and orange-red mistio marble is employed in the moulded plinth beneath. Unlike the Alberici portrait, which is strongly frontal and was intended for inspection from a single point of view, the Caro bust is free-standing and multi-facial and depicts the sitter with the head turned slightly to the spectator's left. The profile views (Fig. 186) are handled with the same conviction as those of the statue at Ascoli Piceno. The base is strongly classicising, and has been made up on one shoulder; it is a moot point whether this part of the bust is antique or dates from the sixteenth century.

So strong is the impression of vitality afforded by the head that we might at first suppose the bust was modelled from the life. The balance of evidence, however, is that it is indubitably posthumous. In a letter written from Rome in January 1562 Caro describes the painted portraits made of him before that time, but makes no mention of a bust.[9] 'De' ritratti passati,' he writes, 'io non ho se non una testa del Salviati, ed un picciolo testino del Bronzino, di quando io era molto giovine. E questi tanto hanno ora da far con me, quanto è la differenza non pur da un medesimo, vecchio e giovine, ma da due diversissime, in diverse età. Un' altro che ne

fecero fare gli Academici di Bologna, è in lor potere, nè anco questo credo che mi simigli.' In the spring and summer of the same year he was engaged, at the request of Piero Stufa, in sitting for a portrait to Jacopino del Conte. 'Il mio ritratto si fa,' we read at the end of May,[10] 'e (come dite) si mandera a messer Pietro la copia del ceffo solamente.' At the end of June the painting had not greatly advanced. 'Del mio ritratto,' writes Caro,[11] 'maestro Jacopino fece, molto di sono, l'effigie, poi si fermò, che sapete i pittori come sono fatti,' but by the first week of July work on it had recommenced. There is no reference in the correspondence to any later painting of Caro and none to any bust, nor is there any proof that Calcagni went to Rome, so we must assume, what the passages in Baldinucci and Ricci would seem to indicate, that the bust was commissioned after Caro's death by members of his family, and was therefore executed between 1566 and 1572.

The members of Caro's family involved in this transaction are likely to have been his brothers, Giovanni and Fabio, and his nephew, Giovanni Antonio, who were responsible at the same time for commissioning a second posthumous sculptured portrait, the marble bust by Dosio on the Caro monument in S. Lorenzo in Damaso (Fig. 187),[12] which seems, on the analogy of Dosio's busts of Giovanni Pacini and Antonio Massa in the same church, to have been executed about 1567–70.[13] At first sight Dosio's rather aloof portrait appears to stand in marked contrast to Calcagni's more animated bust. But as we look at the two busts more closely it transpires that in both the angle of the head is exactly similar, that the treatment of the moustache and beard and of the hair covering the temple is all but identical, that the pockets beneath the eyes are rendered essentially in the same way, and that the single respect in which the structure of the bronze differs from the marble is in the tuft of hair that crowns the head. If both busts are posthumous, it must then be assumed either that one was worked up from the other or that both were worked up from a common prototype. In the first hypothesis, the bronze is likely to precede the marble, in the second both may depend from a death-mask (though neither has the hall-marks of death-mask portraiture) or from a painted portrait. The paucity of painted portraits of Caro has been the subject of some comment.[14] Bronzino's portrait of him as a youth has disappeared, and the portrait in middle life by Salviati has been variously identified with a painting formerly in a private collection in Berlin[15] and with a lost painting of which a small copy in pen and wash exists in the Accademia delle Belle Arti at Venice.[16] The two busts, however, show Caro as an

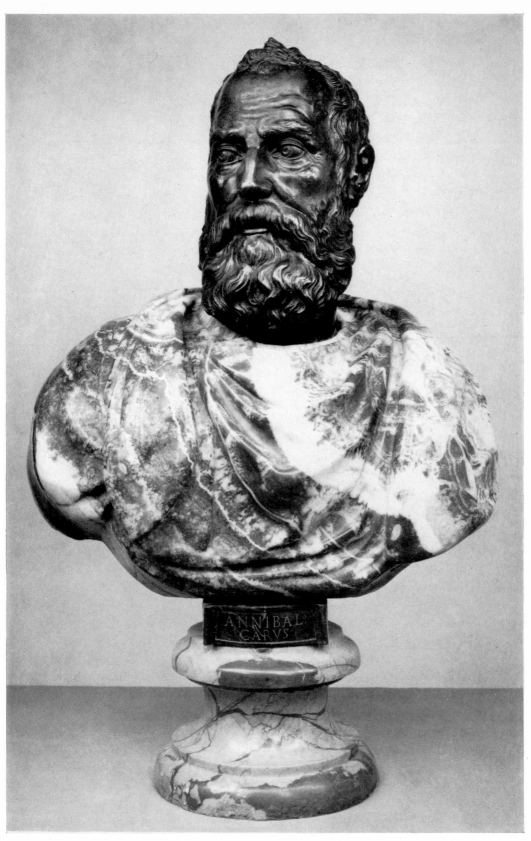

185. Antonio Calcagni: *Annibale Caro*. Bronze and marble, height 76·8 cm.
London, Victoria and Albert Museum

187. Dosio: *Annibale Caro*. Detail from sepulchral monument.

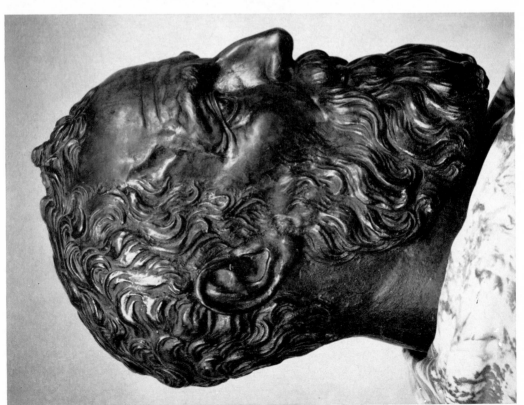

186. Antonio Calcagni: Detail of the bust of *Annibale Caro*.

older man than either of the Salviati portraits, and it is possible that both derive from the painting by Jacopino del Conte to which Caro's letters of June and July 1562 refer.[17] Be that as it may, Calcagni's bust must take its place as the most legible and most convincing of Caro's surviving portraits and as one of the masterpieces of bronze portrait sculpture in the later sixteenth century.

Originally published in *Arte in Europa: scritti di storia dell'arte in onove di Edoardo Arslan*, 1966, pp. 577–80.

Portrait Sculptures by Ridolfo Sirigatti

Iɴ that mine of information on Florentine mannerist art, the *Riposo* of Raffaello Borghini,[1] one of the protagonists is a sculptor, Ridolfo Sirigatti. The book is cast in dialogue form, and it opens one evening in May 1584 with a chance encounter between Sirigatti and the collector Bernardo Vecchietti outside the Baptistery in Florence. Before long they are joined by two further acquaintances, one of them Baccio Valori. On the following day they, and Sirigatti, repair on Vecchietti's invitation to the villa Il Riposo, outside the Porta San Niccolò, where his collection was housed. It is at Vecchietti's villa, from which the book derives its name, that their discussion of artistic problems takes place. A good deal is known about Valori—he was, for example, the subject of a bust by Giovanni Caccini which is now in the Bargello—and Vecchietti is also a relatively familiar figure. He was the patron and mentor of Giovanni Bologna, and owned a quantity of paintings and sculptures some of which can be identified. But one person in the dialogue is an unknown quantity, and that is Sirigatti.

In his own day Sirigatti seems to have been regarded as a sculptor of considerable eminence. He was nobly born and was a Knight of Santo Stefano (the order instituted by the Grand-Duke Cosimo I of Tuscany), and his only documented work is a bust of the Grand-Duke Francesco I in a niche on the façade of the Palazzo dei Cavalieri di Santo Stefano at Pisa. In this case Sirigatti was responsible only for the model for the bust, and was not paid an outright fee but a small sum covering his outlay on the work. Seven years later, in 1601, he designed a new high altar for the church of the Annunziata at Arezzo. The bust of Francesco I, by whomever it was executed, is not specially distinguished, and looking up at it one has often wished that a sculpture that was actually carved by Sirigatti could be identified. The wish becomes the more imperative when it is recalled that Sirigatti was a link between the greatest sculptor of the late sixteenth century and the greatest sculptor of the seventeenth; he was, that is to say, a friend of Giovanni Bologna and was the master of Pietro, the father of Gian Lorenzo Bernini. Pietro Bernini probably entered his studio about 1580, as a boy of seventeen, and it so happens that the *Riposo* of Borghini enumerates three sculptures on which Sirigatti was engaged about this

time. One of them, still unfinished in 1584, was a marble Venus with Cupid at her feet. It is mentioned at the beginning of the dialogue ('I rather think', says Vecchietti to Sirigatti, 'that you are I will not say sated, but at least a little wearied by the task of bringing your beautiful Venus to perfection') and again at a later point in the discussion as 'one of the many paintings and sculptures which messer Ridolfo has executed with his own hands'. A painting by Sirigatti is also specified, a portrait of the author of the *Riposo*, Raffaello Borghini, and two busts, 'a marble head of his father done from life which is extremely like, and another of his mother which enables us to see her as though she were alive. A wonderful thing about it is a most delicate veil, which he has placed on her head. It falls down on her shoulders and is carved free of the neck the whole way round, and it is so diligently worked that one can see the light through it.'

In 1961 there arrived from Rome the photographs of two marble busts (Figs. 188, 189) attributed to Alessandro Vittoria. The attribution was manifestly incorrect—their style was Florentine, and was at first sight reminiscent of the early sculptures of Giovanni Caccini—but they had a feature of special interest, that the names of the sitters were incised on the front. On the male bust was the inscription:

.NICOLAVS . SIRIGATTVS

. M D LXXVI.

and on the female bust were the words:

. CASSANDRA GRILLADARIA

. NICOLAO SIRIGATTO NUPTA

. M.D.L.XXVIII .

The Christian name of Sirigatti's father is not recorded in any published source, but the name of his mother was known to Tanfani-Centofanti when he prepared his invaluable *Notizie di artisti tratte dai documenti pisani;*[2] she was named Cassandra, and was a daughter of the painter Ridolfo Ghirlandaio. There was therefore a fair measure of certainty that these were the lost Sirigatti busts, and they were accordingly bought for the Victoria and Albert Museum. When they arrived in London, probability was translated into fact, for on the back of each of the busts was a second inscription:

QVEM GENVI

RODVLPHVS

ANIMI CAUSA

CAELAVIT

Obviously the word 'animus' is here used in the sense of affection—in Terence, for example, the phrase 'ex animo' means 'from my heart'—and the inscription may be rendered: 'Ridolfo, whom I bore, has carved this as a tribute of love.'

Even without the knowledge of Sirigatti's reputation among his own contemporaries, we should recognise that the busts are rather exceptional works. They are exceptional, first of all, in structure. Niccolò Sirigatti's right shoulder is retracted and his left shoulder is advanced, and his head is turned slightly to his left, so that the bust has the spiral character of Giovanni Bologna's marble groups. But it reveals at the same time an interest in movement that distinguishes it sharply from Giovanni Bologna's portrait busts. The dress below the left shoulder is creased as though the arm were suddenly thrust forwards, and the arms themselves are severed between the shoulder and the elbow although the body is depicted almost to the waist. The arms of Cassandra Sirigatti are severed in precisely the same way, and once more one arm is pushed forwards and the other is pulled back. Illusionistically, moreover, this second bust has another curious feature, that the figure is continued to a point below the waist, and terminates in a line drawn through the skirt. The bodice is creased horizontally. Both in the head and in the portrait type we can sense the influence of the antique.

Borghini's reference to the skill with which the veil in this second bust is carved acquires a new significance before the bust itself, for the technique is unlike Giovanni Bologna's (for one thing the treatment of texture is more meticulous) and is far superior to that of other portrait sculptors, Giovanni Caccini for instance, who were practising at the time. Not only is the veil, as Borghini observed, fully excavated behind the neck, but the texture of the linen on the forward surface is rendered with great exactness, and the protruding flounces of the sleeves also create a physical illusion in that they are drilled in unaccustomed depth. Another instance of this unorthodox and empirical technique occurs in the cavities above the eyes. In the male bust the collar of the cloak is represented as free of the shoulder, and close attention is given to the distortion of the brocaded pattern on the sleeves.

Taken together these two aspects of the busts, their ambitious structure and their highly unusual technique, are of considerable significance. The formal aspirations that can be read into them belong to the seventeenth century rather than to the sixteenth. In the Florence of Giovanni Bologna they offer a foretaste of the Roman portraits of Bernini. And at the same

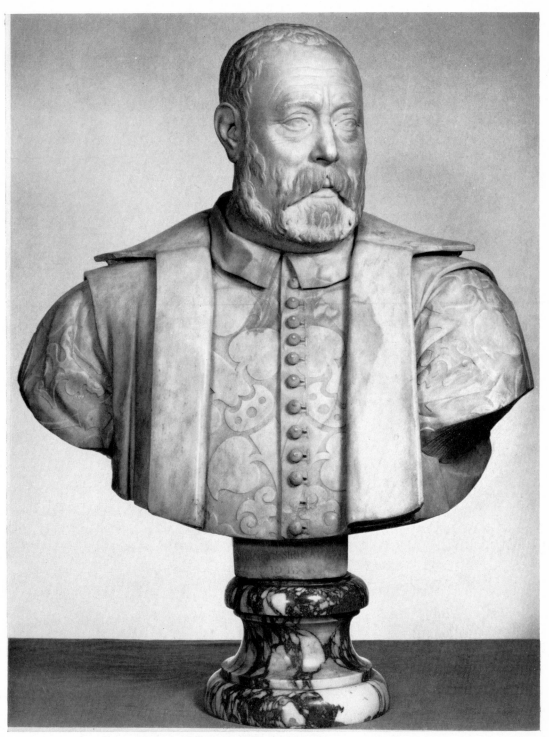

138. Ridolfo Sirigatti: *Niccolò Sirigatti*. Dated 1576. Marble, height 93·3 cm.
London, Victoria and Albert Museum

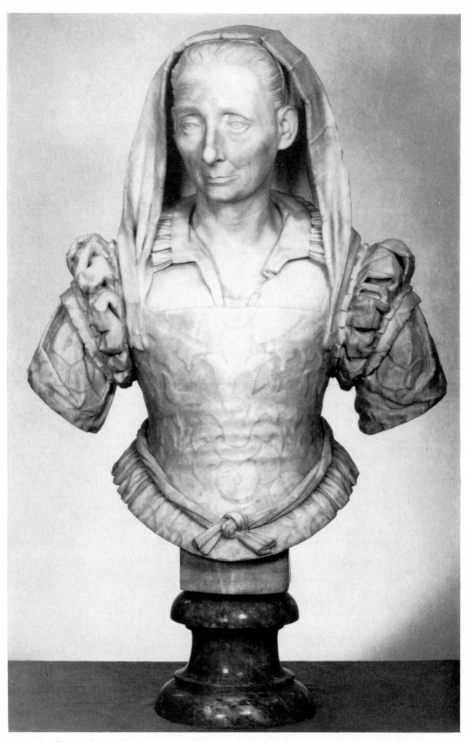

189. *Cassandra, wife of Niccolò Sirigatti*. Dated 1578. Marble, height 102·2 cm. London, Victoria and Albert Museum

time their technique, which Sirigatti must have inculcated in his pupils, does something to explain the virtuosity of Pietro Bernini, which, from the Trinity relief of 1594 over the entrance to Santa Trinita in Florence carved in association with Caccini, to the Assumption relief of 1606 in Santa Maria Maggiore in Rome, makes use of the dynamic drilling he had learned from Ridolfo Sirigatti.

Originally published in the *Bulletin of the Victoria and Albert Museum*, I, April, 1965.

Some Bronze Statuettes by Francesco Fanelli

THE seventeenth century is still for the most part *terra incognita* for students of Italian bronzes, and little notice has so far been given either to makers of bronze statuettes active in Italy or to the Italian bronze sculptors employed abroad. Prominent among the latter is Francesco Fanelli, who describes himself on the title-page of his *Varie Architetvre*[1] as *Scvltore del Re della Gran Bretagna*, and who is supposed to have worked in England from after 1610 till 1642. Sandrart, in a brief biography printed in the *Teutsche Academie*, mentions Fanelli's skill as a bronze caster,[2] and a number of the sculptor's statuettes are recorded in inventories.

We have descriptions of these from two separate sources. The first is Van der Doort, who lists two of them among the sculptures in the Cabinet Room at Whitehall. Van der Doort's entries read as follows:[3]

17

Don by ffrancisco ffannello:	Item in brasse blackt over a little runing horse –/ Cupid sitting on and another of 6½ – of o
Bought by Your Ma^{tie}	Cupid running by/w^{ch} was made by ffrancisco the one eyed Italian –/beeing vernisht over with black vernish, and–/non of the said nomb: of 18^{en}

28

Done by th'afore-said/One eyed Italian/ ffrancisco:	Item a little S George on horseback wth a –/dragon by, beeing of brass upon a black–/ebbone woodden Peddistall of 7 – of o

The second source is Vertue,[4] who describes a number of statuettes by Fanelli at Welbeck. The relevant passage runs:

Fannelli the florentine Sculptor who livd and dyd in England, made many small statues. models & cast them in brass. which he sold to persons that were Curious to sett on Tables cupboards shelves by way of Ornament – and irons. Many were bought by W^m. Duke of Newcastle, and left at Welbeck. where the Earl of Oxford. found them.

This Fanelli had a particular genius for these works and was much esteemd in K Charles I time – and afterwards – so many of this little Statues as I have seen at Ld Oxfords –

2 Horses standing grazeing one a capriol

a horse full gallop

a horse ambling

a Cupid on horseback

a Turk on horseback

a Centaur with a woman

a horse eating standing

S.^t George horseback the dragon dead.

another S.^t George combatant with the dragon.

From these two entries we learn first that Fanelli's bronzes were small in scale, secondly that they were covered with dark lacquer, and thirdly that many of them represented equestrian subjects. It is a reasonable inference that the 'little St George on horseback with the dragon by' in the Royal Collection represented the same model as one of the two versions of St George and the Dragon at Welbeck, and that the 'little runing horse Cupid sitting on' in the Royal Collection was related to the Welbeck 'Cupid on horseback', though in this case the first version seems to have included two figures and the second only one. These points, allied to the first sentence of Vertue's entry, seem to indicate that the statuettes were produced in bulk.

Fanelli is described by Vertue as 'the florentine Sculptor', and is mentioned in a contemporary document as *Franciscus Fanelli quondam Virgilii florentinus.*[5] There is no evidence that he worked in Florence, and the first reference to his activity dates from 1609–10, when he was employed at Genoa on a wooden figure of the dead Christ from a design by Paggi and on a small bronze Crucifix commissioned by Giovanni Domenico Spinola.[6] He is generally thought to have come to England in 1610, and to have been in the employment of Henry, Prince of Wales. According to Sandrart, an ivory statuette of Pygmalion by Fanelli attracted the notice of King Charles I,[7] for whom he also designed a fountain at Hampton Court. The attribution of the latter to Fanelli is attested by Evelyn, who observed during a visit in 1662 to Hampton Court 'a rich and noble fountaine, with syrens, statues &c. cast in copper by Fanelli'.[8]

Little, however, can be learned of Fanelli's style from the fountain in its present state. A heterogeneous list of Fanelli's works composed by Walpole was extended by Dallaway[9] to include documented works by Le Sueur and other sculptors. It was claimed by Cust[10] that the marble effigy of Le Sueur's Cottington monument in Westminster Abbey 'was executed at a later date by F. Fanelli', but there is no proof of this, though the sculptor's name is traditionally associated with Le Sueur's gilt bronze bust of Lady Cottington.[11] The monument of Sir Robert Ayton (1637–8) is also generally regarded as Fanelli's work.[12] Fanelli's only signed work in bronze in England is a portrait bust of Charles II as Prince of Wales at Welbeck, dated 1640, and made for the Earl of New-castle during the latter's tenure of the office of Governor of the Prince of Wales. The presumed connection between Fanelli and Henry, Prince of Wales, arises out of a misreading of the inventory of Van der Doort,[13] and it is probable that Fanelli came to London not in 1610 but at a con-siderably later date. Two payments to the sculptor are recorded, the first of a pension of sixty pounds on May 8, 1635, and the second of a sum of thirty pounds on November 20 of the same year.[14] The bronze statuettes would thus probably have been produced in the fourth decade of the century. Fanelli seems to have left England for Paris in 1642, and to have died in 1665.

For some years there has been on loan at the Victoria and Albert Museum a bronze statuette of *St George and the Dragon*[15] (Fig. 194)), which has now been presented by its owner, Dr W. L. Hildburgh. Recently, through the same donor's generosity, this has been joined by four further statuettes clearly originating from the same studio. The first of these shows an Oriental on horseback attacked by a lion and accompanied by a dog[16] (Fig. 192), and the second a Cupid, armed with a bow and girded with a quiver of arrows, astride a galloping horse[17] (Fig. 198). The third and fourth represent *Nessus and Deianira*; in one of these Deianira is seated on the centaur's back[18] (Fig. 191) and in the other she is supported in his arms[19] (Fig. 196). All five bronzes are covered with dark lacquer, and four of them are set on a flat, naturalistic base. In the case of the Nessus with the seated Deianira the naturalistic base is missing, but it appears in a version of the model in the Beit collection which figured under an ascription to the school of Giovanni Bologna in the exhibition of Italian sculpture at the Burling-ton Fine Arts Club in 1912.[20] The horses in two of the statuettes (the *St George* and the *Cupid*) are variants of a single model, and the horse in the *Oriental on Horseback* is of the same type. These recall Florentine bronzes

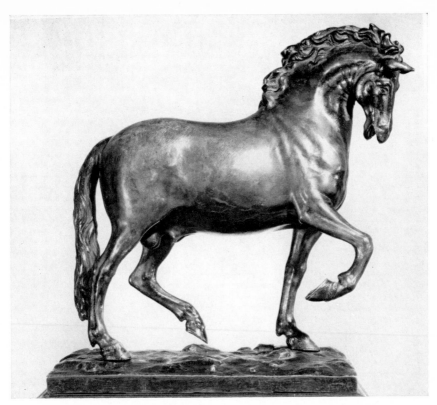

190. Francesco Fanelli: *A Horse*. Bronze, height 19·6 cm. Duke of Portland

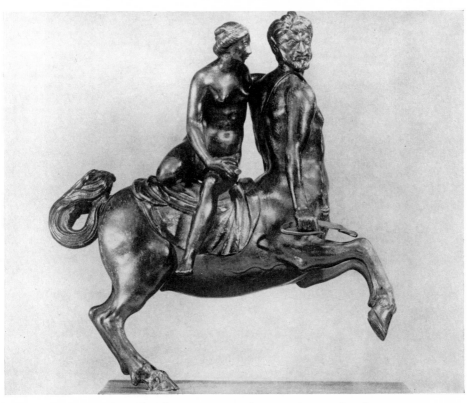

191. Francesco Fanelli: *Nessus and Deianeira*. Bronze, height 18·7 cm.
London, Victoria and Albert Museum

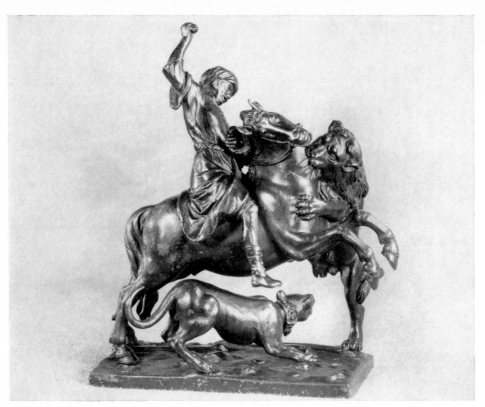

192. Francesco Fanelli: *A Lion Hunt*. Bronze, height 21 cm.
London, Victoria and Albert Museum

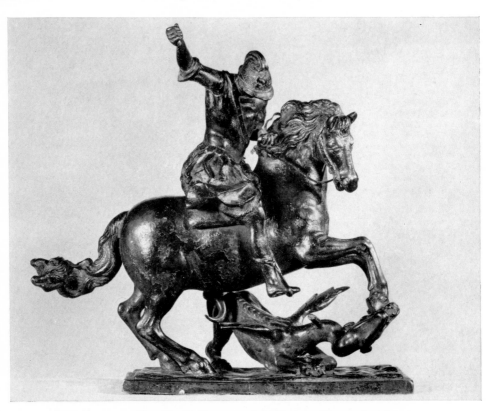

193. Francesco Fanelli: *St. George and the Dragon*. Bronze, height 26·7 cm.
Bath, Holburne of Menstrie Museum

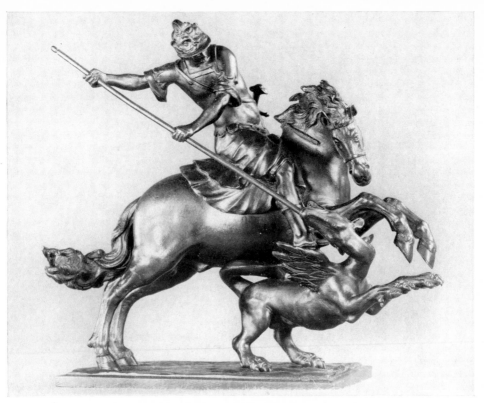

194. Francesco Fanelli: *St. George and the Dragon*. Bronze, height 19·2 cm.
London, Victoria and Albert Museum

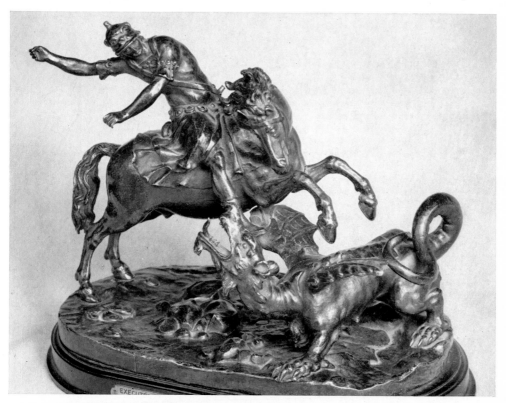

195. Francesco Fanelli: *St. George and the Dragon*. Bronze, height 20·2 cm.
Duke of Portland

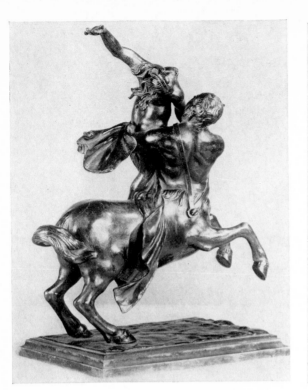

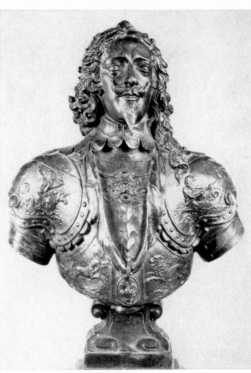

196. Francesco Fanelli: *Nessus and Deianeira*.
Bronze, height 24·3 cm.
London, Victoria and Albert Museum

197. Francesco Fanelli: *King Charles I*. Bronze,
height 16·4 cm. Miss Daphne Ionides

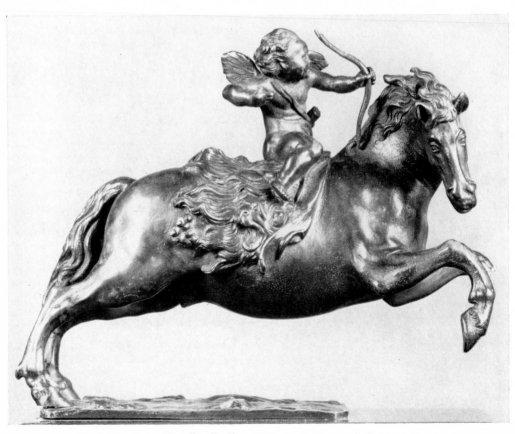

198. Francesco Fanelli: *Cupid on Horseback*. Bronze, height 14·3 cm.
London, Victoria and Albert Museum

of the class of the two horses, ascribed to Tacca, published by Bode as in the Robert von Mendelsohn collection,[21] and of the model by Tacca for the projected statue of Carl Emmanuel of Savoy in the Löwenburg at Cassel.[22] The treatment of the flanks and fetlocks of the two centaurs is very similar to that of the horses in the *Cupid* and *St George*. In the second of the groups of Nessus and Deianira the figure of Deianira depends from Giovanni Bologna, but the figures of St George and of the Cupid are not specifically Florentine. Despite their small scale, all five make use of baroque rhythms which are decisive for a dating in the seventeenth rather than in the sixteenth century.

On grounds of iconography and style alone a strong case could be stated for ascribing the five groups conjecturally to Fanelli. They were certainly produced, as were Fanelli's groups, by a Florentine bronze sculptor active at the end of the first or in the second quarter of the seventeenth century. That they have an English origin is suggested by the fact that examples of three of them (the *St George*, the *Cupid on Horseback*, and the *Oriental on Horseback*) occur in this country comparatively frequently. The motif of the St George depends from the painting by Raphael in Washington, which was engraved in reverse by Vostermann in 1627 when in the collection of the Earl of Pembroke and was later owned by Charles I. Still more remarkable is the measure of agreement between the subjects of the groups and the known subjects of Fanelli's statuettes. Thus the *St George* might correspond with the 'little St George on horseback with a dragon by' in Charles I's collection, and the *Cupid on Horseback* and the *Nessus and Deianira* with the 'Cupid on Horseback' and 'Centaur with a woman' at Welbeck. In the *St George* and the *Oriental on Horseback*, the dragon and hound are cast separately from the main group; the 'other Cupid runing by' in the version of the *Cupid on Horseback* in the Royal Collection may also have been cast in this way. In the Holburne Museum at Bath is a variant of the St George group, in which the Saint, differently posed, is shown plunging his lance into the vanquished dragon (Fig. 193).[23] Perhaps we have here a version of the 'St George horse back the dragon dead' listed at Welbeck. Finally, the *Oriental on Horseback* might correspond with the 'Turk on Horseback' recorded by Vertue. Fortunately the case is placed beyond the sphere of conjecture by two statuettes at Welbeck, both of which bear traditional ascriptions to Fanelli.[24] The first is a more elaborate variant of the St George group (Fig. 195), no doubt the 'St George combatant with the dragon' of Vertue's note, and the other a horse (Fig. 190), presumably the 'horse

ambling' of the Oxford inventory. The horse belongs in the same category as the horse bronzes of Susini, though the treatment is notably less monumental and more realistic than in the signed *Pacing Horse* of Antonio Susini in the Victoria and Albert Museum. In both statuettes a naturalistic base is once more employed.

With the exception of the two compositions of Nessus and Deianira, all of Fanelli's recorded statuettes and all of his surviving groups portray equestrian subjects. It may well be that the influence of the Duke (then Earl) of Newcastle was responsible for the fact that in four of the statuettes at Welbeck riderless horses were shown, as well as for the change in style (a new naturalism and a new emphasis on movement) which differentiates Fanelli's from contemporary Italian statuettes. Newcastle's interest in horsemanship is well attested. Early in the century Jonson celebrated his proficiency in an epigram, and during his exile at Antwerp his riding-house won European fame. There is a striking kinship between the horses in Fanelli's groups and the horses in the plates designed by Diepenbeck for the 1658 edition of Newcastle's *Méthode et Invention Nouvelle de dresser les Chevaux*, and both may reflect Newcastle's taste. By the standards of Roccatagliata, Tacca, and Susini, Fanelli is an artist of the second rank. Had he remained in Italy, neither his models nor the technical competence of his bronze castings would have earned the admiration they seem to have enjoyed abroad. But working in a country where the manufacture of small bronzes was something of a novelty, and adapting his subject-matter to local demands, he secured himself a place in the histories of bronze sculpture and of Caroline art.

Midway between the statuettes and the Welbeck bust of Charles II as Prince of Wales, stands a small bronze bust of Charles I in the possession of Miss Daphne Ionides[25] (Fig. 197). Comparison of the unicorn and marine deities which decorate the armour in this bust with the *Cupid on Horseback* and the *St George* leaves no doubt that this is by the same hand as the statuettes. The free pose and rhythmical design of this little portrait stand in striking contrast to the flaccid mannerism of Le Sueur as we find it in the bust of Charles I in the Bodleian, and tend to corroborate the view that, in the Ayton Monument, at least the bust and bronze tablet beneath are by Fanelli.[26] Dallaway, in a notably misleading summary of the characteristics of Fanelli's style, observes that 'his busts indeed have a Roman air, acquired probably in the school of Bernini'.[27] In practice an Italian parallel for Fanelli's style is to be found in Mochi rather than

Bernini, and it may well be that Fanelli, whose statuettes are some of the earliest Baroque sculptures in circulation in this country, will prove to have been instrumental in establishing in England the vogue of Baroque portraiture.

Originally published in *The Burlington Magazine*, xcv, May 1953.

An Exhibition of Italian Bronze Statuettes

For upwards of thirty years it has been an open secret that some-
thing is radically wrong with the study of bronze statuettes. Put in its
simplest form, it is that the minds of most people who have thought about
the subject are filled with question marks. Admittedly the study of small
bronzes is rather particularly difficult; they can be investigated only at first
hand—in no other way can their weight and facture and all the important
play of movement in the forms be judged—they are resistant to the
camera, and they are extremely hard to carry in the eye. Without facilities
for direct comparison, therefore, the subjective element in judgment is far
higher than it ought to be. Most students of small bronzes must have
dreamed of an imaginary exhibition in which their doubts would be re-
solved and the bronzes from London and Paris and Vienna and Berlin
and the Frick Collection would be shown beside authenticated works,
the documents on which the mythology of the small bronze is based. In
the summer of 1961 it was possible, through the initiative of the Ministry
of Public Instruction in Rome and with the support of the Arts Council
and the generous collaboration of the Louvre, the Rijksmuseum and the
Kunsthistorisches Museum in Vienna to form a sketch-model for an exhibi-
tion of this kind. Neither in its initial form in London, nor in the rather
different forms in which it was later shown in Amsterdam and Florence,
was it an ideal exhibition, but most of the documents were there (the
signed *Dragon* by Severo da Ravenna was the only major absentee), and
the nature of the problems presented by small bronzes could for the first
time be properly defined. Now that the dust has once more in a literal sense
settled on many of the works exhibited, and the bronzes from the Museo
Nazionale in Florence, after a brief period of liberty, have, like the prisoners
in *Fidelio*, been recommitted, unlabelled and untended, to their tomb, the
time has come to describe some of the practical consequences of the
exhibition.

Before doing so, a word of warning must be given to users of the cata-
logue. Owing to the rapid organisation of the exhibition, the London
catalogue was, in respect of the Italian contribution, a compilation of entries
supplied from Italy.[1] Sometimes these were amplified, and just occasionally
the attributions were corrected, but in general the Italian formulation for

172

these entries was preserved. For the Dutch showing of the exhibition the text was thoroughly revised in the light of the experience of the London exhibition. What resulted was still far from definitive, but none the less was an approximation to a serious catalogue.[2] New factual information was incorporated in it, and the haphazard descriptions of facture and surface in the initial entries were replaced by a uniform nomenclature. In the third catalogue,[3] all this was ignored; a few of the new attributions were adopted, but the original descriptions of the bronzes were retained, and the text essentially was a translation of the English catalogue. For purposes of reference, therefore, the Dutch catalogue alone constitutes a proper record of the exhibition.

The earliest document included in the exhibition was the *Hercules and Antaeus* of Antonio Pollajuolo. Unless one has held this bronze in one's hands, it is quite impossible to gauge its preternatural vivacity, and only when it is tipped up on its side can the astonishing head of Antaeus be adequately seen. Yet it remains a puzzling work, partly on account of its condition—the feet of Hercules are a contemporary substitution for a flawed section of the cast, and the three tortoises have been left almost in the rough—and partly on account of the system of modelling in flat planes, which has no precedent and almost no contemporary parallel. The word 'almost' is necessitated by the fact that it appears again in the only other absolutely certain small bronze by Antonio Pollajuolo, the Berlin *Hercules*, where the body is schematised in exactly the same way. It also recurs, less emphatically, in a model traditionally ascribed to Pollajuolo, the *Marsyas*.[4] None of the extant versions of the *Marsyas* is autograph in the sense in which the term is used of the bronzes in Florence and Berlin, not even the fine version from Modena that was included in the exhibition, but given their idiosyncrasies of modelling, it is likely that all of them depend from a classicising prototype by Pollajuolo. Not long ago, in a fascinating article, Ulrich Middeldorf[5] drew attention to the use of this figure by Gozzoli in the Pisa *Destruction of Sodom* and by Signorelli in the Loreto *Conversion of St Paul*. Probably it formed a three-dimensional equivalent for the didactic cartoons whereby knowledge of Pollajuolo's figurative language was diffused to the studio of Squarcione at Padua and to the workshop of Matteo di Giovanni at Siena.

The type of modelling employed in the *Hercules and Antaeus* is astonishingly little like the modelling of the Naples *David* (Fig. 199), in which the surface is broken up pictorially into a number of small, nervous planes, and the structure is less organic and less confident. This bronze was ascribed to

Pollajuolo by Filangieri in 1898,[6] and the attribution has been repeated in all later books. If there were no small bronzes by Pollajuolo, that would be easy to condone. Working from the paintings alone, we might guess that his small bronzes must have looked like this. But the *Hercules and Antaeus* provides unassailable evidence that they did not, and each time I have looked at the *David* in Naples, it has impressed itself upon me as a typical work of Francesco di Giorgio.[7] It has the same insecurity of stance as the Dresden *Aesculapius* (Fig. 200), the same pinched upper arms and the same out-size feet, while in the left background of the *Allegory of Discord* in London there is a small figure posed in the same way (Fig. 201). One learns to mistrust these moments of illumination in Continental museums, even when they are repeated more than once. The *Aesculapius*, I told myself, was more highly worked than the bronze in Naples, and was three and a half times as high, and the *Allegory of Discord* was a stucco squeeze from a lost bronze relief, so that no argument from facture was permissible. The case could be proved, therefore, only if the exhibition contained one work by Francesco di Giorgio in bronze on a comparable scale. The most useful comparison was naturally with the Perugia *Flagellation*, and with the consent of the Soprintendenza alle Gallerie dell'Umbria this was included in the exhibition. To my mind the structure of the figures in the two works is identical, and I feel not the very slightest doubt that they are by one and the same hand.

The second document shown in the exhibition was Bertoldo's *Battle* relief. Despite the rather condescending things that have been said about Bertoldo—the passage on the medals in Hill's *Corpus*[8] and the generally pejorative references in the literature of Michelangelo come to mind—the *Battle* relief has always seemed to me an unassailably great work. But when the crate containing it was first unscrewed in London, and its sad surface and hideous wooden frame came into view, I began to wonder by what process of auto-hypnosis one had convinced oneself of that. However, before long it regained some semblance of vivacity, and it has been re-photographed. This is worth stressing because the figures in it provide the acid test for attributions to Bertoldo. Our difficulty with Bertoldo is not that there is no firm basis for attribution, but that we know practically nothing about his development. Only one work is approximately datable, the Vienna *Bellerophon*, which was cast before 1486 by Adriano Fiorentino.[9] It has been suggested more than once that this bronze may be connected with the commission to Bertoldo in 1483 for two reliefs for the choir of the Santo, since it is first heard of in a Paduan collection.[10] In Bertoldo's only other equestrian bronze, the *Wild Man on Horseback* at Modena, the treatment of

the horse is heavier and much more primitive. A similar distinction can be drawn between the horses on the reverse of the signed medals of the *Emperor Frederick III* of 1469 and on that of *Mahomet II* of 1480–1. The Modena bronze in turn is closely related to the *Battle* relief; one of the horsemen in the background on the right of the relief is really an inversion of the rider in the statuette. But the horses in the relief are rather more evolved than that at Modena, and we might deduce that they represented an intermediate stage between the *Wild Man* and the *Bellerophon*, where the lithe, animated forms reveal a knowledge of the rearing horses in the background of the San Donato a Scopeto *Adoration of the Magi* of Leonardo. There is no practical obstacle to dating the *Battle* scene in the mid-seventies; some of its detail is still so redolent of Donatello as to make any later dating inherently improbable. Two independent statuettes the Fredericks *Hercules*, which was shown at Amsterdam but not in London,[11] and the unfinished *Apollo* in the Bargello seem to be roughly contemporary with the *Battle* scene, and are certainly earlier than the *Bellerophon*. But Bertoldo did not die till 1491, so we have almost a decade unaccounted for. This fact must influence our attitude to the attributed works, above all to the two bronzes ascribed to Bertoldo in London. One of them, the *Hercules and the Nemean Lion*, has never been disputed,[12] while the other, a *Hercules Pomarius*, was rejected by Bode and has been periodically excised from the Bertoldo catalogue.[13] Direct comparison with the *Battle* relief proved that the *Hercules and the Nemean Lion* could not possibly be by Bertoldo. Not only the type and modelling, but the triangular formulation of the group are incompatible with Bertoldo's creative processes. The *Hercules Pomarius*, on the other hand, shows no such incompatibility. The torso and legs reproduce a classical model that was also used at a rather earlier date for the Fredericks *Hercules* and was employed again in the Bargello *Hercules* of Bandinelli,[14] and the strong probability is that the statuette represents the last phase of Bertoldo's work.

It was not to be expected that any exhibition would clarify the bronzes given to Bellano. Only when the reliefs of Biblical scenes in the choir of the Santo have been properly studied and re-photographed can the whole question of Bellano as a maker of small bronzes be submitted to really serious scrutiny. The exhibition none the less included one work whose attribution to Bellano has never been questioned, the magnificent *St Jerome* in the Louvre. Clumsy craftsman though Bellano was considered by Pomponius Gauricus, the *St Jerome* is remarkable not only for its powerful structure but for the immaculate handling of its detail. Yet a distinction

must be drawn between the heavy modelling of this bronze and the minute finish of the *Europa and the Bull* in the Bargello. In relief Bellano's control of form was insecure, as was abundantly apparent in the exhibition from the work most closely related to the Santo scenes, the *Grazing Ox* in the Ca' d'Oro, where the rear hooves are incorrectly rendered and the tail is leaden and inert. If we turn the bull in the statuette to the same angle as the bull in the relief, we shall find that in both respects it is a very different and much superior work. Miss Maria Grazia Ciardi-Dupré, in the course of some light-headed comments on the exhibition, tells us that *'lo squisito "Ratto di Europa" . . . riflette, secondo la gentile communicazione del Prof. Middeldorf, la corrente più amorosamente classica della scultura dell'Italia settentrionale, ed è quindi avvicinabile ad Alessandro Leopardi'*[15] (Fig. 202). The sole basis for any attribution to Leopardi is provided by the three mythological reliefs on the flagstaffs in the Piazza di San Marco, and they have in common with the statuette only the generically classicising handling of the drapery. In practice, the modelling and surface working of the bull find an exact point of reference in the bulls drawing the ark of the covenant in the documented relief by Riccio of *David dancing before the Ark*, and the treatment of the female figure is also perfectly consistent with Riccio's work about this time. So I think we are logically bound to follow Bode[16] in looking on the statuette as a work by Riccio of about 1506.

Our knowledge of Riccio's early style is still extremely thin. We learn from Marcantonio Michiel that after Bellano's death in 1496 or 1497 he completed the Roccabonella monument, and documents tell us that in 1500 he designed the Chapel of St Anthony. His next dated works are two Biblical reliefs in the choir of the Santo, which were modelled and cast by 1507, and these are followed by the Paschal Candlestick, which was in course of manufacture between 1507 and 1516. In terms of style the transition from the Santo reliefs to the Candlestick is imperceptible, but in the chronology imposed on Riccio's work by Planiscig there intervene between them some reliefs in a rather different style, the tabernacle doors and the four scenes from the Legend of the Cross which were cast for the Servi in Venice and are now in the Ca' d'Oro. Not only are the Servi narrative reliefs far less accomplished than the two scenes in the Santo, but the figures are more elongated, and the settings are still stamped with the naivety of Bellano. The relic of the Holy Cross, in connection with which the reliefs and the two doors were made, was given to the church by Girolamo Donati in 1492,[17] and the strong probability is that the bronzes were commissioned not long afterwards and represent Riccio's style in the last half

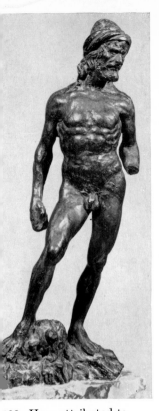

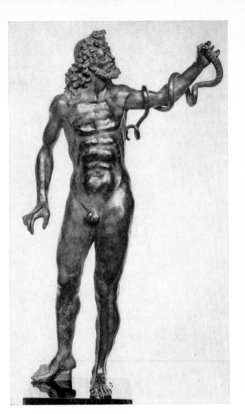

199. Here attributed to
Francesco di Giorgio: *David*.
Bronze, height 33·7 cm. Naples,
Museo Nazionale di
Capodimente

200. Francesco di Giorgio:
Aesculapius. Bronze, height
113 cm. Dresden, Staatliche
Kunstsammlungen

201. Francesco di Giorgio:
Detail from Allegory of Discord.
Stucco. London, Victoria
and Albert Museum

202. Riccio: *The Rape of Europa*. Bronze, height 21·5 cm.
Florence, Museo Nazionale

203. After Riccio: *Kneeling Satyr holding a Shell*. Bronze, height 23·3 cm. Rome, Museo di Palazzo Venezia

204. Riccio: *Seated Satyr holding a Shell*. Bronze, height 20 cm Florence, Museo Nazionale

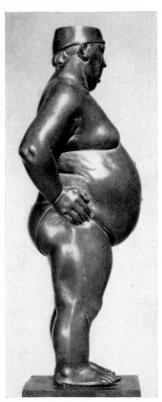

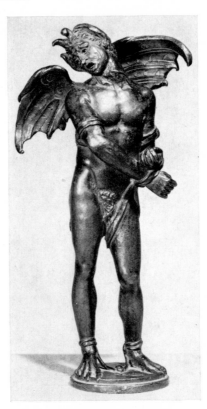

205. Florentine c. 1550: *Sloth*. Bronze, height 17 cm. Milan, Museo del Castello Sforzesco

206. Here attributed to Desiderio da Firenze: *Devil*. Bronze, height 21·4 cm. Belluno, Museo Civico

207-208. Desiderio da Firenze: *Details from Voting Urn*. Bronze, Padua, Museo Civico

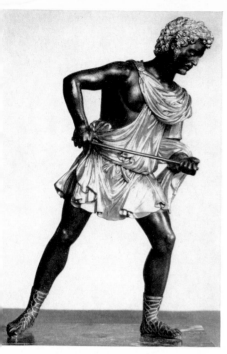

209. Antico: *Meleager*. Bronze percel-gilt, height 30·8 cm. London, Victoria and Albert Museum

210. Severo da Ravenna: *St. John the Baptist*. Marble. Padua, S. Antonio

211. Here attributed to Severo da Ravenna: *St. John the Baptist*. Bronze, height 26 cm. Oxford, Ashmolean Museum

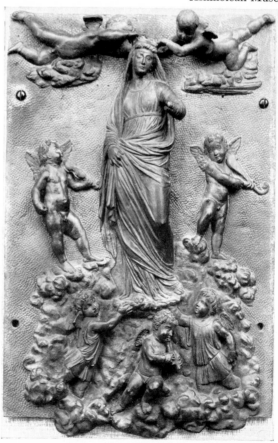

212. Paolo Savin: *Virtue* (detail from Zen sarcophagus). Bronze. Venice, St. Mark's

213. Here attributed to Paolo Savin: *The Assumption of the Virgin*. Bronze, 36 × 25 cm. Venice, Ca' d'Oro

214. Venetian, first quarter of the sixteenth
century: *Spinario*. Bronze, height, 18·8 cm.
London, Victoria and Albert Museum

215. Venetian, first quarter of the
sixteenth century: *Hercules and the Serpent*.
Bronze, height 29 cm. Venice, Museo Correr

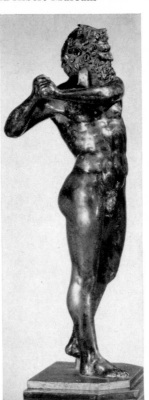

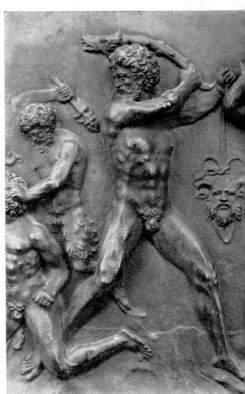

216. Francesco da Sant'Agata:
Hercules. Boxwood, height
26·7 cm. London,
Wallace Collection

217. Here attributed to
Camelio: *Hercules*. Bronze,
height 23·5 cm. Oxford,
Ashmolean Museum

218. Camelio: *Detail from Battle of the Giants*.
Bronze. Venice, Ca' d'Oro

decade of the fifteenth century. Incidentally the suggestion, made in the Italian entry for the London exhibition catalogue,[18] that the marvellous tabernacle doors are by that maid-of-all-work Desiderio da Firenze is utterly absurd. They are autograph works by Riccio of the very highest quality, and have an oblique relevance to the architectural scheme of the Chapel of St Anthony.

The collection of small bronzes by Riccio in the exhibition was the largest ever put together, and it demonstrated very clearly that as he aged he changed not only his style but his technique. The difficulty in expressing that in terms of a precise chronology is that we know even less about the sequence of Riccio's late works than we do about his origins. Broadly speaking, two facts are ascertained, that he was working between 1521 and 1524 on the Trombetta monument, and that at some time after the completion of the Paschal Candlestick and before his death in 1532 he executed for Verona the reliefs of the Della Torre tomb. So we have one work, the Trombetta monument, which is exactly datable but from which no stylistic inferences for the study of small bronzes can be drawn, and another, the Della Torre reliefs, pregnant with stylistic revelations but not exactly datable. Technically the poles are represented among the statuettes by two bronzes from the Museo Nazionale in Florence which were looked upon by Planiscig[19] as constituents of a single group. One of them is the *Abundance*, where the casting is heavy and the modelling recalls that of figures in the Paschal Candlestick, and the other is the *Shepherd milking a Goat*, in which the casting is relatively light and the modelling recalls that of figures in the Della Torre reliefs. The *Shepherd milking a Goat* is inseparable in style and in technique from the *Negro riding a Goat* at Birmingham, whose attribution to Riccio was rejected by Planiscig in favour of a half-ascription to Severo da Ravenna.[20] In both bronzes the flanks of the goat are treated with the same differentiated hammering as the lambs in the sacrificial scene from the Della Torre monument. It follows that the beautiful *Fettered Negro* in Vienna (which was also turned down by Planiscig[21]) is an autograph late work by Riccio. On the plane of style the bronzes in Birmingham and Florence show a wonderful continuity of rhythm which is found also in the great relief of *St Martin and the Beggar* in the Ca' d'Oro. To my way of thinking, infinitely appealing as are the earlier works, it is only in these late works that Riccio emerges as a supremely great because a supremely expressive artist.

Beside the factors of weight and surface treatment there is one other distinction to be drawn between Riccio's earlier and later works, that the

hair in the earlier reliefs is boldly modelled, whereas in the later bronzes it is incised with long rhythmical strokes. The force of this can be confirmed by comparing figures from the Paschal Candlestick with, say, the River God in the foreground of the scene of *Della Torre teaching* in the Louvre. In the small bronze the two poles are represented by the *Seated Satyr holding a Shell* in the Bargello and the *Satyr drinking from a Bowl* at Padua. The Padua bronze was looked upon by Planiscig[22] as inferior to a version of the model in Vienna, and even about the Vienna bronze he was at one time hesitant. The Vienna bronze was not included in the exhibition, but it can be affirmed that the Padua *Satyr* is a late work by Riccio of the very highest quality.

Let it not be supposed that these additions involve a great extension of the Riccio catalogue, for if I had anything to do with it, the Riccio catalogue would be drastically cut down. One of the bronzes I am willing to eliminate is the *Kneeling Satyr holding a Shell* in the Palazzo Venezia[23] (Fig. 203). When it was in the Barsanti Collection, it was accorded a full-page illustration in Planiscig's *Riccio*,[24] and neither there nor seen through the glass of the vitrine in Rome have I much liked its quizzical, wrinkled little face. Handling it, I like it even less, especially the schematic modelling of the back which is totally uncharacteristic of the artist. Once it has been juxtaposed with an indubitably autograph bronze of the same class, the *Seated Satyr* in Florence (Fig. 204), it is immediately revealed as what it is, a counterfeit. Another bronze to be deleted from the Riccio catalogue is the figure of *Sloth* in the Museo Civico in Milan (Fig. 205), of which a second version is in Vienna.[25] This bronze is of excellent quality, is manifestly Florentine—the livid surface is alone sufficient to prove that—and seems to have been made as a small candlestick. Seeing the bronze in profile, one may may well feel astonished that Riccio's name should ever have been foisted on to it. While on the subject of this bronze, it may be noted parenthetically that it was catalogued as Riccio in London,[26] where it was unaccountably described as 'a late work', was reassigned in Holland[27] to an unidentified Florentine sculptor active *c.* 1540, and in Florence[28] was designated as 'Arte Fiorentina verso il 1540', but with the original catalogue entry as Riccio printed underneath. A third bronze wrongly ascribed to Riccio is the *Devil* from Belluno[29] (Fig. 206). This was one of the few bronzes in the exhibition I had never previously seen in the original, and it proved to be a clumsy, flaccid work. The head is bent over the right shoulder, like the heads of the putti on the Desiderio da Firenze Voting Urn at Padua (Fig. 207) and the handling of the eyebrows follows the pattern of those in the

bearded male masks on the Urn (Fig. 208). To my mind the attribution of this bronze to Desiderio da Firenze and not to Riccio is inescapable. Desiderio da Firenze seems to have practised as a maker of bronze utensils rather than a figure sculptor, and the circular base of the *Devil* suggests that it was made as the lid of a receptacle.

Before moving to Venice, a brief visit must be paid to Mantua. In bronze sculpture Mantua connotes Antico. The reason for this is first that Antico was a distinguished and sensitive artist, and second that he is the subject of the only absolutely first-rate study that has ever been written on bronze statuettes, an article by Hermann published more than half a century ago.[30] From an attributional standpoint Antico's work does not present a large number of problems. It was a great pleasure to welcome to London the Venice *Apollo Belvedere*, and a still greater pleasure to be allowed to free it of generations of accumulated grime, so that it can now be seen not in the filthy state in which we have known it for so long in the Ca' d'Oro, but in something resembling the condition in which it was when Isabella d'Este first handled it. But for all its sensual charm, I am not sure that I would willingly exchange it for the *Meleager* (Fig. 209) which came to light recently in London, and which illustrates so perfectly the psychological transmutation Antico imposed on the antique. This bronze derives, as Keutner has rightly pointed out,[31] from the lost '*contadino di marmo appresso al cinghiale grande al naturale in atto di ferirlo*', which is recorded in Medici inventories of 1638 and 1676 and was earlier in the Belvedere.[32] Comparing the bronze with Gori's reproduction of the marble, we find that the changes which Antico introduced into the scheme affect the relative positions of the hands and the angle of the head, and that as a result the pose takes on a new coherence and new rhythmic character. There also arrived in London from Naples a bronze rightly identified by Hermann[33] as a coarse aftercast from a lost *Kneeling Venus* made in 1519 for Isabella d'Este, and an ugly little *Venus Pudica*, unaccountably described in the London and Florence catalogues as a trial cast for the *Venus Felix* in Vienna.[34]

Though bronze sculpture in Mantua connotes Antico, the style that the small bronze assumed there was dictated by a more powerful creative intelligence. If Mantegna had not arrived in Mantua in 1459, the Mantuan statuette would never have assumed the form it did. Our only direct evidence for Mantegna's concern with bronze casting comes from some celebrated letters of 1483, which refer to the making of bronze vessels from his

designs. Two sculptors are mentioned: Gian Marco Cavalli, the medallist, and Giovanni Francesco Ruberti, the putative Master IO. F.F. There is a high degree of probability that both these sculptors made reliefs and statuettes— reliefs like the Martelli Mirror, in which the damascening is typically Mantuan and where the figures seem to reveal some connection with the IO. F.F. plaquettes, or like the splendid *Entombment* in Vienna, where the idiom of Mantegna is translated into three dimensions in what is stylistic- ally a far more rigorous manner than that of Riccio in Padua. One of the most interesting small bronzes of this class is the male bust at Modena.[35] When at home it suffers from the disadvantage of being shown crooked on its base, but once that has been corrected it emerges as the little masterpiece it is. The modelling, on its greatly reduced scale, is extraordinarily close to that of the bronze bust of Mantegna in S. Andrea at Mantua, and if the artist of the bust produced small bronzes, we might expect them to look pretty much like this. What is needed in this area is more documents; the nature of the problems is self-evident, but the data for solving them simply are not there.

In Venice as elsewhere the bronze statuette was a by-product of bronze sculpture in larger forms. Just as the Florentine small bronze originates on the Siena font and the crozier of St Louis of Toulouse, the earliest Venetian bronzes coincide in point of time and style with the Suriano relief of about 1490 in Santo Stefano and with the Zen altar in St Mark's. The exhibition brought together a group of bronzes that have been loosely associated with these works. Among them were the charming female busts from Modena (catalogued as Tullio Lombardo, though the form of the eyes and the modelling of the cheeks suggest a connection with Antonio), the male bust from the Rijksmuseum (which is probably by the same hand as the Modena busts), the *St John Baptist* from Oxford (Fig. 211), *St Jerome with a Lion* from Brescia (of which an inferior example is in London), and the work round which so many of these bronzes have been disposed, the relief of the *Assumption* from the Barbarigo Altar (Fig. 213) which was installed in the church of the Carità before 1515 and is now in the Ca' d'Oro. As soon as these bronzes were seen together it became clear that Planiscig's reintegra- tion of the so-called Barbarigo Master[36] would not bear a moment's scrutiny. In facture the bronzes are closely similar, but within the frame- work of a common attitude to the antique the minds and hands of the artists responsible for modelling them were evidently very different. The *St Jerome* is constructed with a flat frontal plane; in this it follows the usual

practice of the Lombardo studio, as we find it in Tullio Lombardo's *Coronation of the Virgin* in San Giovanni Crisostomo or Antonio Lombardo's Zen *Madonna* in St Mark's. In the Barbarigo altar, on the other hand, the figures are one and all posed on a diagonal to the plane of the relief. It so happens that on the Zen altar there is one statue, the *Baptist*, which is planned in precisely the same way, and since the type of the Zen *Baptist* and the types of the Barbarigo *Apostles* also correspond, we are bound to ascribe the *Apostles* to the author of the statue, Paolo Savin. This can be corroborated by examining the figures of *Virtues* on the Zen sarcophagus (Fig. 212), where the poses and the treatment of the drapery coincide, with remarkable precision, with that of the Virgin of the Barbarigo *Assumption* relief. To the best of my belief, there is not one single surviving statuette that shares the style characteristics of these two works. The *Baptist* at Oxford, which Planiscig in a moment of aberration ascribed to the Parmesan sculptor Filippo da Gonzate,[37] is far livelier in handling than the *St Jerome*. Its closest formal affinities are with the signed marble *Baptist* by Severo da Ravenna at Padua (Fig. 210), and there is a strong presumption that it is by this sculptor.[38]

The purpose of the exhibition was to create new groupings, not to rend old groupings apart, and the lineaments of a new artist active in Venice in the first quarter of the sixteenth century became apparent, though at present he can boast no more than three works. This is the sculptor of the *Apollo Belvedere*, of which versions exist in the Huntington Library[39] and the Victoria and Albert Museum. Both academically and artistically this *Apollo Belvedere* is a good deal inferior to Antico's, from which it differs in the loose handling of the hair and in the fact that the whole surface is treated in a freer, fleshier, more naturalistic way. Particularly notable is the deep reddish colour of the bronze. The very individual attitude to the antique and the physical peculiarities manifest in the *Apollo* are found again in an extremely pretty version of the *Spinario* in London (Fig. 214), in which the axis of the pose is changed and the right foot is raised on the left knee.[40] The artist of the *Apollo* and *Spinario* produced a more substantial statuette, the *Hercules and the Serpent* in the Museo Correr (Fig. 215), where the free modelling and rich handling of the surface are exactly similar. The *Hercules* is a large bronze—its height is nearly 30 cm.—and like the *Apollo* and *Spinario* it is a heavy casting of conspicuously impressive quality. Other bronzes by the same hand will no doubt come to light.

More significant is the reconstitution of Camelio, for Camelio is undoubtedly the author of all the small bronzes hitherto ascribed to Francesco

da Sant'Agata.[41] His birthdate is not recorded but he was an established medallist by 1484, when he became Master of the Dies at the Venetian Mint, and before that was in Rome, where he signed a medal of Pope Sixtus IV. He cast a medal of Julius II in 1506, and then in 1516 or 1517 moved back to Venice, where he resumed work at the Mint, and died, in his 70's, in 1537. Logically, therefore, he must have formed a link between the Rome of Caradosso and Pollajuolo's *Sixtus IV* monument and the Venice of the Lombardi. Camelio's extant works comprise two signed reliefs from his monument in the Carità, now in the Ca' d'Oro, the *Sixtus IV* and *Julius II* medals, and a medallic self-portrait dated 1508. Of the medals only the self-portrait has any evidential value for the figure sculptures.

The single signed work by Francesco da Sant'Agata is a boxwood *Hercules*, which was seen by Scardeone in the collection of Marcantonio Massimo at Padua and is now in the Wallace Collection (Fig. 216). Its pose corresponds with that of a bronze *Hercules* at Oxford (Fig. 217), round which Bode,[42] correctly, assembled certain other statuettes. Their attribution to Sant'Agata seemed to be more reasonable in that another of the statuettes, in the Frick Collection, corresponded with a boxwood *St Sebastian* in Berlin, which was unsigned but was manifestly by the same woodcarver as the *Hercules*. There was only one fly in the ointment, that though the poses of the bronzes and the carvings were identical, the types were altogether different, and a few years ago it was inferred by Landais,[43] rightly in my view, that the boxwood *Hercules* was copied from the bronze. What was not correct was Landais' second inference, that the bronzes were made about 1500 by an unidentified Paduan bronze sculptor.

Four years ago at an exhibition in Detroit where the *Battle of the Giants* from the Ca' d'Oro was, for the first time in living memory, shown in a good light, it was impressed upon me that the Oxford *Hercules* was by the same hand as the relief, and as soon as they were juxtaposed in London it transpired that this was actually the case. The finish of the central figure in the relief (Fig. 218) proved a trifle less fine, but the type and modelling were undeniably the same. Camelio, not Sant'Agata, therefore, was the author of the Oxford statuette. But the corpus of Sant'Agata bronzes also includes some statuettes of a rather different type. Among them is the lyrical *Hercules and Antaeus* in the Widener Collection in the National Gallery of Art, a bronze choreographed by Balanchine, as well as one of the most sheerly beautiful Italian bronzes, the *Faun playing a Double-Flute*. In the Frick catalogue[44] Maclagan questions the autograph character of the known versions of this model; this judgment seems to me wrong both in

the case of the Frick bronze, which is extremely fine, and of the version in the Louvre (Fig. 220) which figured in the exhibition. It is at this point that we must have recourse to another certain work, the medallic self-portrait, or rather the reverse of the self-portrait with a sacrificial scene (Fig. 221), for the lyrical figures on the medal are related to the statuettes not only in their spirit, but in their whole repertory of form. If we revolve the bronze in Paris so that we see it from the back, the resemblance becomes too strong to be denied. We have, therefore, a double point of reference for the statuettes in two signed works.

As we might expect, the maker of these statuettes was also a maker of plaquettes. He was the author of the *Sacrificial Scene* which normally goes under the name of Riccio, and of which an example in the Dreyfus Collection was catalogued by Seymour de Ricci as Riccio with a prudent question-mark,[45] and of the lost original of a relief of *Vulcan forging the Wings of Cupid*, of which a coarse aftercast in London (Fig. 219) is accepted by Bode and Planiscig as an autograph Bertoldo.[46] Actually there is independent evidence that this latter plaquette must be Venetian, since its scheme was adopted by Carpaccio in the *St Ursula* cycle as the basis of a fictive marble relief. Another version of it is in the Museo Correr, and when I concluded, for the reasons I have given, that the London relief must be by Camelio, I found that the impeccable Paoletti[47] had formed precisely the same view of the Correr relief seventy-odd years before.

The reintegration of Camelio in turn impinges on that of yet another bronze sculptor, Desiderio da Firenze, whom we know solely through one documented work, the Voting Urn at Padua. In the London exhibition there were quite a number of putative Desiderio da Firenzes—works attributed to Desiderio by Planiscig—but it was abundantly apparent that Planiscig's reading of the Voting Urn was incorrect, and that the *Devil* in Belluno was the only bronze which was by the same hand as the male masks on the Urn. For one of the most beautiful of the putative Desiderio da Firenzes, the *Satyr* from the Lederer Collection, which was bought for the Victoria and Albert Museum a few years ago,[48] Camelio again proved to be responsible. The splendid *Seated Pan* from the Donà dalle Rose Collection, which was published by Planiscig as Riccio, must also be by Camelio.[49]

When were these works produced? Paoletti[50] and Thieme-Becker[51] suppose that the reliefs built by Camelio's brother Briamonte into the sculptor's monument were made at the extreme end of his life. It cannot be assumed that this was necessarily so. Iconographically they have no funerary significance, and so anomalous are they in the context of Venetian memorial

sculpture that the opposite case might well be advanced, that they were made for some other purpose and were incorporated posthumously in the tomb. There is no reason, therefore, to suppose that they post-date Sansovino's arrival in Venice in 1527, the less so that the style of the *Faun playing a Double-Flute* was arrived at by Camelio by 1508. Carpaccio's *Return of the Ambassadors to the King of England* is plausibly dated by Lauts *c.* 1496–8,[52] and the original of the *Vulcan forging the Wings of Cupid* must have been produced before this time. So historically Camelio is no longer the isolated, rather archaic sculptor he once appeared to be, but a figurative artist whose work in the first decade of the sixteenth century runs parallel to that of Riccio in Padua, who pursued his career independently of the more ambitious, more heavy-footed, less lyrical Lombardi, and who distilled from the antique a vision of poetic form that offers an equivalent, both in the round and in relief, for the Bacchic scenes of Cima and for the Allegories of Bellini.

The reintegration of Camelio transforms our picture of Venetian sculpture as it was in 1527, when Jacopo Sansovino arrived from Rome, for it is these powerful and elegant figures that provide the background to Sansovino's statuettes. A good many of the small bronzes ascribed to Sansovino by Planiscig are by other hands. None of these doubtful statuettes was included in the exhibition, save for two bronzes which have oscillated between Sansovino and Tiziano Minio, the well-known *Neptune in a Chariot drawn by Seahorses* (in a version without the chariot from the Victoria and Albert Museum)[53] and the cognate figurated base in the Bargello.[54] It seemed reasonably clear that both these bronzes belonged in the Sansovino workshop and were not by Minio. Two of Sansovino's finest autograph statuettes, the Modena *Christ*[55] and the Vienna *Jupiter*,[56] were for the first time juxtaposed. Like the Loggetta figures (with which it is compared by Planiscig), the *Jupiter* makes its effect through contour, but its structure is less compressed, and the head finds a close point of reference in the marble *Baptist* in the Frari. The *Baptist* was carved before 1557, when it is mentioned by Dolce in the *Aretino*, and it is likely that the *Jupiter* also dates from the middle of the century. The Modena *Christ* is that rare thing in Sansovino's work, a multi-facial group, and must have been intended for a free-standing position in which it was inspected from beneath. Stylistically a context is supplied by the Medici tabernacle in the Bargello, which was cast in or about 1543. There is thus a case for inverting the presumed time sequence of these two statuettes.

Danese Cattaneo inhabited a world of allegory more complex and more

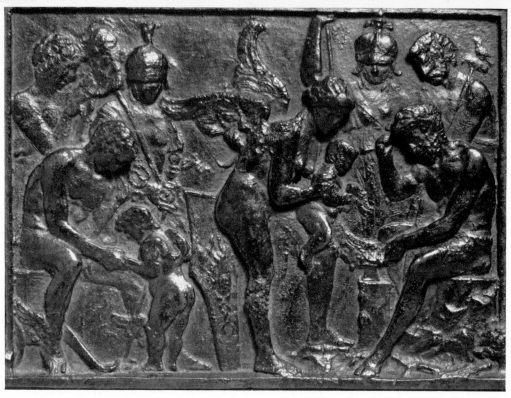

219. Here attributed to Camelio: *Vulcan forging the wings of Cupid*. Bronze, 17·5 × 25 cm. London, Victoria and Albert Museum

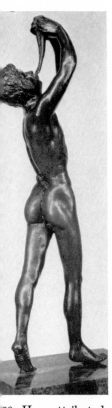

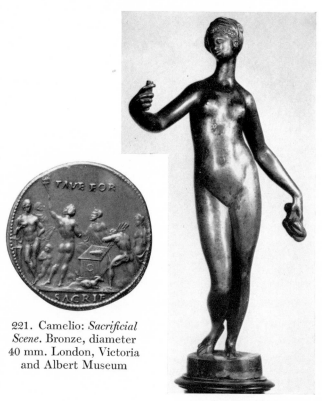

221. Camelio: *Sacrificial Scene*. Bronze, diameter 40 mm. London, Victoria and Albert Museum

20. Here attributed to Camelio: *Faun playing a double Flute*. onze, height 32·5 cm. Paris, Louvre

222. Danese Cattaneo: *Negro Venus*. Bronze, height 32·5 cm. Vienna, Kunsthistorisches Museum

223. Danese Cattaneo: *Luna*. Bronze, height 51 cm. Vienna, Kunsthistorisches Museum

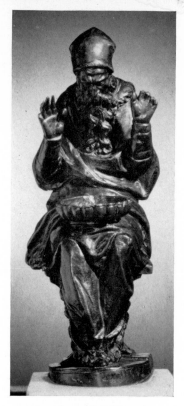

224. Alessandro Vittoria:
Allegory of Winter.
Bronze, height 33 cm.
Vienna, Kunsthistorisches
Museum

225. Alessandro Vittoria:
Woman warming her Hands.
Bronze, height 20 cm.
Naples, Museo Nazionale
di Capodimonte

226. Alessandro Vittoria:
Allegory of Winter.
Bronze, height 17 cm.
London, Victoria and Albert
Museum

227. Giuseppe de Levi: *Inkstand with Christ and the Woman
of Samaria*. Signed. Bronze, height 16·5 cm.
London, Collection Sir Leon Bagrit

228. Tiziano Aspetti: *Faith*.
Bronze, height 47 cm. Rome,
Collection H. E. Giacinto Auriti

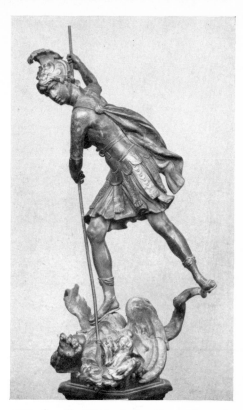

229. Niccolo Roccatagliata: *The Three Graces.*
Bronze, height 17 cm. Modena, Galleria Estense

230. Camillo Mariani: *San Crescentino and the Dragon.* Bronze, height 83 cm.
Urbino, Municipio

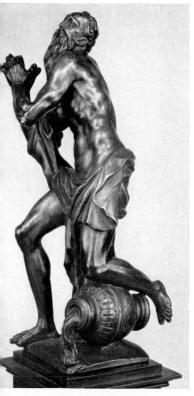

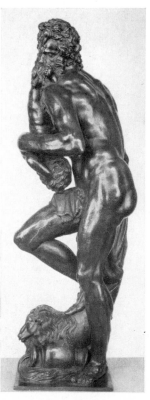

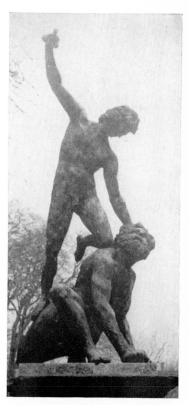

1. Camillo Mariani (?): *Allegory of Ocean.* Bronze, height, 24·1 cm. ienna, Kunsthistorisches Museum

232. Camillo Mariani (?): *Saturn devouring his Children.* Bronze, height 50·5 cm. London, Victoria and Albert Museum

233. After Vincenzo de Rossi (?): *David and Goliath.* Lead. Seaton Delaval

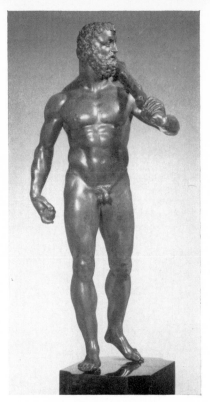

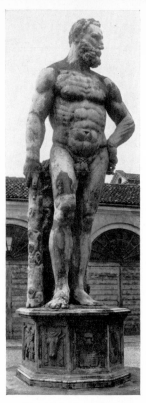

234. Bartolommeo Ammanati:
Hercules. Bronze, height 37·2 cm.
San Marino, Huntington Library

235. Bartolommeo Ammanati:
Hercules. Marble. Padua,
Palazzo Mantova-Benavides

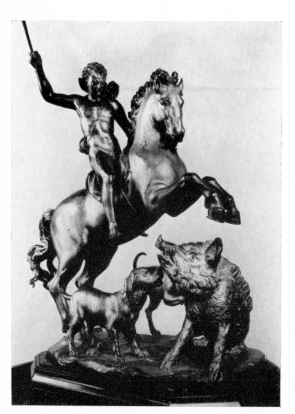

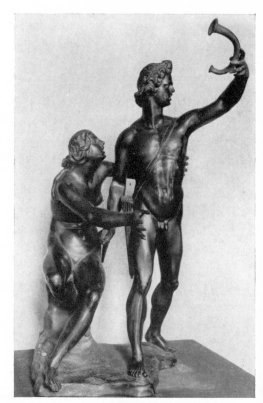

236. Giovanni Bandini: *Hunting Scene*. Gilt bronze.
Madrid, Prado

237. Giovanni Bandini: *Venus and Adonis*.
Bronze. Budapest, Szepmuveszeti Museum

recondite than Sansovino's. Two of his small bronzes were shown in the
exhibition—the *Luna* from Vienna (Fig. 223) and the so-called *Venus Marina*
from the Bargello. The Bargello bronze is really a *Fortuna*—there is a closely
similar figure with hair blowing in the wind on the reverse of a medal of
Niccolò di Marco Giustinian of 1520[57]—and the *Luna* has a medallic parallel
in the *Diana* on the reverse of Leone Leoni's medal of Ippolita Gonzaga. In
both statuettes the yellowish colour of the bronze, the lacquer, and the
relatively light casting are uniform. The version of the *Allegory of Vanity*,
known as the *Negro Venus*, in Vienna (Fig. 222) conforms to them in every
way. This model is looked upon by Schlosser[58] and Landais[59] as Floren-
tine, is given by Planiscig to Vittoria,[60] and is explained by Cessi, in a
recent book on Vittoria's bronzes,[61] as the work of a Tuscan sculptor close
to Danese Cattaneo. No finish of this type is ever met with in Tuscany,
there is no Tuscan artist whose style at all recalls Cattaneo's, and if the
bronze is photographed from the same angle as the *Venus* and the *Luna*,
Cattaneo's authorship admits of no dispute.

Another work ascribed to Cattaneo, the *Feast of Marine Deities*, was
represented in the exhibition by an unpublished version in London[62] of
rather better quality than the example in the Metropolitan Museum and
somewhat less highly chased than that at Cleveland. In this work the treat-
ment of the relief surface is far more ambitious and sophisticated than in the
bronze reliefs by Cattaneo on the Loredano monument or the dull marble
relief on the Loggetta. Juxtaposed in London with the Vittoria *Winter* from
Vienna (Fig. 224), the relief proved to be by Vittoria. There is only one
datable Vittoria relief in bronze, the Fugger *Annunciation* of 1580 at
Chicago. The *Feast of Marine Deities* is a little less evolved than the
Annunciation, so we might presume tentatively that it was made about
1575. The date must in turn affect our attitude towards its subject, which
was explained by Planiscig,[63] in an access of scholarly whimsy, as Cat-
taneo, the adopted son of Venice, feasted by Neptune and protected by
Apollo from the assaults of Mars, and by Phillips,[64] in a more prosaic
fashion, as an apotheosis of Sebastiano Venier. The head of the male figure
in the foreground is not unlike that of Venier, and the change in date lends
additional force to the second interpretation.

In any exhibition confined to modelled sculpture, Vittoria must stand out
as one of the very greatest High Renaissance sculptors. Considering the rich
documentation of his work, it is rather surprising that his development has
not been more fully analysed. A little book has recently been dedicated by
Dr Cessi to his bronze statuettes, and they have as a result become even

less intelligible than they were before. To take a single instance the
Juno,[65] of which a good workshop version from the Padua was shown in the
exhibition, often occurs as a pair to the *Jupiter*, the best-known version of
which is in Vienna.[66] Yet in the new book the *Jupiter* is dated about
1555–60 and the *Juno* about 1583–4.[67] Clearly the two bronzes were pro-
duced in close proximity, probably in the late seventies; a parallel for the
Juno is provided by *Faith* from the Bollati monument of 1577 at
Brescia. If the *Jupiter* cannot possibly have been conceived about 1555, how
much less likely is it that the *Milo of Croton* in the Ca' d'Oro was modelled
about 1553.[68] There is, after all, one point in the chronology of Vittoria's
statuettes that is absolutely firm, that in 1566 he adapted the *St Sebastian*
from the altar in San Francesco della Vigna as a bronze statuette. The task
of adaptation meant that a niche figure with a single view had to be trans-
formed into a figure fully in the round, and the weak pose and elegant
modelling of the statuette (which is now in the Metropolitan Museum)
show that it strained Vittoria's resources to the full. Clearly it is incon-
ceivable that the far better integrated *Milo of Croton* was made thirteen
years before this bronze. Still harder is it to believe that the bronze
Baptist in San Francesco della Vigna was also planned before the *St
Sebastian*.[69] Not only is the *Baptist* modelled with great strength, but its
pose is fully circular, and there is no reason why the conventional dating
given for it in the early eighties should be revised. Vittoria's was a long pro-
cess of self-education, each phase of which is clearly marked, and in the
small bronze it finds its climax in the *Quos Ego* in London, where the
compositional scheme of the bronze *Baptist* is transferred to a secular theme
and to a two-figure statuette.

It may also be objected that Dr Cessi's book includes bronzes that are not
by Vittoria and omits bronzes that are. In this second category belongs the
fine but sadly deteriorated lamp at Naples with a woman warming her
hands at the flame (Fig. 225), which Bode[70] rightly linked with the Vienna
Winter at a time when he believed the *Winter* to be Florentine. A second
lamp of the same type, with a male figure warming his hands, is in the
Victoria and Albert Museum (Fig. 226). Conversely the firedogs from the
Donà dalle Rose Collection ('*ora a Londra*' according to Dr Cessi)[71] have
been rightly ascribed by Gramberg to Giuseppe de Levi.[72] Of the provin-
cial bronze sculptors active in north Italy in the later sixteenth century,
Giuseppe de Levi is likely to establish himself as one of the most interesting,
if further figurated bronzes can be identified. The only example of his work
included in the exhibition, a signed inkstand with *Christ and the Woman of*

Samaria owned by Sir Leon Bagrit[73] (Fig. 227), reveals him as a narrative artist of great delicacy and inventiveness. Certainly on both counts he was the superior of Francesco Segala, who was identified by Lauts[74] as long ago as 1936 as the author of two fire-dogs in Berlin with *Hercules* and *Omphale*, versions of which from the Museo Civico at Padua were shown under a wrong attribution of Moschetti to Ammanati. Another version of the *Hercules* at Budapest with the club differently posed and the head turned over the right shoulder has been ascribed by Balogh to Bandinelli.[75]

One of the most puzzling aspects of the Venetian cinquecento statuette is the activity of Girolamo Campagna, who must, on the evidence of the reliefs on the Grimani monument in San Giuseppe in Castello, have been a more distinguished small-scale artist than any of the bronzes that now bear his name suggest. In the exhibition Campagna was represented by a work assigned to him by Planiscig, the *Kneeling Youth carrying a Shell*,[76] and by two debased fire-dog finials from the Palazzo Venezia.[77] Aspetti, on the other hand, appeared at his impressive best, with two unrecorded bronzes from the collection of Mr Peter Harris,[78] and a fine statuette from the Auriti Collection (Fig. 228), which is not, as stated in the London and Florence catalogues,[79] a 'versione ridotta di una delle Quattro Virtù cardinali eseguite per l'altare del Santo a Padova', but a wholly independent model of which a second version is in the Worcester Museum of Art.[80] A great part of Aspetti's appeal rests in the facture of his bronzes.

Technically the bronzes of Roccatagliata are less fine. The dense black lacquer which he favoured is effective enough where it is properly preserved, but more often than not it has failed to adhere properly to the surface, and the statuette in consequence makes an unpleasantly blotchy effect. In no other studio is an exactly similar technique employed, and on this account alone an attribution to Roccatagliata for the enchanting *Three Graces* at Modena[81] (Fig. 229) would be mandatory, even if the structure of the figures and the treatment of the profiles were less characteristic of the artist. Incidentally in at least two surviving versions of this model one of the figures is depicted holding dice. The central figure in a fresco in the Palazzo Porta-Barbaran at Vicenza carries the same attribute, and it may be inferred that the holes bored in the hands of the two lateral figures of the Modena bronze were for springs of rose and myrtle like those carried by the lateral figures in the fresco.[82] Studied more closely, Roccatagliata should prove a richly rewarding sculptor. The catalogue of his works includes a certain number of impossibly bad workshop bronzes—in London I took the liberty of suppressing that horrid little *St George* from the Ca' d'Oro—and

attention has been focused on decorative aspects of his work, as they are seen in the pretty but rather repetitious bronzes of putti, to the detriment of the more serious and essential phase recorded in the paliotto in San Moisè. In the exhibition the dramatic genius of the paliotto was hinted at in the moving *Expulsion from Paradise* from the Kunsthistorisches Museum.[83]

At this point reference should be made to one artist in the following of Vittoria on whom practically nothing has been written since his works were first brought to light by Planiscig.[84] This is the Meister der Hageren Alten, whose œuvre comprises four statuettes in Vienna that are clearly by one hand, and two incorrectly attributed bronzes, a *St Jerome* in the Estensische Kunstsammlung and a second *St Jerome* in London. Iconographical groupings are always treacherous—a great many of Planiscig's multitudinous mistakes go back to the belief that bronzes of analogous subjects are likely to be by one hand—and it is improbable that the Meister der Hageren Alten was exclusively a gerontophile artist. None the less he produced yet another bronze of an old man, a *Saturn devouring his Children*, which exists in a number of versions, one of them in London[85] (Fig. 232). Not only is the structure of this bronze closely bound up with that of the bronzes in Vienna, and especially with the *Allegory of Ocean* (Fig. 231) which was shown in the exhibition, but the surface working is a coarser derivative of that in the Vienna statuettes.

Planiscig, when he published the Vienna bronzes, described the master as active between 1560 and 1580, but the more closely one looks at them, the less likely does it seem that they were made at quite so early a time. Their analogies in Vittoria are with the *St Jerome* from the Scuola di San Fantin, not with the *St Jerome* in the Frari, and on general grounds it is probable that they were made in the bracket 1580–1600 and not at any earlier date. The burnished, smoky surfaces of the Vienna bronzes are unique in Venice, and conform so little to Venetian taste that they might lead us to suspect the statuettes were cast by a Venetian artist working in some other town. The style idiosyncrasies of the *Ocean*, its flattened, open pose and profile head, recall the sculptural thinking of Camillo Mariani, in whose colossal figures in San Bernardo alle Terme the same structural devices are employed. Given the disparity in medium and in scale, that analogy could not be seriously sustained without some further evidence. But luckily we know one work in bronze on an intermediate scale which is almost certainly by Mariani, and luckily it could be shown in the exhibition. This is the *San Crescentino and the Dragon* at Urbino (Fig. 230), which is not documented but seems to have been made for Francesco della Rovere about 1596.[86] The compositional

pattern of the small bronzes is closely reproduced in the *San Crescentino*, and not the pattern only but details of surface working on the urn and loin-cloth of the *Ocean* recur in it as well. It may, therefore, have been Mariani who transferred to Rome not only the style of Vittoria's stucco statues, but the style of his small bronzes too.

The whole question of Florentine cinquecento bronzes remains enormously more difficult. Vasari gives us no aid at all; he was rather a snob about size—in his quite long life of Tribolo, for instance, he did not think it worth while to mention that Tribolo modelled small bronzes, and he says nothing of small bronzes by other artists. Moreover, there are a number of bronze casters, Zanobi Lastricati and Zanobi Portigiani for example, about whose activity we are imperfectly informed. At the very end of the century, standing before the Pisa doors, we are once more left with the uncomfortable feeling that some of the artists who worked on them must have modelled statuettes. So the habit of bandying names for most small bronzes in the area of the second generation of Florentine cinquecento sculptors ought for the present to be dropped unless there are real grounds for the attribution, or we are humble enough to qualify it with a question-mark. One such case is the bronzes ascribed to Pierino da Vinci. On what evidence is the attribution to Pierino of that celebrated bronze of *Samson and two Philistines* based? Simply on Vasari's statement[87] that Pierino carved a group of *Samson slaying a Philistine* (one Philistine not two), and that '*mentre che'l marmo veniva, messosi a fare più modelli variati l'uno dall'altro, si fermò a uno; e dipoi venuto il sasso, a lavorarlo incominciò*'. All different from one another certainly, but not as different as is the marble in the Palazzo Vecchio from this bronze. The group owed its great popularity in the sixteenth century—it is introduced by Daniele da Volterra into the *Massacre of the Innocents* in the Accademia in Florence, and was studied with obsessive interest by Tintoretto—solely to its connection with Michelangelo, and with the best versions, the example in the Frick Collection or that in the possession of Judge Untermyer, the sense of Michelangelo's presence is overpoweringly strong. The cast may well have been produced in Florence in the workshop of Tribolo, but if Tribolo, or Pierino da Vinci, or any other artist had imposed their personalities upon the model, it would never have secured the wide diffusion that it did. The proper designation in this case is 'after Michelangelo'. There were two versions of the bronze in the exhibition, one from the Bargello,[88] which is notably less fine than the two examples in New York but superior to the version in the Louvre, and the

other from Rotterdam, an aftercast of later date in which the surface is treated with green paint.[89] What an odd rag-bag they are, the bronzes ascribed to Pierino by Planiscig; they include bronzes as incompatible as that weak group of *Mercury and Argus* in the Louvre[90] and the *Jealousy* at Rotterdam, a coarse, heavy casting with a mould mark round the waist, for which Weinberger, in a brilliant review of Planiscig's *Piccoli Bronzi* in the *Zeitschrift für Bildende Kunst* in 1931, rightly proposed a dating late in the seventeenth century.[91] The single certain bronze by Pierino da Vinci remains a tiny base with a female nude in the British Museum, which was identified thirty years ago, on the basis of a drawing, by Middeldorf.[92] The exhibition, however, left me with the strong impression—and I put this in the first person singular since the point is rather a contentious one—that the well-known *Apollo* at Vienna (which Planiscig looked on as a Bacchante and which he ascribed on more than one occasion to Francesco di Giorgio[93]) is a Florentine bronze of about 1540 by an artist related to the young Pierino.[94]

There are only three makers of bronze statuettes in the second quarter of the century about whom we know anything at all. The first is Bandinelli, whose solipsistic personality conferred one benefit upon posterity, that he signed his statuettes. His style anyway is unmistakable or would have appeared so had one gratuitous addition, in a Dutch private collection, not been made to his catalogue by Planiscig.[95] The second artist is Cellini, for whom we have a firm criterion of authorship in the four statuettes beneath the *Perseus*. These figures rule out of court not only the pretty *Venus and Cupid* once in the Lederer Collection,[96] but the reclining female figure at Oxford[97] and the *Ganymede* in the Bargello.[98] The only independent small bronze by Cellini known to me is the *Neptune* in the North Carolina Museum of Art, for which Valentiner's attribution is very possibly correct.[99] The third artist is Tribolo, who has been convincingly identified on the basis of a document as the author of the *Pan* in the Bargello,[100] and who was also responsible for the *Aesop* in London and its pair, the *Dwarf on a Snail* in the Louvre.[101] One hesitates to press outwards from this area of fact into the unknown, but at the London exhibition I was greatly struck by the relationship between the posture and modelling of the *Aesop* and that of the little *Satyr on a Tortoise* in the Ashmolean Museum.[102] Bode looked on the *Satyr* as Venetian, Fortnum gave it to Ammanati (the rather forbidding name it bore during the London, Amsterdam and Florence exhibitions), and more recently Miss Ciardi-Dupré, in her happy-go-lucky fashion, has concluded that '*parrebbe persino per certi dati di patina e di*

stile, quali la fattura dei capelli ed il modellato serpente delle membra del satiro, un oggetto "stile liberty"'.[103] Unbeknown to Miss Ciardi-Dupré, one '*oggetto "stile liberty"*' really was included in the London exhibition, a bronze door-knocker which Planiscig looked on as the work of an otherwise unrecorded A. E. Levis, active in Verona in 1594. This proved to have been made by a certain Alfred E. Lewis, of 4 Victoria Villas, Kilburn, and was shown at the Royal Academy in London in 1894 as No. 1766.[104]

In the third quarter of the century the Studiolo supplied a group of bronze sculptures from which the styles of all the bronze artists active in Florence about 1570 can be deduced. The correct attributions for these bronzes have only been arrived at comparatively recently, and earlier, when all save three were wrongly identified, the eddies of misattribution naturally spread to the little works depending from them. When Vincenzo Danti's *Venus* was given to Ammanati, and Ammanati's *Ops* to Poggini, and Stoldo Lorenzi's *Amphitrite* to Vincenzo de' Rossi, the consequential attributions were almost bound to be nonsensical. The fact that four of the Studiolo bronzes were shown in London made it possible to re-examine their relationship to the works depending from them. The so-called Poggini *David* in the Victoria and Albert Museum reproduces the *Pluto* in the Studiolo. It was looked on by Bode as a 'free reproduction ... essentially finer',[105] and has since become the lynch-pin of a revised Poggini chronology,[106] but there is no doubt that it dates from the nineteenth century. In London, too, there is a stucco version of Stoldo Lorenzi's *Amphitrite*, which is not, as Venturi supposed, a model for the Studiolo figure, but what it was claimed to be when it was bought in 1859, 'an ancient reproduction of the bronze'.[107]

The only small bronze that can be given confidently to Ammanati, that is to the author of the *Ops*, is the excellent statuette of *Hercules* in the Huntington Library (Fig. 234).[108] This figure is linked to Ammanati first by its action, which reproduces the movement of the Mantova-Benavides *Apollo*, second by its modelling, which recalls the torso of the Uffizi *Mars*, and third by its type, which conforms to that of the colossal *Hercules* at Padua (Fig. 235). Vincenzo de' Rossi was probably responsible for the interesting *David and Goliath* group published by Valentiner[109] some years ago as Bandinelli, in which the David looks forward to Landini and the Goliath looks back to Bandinelli. There is a good version of it in a private collection in New York, and another example is in the storeroom of the Pushkin Museum in Moscow. The basis of comparison is not the ungainly *Vulcan* in the Studiolo (though no bronze which is incompatible with the *Vulcan* can be ascribed to Vincenzo de' Rossi), but the marble *Adonis* in the

courtyard of the Bargello, where the two ends are rationalised as triangles in much the same fashion as the main view of the bronze group. My reason for mentioning it here is not that it was in the exhibition, but that I recently came across another piece of evidence regarding it. In quite a number of English gardens there are full-scale lead copies of Florentine marble groups dating from the late seventeenth or eighteenth century; Giovanni Bologna's *Samson and a Philistine* (invariably described as *Cain and Abel*) occurs particularly frequently. At Seaton Delaval the *Cain and Abel* has a pair on the same scale, and it is the *David and Goliath* of this statuette[110] (Fig. 233). So the statuette is evidently based on a life-size prototype in marble, and on a prototype which at one time may have been in English hands. When it is rediscovered, it should prove to be Vincenzo de' Rossi's masterpiece.

Vincenzo Danti, the most accomplished bronze sculptor in Florence after Giovanni Bologna, has been discounted by students of bronze statuettes. An effort to secure the *Venus Anadyomene* for the exhibition was not successful —Giovanni Bandini's *Juno* tramped to London in her place—but from the Museo degli Argenti came the bronze of *Honour triumphant over Falsehood*, and the Bargello disgorged that masterpiece, the *Brazen Serpent* relief. All things considered it is surprising how little we know about this second work. References to it occur in Vasari and Borghini,[111] when it was in the Medicean guardaroba, but we cannot tell how it got there nor when it was made. From its shape and size it would appear to have been planned as an antependium relief, perhaps for the chapel in the Palazzo Vecchio, the grille for which was made by Danti. The same scene occurs in one of the Bronzino frescoes in the Chapel of Eleanora of Toledo. What is clear is that its size, presumably determined by the altar for which it was intended, was inconveniently large, and that for this reason it was modelled and cast in two parts, which join down the centre of the scene. For so ambitious a work this is an amazingly clumsy device; the join runs through the forearm of Moses, and has the effect of depriving his gesture (which should form the narrative climax of the scene) of almost all its force. That is perhaps the reason why it remained in the guardaroba and was not put to use. But provided we regard it as two reliefs not one, it is an exceedingly impressive work. Characteristically enough the figure style depends from the last phase of the Sistine Ceiling, not from the *Last Judgement;* the relief is an attempt to readapt to sculpture the idiom of Michelangelo's pendentive of the same scene. There is a manifest connection between the figures and the reliefs on the cope of the statue of Pope Julius III at Perugia, which was completed in

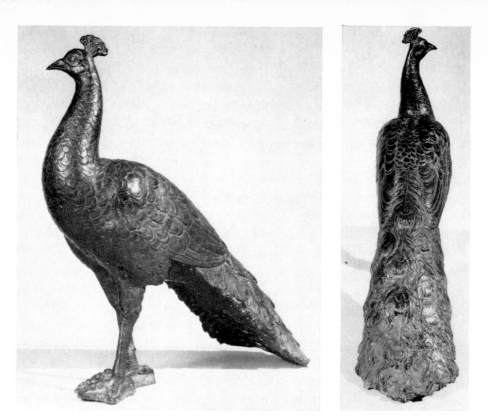

238-239. Giovanni Bologna (?): *Peacock*. Bronze. Florence, Palazzo Vecchio

240. Giovanni Bandini: *Adonis*. Bronze, height 20·5 cm.
London, Victoria and Albert Museum

241. Giovanni Bandini: *Venus*. Bronze, height
20·5 cm. London, Victoria and Albert Museum

242. Giovanni Bandini: *Meleager*.
Bronze, height 28 cm.
London, Victoria and Albert Museum

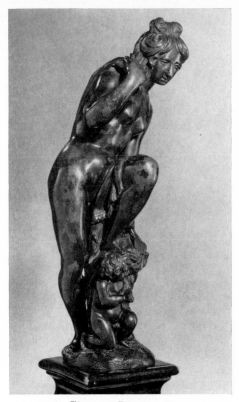

243. Giovanni Bandini: *Venus*.
Bronze, height 36 cm.
London, Victoria and Albert Museum

244. Pietro Tacca: *Monkey taking a Baby from its Cradle*.
Bronze, height 20·5 cm. London, Victoria and Albert Museum

245. Ferdinando Tacca: *The Martyrdom of St. Lawrence*. Bronze, height 19·4 cm.
London, Victoria and Albert Museum

246. Alessandro Algardi: *Charity*.
Bronze, height 47·6 cm.
London, Victoria and Albert Museum

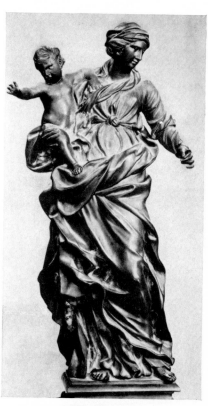

247. Alessandro Algardi: *Madonna and
Child*. Bronze, height 48·5 cm.
Urbino, Galleria Nazionale delle Marche

248. Gian Lorenzo Bernini: *One of four grotesque masks.*
Gilt bronze, height 15 cm. Rome, Eredi Bernini

1555 and installed in the following year, and the balance of probability is that it was cast soon after Danti moved to Florence in 1557, when the memories of his Roman visit of three years earlier were still fresh in his mind, and is therefore somewhat earlier than the safe door in the Bargello. No more than any other sculptor could Danti resist the sterilising taste of the court of Cosimo I, and the measure of his failure is the speed with which the Rodin-like forms of the *Brazen Serpent* give way to the more elegant, less meaningful forms of the safe door. In the same way the splendidly vigorous marble group of *Honour triumphant over Falsehood*, which must have been carved in the early 1560's and which conjecturally derives from a model by Michelangelo, is progressively transformed, first into the flattened terracotta statuette in the Bargello, and then, as a result of further thought, into the bronze in the Museo degli Argenti, where the memory of Michelangelo has been expelled and the detail reminds us irresistibly of the paintings of Bronzino.[112]

Danti's most familiar bronze figures, the group of the *Decollation of the Baptist* over the south entrance to the Baptistery and the *Venus Anadyomene* in the Studiolo, date from very late in his career: the Baptistery group was installed in 1571 and was probably modelled some two years earlier, and the *Venus* belongs with a series of sculptures which were, with one exception, completed in the summer of 1573. In the exhibition the *Juno* of Giovanni Bandini was substituted for Danti's *Venus Anadyomene* (whose presence might well have cleared up a number of disputed points), and it provided one of the surprises of this part of the exhibition, that the peacock (Figs. 238, 239) (which is cast separately from the main figure and is screwed into the base) was not modelled by Bandini.[113] This can be stated dog-matically, because we know one small bronze by Bandini in which animals are shown. The bronze is described by Borghini,[114] who tells us that Bandini '*di presente prepara di gittar di bronzo una figura, che essendo sopra un cavallo che salta, ferisce un cinghiale: e vi sono due cani, l'uno che ha preso la fiera per un orecchio, e l'altro in atto di abbaiare: la qual opera si spera, che sara bellissima, siccome tutte le altre sue*'. Professor Middeldorf has generously drawn my attention to the fact that this group is identical with an unpublished gilt bronze group in the Prado in Madrid (Fig. 236), in which the figurative elements derive from the right side of a Hippolytus sarcophagus.[115] The interest of this discovery should not blind us to the relatively poor quality of the Prado bronze; never could the hand that modelled the boar and hounds in the small bronze have achieved the smooth forms and confident movement of the peacock in the Studiolo.

Inseparable from the *Boar Hunt* is a group of *Venus and Adonis* at Budapest (Fig. 237) which was published by Balogh with a wrong attribution to Giovanni Francesco Susini.[116] The *Boar Hunt* seems to date from 1583, and we know that Bandini, when he arrived at Pesaro a year before, had little experience of bronze sculpture. This is stated explicitly by Simone Fortuna in a letter written from Florence to Francesco Maria II della Rovere at Urbino when Bandini's appointment as sculptor to the Duke of Urbino was first contemplated. '*Nel getto*', says Fortuna,[117] '*egli non s'è molto esercitato havendola per cosa assai facile, non di meno mi ha fatto vedere una statuetta di bronze che fece a concorrenza di molti altri nello studiolo del Gran Duca, la quale è tenuta molto bella.*'

Bandini's appointment was inspired by the Duke's wish to procure for his study two marble groups of *Venus* and *Adonis* each one braccia in height. The two groups have disappeared, but in 1584 they were described in the *Riposo* of Borghini:[118] '*Oggi si sta Giovanni in Pesaro in servizio di Francesco Maria Feltrio della Rovere Duca d'Urbino, dove ha fatto . . . dua figure di marmo per metà del naturale l'una rappresentante Venere con Cupido, che ha un pesce sotto il sinistro piede: e l'altra Adone con uno spiede in mano, e un cane allato, che sono ancora appresso di Giovanni.*' It has already been noted[119] that this description corresponds exactly with two well-known bronze statuettes of *Venus* and *Adonis* (Figs. 240, 241), of which examples from the Victoria and Albert Museum were shown in the exhibition under a conventional attribution to an unidentified Paduan sculptor of the first half of the sixteenth century. In preparing the catalogue entry for the bronzes I thought it worth while to point out that the casting, though flawed and rough, was extremely thin, and precluded a dating before the middle of the sixteenth century.[120] One of the most individual features of these bronzes is the type of the seated Venus, and this corresponds exactly with that of the Venus in the group at Budapest. There is, therefore, no alternative but to regard the London bronzes (and the variants of the models in the Frick Collection and elsewhere) as reductions by Giovanni Bandini from his marble groups, and to explain their deceptively primitive facture by the accident that they were cast in a provincial foundry and not by the date when they were made.[121]

The ramifications of Giovanni Bandini's activity as a bronze sculptor are much greater than even these attributions suggest. Already in the Berlin bronze catalogue of 1904[122] Bode noted that a *Venus on a Dolphin* in Berlin was palpably by the same hand as the model of *Venus and Cupid* in London, and the two bronzes are indeed so similar in type that common

authorship is the only admissible explanation of their uniformity. A large bronze of *Venus and Cupid* in London (Fig. 243), which was regarded by Bode as 'thoroughly Flemish in form, type and movement' and was dated by him about 1600,[123] is also unmistakably by the same hand as the *Seated Venus* in London and the *Venus and Adonis* at Budapest. Perhaps this is a reduction of one of the two marble Venuses which, according to Borghini,[124] Bandini carved in Florence ('*due Venere d'altezza di due braccia, le quali sono state comprate da forestieri, e mandate fuor di Firenze*'). Some years ago a small bronze *Meleager with a Dog* was bought for the Victoria and Albert Museum (Fig. 242), for no better reason than that it was by the same artist as the standing *Venus*, and that the conjunction of two bronzes by one hand might enable the sculptor in due course to be identified. This bronze in turn finds points of reference in the groups in Madrid and Budapest, and must be weighed in Bandini's debit account.

The bronzes in the Studiolo have a curious history, in that they occupied their niches only for a short time, and were then moved by Francesco de' Medici to positions in which they were more fully visible. But just before the first world war they were put back into the dark, inaccessible niches for which they were designed. This decision was academic and short-sighted, and we may hope that some official, inspired by the memory of the reddish gold surfaces of the eight figures (the bronzes are probably the earliest examples of this form of Medicean patination), will have the strength of mind to follow Francesco de' Medici's example, and treat them not as constituents of an arid mannerist programme, but as independent works of art. When that is done, Giovanni Bologna's *Apollo* will appear in its true colours as what it has long seemed to be from photographs, one of the supreme achievements of bronze sculpture in the sixteenth century.

The works of Giovanni Bologna were very amply represented in the exhibition, mainly by fully authenticated bronzes. There was the bronze *Neptune* model from Bologna, which could be confronted for the first time since 1565 with the clay model for the Neptune in the Victoria and Albert Museum. An attempt has recently been made to give the clay model to the circle of Ammanati,[125] but it has a firm provenance from Bologna, and even if its origin were less certain than it is, comparison with the Bologna bronze would be amply sufficient to prove its authorship. Two *Mercuries* were shown, the Bologna bronze of about 1563 and the Farnese bronze of about 1578. The essence of Giovanni Bologna's development is comprised in the differences between them, and the apparent inferiority of the Naples bronze is due solely to its unspeakably neglected state. Two of the *Angels* from the

Grimaldi Chapel at Genoa were also present, and very strange they looked, foreign intruders on the Italian scene. One of the problems of Giovanni Bologna's small bronzes is that of studio execution, and an attempt was made in the exhibition to define the handling of some of his followers, especially of that smooth, uninventive artificer, Antonio Susini. The paired bronzes of rearing horses (of which two in the Mendelssohn Collection in Berlin were published by Bode as Giovanni Bologna, and two from the Palazzo Venezia appeared in the exhibition as Tacca) are surely transcriptions by Antonio Susini of models by Giovanni Bologna, and are not by Tacca.[126]

The hero of this part of the exhibition was not Antonio but Giovanni Francesco Susini, on two levels, moreover, as a technician and as a creative artist. Susini's authorship of the small *Porcellino*[127] now in the Bargello is vouched for by Baldinucci, and technically it is a remarkably fastidious work. No less accomplished are the four little figures, also by Susini, at the corners of its *pietra dura* base. These are palpably by the same hand as the very pretty *Music-making Putti in a Shell* in the Palazzo Venezia, for which Pollak in the Barsanti catalogue proposed an ascription to Ferdinando Tacca, but which Dr Santangelo, in the catalogue of the Palazzo Venezia sculpture, has dated back to *c.* 1575.[128] Another Barsanti bronze, the little *Venus chastising Cupid*, which is wrongly connected by Dr Santangelo with the Modena *Three Graces*, is also inseparable from the subsidiary figures on the *Porcellino* base.[129] The surface of Susini's *Dying Gladiator* in the Bargello is somewhat impaired, but the signed *Ludovisi Ares* at Oxford[130] is perfectly preserved, and is the outcome of a state of mind in which the antique is approached not with the ebullience of the young Bernini, but with the sensibility and single-mindedness of a seicento Winckelmann.

One of the defects of this part of the exhibition was the omission of bronzes from the Tacca workshop. Pietro Tacca died in 1640, and for the next forty-six years bronze sculpture in Florence was dominated by his son. No attempt has been made to assemble his small bronzes or to define his contribution to the statuette, and several of the statuettes reproduced in the standard book dealing with his work are by Bertos and other artists. But Tacca on a large scale was an extremely distinguished artist, and if the evidence of the model for or reduction from one of the Annunziata fountains is to be credited,[131] he was an extremely distinguished small-scale bronze sculptor as well. One of the statuettes for which he was certainly responsible is the attractive model of a *Monkey abducting a Baby from its Cradle*, which exists in a single version in London[132] (Fig. 244). A note on

this bronze prepared when it reached the Victoria and Albert Museum in 1910 with the Salting Bequest observed perfectly correctly that 'the demon feet and the punched work on the clothes in the cradle suggest the atelier of Giovanni Bologna'. The fact that this just dating has since been replaced with an ascription to a Paduan studio of *c.* 1500 is due once more to the blind eye of Planiscig.[133] Some of the most Tacca-like features of the bronze are the little grotesque faces on the inside of the supports, which are visible only when the bronze is looked at from beneath. The notion of the bronze group as an association of figures and objects set on a flat, raised platform was peculiar to the Tacca shop, and it occurs again in one of the few small bronzes that are ascribable to Ferdinando Tacca. Though he occupied the office of Grand-Ducal sculptor from 1642 until his death in 1686, Ferdinando Tacca is a rather obstinately elusive artist, and neither the Fontana del Bacchino at Prato nor the svelte *Angels* in the Duomo at Pietrasanta and in the Wallace Collection[134] offer a satisfactory basis for the identification of his statuettes. In the *Stoning of St Stephen* which was formerly in the high altar of Santo Stefano in Florence, however, we have a documented work of 1656 to which small bronzes might reasonably be expected to conform. One bronze indubitably does so, the fascinating ink-stand with the *Martyrdom of St Lawrence* from the Pierpont Morgan Collection[135] (Fig. 245), where the protracted proportions and open poses of the figures are indissociable from the relief. This group (which was recently secured for the Victoria and Albert Museum) must be by Ferdinando Tacca, and not Pietro Tacca to whom Bode ascribed it. It is constructed in the same way as the *Monkey abducting a Baby*, though the figures are rather more rigid and are much less highly finished, and the triangular platform is raised on three little devils, which are not mere decorative adjuncts, but have a programmatic relevance to the scene.

Before Ferdinando Tacca's death the last haven of High Renaissance classicism had become the scene of a palace revolution instigated by Foggini and Soldani. Quite a number of bronzes by both artists were included in the exhibition, and very fine they were, but there is no obligation to discuss them here, since they constitute the only point in the history of the bronze statuette in which real progress has recently been made. Would that a fraction of this study had been devoted to the bronze statuette in Rome in the watershed between High Renaissance and Baroque. As it is, we are almost wholly ignorant of the activity of Maderno as a bronze sculptor, and until the exhibition it would have been denied that his contemporary Cordieri was responsible for any statuettes. But the figure of *Charity* in the

Salting Collection in the Victoria and Albert Museum, which was looked on by Bode as Michelangelesque[136] and was reproduced by Planiscig as a Venetian bronze,[137] in fact corresponds (as Balogh first observed[138]) with the marble group of *Charity* on the Aldobrandini monument in Santa Maria sopra Minerva. Let us hope that before long some student may be stimulated to reopen this forgotten chapter in the history of the small bronze.

There was another *Charity* in the exhibition[139] (Fig. 246), an unpublished group which is clearly by the same hand as the *Virgin and Child* of which examples exist in Berlin and the Rhode Island School of Design and at Urbino (Fig 247). The Berlin and Providence bronzes are conventionally given to Ercole Ferrata, but as long ago as 1928 Wittkower, in an admirably argued article buried away in *Rassegna Marchigiana*,[140] claimed the Urbino bronze as an Algardi, and it is Algardi who is also answerable for the *Charity* in London. A bronze group of this subject by Algardi is recorded in the Segni collection at Bologna.[141]

The baroque section of the exhibition was less full than one would have wished. I had hoped, for example, that it might be possible to investigate through it the status of the small bronzes deriving from the *Neptune and Triton*, and to borrow those little-studied statuettes ascribed to Bernini in the Palazzo Schifanoia at Ferrara and in the Royal Palace in Madrid. For one reason or another that was impracticable, and there is only one achievement to be marked up on the credit side, that the exhibition, thanks to the insistence of Dr Santangelo, included four gilt bronze masks (Fig. 248) in the possession of Bernini's heirs which were illustrated by Fraschetti but are omitted from more recent books.[142] These are the only surviving small bronzes by Bernini. Their history goes back to 1706, when they are described in an inventory as '*li nasi della carrozza del Cavaliere*', and there is no reason to question the tradition that they were made by Bernini himself for his own use. Shown at the end of the London exhibition, not far from the *Hercules and Antaeus* of Antonio Pollajuolo at its beginning, they offered a vivid illustration of the expressive possibilities of bronze, and of what the term 'autograph small bronze' should mean.

Originally published in *The Burlington Magazine*, cv, January, February, 1963.

Portrait of an Art Historian

'I FOR one,' wrote Bernard Berenson in 1945 in the preface to his *Sketch for a Self-Portrait*, 'am not sure just which of my so many selves, at different moments of my life, would represent me most faithfully.' The book ends with a quotation from La Fontaine:

> and shall I tell thee, dear Delight,
> Of this our joy the measure true?
> A century at least we'ld claim of right
> For thirty years were all too few.

Berenson died in Florence last October, and already, with a precipitancy that may seem a little indecent in the case of a life so timeless and serene and a character so many-faceted, the first biography has come off the press.[1] Length of life—he was in his ninety-fifth year—and range of interests are not the only problems that he presents to a biographer. For almost seventy years his writings offered a faithful picture of his thought. Some of them were overtly autobiographical, others were autobiographical by implication, a personal record of aesthetic experience. They describe an evolving attitude to works of art, and form, if they are correctly read, a key for study of his mind. Here is the natural starting-point for any book on Berenson.

Heedless of the warning in the *Sketch for a Self-Portrait*, oblivious of the written work, Mrs Sprigge has instead concentrated upon fact. She has unearthed Berenson's tinker father, she has delved into his school reports, she has raked over his relations with Duveen, and when factual material is short she has filled out her book with padding about Vernon Lee and Mrs Strong. As a result all those activities which were central to the personality of Berenson have in some mysterious fashion passed her by. In 1831 a sculptor called Macdonald was sent to Abbotsford to make a record of Scott's head; he measured it with the callipers and produced a bust which was phrenologically accurate but had one disadvantage, that it was unrecognisable. This is Mrs Sprigge's achievement for Berenson. Fortunately, however, there appear at the same time two books in which Berenson's own voice is heard. The first, *One Year's Reading for Fun*, is a diary of his reading in the enforced seclusion of 1942; the second, *The Passionate Sightseer*, consists of

travel diaries compiled between 1947 and 1956. Fortunately, too, Miss Barbara Skelton took her Leica with her when she visited I Tatti, and has published in the January issue of *Encounter* a vignette which captures to perfection the dragonfly flight of Berenson's mind and the rhythm of his speech.

Berenson's was a life in which the facts are in large part irrelevant. He was born at Butremanz, in Lithuania, in 1865, and was brought up there until the age of ten, when his family migrated to the United States. Mrs Sprigge's reconstruction of life in the Pale of Settlement is perhaps the best thing in her book. Existence in Boston seems to have been precarious, but there, while still at school, Berenson formed the habit of gluttonous reading that he carried with him throughout life. In these years the foundations of his visual taste were also laid when Flaxman introduced him to the antique. After a short period at Boston University he entered Harvard. In 1942, when he was reading Van Wyck Brooks's *Emerson and Others*, he noted in his journal:

Reading about the Concord circle now, I realize how much I, despite my foreign birth and childhood, despite all superposed impressions of living away from America, owe to these New England precursors—most of my brain values, many of my prejudices, and any number of my hopes and fears.

In 1887 he came to Europe, making his first extensive contacts with Italian painting in the National Gallery and the Louvre, and in the following year visited Italy, where he got to grips for the first time with the study he was to make his own. In Boston he had won the friendship of Mrs Gardner, and in 1894 he made the first of a long series of purchases on her behalf, a painting by Botticelli from Ashburnham which was the pendant of a panel he knew at Bergamo. His acquisitions for Mrs Gardner, which continued until 1905, freed him from financial pressure, and formed the background of a period of otherwise unremunerative study and of intense literary productivity. They enabled him, moreover, after his marriage in 1900 at first to rent and then to buy the house near Florence the name of which later became a cultural symbol, I Tatti.

Two years after Mrs Gardner had ceased buying paintings Berenson entered on a thirty-year-long connection with Duveen. Mrs Sprigge goes in detail into the whole question of his relations with the art market, and devotes some space to 'refuting tangible as well as shadowy allegations against his probity'. She quotes that distinguished connoisseur the late

F. Mason Perkins as expressing his conviction that Berenson was 'incapable of giving an attribution of which he was not convinced'. This is unquestionably true. But no scholar's reputation will survive the publication of his certificates. The certificate is a dealer's expedient to assist his sales; its function is not simply to state by whom a work is executed but why it is worth purchasing. It is a clandestine advertisement.

Mrs Sprigge prints a certificate prepared by Berenson for a Piero della Francesca predella panel in a private collection in New York, and many of her readers will purse their lips when they find that this perfectly authentic minor painting is contrasted favourably with the Arezzo frescoes and compared with Giorgione and Cézanne. Only those who have practical experience of the penumbral world of the certificate, who are familiar with those strange documents which can combine in equal ratios the casual, the crooked and the incorrect, will accept this sales talk as what it was, the indispensable top-dressing for a judgment which was invariably honest and seldom wrong. Mrs Sprigge gives a graphic account of the temptations to which museum officials 'in one form or another, sooner or later, and in every country' are exposed, but this line of argument is both unreal and inapposite, since Berenson's was a way of life that was deliberately espoused, which was not discreditable, and which was amply justified by its results.

Not only its results for Berenson. As he admits in the *Sketch for a Self-Portrait*, he felt a deep-seated scorn for the collector, but his influence upon collecting was incalculable. The *locus classicus* for this is Fenway Court. The miracle of Fenway Court, however, is that Berenson succeeded in selling so many masterpieces to a woman whose interest in art was scenographic, whose taste was fallible and whose sense of quality was insecure. The main emphasis should rest rather on the National Gallery of Art in Washington, with its splendid Italian paintings drawn from private collections which could not have been formed in any climate but that of Berenson's own taste. In addition, no life of Berenson can be regarded as complete that does not include at least a brief account of the collection at I Tatti. This is important both for what it signifies and for what it is. It contains a number of masterpieces—a great Madonna by Domenico Veneziano, two magnificent Signorelli portraits, a famous Sassetta altarpiece and many more—but it is also, in its diversity and scope, a profession of faith. The only glimpse of this that Mrs Sprigge allows us is in her frontispiece, which shows Berenson in his study standing beneath an ethereal Madonna by Neroccio.

There were two important periods in Berenson's life. One was what he himself described as 'the first thirty-six years', the time, that is, that saw the publication of the *Venetian*, the *Florentine* and the *Central Italian Painters of the Renaissance*, the monograph on Lotto, and the first volume of *The Study and Criticism of Italian Art* and witnessed most of the preliminary work for *The Drawings of the Florentine Painters*. Berenson himself looked back with unconcealed nostalgia on these idealistic years.

Where a Lotto was to be found or seen [he wrote in 1953] there I went, regardless of wind and rain, cold and discomfort. . . . In the remotest villages of the Marches there was often nothing to eat but hard bread, onions and anchovies, but every morning I awoke to a glamorous adventure, tasted the freshness of a spring or autumn morning in a Bergamasque valley as if it were a deliciously invigorating draught. Each altarpiece . . . I enjoyed like the satisfaction of a vow, and it remained fixed in memory as a crystalline individuality and not as a mere particle in the *oeuvre* of a painter. Its overtones lingered in recollection and its taste on the palate.

Mrs Sprigge is almost wholly unsuccessful in reviving the enthusiasms of this far-off time. One would ascribe this to lack of knowledge of the subject, had not an experienced biographer, Marchesa Origo, working from the same material, Berenson's early letters collected by his wife, produced, in the spring issue of the *Cornhill*, a masterly evocation of these years. She describes how 'on first seeing Monte Oliveto, the ash-grey hills and steep, bare canyons at once reminded him of Doré's wildernesses'. She sketches him 'quite dizzy with happiness' outside San Biagio at Montepulciano. She follows him and his future wife through their frugal days of study at Verona in the autumn of 1891. Not the least of Marchesa Origo's gifts is what Pater calls 'the tact of omission', and if we wish to scrape acquaintance with the young Berenson it is to her article that we must turn.

The second important period in Berenson's life was the last fifteen years, that time of slow apotheosis, an Indian summer in which old hostilities had faded and the reaction against his work had ceased, and when gnawing regrets for what might have been done broke in less often on tranquil satisfaction at what had actually been achieved. It was at this time that he exercised his greatest influence. Books he had written half a century before were still living and still read, and new books reached a public of which he had not previously dreamed. The new books were in the main concerned with values rather than with connoisseurship, but his devotion to art

history became more, not less, complete, until at last, when his powers failed and other interests were one by one extinguished, this flame alone burned bright.

The life of Berenson, then, is the story of a mind. But the unwary reader who turns to Mrs Sprigge for his views on any topic will be in for some rude shocks. One instance of her use of sources must suffice. In 1916 Berenson published a well-known essay on Leonardo da Vinci, in which he describes how, when he first arrived in Europe, he stood before the *Mona Lisa* 'trying to match what I really was seeing and feeling with the famous passage of Walter Pater, that, like so many of my contemporaries, I had learned by heart'. Mrs Sprigge makes use of this passage, with some licence, when she describes Berenson in Paris in 1887. 'Within a few months of these first days at the Louvre,' she continues, 'Berenson cast his boyish eyes on Leonardo's *Last Supper* (or what was left of it) in Milan, and there, too, felt a repulsion. He found "the faces uncanny, too big and too many."' But Berenson's account of the 'Last Supper' (from which this passage is drawn) is dated to a period forty years before the publication of the essay; it records impressions formed not in Milan in 1888 but in Boston in 1876, and is interesting solely on this account. Mrs Sprigge goes on, 'Leonardo as a painter never won Berenson. He had been too experimental; his paint had not lasted. . . . Leonardo's women certainly appalled him.' Leonardo, she tells us in another place, 'never really won Berenson's devotion either in line or colour'. But Berenson's objection, as it was expressed in the essay of 1916, was to 'Leonardo's surrender of his native genius to professional problems and academic ideals', and the chapter on Leonardo in *The Drawings of the Florentine Painters* is cast throughout in serious, appreciative terms. It includes, indeed, in the account of Leonardo's cartoon at the Royal Academy, a little classic of descriptive criticism which Mrs Sprigge has evidently overlooked:

One will scarcely find draped figures conceived in a more plastic fashion, unless one travels back through the centuries to those female figures that once sat together in the pediment of the Parthenon. In Italian art we shall discover nowhere a modelling at once so firm and so subtle, so delicate and so large as that of the Virgin's bust here. We should look in vain, also, for draperies which, while revealing to perfection the form and movement of the parts they cover, are yet treated so unacademically, are yet so much actual clothing that you can think away.

Berenson's written work is entirely unlike that of any other art historian. A reader who picked up *The Study and Criticism of Italian Art* for the first

time might well be deceived by its urbane, slightly dilettantish tone into believing that the results reported in it were the fruit of casual observation and not of a long period of close work. On a large canvas Berenson maintained the same texture as on a small, and the monograph on Lotto (methodologically one of the most forward-looking of his books) is couched in precisely the same tone. In the most rigorous and elaborate of his publications, *The Drawings of the Florentine Painters*, the text volume can be read with pleasure by the non-specialist. The importance of this cannot be overstressed. With industry, method and average intelligence, it is comparatively easy to produce a mammoth volume in which footnote is piled on footnote and fact on fact. It is infinitely harder to achieve a distillation which deals only with essentials and which is addressed to all the faithful and not simply to one sect.

For Berenson art history was the study of the artist's effort to communicate. This preoccupation runs through his entire work. In *Venetian Paintings in America* (which Mrs Sprigge, rather humourlessly, retitles *Venetian Painters in America*, and describes as 'an essentially professional book for the use of the new collectors in the United States') it inspired a memorable account of Antonello da Messina:

Antonello was not an imaginative artist. As was the case with Piero della Francesca and Velasquez, his greatness consisted in presenting objects more directly, more penetratingly, more connectedly and more completely than we could see them for ourselves, and not in making a dramatic or moving arrangement of his vision that might make a further appeal to our emotions. He was more bent upon extracting the corporeal than the spiritual significance of things.

In *The Drawings of the Florentine Painters* it produced an extraordinary account of Andrea del Sarto's use of the medium of red chalk:

With red chalk you could dash down some idea that was quickening your mind; with red chalk you could shade broadly when you liked ... with red chalk, if you had the gift, you could delineate a contour as with a quill, making it fainter and fainter when you liked, and giving such accent that your line would seem not drawing, but the infallible registration, made automatically by your nerves, of your acts of most searching vision.

And it shines out from the pages of the essay on Sassetta which first appeared in 1903:

While it would be interesting at this point to ask what means the art of painting has of conveying this mystic feeling, I must here limit myself to saying that the instruments at the disposal of European art for this object are nearly confined to one—space composition—and that little understood and seldom employed by our artists. But the East has all the treasures of imaginative design, and Sassetta, with the quasi-oriental qualities of a Sienese, has left us such a design, which, as a bearer of the true Franciscan perfume of soul, has no rival. Over the sea and the land, into the golden heavens towers the figure of the blessed Francis, his face transfigured with ecstasy, his arms held out in his favourite attitude of the cross, his feet firmly planted on a prostrate warrior, in golden panoply.

To a greater extent than that of any other art historian Berenson's written work is visual. It springs from a belief in the capacity of the human eye to appraise, assess and differentiate. This lies at the base of that great edifice, *The Italian Pictures of the Renaissance*, but in a less obvious fashion all his published writings on art history were dedicated to things seen. The appeal of the visual arts was in his view not to the intellect but to the eye, and the eye therefore was the organ by which they must be analysed. Visual analysis presupposed visual assimilation, the slow drinking in of works of art until they became part of the fabric of his personality. His observation was not, however, limited to works of art, and he was perhaps the only great writer on art since Ruskin whose aesthetic response was balanced by an intense response to the beauty of the natural world. Trained minds are more commonly encountered than trained eyes, and his ferocious mistrust of iconographical research was due not to the fact that he believed this to be valueless but that he regarded it as an evasion of the art historian's main task. 'The trouble is he has no eye,' he would say as he read some learned book—and how often he was proved correct.

Berenson was never an easy or seductive writer. This was due not, as Mrs Sprigge suggests, to an inadequate command of grammar but to the nature of the task he was trying to perform. Translating paintings into words is only one degree less difficult than translating the real world into paint, and the writer's success cannot be measured in terms of his articulacy. Some of the most deep-searching students of style have been almost completely inarticulate, and others have bought articulacy at the price of directness or integrity. The common wail of literary critics—'if only he could write'—rests on a misapprehension of the problems that are involved. Berenson was no Pater. His writing is not literature, but at its best it rings out deep and

clear, and save in some of his late works is an unfailingly adequate vehicle for the ideas that he intended to communicate. No reader of *The Italian Painters of the Renaissance* will gain from it the deep aesthetic satisfaction that is afforded by Pater's *Renaissance*, but a case could certainly be stated for the view that of the two books Berenson's is the tougher, more fertile and more profound.

The significance of Pater for Berenson's development was great. According to Mr Raymond Mortimer, who writes a brief preface to *The Passionate Sightseer*, he 'talked with Pater in person'. Mrs Sprigge, on the other hand, tells us that 'Berenson never met Pater but never ceased reading him'. Perhaps the conversation with Pater about Botticelli (to which Mr Mortimer refers) is no more than a pious myth. While still at Harvard Berenson was influenced by *Marius*—for what reason does Mrs Sprigge suppose that 'hardly any women since Pater's day have read this book'?—and years later he wrote:

Rereading Pater's *Marius*, I am surprised to discover to what extent it is my own spiritual biography. Its direct influence on me was no doubt great. Still, no outside influence could have affected me so deeply, pervasively and permanently if the current of my spirit had not been in the same direction. Surely I read and reread much else at that time, but never when rereading have I felt myself so identified with the thoughts, aspirations, doubts and consents that I rediscover in *Marius*.

This formulation is surely more correct than Mrs Sprigge's statement that Berenson 'stole' from Pater 'with both hands and much delight'. What Berenson took over from Pater was the attitude of mind that is described in the preface to *The Renaissance*:

The aesthetic critic regards all the objects with which he has to do, all works of art, and the fairer forms of nature and human life, as powers or forces producing pleasurable sensations, each of a more or less peculiar or unique kind. ... Our education becomes complete in proportion as our susceptibility to these impressions increases in depth and variety.

Berenson was, however, more than an 'aesthetic critic', and the reason for this was that he was continuously alive to his intellectual responsibilities. He was concerned with the whole hierarchy of works of art, and in old age he grew increasingly intolerant of the limited critical equipment of the specialist who could equate Girolamo di Benvenuto with Mantegna or Caravaggio with Titian. His breach with the most gifted Italian scholar of the generation following his own was due not to the trivial causes to which

Mrs Sprigge ascribes it but to a fundamental disagreement on the nature of value judgments and their place in the study of art history. He disliked Wickhoff's work because he was convinced that Wickhoff had interpreted a decline in quality as a change of style, and the same reasoning dictated his attitude to the art of his own time. His scorn of contemporary art may have been mistaken, but it was excusable in so far as it resulted from the application of a humane standard that had been tested on a vast variety of artefacts, and to which modern art would not conform.

Berenson had no formal pupils, but his impact was none the less more widely felt than that of any other writer on Italian painting. With most art historians there is a subconscious wish to freeze their subjects at the point at which their own work ends. They unload their luggage on the platform as though the train had reached its destination, and look up resentfully when they find that it moves on. For Berenson, however, art history was a growing organism, and his own conclusions were subject to continuous review. 'Instead of concealing my efforts,' he wrote in the introduction to the 1938 edition of the *Florentine Drawings*,

and presenting a finished surface as hard as conviction itself, I have in this new edition left the marks of former groupings, of discarded decisions in so far as these were the result of the method I was pursuing, and not merely the products of carelessness or of temporary blindness. For this book, like every book I have attempted to write, is an essay in method, and to understand it the student should be invited to see how it has developed in the course of a lifetime of work.

For this reason his sympathies lay not with Cavalcaselle, the instinctive eye, but with Morelli, the methodologist. He approached his subject with humility, and never for a moment did he deceive himself into believing that the process of trial and error by which attributions are arrived at was a scientific one, or that his findings were absolute. One of the causes of his vast influence on methodology was that the chain of reasoning by which he came to his conclusions was always presented honestly, and was not concealed by patter or sleight of hand.

He was never more than spasmodically interested in minor artists, and the lists of their works that he compiled included many attributions that were provisional and many groupings that were wrong. But to major artists he brought the whole of his formidable powers of concentration, and about them he published nothing until after the mysterious moment at which intuition becomes belief. The value of his attributions rested in the weight of conviction that lay behind them. None the less, at the extreme end of his

life he was still ready to revise his views—the last edition of *The Venetian Pictures of the Renaissance* is a marvel of senescent flexibility—and when at the age of more than ninety he set about a final recension of his Florentine lists, his criterion of method was that each of the myriad decisions on authorship should be taken objectively as though he had never himself taken it before. To the outsider the lists published as *Italian Pictures of the Renaissance* may appear arid, but as an introduction to the concept of artistic personality and to the principles of connoisseurship they have no peer.

Mrs Sprigge's book is ill-proportioned and ill-written, and is blown forward on the crest of a rather uncritical enthusiasm which is likely to embarrass those who knew Berenson and repel those who did not. Later books no doubt will be superior to this, more serious, more perceptive and more competent. But they too will fail if it is not recognised from the beginning that their subject is not a friend for whom indulgence must be sought, but the standard-bearer of a coherent set of values and the most sensitive precision-instrument that has ever been applied to the study of Italian art.

Originally published in *The Times Literary Supplement*, March 25, 1960.

Postscript

THE articles and lectures have been reprinted in the form in which they first appeared, and have not been revised in the light either of my own later conclusions or of the views advanced by other students. The postulates relating to the authorship of the reliefs in the Tempio Malatestiano at Rimini that underlie 'A Relief by Agostino di Duccio' differ in certain respects from those advanced in my *Italian Renaissance Sculpture* (1958), though the argument is not thereby invalidated. It has been contended by Professor Frederick Hartt (in *Burlington Magazine*, CIII, 1961, pp. 387–92) that the *Martelli David* is a work by Bernardo not Antonio Rossellino. I do not share this view. Since the appearance of 'A Relief by Sansovino' two monographs on Andrea del Sarto have been issued, both of which discuss the relationship between Sarto and Sansovino. The connection presumed in the earlier of these books, by Professor S. J. Freedberg, is in my view the more acceptable. The translation of Michelangelo's letters sponsored by Mr Irving Stone has been superseded by an excellent English version by E. H. Ramsden (*The Letters of Michelangelo*, 2 vols., London, 1963). If I were rewriting 'An Exhibition of Bronze Statuettes', there are four points that I should wish to modify. The first (p. 173) is a reference to the Berlin *Hercules* as 'the only other absolutely certain small bronze by Antonio Pollajuolo'. This reflects an unjustified doubt which I at that time entertained as to the authorship of the Pollajuolo *Hercules* in the Frick Collection, New York. The second (p. 177) arises from the discovery by Dr T. Buddensieg (in *Jahrbuch der Berliner Museen*, v, 1963, pp. 121–50) that Riccio's *Shepherd milking a Goat* is reproduced in a fresco by Falconetto at Mantua, and therefore dates from before 1520. The third (p. 193) relates to the versions of the *Honour triumphant over Falsehood* of Vincenzo Danti. The head of the terracotta model in the Bargello has proved, on investigation, to be a later replacement for the original head, and I am now in full agreement with Keutner's view that the bronze depending from it dates from *ca.* 1700. Since I described the four gilt-bronze masks in Rome as 'the only surviving small bronzes by Bernini' (p. 198), a documented small bronze by Bernini of Paolo Giordano II Orsini, Duke of Bracciano, has come to light.

J. P–H.

Notes to the Text

NEW WORKS BY GIOVANNI PISANO—I

1. A. 13–1963. H. 63.8 cm., W. 47.9 cm., D. 41.3 cm. Purchased from Messrs Colnaghi. A nineteenth-century gummed label with the manuscript number 125 on the back of the bust has been identified by the Rector of Siena Cathedral as of a type used in the magazines of the Opera del Duomo.

2. For the documentation of Giovanni Pisano's activity at Siena see Bacci, 'Documenti e commenti per la storia dell'arte', in *Le Arti*, IV (1941–2), p. 185–92, 269, 277, 329–40.

3. The condition of the statues is described by Keller, 'Die Bauplastik des Sieneser Doms', in *Kunstgeschichtliches Jahrbuch der Biblioteca Hertziana*, I (1937), pp. 161–4.

4. The dates of restoration of the figures are naturally hypothetical. An interesting preliminary survey of the condition of the figures after their removal from the façade is given by E. Carli ('Giovanni Pisano a Siena', in *Acts of the 20th International Congress of the History of Art—Romanesque and Gothic*—I, Princeton (1963), pp. 183–97). I am indebted for facilities for studying the statues to the Rector of Siena Cathedral and to Professor Enzo Carli.

5. As noted by Keller, *loc. cit.*, the axis of the head was changed. Carli, *Sculture del Duomo di Siena*, Turin (1941), p. 42, dates this restoration to the seventeenth century.

6. Despite the criticisms of Francovich (in *Le Arti*, IV, p. 204), Keller's division of the statues into three main stylistic groups seems to me justified. The criterion for dating must, however, as observed by Carli, *op. cit.*, pp. 39–51, be the connection of the figures on the one hand with the half-length figures formerly in the tabernacles outside the Pisa baptistery, and on the other with the Pistoia pulpit. It may be noted that those statues which are most closely associable with the Pisa figures (the *Joshua, Balaam* and *Plato*) adhere to the plane of the Cathedral wall, while those statues which are most closely related to the Pistoia pulpit (the *(Simeon* and *Mary of Moses)* are planned in opposition to the wall surface. It is in terms of this distinction rather than of mass or line that a consistent evolution through the cycle can be traced.

7. When Keller prepared his exhaustive account of the façade (*op. cit.*, pp. 141–221), he was informed by the then Superintendent of Fine Art in Siena that *'haben sich Akten über die Restaurierungsarbeiten weder in der Soprintendenza noch im Staatarchiv in Siena erhalten'*. An index of the contents of the Archivio dell'Opera del Duomo deposited in the Archivio di Stato lists a number of volumes in the Cathedral archives with payments relating to work on the façade, but in the account books which I have examined no details are given of the figures to whose restoration the payments relate.

8. For the movements of the façade statues see Lusini, *Il Duomo di Siena*, Siena (1911), pp. 110–12, and Keller, *loc. cit.*

9. Lusini, *op. cit.*, p. 111; Keller, *op. cit.*, p. 162; Carli, *op. cit.*, p. 46.

10. Keller, *op. cit.*, p. 157.

11. Lusini, *op. cit.*, p. 111.

12. Keller, *op cit.*, pp. 182, associates the *Moses* with the *Plato* and *Joshua*, to my mind mistakenly.

13. Keller, *loc. cit.*

14. Papini, 'Promemoria sulla classicità di Giovanni Pisano', in *Miscellanea Supino* (1933), pp. 113–23.

NEW WORKS BY GIOVANNI PISANO—II

1. 212–1867. H. 15.2 cm. Victoria and Albert Museum, *Catalogue of Carvings in Ivory*, by Margaret H. Longhurst, II, London (1929), p. 58, as Italian: fourteenth century.

2. W. Maskell, *Ivories Ancient and Mediaeval in the South Kensington Museum*, London (1872), p. 81.

3. W. Maskell, *South Kensington Museum*

Art Handbook: Ivories, London (1875), p. 257.

4. R. Koechlin, Les Ivoires Gothiques Français II, Paris (1924), p. 265, No. 737: 'Le morceau est donné comme italien'.

5. Königliche Museen zu Berlin, Altchristliche und Mittelalterliche Byzantinische und Italienische Bildwerke, bearbeitet von Oskar Wulff. The attribution to Giovanni Pisano is maintained by Francovich, 'L'origine e la diffusione del crocifisso gotico doloroso', in Kunstgeschichtliches Jahrbuch der Biblioteca Hertziana, XI (1938), p. 231, and contested by H. Keller, Giovanni Pisano, Vienna (1942), p. 42.

6. For the attributional vicissitudes of the Siena Crucifix see particularly E. Carli, Scultura lignea senese, Milan–Florence (1951), pp. 102–3.

7. Francovich, op. cit., pp. 227–30.

8. An exception must, however, be made for the author of a Crucifix in the Chiesa dei Cappuccini at Pisa, wrongly ascribed by Francovich to Giovanni Pisano.

9. Dated by Keller, op. cit., p. 71, after 1312, but possibly somewhat earlier in date.

10. The pulpit was commissioned in 1302 and completed in 1312.

11. The documents relating to the ivory are republished and discussed by R. Barsotti, 'Nuovi studi sulla Madonna eburnea di Giovanni Pisano', in Critica d'Arte, IV (1957), pp. 47–56.

12. R. Barsotti, 'Gli antichi inventari della Cattedrale di Pisa—2', in Critica d'Arte, IV (1957), p. 161.

13. R. Barsotti, in Critica d'Arte, IV (1957), p. 516.

14. The condition of the ivory Virgin and Child is analysed by Ragghianti, 'La Madonna eburnea di Giovanni Pisano', in Critica d'Arte, I (1954), pp. 385–96.

15. Keller, op. cit., Figures XII, XIII.

16. Koechlin, op. cit., Nos. 103, 105, 107.

17. Koechlin, op. cit., No. 16.

18. E.g. Koechlin, op. cit., No. 47.

19. Koechlin, op. cit., No. 19.

THE ARCA OF ST DOMINIC: A HYPOTHESIS

1. No. 5798–1859.

2. No. 5800–1859.

3. No. 5797–1859.

4. No. 5799–1859.

5. South Kensington Museum, Italian Sculpture of the Middle Ages and Period of the Revival of Art, by J. C. Robinson, London (1861), p. 1.

6. Graber, Beiträge zu Nicola Pisano (1911), p. 99 n.

7. Victoria and Albert Museum, Catalogue of Italian Sculpture, by Eric Maclagan and Margaret H. Longhurst, London (1932), pp. 4–5.

8. Mendelsohn, Die Engel in der bildenden Kunst (1907), pp. 8–9.

9. Maclagan and Longhurst, loc. cit.

10. Graber, loc. cit., Von derselben Hand wie diese beiden Engel stammt vielleicht die Pila im Museo nazionale in Florenz... Die Pila wird zwar meist (so von Venturi und Swarzenski) dem Guglielmo gegeben, doch scheint sie mir für diesen zu gut gearbeitet, besonders in den Köpfen.

11. Swarzenski, Nicolo Pisano (1926), p. 69.

12. Maclagan and Longhurst, loc. cit. 'They seem to be by the same hand as a pedestal

for a holy-water stoup in the Bargello at Florence.'

13. Swarzenski, 'An early Tuscan Sculpture', in Bulletin of the Boston Museum of Fine Arts, XLVI (1948), pp. 2–11.

14. Nicco Fasola, Nicola Pisano, Rome (1941), p. 170.

15. Ragghianti, 'Arnolfo di Cambio ed altri problemi dell'arte pisana', in Rivista del R. Istituto d'Archeologia e Storia dell'Arte, V (1936), p. 320.

16. Gnudi, Nicola, Arnolfo, Lapo; l'Arca di San Domenico in Bologna, Florence (1948).

17. Swarzenski, Bulletin of the Boston Museum of Fine Arts, loc. cit.

18. Gnudi, op. cit., p. 104.

19. Gnudi, op. cit., p. 101.

20. Gnudi, op. cit., p. 102.

21. Piò, Uomini illustri domenicani (1620), col. 119.

22. Gnudi, op. cit., p. 102.

23. Gnudi, op. cit., p. 85.

24. No. 569. Ex-coll. Victor Gay.

25. Swarzenski, Bulletin of the Boston Museum of Fine Arts, XLVI (1948), p. 11. 'Hitherto only two other works are known

which suggests a special relation to our groups: the remarkable pair of St. Michael and Gabriel from an unknown pulpit in London, and the figure of an angel . . . in the Louvre.'

26. Musée National du Louvre, *Catalogue*

des Sculptures du Moyen-Age et de la Renaissance (1922), p. 70.

27. Toesca, *Storia dell'Arte Italiana*—i: *Il Medioevo* (1927), p. 913 n.

28. Gnudi, *op. cit.*, p. 105.

NOTES ON A FLORENTINE TOMB-FRONT

1. No. 46–1882. Dimensions: 86 by 213 cm. Apart from Robinson's assurance that the relief was acquired in Florence, there is no indication of the source from which it was obtained.

2. Science and Art Department of the Committee of Council on Education, *List of Objects in the Art Division, South Kensington Museum acquired during the year 1882*, London (1883), pp. 4–5.

3. Victoria and Albert Museum, *Catalogue of Italian Sculpture*, by Eric Maclagan and Margaret Longhurst, London (1932), pp. 2–3.

4. Richa, *Notizie istoriche delle Chiese Fiorentine*, ii (1755), pp. 178–9. I am indebted to Dr George Kaftal for assistance in identifying the sarcophagus, Cinelli, *Le Bellezze della Città di Firenze*, Florence (1677), p. 170, wrongly describes the monument of the Beata Chiara degli Ubaldini as existing in the church of S. Chiara. This statement, and the chain of mistakes to which it gives rise, is corrected by Richa, *op. cit.*, ix, pp. 78–9.

5. Follini-Rastrelli, *Firenze Antica, e Moderna illustrata*, v (1794), pp. 185–6. I am indebted for this reference to Mr Ellis Waterhouse.

6. Razzi, *Vite de' Santi e Beati Toscani de' quali infino a hoggi comunemente si ha Cognizione*, Florence (1593), p. 313.

7. Richa, *op. cit.*, pp. 176–201 *passim*.

8. Wadding, *Annales Minorum*, iv, p. 173: '*De hac prestantissima fœmina plures scripserunt Mariano Florentinus, Petrus Rodolphus, Marcus Ulyssipponensis, Joannes Baptista Ubaldinus in historia Ubaldinæ familiæ inter Hetruscos nobilissimæ, frater Julianus de Ordine Minorita peculiari historia MS.*'

9. Richa, *op. cit.*, iv, p. 190.

10. Razzi, *op. cit.*, p. 314.

11. Wadding, *loc. cit.*

12. Richa, *op. cit.*, iv, p. 193.

13. Razzi, *op. cit.*, p. 315.

14. All sources describe this incident though Razzi, *op. cit.*, p. 315, was unaware of the reason for the opening of the sarcophagus. The information that this was undertaken by an abbess 'Magdalena Bononiensis' as the result of a decision to enlarge the choir derives from Wadding, *op. cit.*, iv, p. 173.

15. Richa, *op. cit.*, ii, pp. 185–6. The account of this incident is transcribed by Richa from the *Sepoltuario* of Stefano Rosselli.

16. Limburger, *Die Gebäude von Florenz* (1910), p. 118. No inventory of the contents of the convent made at the time of the suppression has been preserved. The lid and lateral sections of the Arca are untraced.

17. Luigi Santoni, *Diario sacro e guida perpetua delle principali chiese della città, suburbio ed Archidiocesi Fiorentina arrichito dell'elenco di tutti i Santi, Beatie e Venerabili che sono nati domicili ati e morti in Toscana*, Florence (1853).

18. Pio Rajna, 'L'iscrizione degli Ubaldini e il suo autore', in *Archivio Storico Italiano*, xxxi (1903), pp. 3–70.

19. Davidsohn, *Forschungen zur Geschichte von Florenz*, iv, Berlin (1908), pp. 413–14.

20. Davidsohn, *op. cit.*, iv, p. 414. Professor Walter Paatz, to whom I am indebted for answering a number of enquiries in connection with this article, and for supplying a transcript of the relevant extract from the then unpublished volume of his *Kirchen von Florenz*, notes the sarcophagus as 'Marmorgrabmal der seligen Chiara Ubaldini (gestorben 1324)'. See also Paatz, *Die Kirchen von Florenz*, Frankfurt (1940–54), iv, p. 338.

21. Bodmer, 'Una scuola di scultura fiorentina nel trecento: i monumenti dei Baroncelli e dei Bardi', in *Dedalo*, x (1929–30), pp. 616–38, 662–78.

22. Bodmer, *op. cit.*, p. 622.

23. Evidence from the epigraphy of the inscription is negative.

SOME DONATELLO PROBLEMS

1. Vasari, *Vite*, ed Milanesi (1906), II, p. 460.

2. *Memorie istoriche per servire di guida al forestiere in Arezzo*, Arezzo (1819), p. 86.

3. Burckhardt, *Cicerone*, 9th ed. (1908), p. 190.

4. C. von Fabriczy, 'Die Bildhauerfamilie Ferrucci aus Fiesole', in *Jahrbuch der Preussischen Kunstsammlungen*, XXIX (1908), Beiheft, p. 2.

5. F. Schottmüller, 'Zur Donatello Forschung', in *Monatshefte für Kunstwissenschaft*, II (1909), pp. 38–45.

6. Pasqui, *La Cattedrale Aretino e i suoi monumenti*, Arezzo (1880), p. 81. M. Falciai, *Arezzo, la sua storia e i suoi monumenti*, Florence (1910), p. 110.

7. H. Kauffmann, *Donatello: eine Einführung in sein Bilden und Denken*, Berlin (1935), p. 217, relates the relief to the Siena *Banquet of Herod*, and comments: 'In zeitlicher Nähe könnte auch das von F. Schottmüller eingeführte obwohl ein wenig stumpfe Relief der Taufe Christi (Arezzo) Platz finden.'

8. Schottmüller, *loc. cit.*

9. No. 7577–1861. Dimensions: 81 × 114.5 cm.

10. A. Migliarini, *Museo di sculture del risorgimento raccolto e posseduto da O. Gigli*, Florence (1868), p. 35, pl. xxix.

11. J. C. Robinson, *Italian Sculpture of the Middle Ages and Period of the Revival of Art: a descriptive Catalogue*, London (1862), p. 14.

12. W. von Bode, *Denkmäler der Renaissance-Skulptur Toscanas*, Munich (1892–1905), pl. 66, p. 21.

13. F. Schottmüller, *Donatello*, Berlin (1904), p. 87.

14. Balcarres, *Donatello*, London (1908), p. 165.

15. A. Venturi, *Storia dell'arte italiana*, Milan (1908), VI, p. 285.

16. Victoria and Albert Museum, *Catalogue of Italian Sculpture*, by Eric Maclagan and Margaret H. Longhurst, London (1932), p. 20.

17. Kauffmann, *op. cit.*, pp. 83–5.

18. L. Planiscig, *Donatello*, Florence (1947).

19. V. Martinelli, 'Donatello a Michelozzo a Roma—I', in *Commentari*, VIII (1957), pp. 167–94.

20. For the critical history of the *Madonna with the Clouds*, see H. W. Janson, *The Sculptures of Donatello*, Princeton (1957), II, pp. 86–8. Janson attributes the doubts expressed by Balcarres, Cruttwell, Colasanti and other students as to the authorship of the relief to the inferior quality of the reproduction included in Bode's *Denkmäler*. Restudying the relief in the original, in the light of a fairly thorough knowledge of the London *Ascension*, I am bound to record the view that only the head of the Virgin seems to me eligible for consideration as autograph work by Donatello.

21. A. Venturi, *loc. cit.*

22. Kauffmann, *op. cit.*, p. 84.

23. G. Marchini, 'Di Maso di Bartolommeo e d'altri', in *Commentari*, III (1952), pp. 114–17.

24. Janson, *op. cit.*, pp. 108–18.

25. Martinelli, *loc. cit.* Martinelli's attempt to establish the *Ascension with Christ giving the Keys to St. Peter* as the predella of the Altar of the Sacrament and the London *Lamentation* as the dossal of the altar is informed by enthusiasm rather than good sense, and is argued with a distressing lack of verbal exactitude. Thus we read in the text that 'Roma è certamente anche la terra d'origine, per opinione quasi concorde, d'un altro bassorilievo donatelliano: un *Cristo morto sorretto da due angeli* del Victoria and Albert Museum di Londra'. In the footnote appended to this wholly tendentious statement, however, we learn that 'per opinione quasi concorde è ritenuta cosa non molto lontana dal periodo romano di Donatello; viene generalmente accostata ai rilievi di Prato'. At the end of the same footnote it is stated that 'Middeldorf... avanza con giustificata incertezza il nome di Desiderio'. In the article in question Middeldorf, so far from advancing this attribution, specifically rejects it; the attribution itself (as all Donatello students are aware) was advanced by Schottmüller in the 1933 edition of the Berlin catalogue.

26. No. 59. Dimensions: H. (with moulding) 120.5 cm., (without moulding) 107 cm., W. (with moulding) 64 cm., (without moulding) 50.5 cm. The depth between

the frame and ground varies between 4.5 and 5 cm. The cruciform halo of Christ corresponds with that of the London relief. The quality of the carving is difficult to assess in its present state, since the stone is considerably weathered and in places has been coloured down in wash. The malformed haloes of the two angels and certain other details suggest that the relief may have been abandoned in an unfinished state.

27. W. von Bode, 'A newly discovered Bas-Relief by Donatello', in *Burlington Magazine*, XLVI (1925), pp. 108–14. Bode's claim that the relief is 'entirely from the artist's own chisel' is inadmissible.

28. Martinelli, *loc. cit.*, superimposes the St Peter's tabernacle on the predella of the *Ascension with Christ giving the Keys to St. Peter* in London, and suggests that the tabernacle formed the upper part of the altar in the Chapel of the Sacrament in the Vatican.

29. No. 8552–1863. Dimensions: 33.5 × 41.5 cm. Provenance not recorded.

30. C. D. Fortnum, *A Descriptive Catalogue of the Bronzes of European Origin in the South Kensington Museum*, London (1876), p. 59.

31. Schottmüller, *op. cit.*, pp. 87–8.

32. W. von Bode, *Denkmäler der Renaissance-Skulptur Toscanas*, Munich (1892–1905), pl. 137A, p. 38.

33. Kauffmann, *op. cit.*, pp. 183–4.

34. U. Middeldorf, in *Art Bulletin*, XVIII (1936), p. 579.

35. Janson, *op. cit.*, pp. 206–8.

36. Middeldorf, *loc. cit.* The comment of Maclagan and Longhurst, *op. cit.*, p. 23, 'No background: the accidental flaws in the casting unrepaired', implies a contrary view. An excellent account of the physical condition of the relief is given by Janson.

37. A. Lensi, 'Il Museo Bardini: stucche e terracotte', in *Dedalo*, IV (1923–4), p. 506.

38. No. 2387 (Sch. 47). Dimensions: 76.5 × 75 cm.

39. Lensi, *op. cit.*, p. 498. Another version appeared in the Tolentino Sale, New York, 1920, April, No. 784.

40. No. 60 (Sch. 48). Dimensions: 77 × 75 cm.

41. No. 860.

42. A version also exists in the Chicago Art Institute (Ryerson collection).

43. No. 61 (Sch. 49). Diameter: 44 cm.

44. No. 4–1890. Dimensions: 66.5 × 66.5 cm.

45. Bode, *Florentiner Bildhauer der Renaissance* (1902), pp. 117–19, and *Denkmäler der Renaissance-Skulptur Toscanas*, Munich (1892–1905), p. 52.

46. Kaiser Friedrich Museum, Berlin: *Die Italienischen und Spanischen Bildwerke der Renaissance und Barock*, I. *Die Bildwerke in Stein, Holz, Ton und Wachs*, bearbeitet von Frida Schottmüller (1933), pp. 12–13.

47. Maclagan and Longhurst, *op. cit.*, p. 22.

48. No. 57–1867.

49. No. 67 (Sch. 45).

50. Schottmüller, *loc. cit.*

51. For the relevant documents see Milanesi, *Documenti sulla storia dell'arte senese*, II (1859), pp. 271–3, Schubring, *Urbano da Cortona* (1903), pp. 73–4, and Lusini, *Il Duomo di Siena*, II (1939), pp. 68–9. The whole series of reliefs is reproduced by Lusini, pp. 57–74. I owe the photographs which accompany this article to the kindness of Professor Enzo Carli.

52. Bacci, 'Documenti e Commenti', in *La Balzana*, I (1927), pp. 231–6.

53. Schubring, *op. cit.*, pp. 62–3.

54. Schubring, *op. cit.*, pp. 54–5, appears to have been unaware of the date of Felici's death (22 November 1463), which he assigns to the year 1472.

55. Schubring, *op. cit.*, pp. 46–7, fig. 14.

56. C. L. Ragghianti, 'La mostra di scultura italiana antica a Detroit (U.S.A.)', in *Critica d'Arte*, III (1938), p. 58. For the ascription to Federighi see W. R. Valentiner, *Catalogue of an Exhibition of Italian Gothic and Early Renaissance Sculptures*, Detroit (1938), No. 73, where the relief is stated to have come from the Palazzo Malvezzi, Siena.

57. Venturi, *op. cit.*, p. 482.

58. Schubring, *op. cit.*, pp. 45–6, fig. 13.

59. The head of St Joseph in the second of the reliefs, tilted at an angle of forty-five degrees from the axis of the body, finds a particularly striking analogy in the head of St Anthony of Padua in the Berlin *Madonna* of Matteo di Giovanni.

THE MARTELLI DAVID

1. H. Kauffmann, *Donatello*, Berlin (1935), pp. 43–7.
2. L. Planiscig, *Donatello*, Florence (1947).
3. L. Planiscig, in *Phoebus*, II (1949), pp. 56 f.
4. H. W. Janson, *The Sculpture of Donatello*, II, Princeton (1958), pp. 21–3.
5. Vasari, *Vite*, II, ed. Milanesi (1906), p. 408.
6. R. Borghini, *Il Riposo* (1584), p. 320.
7. Königliche Museen zu Berlin: *Beschreibung der Bildwerke der christlichen Epochen*. II, *Die Bronzestatuetten*. No. 235 (1904), pp. 3–4, as 'Abguss des Wachsmodelle zu der Marmorstatue Donatellos im Palazzo Martelli'.
8. Staatliche Museen zu Berlin: *Bildwerke des Kaiser-Friedrichs-Museum, Die Italienischen Bildwerke der Renaissance und des Barock*. II, *Bronzestatuetten*, No. 25 (1930), p. 7.
9. Kauffmann, *op. cit.*, p. 211 n.
10. Janson, *op. cit.*, p. 22n.
11. M. Weinberger, in *Zeitschrift für Bildende Kunst*, LXV (1931–2), p. 53.
12. C. Seymour, *Masterpieces of Sculpture from the National Gallery of Art* (1949), p. 175.
13. Quoted by Janson, *loc. cit.*

TWO PADUAN BRONZES

1. Bode, *The Italian Bronze Statuettes of the Renaissance*, Berlin, I (1908), p. 22, pl. xxv, xxvi.
2. Planiscig, *Andrea Riccio*, Vienna (1927), *Œuvre-Katalog, No.* I. Height 27 cm. Diameter of base 24.6 cm.
3. Planiscig, *op. cit.*, *Œuvre-Katalog*, No. 2. Height 27 cm.
4. Henkel, 'Illustrierte Ausgaben von Ovids Metamorphosen im XV, XVI, und XVII Jahrhunderts', in *Vorträge der Bibliothek Warburg*, VI (1926–7), p. 68, Fig. 9. I am indebted for this observation to Dr L. D. Ettlinger.
5. Planiscig, *op. cit.*, pp. 155–8.
6. Height 28.5 cm.
7. Height 28 cm. Diameter of base 24.5 cm. Circumference 76.1 cm. The bronze appeared as lot 237 in the sale of works of art from the Humphrey W. Cook Collection (Christie's, 8 July 1925, bt. Durlacher, £504).
8. Bode, *loc. cit.*
9. Planiscig, *op. cit.*, p. 77.
10. Planiscig, *op. cit.* pp. 157–8.
11. Height 26 cm. Diameter of base 25 cm. Circumference 80.1 cm.
12. Gonzati, *La Basilica di S. Antonio di Padova*, Padua, I (1852), pp. 133–4.
13. Vasari, *Vite*, ed. Milanesi, Florence, II (1878), p. 605.
14. Venturi, *Storia dell'arte italiana*, Milan, VI (1908), p. 493.
15. *De Sculptura von Pomponius Gauricus*, ed. Brockhaus, Leipzig (1886), p. 256.
16. 'Verzeichnis der im Flakturm Friedrichshain verlorengegangenen Bildwerke der Skulpturen-Abteilung', in *Berliner Museen*, n.f., III (1953), p. 18, Nos. 7268, 7269.
17. The relative weights of the Bellano bronze and of the Cook copy are 11 lb. 5 oz. and 10 lb. 12 oz. If it were complete with its free-standing figures, the Bellano bronze would be almost 2 lb. heavier than the copy.
18. Planiscig, *op. cit.*, p. 86.

TWO CHIMNEY-PIECES FROM PADUA

1. No. 655–1865. H. 229 cm.
2. L. Planiscig, *Die Estensische Kunstsammlung: I, Skulpturen und Plastiken des Mittelalters und der Renaissance*, No. 122, Vienna (1919), pp. 76–81. H. of frieze 51 cm. L. of frieze (front) 237 cm.
3. J. C. Robinson, *Catalogue of the Soulages Collection . . . exhibited to the Public at the Museum of Ornamental Art Marlborough House*, No. 442 (1856), pp. 133–4.
4. A. Meneghelli, *Sopra un alto rilievo*, Padua (1832). I am indebted for this reference to Mr R. A. Lightbown. From MS. BP-2129 of the Biblioteca Comunale, Padua

(*Famiglie di Padova: memorie storiche raccolte e trascritte dal Notara Giuseppe Antonio Berti Padovano, 1850*, pp. 90–1), it transpires that the 'nobili fratelli Pettenello' who owned the chimney-piece in 1832 were the Conti Giulio (1765–1844), Giovanni (1768–1851) and Marsilio (1768–1838).

5. Padua, Archivio di Stato, *Atti anagrafici: S. Francesco*, III, p. 83.

6. The stylistic affinities claimed by Planiscig with the Borgherini chimney-piece and the S. Giovanni Gualberto monument do merit detailed discussion. In 1856 the London chimney-piece was already 'believed to be the work of one of the Lombardi family, one of whom (Tullio) is known to have been extensively employed on similar works at Padua, towards the beginning of the sixteenth century' (Robinson, *loc. cit.*).

A RELIEF BY SANSOVINO

1. A. 5–1958.

2. 7595–1861. The model, which until recently was covered with gilding dating from the early eighteenth century, is here reproduced in its cleaned state.

3. For the evidence relating to the use and date of the *Deposition* model, see U. Middeldorf, 'Sull'attività della bottega di Jacopo Sansovino', *Rivista d'Arte*, XVIII (1936), pp. 249–60.

4. Though H. Weihrauch, *Studien zum bildnerischen Werke des Jacopo Sansovino*, Strassburg (1935), p. 29, limits Sansovino's intervention in the monument to the effigy and the Madonna relief in the lunette, there can be no doubt at all that both the SS. Peter and Paul are characteristic autograph works by Sansovino. Weihrauch also (*op. cit.*, p. 97) dismisses the London *Deposition*, a view later retracted in Thieme: *Künstler-Lexikon*, XXXII (1938), p. 466.

5. U. Middeldorf, *loc. cit.*

6. W. and E. Paatz, *Die Kirchen von Florenz*, Frankfurt-am-Main, III (1952), p. 373, 508 n.

7. H. Weihrauch, *op. cit.*, pp. 21–2.

8. H. Weihrauch, *op. cit.*, pp. 24–5. The statue was commissioned for the chapel of St James in S. Giacomo degli Spagnuoli by Cardinal Giacomo Serra (d. 1517).

9. H. Weihrauch, *op. cit.*, p. 28. A *terminus post quem* for this work is supplied by the fire in S. Marcello (22 May 1519) and the subsequent rebuilding of the church.

10. Vasari, *Vite*, ed. Milanesi, Florence, VII (1906), pp. 487–8.

11. The date of this statue is established by L. Ginori Lisci, *Gualfonda: un antico palazzo ed un giardino scomparso*, Florence (1953), with the publication of a payment of 1512 to 'Jachopo d'antonio detto el sansovino schultore ... per fattura d'uno bacco di marmo con suo marmo fece a Giovanni Bartolini.' The statue was set up on a marble base by Benedetto da Rovezzano in 1519.

12. For the dating of the Chiostro dello Scalzo frescoes, see I. Fraenkel: *Andrea del Sarto*, Strassburg (1935).

13. Vasari, *op. cit.*, VII, p. 491.

14. Vasari, *op. cit.*, VII, pp. 491–2.

15. R. Borghini, *Il Riposo*, Florence (1584), p. 20: '*Sansovino vi fece un ricco panno, che scendere infino in terra, ma nel maneggiare la figura si ruppe, e di qui nasce, che ella è povera in quella parte.*'

16. *Diario Fiorentino dal 1450 al 1516 di Luca Landucci*, ed. Iodoco del Badia, Florence (1883), pp. 353–7.

17. *De Ingressu summi pont. Leonis X Florentiam descriptio Paridis de Grassis civis bononiensis pisauriensis episcopi ex cod. ms. nunc primum in lucem edita et notis illustrata a Domenico Moreni*, Florence (1793), pp. 9–11.

18. The sums paid to the artists working on the decorations are recorded in an extract from the *Libro di Condotta e di Stanziamenti fatto dagli Otto di Pratica cominciato il 1514, c.89, 8 Dicembre 1515*, printed by P. Minucci del Rosso, 'Curiosità artistiche', in *Archivio storico italiano*, ser. IV, III–IV (1879), pp. 481–2.

19. The dimensions of the base are recorded by Landucci. Some confusion has been caused by the statement of Paris de Grassi (*op. cit.*, p. 9) that the Piazza Santa Maria Novella contained an '*equus armatus magnus, sicut ante aedes Lateranenses*'. The anonymous source quoted by Moreni states specifically that this was '*un bello e grandissimo Cavallo a similitudine di quei*

due, che sono in Roma a Monte Cavallo'.
A statement by Wackernagel (*Der Lebens-raum des Künstlers in der Florentinischen Renaissance,* Leipzig (1938), p. 204) that the figure represented was the *Marcus Aurelius* is therefore incorrect.

20. Landucci, *loc. cit., 'Facevano stupire ogniuno con tanti quadri e ornamenti; e dissesi che gli era fatto per modello a fare detta faccia, perchè piaceva a ogniuno, tanto pareva superbo e signorile.' Istorie di Giovanni Cambi,* III, in *Delizie degli Eruditi Toscani,* Florence, XXII (1786), p. 84: '*Dipoi S. Maria del Fiore si chopri la faciata dinanzi tutta, chessu un modello per fare detta faciata di marmo.'*

21. Vasari, *op. cit.,* VII, pp. 494–5.

22. Vasari, *op. cit.,* V, p. 25.

23. Landucci, *loc. cit.*

24. Though Wackernagel (*op. cit.,* p. 266) states as a fact that '*der Magnifico selbst einen Konkurrenzentwurf verfasst und eingerichtet hat'*, some doubt remains as to whether such a design was prepared. For the relevant material, see L. del Moro: *La*

Facciata di S. Maria del Fiore, Florence (1888), pp. 20–1.

25. Landucci, *loc. cit.*

26. Vasari, *op. cit.,* VI, p. 255, '*solo ne rimase una, nella qual Pallade accorda uno strumento in sulla lira d'Apollo con bellissima grazia.'*

27. Vasari, *op. cit.,* VII, p. 495.

28. O. Giglioli, 'Chiaroscuri inediti di Andrea del Sarto, di un suo aiuto e del Pontormo', in *L'Arte,* XXIX (1926), pp. 261–6.

29. Vasari, *op. cit.* VI, p. 602, '*Onde nella venuta, l'anno mille cinquecento e quindici, di papa Leone a Fiorenza, a richiesta d'Andrea del Sarto suo amicissimo fece alcune statua, che furono tenute bellissime.'*

30. The three paintings measure (i) 91461: 55.3 by 144 cm, (ii) 91464: 57.3 by 115 cm, (iii) 91462: 57.3 by 115 cm.

31. Cambi, *loc. cit.*

32. K. Frey, *Sammlung ausgewählter Briefe an Michelangelo-Buonarroti,* Berlin (1899), pp. 72–3.

33. H. Thode, *Michelangelo und das Ende der Renaissance,* Berlin (1912), I, pp. 205–6.

MICHELANGELO IN HIS LETTERS

1. *Michelangelo, Sculptor.* Translated by Charles Speroni. Edited by Irving and Jean Stone. London, 1963.

'MICHELANGELO'S CUPID': THE END OF A CHAPTER

1. South Kensington Museum, *Italian Sculpture of the Middle Ages and Period of the Revival of Art,* by J. C. Robinson, London (1862), p. 134.

2. A. M. Migliarini, *Museo di sculture del Risorgimento raccolto e posseduto da O. Gigli,* Florence (1858), pp. 73–4.

3. C. H. Wilson, *Life and Works of Michelangelo Buonarroti,* 2nd ed., London (1881), pp. 33–4.

4. E. Maclagan, 'Michael Angelo's Cupid: some disputed points', *Art Studies,* VI (1928), pp. 2–11.

5. Wilson, *loc. cit.,* specifically states that 'Signor Santarelli related to me the above anecdote, and informed me of his restoration precisely as stated in the text'.

6. Migliarini, *loc. cit.*

7. The two certificates are transcribed by

Robinson, *loc. cit.,* who also records that a cast was made for the Accademia di San Luca before the statue left Italy.

8. Maclagan, *op. cit.,* p. 8.

9. A. Condivi, *Vita di Michelangelo,* ed. A. Maraini (1927), p. 28.

10. Vasari, *Vite,* ed. Milanesi, VII (1906), pp. 149–50: '*Conobbe bene poi la virtu di Michelagnolo messer Jacopo Galli gentiluomo romano, persona ingegnosa, che gli fece fare un Cupido di Marmo, quanto il vivo.'*

11. Lomazzo, *Trattato dell'arte della pittura, scultura e architettura,* III, Rome (1844), p. 96, lib. VII, cap. X.

12. L. Mauro, *Le antichità della città di Roma,* Venice (1556), p. 172.

13. Gori, *Museum Florentinum,* III (1734), pp. xvi–xvii. See also Maclagan, *art. cit.,* p. 5.

14. F. Kriegbaum, 'Zum "Cupido des Michelangelo" in London', *Jahrbuch der Kunsthistorischen Sammlungen in Wien* (1929), p. 256.
15. Migliarini, *loc. cit.*
16. A. J. Symonds, *The Life of Michelangelo Buonarroti*, I, 2nd ed., London (1893), pp. 63–4.
17. A. Michaelis, 'Der sogennante Cupido Michelangelos im South-Kensington-Museum', *Zeitschrift für bildende Kunst*, XIII (1878), pp. 178–80.
18. H. Grimm, *Leben Michelangelos*, I, 5th ed. (1879), pp. 184–5.
19. A. Springer, *Raffael und Michelangelo*, II, 3rd ed. (1895), p. 22.
20. F. Wickhoff, 'Die Antike im Bildungsgange Michelangelos', *Mitteilungen des Instituts für Oesterreichische Geschichtsforschung*, III (1882), p. 425.
21. Maclagan, *op. cit.*, pp. 7–9.
22. Kriegbaum, *loc. cit.*
23. Migliarini, quoted in translation by Robinson, *loc. cit.*
24. C. Justi, *Michelangelo: neue Beiträge zur Erklärung seiner Werke* (1909), pp. 79–85.
25. K. Frey, *Michelangniolo Buonarroti: sein Leben und seine Werke*, I (1907), pp. 319–329.
26. H. Thode, *Michelangelo: Kritische Untersuchungen über seine Werke*, I, Berlin (1908), p. 56.
27. H. Thode, *Michelangelo und das Ende der Renaissance*, III, 1 (1912), p. 120.
28. H. Wölfflin, *Die Jugendwerke des Michelangelo* (1891), p. 30.
29. B. Berenson, *The Drawings of the Florentine Painters*, II (1938), p. 181.
30. Kriegbaum, *op. cit.*, p. 249.
31. M. Reymond, *La Sculpture Florentine*, IV (1900), p. 77.
32. G. S. Davies, *Michelangelo* (1909).
33. C. Holroyd, *Michael Angelo Buonarroti* (1903), p. 109.
34. H. Mackowsky, *Michelagniolo* (1908), pp. 364–6.
35. Kriegbaum, *op. cit.*, pp. 251–2.

36. Victoria and Albert Museum, *Catalogue of Italian Sculpture*. By Eric Maclagan and Margaret Longhurst, London (1932), pp. 126–7.
37. A. Venturi, *Storia dell'arte italiana*, X, ii (1936), pp. 12–14.
38. Kriegbaum, *loc. cit.*
39. C. de Tolnay, *The Youth of Michelangelo* (1943), p. 204.
40. Gaye, *Carteggio inedito d'artisti*, III (1840), p. 402.
41. Maclagan and Longhurst, *loc. cit.*
42. Robinson, *loc. cit.*
43. Maclagan and Longhurst, *loc. cit.*
44. Holroyd, *loc. cit.*
45. F. Wickhoff, *op. cit.*, p. 426.
46. Clarac, *Musée de Sculpture* (1841), pl. 859, No. 2153; pl. 857, No. 2178.
47. Springer, *loc. cit.*
48. Kriegbaum, *op. cit.*, p. 254: 'der (am Cupido nicht vollendeten) Haare'.
49. *Vita di Benvenuto Cellini*, per cura di Orazio Bacci (1901), p. 351.
50. Vasari, *Vite*, VI, ed. Milanesi (1906), p. 478.
51. Baldinucci, *Notizie dei professori del disegno da Cimabue in qua*, IX (1771), p. 111.
52. M. Neusser, 'Die Antikenergänzungen der Florentiner Manieristen', *Wiener Jahrbuch für Kunstgeschichte*, VI (1929), pp. 27–42.
53. M. Weinberger, 'A Sixteenth Century Restorer', *Art Bulletin*, XXVII (1945), pp. 266–9.
54. Repr. Venturi, *op. cit.*, Fig. 375 (as *Painting* by Battista Lorenzi).
55. M. Cagliano de Azavedo, *Il gusto nel restauro delle opere d'arte antiche* (1948), p. 21.
56. Cellini, *loc. cit.*
57. Wölfflin, *loc. cit.*
58. Kriegbaum, *op. cit.*, p. 257: '*Der Geist des Cupido ist von dem Begriff, den die Hochrenaissance von den antiken Göttern hatte, genau so weit entfernt wie die Weichheit der Aminta oder die üppige Sentimentalität des Pastor Fido von der inneren Gewalt lyrischer Partien bei Polizian*'.

THE PALESTRINA PIETÀ

1. Grenier, 'Une Pieta inconnue de Michel-Ange à Palestrina', in *Gazette des Beaux-Arts*, iii pér. XXXII (1907), pp. 177–94.
2. Wölfflin, *Die Klassische Kunst* (1899), p. 182 n.
3. Wölfflin, *op. cit.* (1908), p. 185 n.

4. The relevant passage in the standard Italian translation of Wölfflin reads: 'altri, independentemente da me, hanno confermato mia scoperta.'

5. Cecconi, *Storia di Palestrina*, Ascoli (1756), p. 309.

6. Gori, 'Anedotti e lavori di Michelangelo Buonarroti ignoti ai biografi', in *Archivio storico-artistico archeologico e letterario della città e provincia di Roma*, Rome (1875), p. 7.

7. Vasnier, in *Chronique des arts* (1907), p. 107.

8. Wallerstein, 'Die Pieta des Michelangelo zu Palestrina', *Zeitschrift für Bildende Kunst*, n.f. xxv (1914), pp. 325–32.

9. Thode, 'Die Pieta im Palazzo Barberini zu Palestrina', in *Michelangelo: Kritische Untersuchungen*, ii, pp. 281–2.

10. Steinmann, 'Römische Ausstellungen', in *Cicerone*, iii (1911), pp. 339–40.

11. Mackowsky, *Michelangelo*, 4th ed. (1925), pp. 304–6.

12. Popp, in *Zeitschrift für Bildende Kunst*, lviii (1924–5).

13. Bertini, 'A proposito di note Michelangiolesche', in *L'Arte*, n.s. ii (1931), pp. 355–358.

14. Toesca, 'Un capolavoro di Michelangelo, "La *Pieta* di Palestrina"', in *Le Arti*, i (1938–40), pp. 105–10.

15. De Tolnay, *Michelangelo V: The Final Period*, Princeton (1960), p. 155.

16. Ottonelli/Berretini, *Trattato della Pittura e Scultura*, Florence (1652), p. 210.

17. Toesca, *loc. cit.*, 'Avuto il grande marmo, lo scultore l'attaccò da un sol lato come per un altorilievo... Anche in questo è l'impronta di Michelangelo'.

18. Mariani, 'La Pieta di Palestrina a Roma', in *L'Arte*, xlii (1939), pp. 3–12.

19. Wittkower, in *The Burlington Magazine*, lxxviii (1941), p. 133.

20. De Tolnay, in Thieme *Künsterlexikon voce* Michelangelo (1930).

21. Von Einem, 'Bemerkungen zur Florentiner Pieta Michelangelos', in *Jahrbuch der Preußischen Kunstsammlungen* (1940), p. 82 n.

22. Kriegbaum, *Michelangelo: die Bildwerke*, Berlin (1940).

23. Martini, 'La "Pieta di Palestrina"' in *Il Ponte*, No. 7 (1964), pp. 948–53.

24. Goldscheider, *Michelangelo* (1953), p. 22.

25. Russoli, *Tutte le opere di Michelangelo* (1953), p. 67.

26. De Tolnay, *op. cit.*, pp. 152–4.

27. Blaise de Vigenères, *Les Images des deux Philostrates*, Paris (1614), pp. 853–5.

28. Von Einem, *Die Pieta im Dom zu Florenz*, Stuttgart (1956).

29. Parker, *Catalogue... of Drawings in the Ashmolean Museum*, Oxford (1956), pp. 176–7.

30. De Tolnay, 'The Rondanini Pieta', in *The Burlington Magazine*, lxv (1934), p. 146.

31. Venturi, *Storia dell'arte italiana*, x, ii (1936), pp. 38–40.

32. De Tolnay, *Michelangelo V*, p. 154.

33. De Tolnay, 'Michelangelo's Pieta Composition for Vittoria Colonna', in *Record of the Art Museum Princeton University*, xii (1953), pp. 44–62.

34. De Tolnay, *Michelangelo V*, p. 150, quoting C. Mallarmé, *L'ultima tragedia di Michelangelo*, Rome (1929), p. 79 f.

35. Suaresius, *Praenestis antiquae libri*, ii, Rome (1655), p. 259.

36. Tosatti, in *Bolletino d'Arte*, vii (1913), p. 177 n.

37. Petrini, *Memorie Prenestine disposte in forma di annali* (1795), p. 259.

TWO MODELS FOR THE TOMB OF MICHELANGELO

1. No. 4121–1854. H. 34. 1 cm.

2. *Catalogue of a collection of models in wax and terracotta, by various ancient Italian masters, known as the Gherardini Collection, now being exhibited at the Museum of Ornamental Art at Marlborough House*, London (1854), p. 9.

3. G. Gaye, *Carteggio inedito d'artisti dei secoli xiv, xv, xvi.* iii, Florence (1840), pp. 148–51.

4. London, South Kensington Museum: J. C. Robinson, *Italian sculpture of the Middle Ages and period of the revival of art*. A descriptive catalogue of the works forming the above section of the Museum, with additional illustrative notices. London (1862), pp. 158–9.

5. A. E. Brinckmann, *Barock-Bozzetti*. i, Frankfurt am Main (1923), pp. 62–3. Brinckmann wrongly observes that 'die

rechte Hand faßt den Zirkel, ihn auf den Oberschenkel stützend', but infers, probably correctly, that the missing left hand rested on the left breast.

6. Königliche Museen zu Berlin: F. Schottmüller, *Die Italienischen und Spanischen Bildwerke der Renaissance und des Barock in Marmor, Ton, Holz und Stuck*, Berlin (1913), p. 153. The attribution of the Berlin Charity to Bandini was later withdrawn by Schottmüller (2nd ed. (1933), p. 161).

7. U. Middeldorf, 'Giovanni Bandini, detto Giovanni dell' Opera', in *Rivista d'Arte*, xi (1929), pp. 501–2.

8. London, Victoria and Albert Museum, E. R. D. Maclagan and M. H. Longhurst, *Catalogue of Italian Sculpture*, London (1932), p. 144.

9. A Venturi, *Storia dell'arte italiana*, x–ii, Milan (1936), pp. 253–61.

10. *Esequie del divino Michelangelo Buonarroti*, Florence (1564).

11. Inv. No. A. 58. H. 35.1 cm. There is no record of the provenance of the statuette, which must, however, have been acquired before 16 August 1825 when it is shown in a water-colour of the Monk's Parlour in Soane's house. I am indebted for this information to Sir John Summerson.

12. Gaye, *loc cit.*

13. K. Frey, *Vasaris Litterarischer Nachlass*, Munich (1930), No. CDLXXIX and p. 139.

14. Vasari *Vite*, ed. Milanesi, VIII, p. 436.

15. E. Steinmann and H. Pogatschek, 'Dokumente und Forschungen zu Michelangelo', in *Repertorium für Kunstwissenschaft*, XXIX (1906), pp. 408–9.

16. R. Borghini, *Il Riposo*, Florence (1584), pp. 108–9.

17. A. Lorenzoni, *Carteggio artistico inedito di D. Vincenzo Borghini*, Florence (1912), pp. 91–3.

18. Borghini, *op. cit.*

19. Gaye, *loc. cit.*

A SMALL BRONZE BY TRIBOLO

1. 2626–1855. H. 32.5 cm.

2. C. D. E. Fortnum, *A Descriptive Catalogue of the Bronzes of European Origin in the South Kensington Museum*, London (1876), p. 17.

3. W. Von Bode, *The Italian Bronze Statuettes of the Renaissance*, London, III (1912), p. 22, pl. CCXLVII.

4. L. Planiscig, 'Der "Zwerg auf der Schnecke" als Repräsentant einer bisher unbekannten naturalistischen Richtung des venezianischen Cinquecento', *Jahrbuch der Kunsthistorischen Sammlungen in Wien*, n.f. XIII (1944), pp. 243–54.

5. H. Keutner, 'Der Giardino Pensile der Loggia dei Lanzi und seine Fontäne', *Kunstgeschichtliche Studien für Hans Kauffmann*, Berlin (1956), pp. 240–51.

6. A.S.F., Fabbriche Medicee, Appendice, fil. 122, c.25r.

7. A.S.F., Fabbriche Medicee, Appendice, fil. 123, c.31v.

8. A.S.F., Fabbriche Medicee, Appendice, fil. 123, c.32v.

9. A.S.F., Fabbriche Medicee, Appendice, fil. 123, c.31v.

10. No. 390. H. 26 cm.

11. J. Holderbaum, 'Notes on Tribolo—1: A Documented Bronze by Tribolo', *The Burlington Magazine*, XCIX (1957), pp. 336–43.

12. This was recognised by Robinson (in Fortnum, *loc. cit.*), 'Mr. Robinson suggests that it may be the portrait of Morgante, Duke Cosimo II's [*sic*] dwarf.'

13. Fortnum, *loc. cit.*, 'This may, perhaps, be a portrait of some favourite dwarf, impersonating the ancient Aesop, the antique portrait bust of whom it certainly does not resemble.'

14. E. Tietze-Conrat, *Dwarfs and Jesters in Art*, London (1957), p. 98.

15. J. Holderbaum, 'A Bronze by Giovanni Bologna and a Painting by Bronzino', in *The Burlington Magazine*, XCVIII (1956), pp. 439–45.

ANTONIO CALCAGNI'S BUST OF ANNIBALE CARO

1. Baldinucci, *Notizie dei professori di disegno*, III, ed. Florence (1846), p. 106.

2. A. Greco, *Annibal Caro*, Rome (1950), p. 134.

3. A. Ricci, *Memorie storiche delle arti e degli artisti della Marca di Ancona*, II, Macerata (1834), p. 53.

4. G. Pauri, *I Lombardi-Solari e la scuola*

recanatense di scultura, Milan (1915), p. 41.

5. No. 230.

6. Bernath in Thieme *Künstlerlexikon*, v (1911), p. 375.

7. For the chronology of these sculptures see the notably well-informed life of Calcagni by Baldinucci, and Pauri, *op. cit.*, pp. 39–52.

8. Purchased for the Victoria and Albert Museum, London, 1963, with the assistance of the National Art-Collections Fund. H. 76.8 cm. (A.5–1963).

9. Annibale Caro, *Lettere Familiari*, iii, Florence (1961), No. 648, pp. 74–5.

10. Caro, *op. cit.*, No. 661, pp. 111–12.

11. Caro, *op. cit.*, No. 663, p. 114.

12. For the Dosio bust see A. Grisebach, *Römische Porträtbüsten der Gegenreformation*, Liepzig (1936), No. 27, pp. 84–6. The names of Giovanni and Fabio Caro

and Annibale Caro's nephew Giovanni Battista Caro appear in the inscription on the Dosio monument.

13. C. Hülsen, *Das Skizzenbuch des Giovanantonio Dosio im Staatlichen Kupferstichkabinett zu Berlin*, i, Berlin (1933), p. iv.

14. E. Steinmann, 'Freskenzyklen der Spätrenaissance in Rom', in *Monatshefte für Kunstwissenschaft*, iii (1910), pp. 45–58.

15. Photograph in Kunsthistorisches Institut, Florence.

16. E. Bassi, 'Annibal Caro, Ranuccio Farnese, e il Salviati', in *Critica d'Arte nuova*, iv (1957), pp. 131–4, publishes the drawing as a work of Salviati and dates it *c.* 1547–8 on the strength of a drawing on the verso reputedly of Ranuccio Farnese.

17. The possibility of a connection with the Jacopino del Conte painting is also raised by Grisebach, *loc. cit.*, in connection with the Dosio bust.

PORTRAIT SCULPTURES BY RIDOLFO SIRIGATTI

1. *Il Riposo di Raffaello Borghini*, Florence (1584). The passages referred to in this article occur on pp. 10–11 and 21–2.

2. L. Tanfani Centofanti, *Notizie di artisti tratte dai documenti pisani*, Pisa, 1897, pp. 454–5.

SOME BRONZE STATUETTES BY FRANCESCO FANELLI

1. *Varie Architetvre di Francesco Fanelli fiorentino Scultore del Re della Gran Bretagna* (n.d.).

2. Sandrart, *Teutsche Academie*, Nuremburg (1675), i, p. 350: '*Besonderlich ist er in metallenen Bildern zu giessen verwunderlich gewesen und konnte alles dermassen sauber heraus bringen wie das* modell *in sich selbst es erfordert so dass nicht vonnöhten gewesen mit Schneiden oder Feilen weiters demselben zu selffen wilche Wissenschaft dann er überaus* Perfect *gehabt ein ganz grosses Bild allein in eines Reichsthalers Dicke zu giessen gewusst und dahero zu Gedächtnis seiner Hand ich noch etliche Kunststück von ihme in Metall habe und aufbehalte.*'

3. MS. in Royal Library, deposited in the office of the Surveyor of the Queen's Pictures; also MS. Ashmole 1513, ff. 26, 28; I am indebted for this transcription to Mr. Oliver Millar.

4. Vertue Note Books (iv) in *Twenty-fourth*

Volume of the Walpole Society (1936), p. 110.

5. B.C.K. in Thieme, *Künstlerlexikon*, xvi (1915), p. 247.

6. Alizeri, *Notizie de' professori di disegno in Liguria*, vi (1870), pp. 196–9, 394 f.

7. Sandrart, *loc. cit.*, '*Francisco Fanelli ein gebohrner Florentiner wurde wegen seiner Fürtreflichkeit besonders eines in Helfenbein gefärtigten* Pigmalions *nach Engeland zum König beruffen allwo er theils Bilder theils Geschirr mit andern so genannten* Grotesken *von Stein und Helfenbein ausbündig gut gestaltet.*'

8. *Memoirs illustrative of the Life and Writings of John Evelyn*, i, London (1819), p. 349. I am indebted for this reference to Dr Margaret Whinney.

9. Horace Walpole, *Anecdotes of Painting in England*, ed. Dallaway, ii, London (1828), p. 326. Dallaway's material forms the basis of the paragraphs dealing with Fanelli in E. Beresford Chancellor's *Lives of the*

British Sculptors, London (1911), pp. 55–57.

10. L. Cust, 'Hubert le Sueur' in *Dictionary of National Biography*, xi (1909), p. 1008. The contract for the Cottington monument was allotted on 18 July 1634 to Hubert le Sueur (*Calendar of State Papers: Domestic, Charles I* (1634–5), p. 158). Only the bronze mask and cartouche on the front of the monument has any similarity to the work of Fanelli as we know it from the *Varie Architetvre*.

11. Dallaway, *loc. cit.* The bust of Anne, Lady Cottington, seems to have been executed in 1633–4 (*Royal Commission on Historical Monuments: London, I: Westminster Abbey* (1924), p. 37).

12. *Royal Commission on Historical Monuments, vol. cit.*, p. 34.

13. L. Cust, 'Francesco Fanelli' in *Dictionary of National Biography*, vi (1908), p. 1045, incorrectly ascribes to Fanelli a group of eighteen bronzes stated by Van der Doort to have passed to the King by the decease of Prince Henry.

14. *Calendar of State Papers: Domestic, Charles I* (1635), pp. 63, 492.

15. A.5–1953. H. 7$\frac{9}{16}$ in. (19.2 cm).

16. A.4–1953. H. 8$\frac{5}{16}$ in. (21 cm). A sword which appears in other examples in the right hand of the mounted figure has been broken off.

17. A.37–1952. H. 5$\frac{5}{8}$ in. (14.3 cm). An example of this model appeared in the Cottreau Sale (Paris, 1910, 28–29 August, No. 91). Another, in which the wings and bow have been broken off, is in the collection of Professor Xavier de Salas.

18. A.6–1953. H. 7$\frac{3}{8}$ in. (18.7 cm).

19. A.7–1953. H. 9$\frac{9}{16}$ in. (24.3 cm).

20. Burlington Fine Arts Club, *Catalogue of a Collection of Italian Sculpture and other Plastic Art of the Renaissance* (1913), No. 25 (pl. xxxviii): 'perhaps by an artist of the school of Giovanni Bologna'.

21. Bode, *The Italian Bronze Statuettes of the Renaissance*, iii (1912), pl. ccii.

22. E. Lewy, *Pietro Tacca* (1929), pp. 63–5.

23. H. 10$\frac{1}{2}$ in. (26.7 cm). Coll.: Sir Thomas Holburne.

24. I am obliged to Mr Francis Needham for identifying these statuettes.

25. H. 6$\frac{1}{2}$ in. (16.4 cm).

26. The overall design, the two putti at the apex of the monument and the supporting figures of Apollo and Athene are incompatible both with the style of the *Varie Architetvre* and with that of Fanelli's authenticated works.

27. Dallaway, *loc. cit.*

AN EXHIBITION OF ITALIAN BRONZE STATUETTES

1. Victoria and Albert Museum, *Italian Bronze Statuettes*, London (1961). (Hereafter as *London*.)

2. Rijksmuseum, *Meesters van het brons der Italiaanse Renaissance*, Amsterdam, 1961–1962. (Hereafter as *Amsterdam*.)

3. Palazzo Strozzi, *Bronzetti Italiani del Rinascimento*, Florence (1962). (Hereafter as *Florence*.)

4. For the bibliography of this model see Maclagan, *The Frick Collection*, v (1954), pp. 9–12.

5. Middeldorf, 'Su alcuni bronzetti all'antica del Quattrocento', in *Il Mondo Antico nel Rinascimento*, Florence (1958), pp. 170–3.

6. Filangieri di Candida, in *L'Arte*, i (1898), pp. 188–9. For the later bibliography see *Amsterdam*, No. 23.

7. *London*, No. 9 as Pollajuolo; *Amsterdam*, No. 23, and *Florence*, No. 22 as Francesco di Giorgio. The attribution to Francesco di Giorgio is accepted by Keutner (in *Kunstchronik*, xv (1962), p. 172). A note on the exhibition by Roli (in *Arte antica e moderna*, xvii (1962), p. v) includes the surprising sentence: '*Concordiamo nel ritenere di Michelangelo, come su questa Rivista dimostrerà presto il Parronchi, il "David" (22) di Capodimonte.*'

8. Hill, *A Corpus of Italian Medals before Cellini*, London (1930), p. 238.

9. It is assumed by Bode, *Bertoldo und Lorenzo dei Medici*, Freiburg-im-Breisgau (1925), p. 90, that the association between Bertoldo and Adriano Fiorentino dates from soon after 1480, and terminated when Adriano Fiorentino entered the service of Virginio Orsini in 1486.

10. Frimmel, 'Die Bellerophongruppe des Bertoldo', in *Jahrbuch der Kunsthistorischen Sammlungen des Allerhöchsten Kaiserhauses*, v (1878), pp. 90–6.

11. *Amsterdam*, No. 16.

12. For bibliography see *Amsterdam*, No. 20.

13. For reasons which it is no longer possible to reconstruct, the bronze was regarded by Bode (*The Italian Bronze Statuettes of the Renaissance*, II, London (1908), p. 8, pl. CI) as reminiscent of the work of Antonio Pollajuolo. The attribution to Bertoldo is due to Hill (in *The Burlington Magazine*, XIV (1910), p. 312). An excellent analysis of the model and of its connection with Bertoldo is given by Gengaro: 'Maestro e scolaro: Bertoldo di Giovanni e Michelangelo', in *Commentari*, XII (1961), pp. 52–6.

14. The classical original is reproduced by Gori, *Museum Florentinum*, III, Florence (1765), pl. LXVII. Ciardi-Dupré, in *Paragone* (1962), No. 151, p. 61, infers that the London *Hercules* is a work by Bandinelli of about 1540. The revised dating proposed in the same article for Nos. 6 and 11 in the Florence catalogue is also incorrect.

15. Ciardi-Dupré, *op. cit.*, p. 63.

16. Bode, *op. cit.*, I (1908), pl. XXXV.

17. Paoletti, *L'Architettura e Scultura del Rinascimento in Venezia*, I, Venice (1893), p. 270. Paoletti suggests that reliefs were cast '*forse per lascito testamentario*' after the death of Donati in 1521. Cicogna: *Delle iscrizioni veneziane*, I, Venice (1824), p. 90, records the inscription on the reliquary and the date 1492. Planiscig: *Andrea Riccio*, Vienna (1927), pp. 221–2, argues that the provision made by the Signoria for Donati's family after his death precludes the possibility of any substantial bequest for this purpose, and proposes a dating before 1509.

18. *London*, No. 76. The attribution to Desiderio da Firenze is due to Moschetti, in *Bollettino del Museo Civico di Padova*, n.s. III (1927), pp. 143 ff.

19. Planiscig, *op. cit.*, p. 258.

20. Planiscig, in *Jahrbuch der Kunsthistorischen Sammlungen in Wien*, n.f. XIII (1944), pp. 249–50. The statuette is attributed to Riccio by Sewter, in *The Connoisseur*, CXXIV (1949), p. 24.

21. Bode, *Die Italienischen Bronzestatuetten der Renaissance*, Berlin (1922), Fig. 18, as Riccio. Planiscig comments: ('Der "Zwerg auf der Schnecke"', in *Jahrbuch der Kunsthistorischen Sammlungen in Wien*, n.s. XIII (1944), p. 249): '*mit der Kunst Riccios verbindet das Stück nur sehr wenig*'.

22. The Vienna bronze was given by Planiscig initially (*Bronzeplastiken*, No. 157, p. 90) to Desiderio da Firenze and subsequently (*Riccio*, pp. 342–6) to Riccio. The Padua bronze is regarded by Planiscig (*op. cit.*, p. 484, No. 115) as a '*schwächere Werkstattreplik*'.

23. For bibliography see *Amsterdam*, No. 56.

24. Planiscig, *op. cit.*, Fig. 380.

25. Planiscig, *Bronzeplastiken*, No. 34, pp. 22–3. The relative heights of the examples in Milan and Vienna are 17 cm. and 17.3 cm.; Planiscig's description of the former as '*ein grösseres Exemplar*' is therefore unjustified.

26. *London*, No. 53.

27. *Amsterdam*, No. 69.

28. *Florence*, No. 68.

29. The attribution to Riccio is due to Venturi (in *Bollettino d'Arte*, IV (1910), p. 353) and Planiscig (*Riccio*, Vienna (1927), pp. 95, 477, No. 5, Figs. 88–9; *Piccoli Bronzi Italiani del Rinascimento*, Milan (1930), pl. XLVI, Fig. 70). Bode (*op. cit.*, I, pl. LXII) gives the bronze to an anonymous Paduan artist active *c.* 1500.

30. Hermann, 'Pier Jacopo Alari genannt Antico', in *Jahrbuch des Kunsthistorischen Sammlungen des Allerhöchsten Kaiserhauses*, XXVIII (1910), pp. 202–88.

31. Keutner, in *Kunstchronik*, XV (1962), p. 172.

32. Mansuelli, *Galleria degli Uffizi: le Sculture*, I, Rome (1958), p. 264, Fig. 324.

33. Hermann, *op. cit.*, p. 263.

34. *Florence*, No. 32: '*Prova di fusione, non rinettata, dell'esemplare conservato nel Museo di Vienna.*'

35. *Amsterdam*, No. 35. The bust is assumed by Bode, *op. cit.*, II, pl. CVII, to depend directly from the antique.

36. For the integration of the Barbarigo Master see Planiscig, *Venezianische Bildhauer der Renaissance*, Vienna (1921), pp. 209–15.

37. Planiscig, 'Bronzeplastiken der Da Gonzate', in *Pantheon* (1929), pp. 43–6; *Piccoli Bronzi Italiani del Rinascimento*, p. 24, pl. CXII, Fig. 195.

38. One of the principal desiderata in the

study of Paduan bronzes is a serious study of Severo da Ravenna's work. Planiscig's assumption ('Severo da Ravenna (Der "Meister des Drachens")', in *Jahrbuch der Kunsthistorischen Sammlungen in Wien*, n.f. ix (1935), pp. 75–80) that the many variants of the signed Severo da Ravenna *Dragon* necessarily originate in this sculptor's studio is at variance with the visual evidence. In particular the relations between Severo da Ravenna and Bellano require close analysis.

39. Wark, *Sculpture in the Huntington Library*, Los Angeles (1959), pp. 61–2, pl. i–ii, rightly rejects Bode's attribution to Antico, and suggests 'some connection with the Lombardi family of Venetian sculptors'.

40. This attribution is due to Mr L. T. Joyce. Another version of this bronze appeared in the Taylor sale, Christie's, 1 July 1912, No. 37, and was later in the Sambon sale, Paris, 1914. I suspect that two fragmentary versions of an inverted *Spinario* in Vienna, given by Planiscig (*Bronzeplastiken*, pp. 17–19, Nos. 23, 24) to an unidentified late fifteenth-century Paduan studio, are by the same sculptor; it has not been possible to check this at first hand.

41. For an initial statement of this case see *Amsterdam*, Nos. 86–9.

42. Bode, *op. cit.*, i, pp. 40–1, pl. lxxviii.

43. Landais, *Les Bronzes italiens de la Renaissance*, Paris (1958), p. 42.

44. Maclagan, in *The Frick Collection*, v, New York (1954), p. 51.

45. Seymour de Ricci, *The Gustave Dreyfus Collection: Reliefs and Plaquettes*, Oxford (1931), pp. 110–11: 'Although nearly all specialists agree in ascribing to Riccio's hand this curious and charming plaquette, I feel, after a careful study, that the tighter technique of the figures points to one of his assistants rather than to the master himself.'

46. Bode, *Bertoldo*, pp. 80–3. Also by Camelio are the plaquettes reproduced on pp. 42, 47, 79 and 82 of this book.

47. Paoletti, *op. cit.*, i, p. 272.

48. Planiscig, *Venezianische Bildhauer der Renaissance*, Vienna (1921), pp. 400–1.

49. Planiscig, 'Eine unbekannte Bronzestatuette des Andrea Riccio', in *Zeitschrift für Bildende Kunst* (1929), pp. 170–1 as Riccio: Hackenbroch: *Bronzes and other Metalwork and Sculpture in the Irwin Untermyer Collection*, New York (1962), p. 9, Figs. 16–17, as Riccio.

50. Paoletti, *op. cit.*, p. 272, assumes that Gambello designed the tomb after his brother's death, '*decorandolo con le ultime opere del fratello*'.

51. Thieme, *Künstlerlexikon*, xiii (1920), p. 140: '*Zwei Bronzereliefs aus seinen letzten Jahren.*'

52. Lauts, *Carpaccio*, London (1962), p. 230.

53. *Amsterdam*, No. 142 as Tiziano Minio. The Tiziano Minio attribution originates with Planiscig (*Venezianische Bildhauer*, Vienna (1921), p. 406), who later (*Kunsthistorisches Museum in Wien: Bronzeplastiken* (1924), p. 406) reverted to Bode's ascription to Sansovino.

54. *Amsterdam*, No. 143 as Tiziano Minio. The Tiziano Minio attribution originates with Planiscig (*Venezianische Bildhauer*, Vienna (1921), pp. 404–5; *Piccoli Bronzi Italiani*, Milan (1930), pl. 256). The three seated angle figures on the base are inseparable from the Sansovino *St John the Evangelist* of 1550–2 in St Mark's.

55. *Amsterdam*, No. 137.

56. *Amsterdam*, No. 136.

57. Hill, *A Corpus of Italian Medals of the Renaissance before Cellini*, i, London (1930), p. 137, No. 532.

58. Schlosser, *Werke der Kleinplastik in der Skulpturen Sammlung des A. H. Kaiserhauses*, i (1910), p. 12.

59. Landais, *Les Bronzes Italiens de la Renaissance*, Paris (1958), p. 116.

60. Planiscig, *Venezianische Bildhauer der Renaissance*, Vienna (1921), pp. 494–6, and subsequently.

61. Cessi, *Alessandro Vittoria bronzista*, Trent (1960), p. 57.

62. *Amsterdam*, No. 155.

63. Planiscig, in *Jahrbuch der Kunsthistorischen Sammlungen in Wien*, n.f. x (1936), pp. 131–6.

64. Phillips, in *Bulletin of the Metropolitan Museum of Art*, xxxiv (1939), pp. 192–6.

65. *Amsterdam*, No. 151.

66. No. 176 (5663). Planiscig, *Kunsthistorisches Museum in Wien: Bronzeplastiken*, Vienna (1924), pp. 101–2.

67. Cessi, *op. cit.*, pp. 41–56. The status of

the Vienna bronze as an autograph work of Vittoria is debatable. The height of the Padua bronze (which is given by Cessi, p. 111, as '*cm. 100 circa*') is 33 cm.

68. Cessi, *op. cit.*, pp. 40–1.

69. Cessi, *op. cit.*, p. 45.

70. *Amsterdam*, No. 152. Bode: *The Italian Bronze Statuettes of the Renaissance*, III, London (1912), pl. ccxxv.

71. Cessi, p. 45, pl. 16, 17: '*fra gli unici forse ... ad aderire maggiormente al gusto e allo stile del Maestro.*'

72. Gramberg, in *Jahrbuch der Kunsthistorischen Sammlungen in Wien*, n.f. XI p. 167. Two silver figures of SS. *Peter and Paul* in the Boymans-van Beuningen Museum at Rotterdam, given to Vittoria by Hannema (*Catalogue of the D.G. van Beuningen Collection* (1949), p. 178, pl. 7, 8) and shown under Vittoria's name in London, Amsterdam and Florence, have no direct connection with Vittoria, and were perhaps made in Rome in the last quarter of the sixteenth century.

72. *Amsterdam*, No. 160.

74. Lauts, in *Berliner Museen*, LVII (1936), pp. 69–73.

75. Balogh, in *Az Orszagos Magyar Szepmuveszeti Muzeum Evkönyvei*, IX (1940), p. 66, Fig. 124.

76. *Amsterdam*, No. 158.

77. *Amsterdam*, No. 159.

78. *Amsterdam*, Nos. 161, 162.

79. *London*, No. 165. *Florence* No. 161.

80. *Bulletin of the Worcester Art Museum*, IX (1919), No. 4.

81. *Amsterdam*, No. 169. Bode, *op. cit.*, II, pl. clxi as by an unidentified Venetian sculptor *c.* 1570. Planiscig: *Piccoli Bronzi Italiani del Rinascimento*, Milan (1939), pl. clxvii, Fig. 289, as Campagna. The attribution of this model to Campagna has been restated by Keutner (in *Kunstchronik*, XV (1962), p. 176), to my mind mistakenly.

82. Loukomsi, *Les Fresques de Paul Véronèse et de ses Disciples*, Paris (1928), p. 241. The attribute of the dice is mentioned by Cartari: *Le imagini de i dei de gli antichi*, Venice (1580), p. 562: '*In Grecia appresso de gli Elei havevano le Gratie un tempio, nelquale le statoe loro erano di legno con le vesti dorate, & havevano le faccia, le mani, & i piedi di bianco Avorio. L'una di loro havea una rosa in mano, l'altra certa cosa fatta come un dado: la terza un ramo di mirto.*' Cartari offers the alternative explanation that the dice '*significa i giuochi che tra loro fanno le semplici verginelle con piacer suo, e di chi le vede: il che non aviene nelle donne di maggiore età*', and that the Graces '*hanno ad andare, e ritornare a vicenda, come vanno i dadi, quando si giuoca con essi*'. According to Seznec (*The Survival of the Pagan Gods*, New York (1954), p. 303) 'the die marks a reciprocity of benefits, since dice come and go'. In a version of the model owned by Sir Leon Bagrit (for which see Hackenbroch, in *The Connoisseur*, CXLIII, p. 216) the dice is held by a figure on the left, and the corresponding figure on the right carries a sprig of foliage.

83. *Amsterdam*, No. 165.

84. Planiscig, *Venezianische Bildhauer der Renaissance*, Vienna (1921), pp. 471–3; *Kunsthistorisches Museum in Wien: Bronzeplastiken*, Vienna (1924), pp. 106–108.

85. Another version appeared in 1913 in the Partridge Sale in Berlin (No. 28).

86. The attribution to Mariani is due to Fiocco (in *Le Arti*, III (1940–1), p. 80). For the documents relating to Mariani's activity at Urbino see Gronau: *Documenti artistici urbinati*, Florence (1935), pp. 39–40.

87. Vasari, *Vite*, ed. Milanesi, VI, Florence (1878), p. 128. The claim has been recently repeated by Hackenbroch (*Bronzes and other Metalwork and Sculpture in the Irwin Untermyer Collection*, London (1962), p. xxv) that 'Pierino's authorship of the group of Samson and the Philistines is confirmed beyond dispute by Vasari's statement'. I am unable to follow Levi d'Ancona (*The Frick Collection*, V (1954), p. 58) in her conviction that the Frick bronze reveals 'the vocabulary of Daniele da Volterra', and that the known versions of the model should be 'assigned variously to Pierino da Vinci, Daniele da Volterra, and Giovanni da Bologna, or their schools'.

88. *Amsterdam*, No. 101.

89. *Amsterdam*, No. 100.

90. Planiscig, *Piccoli Bronzi Italiani del Rinascimento*, Milan (1930), pl. clxxxvii, Fig. 325.

91. Planiscig, *op. cit.*, pl. clxxxv, Fig. 322.

Weinberger, in *Zeitschrift für Bildende Kunst*, LXV, p. 54.

92. Middeldorf, in *The Burlington Magazine*, LXXII (1938), pp. 204–9.

93. For the bibliography of this bronze see *Amsterdam*, No. 24.

94. Keutner, in *Kunstchronik*, XV (1962), pp. 171–2, suggests that this bronze was cast in Florence about 1490. Both the light casting and the surface working seem to me to militate against this view.

95. Planiscig, *op. cit.*, pl. clxxxiv, Fig. 321.

96. Planiscig, *op. cit.*, pl. cxciii, Fig. 334.

97. Planiscig, *op. cit.*, pl. cxcii, Fig. 332.

98. Planiscig, *op. cit.*, pl. cxci, Fig. 331.

99. Valentiner, *Bulletin of the North Carolina Museum of Art* (Fall 1957), pp. 5–10.

100. Holderbaum, in *The Burlington Magazine*, XCIX (1957), pp. 336–43.

101. Pope-Hennessy, in *The Burlington Magazine*, CI (1959), pp. 85–9.

102. *Amsterdam*, No. 112.

103. Ciardi-Dupré, in *Paragone* (1962), No. 151, p. 64.

104. Mr John Mallet and Miss Jennifer Montague are responsible for questioning the date of this bronze and for establishing its authorship. The bronze was shown as No. 162 in the London exhibition, and was omitted from the exhibition in Amsterdam and Florence. According to the Italian entry for the London catalogue, the attribution originates in a manuscript catalogue by Planiscig.

105. Bode, *The Italian Bronze Statuettes of the Renaissance*, II, London (1908–12), pl. cxli, p. 18.

106. Middeldorf and Kriegbaum, in *The Burlington Magazine*, LIII (1928), pp. 9–17.

107. Venturi, *Storia*, x, ii (1936), pp. 446–447.

108. Wark, *Sculpture in the Huntington Library*, San Marino (1959), p. 62, pl. iii, iv, as by an artist in contact with Bandinelli active in Florence in the middle of the sixteenth century. Ciardi-Dupré ('Bronzi di Bartolommeo Ammanati' in *Paragone* (1962), No. 151, pp. 57–9) credits Ammanati with the great bronzes of *Mars* and *Neptune* at Detroit. The analogies cited in favour of this attribution are invalid, and the two bronzes are certainly Venetian. I am inclined to think that they are by Danese Cattaneo, not Sansovino.

109. Valentiner, in *Art Quarterly*, XVIII (1955), pp. 241–62.

110. *Country Life*, LIV (1924), p. 867.

111. Vasari, *Vite*, ed. Milanesi, VII, Florence (1878), pp. 631–2: '*Apresso gettò . . . un altro quadro alto un braccio e mezzo e largo due e mezzo, dentrovi Mose, che, per guarire il popolo ebreo dal morso delle serpi, ne pone una sopra il legno.*' Borghini: *Il Riposo*, Florence (1584), p. 521.

112. *Amsterdam*, No. 106. The view that the terracotta model represents a later phase of Danti's work than the marble group was advanced many years ago by Venturi (*Storia*, x, ii, p. 519). Ciardi-Dupré regards the bronze as '*una fusione più tarda, forse settecentesca (Middeldorf), del "modelletto" in terracotta sempre nel Museo Nazionale di Firenze*'. Keutner, in *Kunstchronik*, XV (1962), p. 175, comments that '*die Vincenzo Danti zugeschriebene Gruppe des "L'onore vince l'inganno" mag auf ein Modell seiner Hand zurückgehen, doch die ausgestellte Bronze des Pal. Pitti ist gewiss ein Guss des 17 Jahrhunderts.*' There are a number of differences between the bronze and the terracotta model, and I am by no means convinced that it was not made in Danti's lifetime; in no event can it date from the eighteenth century.

13. I cannot suppress the suspicion that the peacock was cast from a model by Giovanni Bologna.

114. Borghini, *Il Riposo*, Florence (1584), pp. 639–40.

115. I am indebted to Professor Middeldorf for permission to publish this identification.

116. Balogh, in *Az Orszagos Magyar Szepmuveszeti Muzeum Evkonyvei*, IX (1940), pp. 67–8, Figs. 127 and 128.

117. Gronau, *Documenti artistici urbinati*, Florence (1935), p. 44. See also Middeldorf, in *Rivista d'Arte*, IX (1929), p. 519 H.

118. Borghini, *Il Riposo*, Florence (1584), p. 639.

119. Maclagan, in *The Burlington Magazine*, XXXVI (1920), pp. 234–9.

120. This consideration was probably present in the mind of Bode when he modified his original dating for the two groups (*The Italian Bronze Statuettes of the Renaissance*, III, London (1912), pp. 13–14: 'first quarter of the Cinquecento and probably even somewhat later') in favour of a dating in the late sixteenth century (*Bronzes in the Collection of J. Pierpont Morgan*, I, Paris (1910), p. xxxvi; II, p. 9). A dating in the late fifteenth century is proposed by Planiscig (*Riccio*, Vienna (1927), pp. 109–10; *Piccoli Bronzi Italiani del Rinascimento*, Milan (1930), p. 13, pl. xxx, Fig. 50). Keutner, in *Kunstchronik*, XV (1962), p. 173, questions the interrelationship of the two groups, assigning the *Meleager* to a Paduan sculptor of the sixteenth century and the *Venus* to a Florentine sculptor from the circle of Moschino. This analysis is wrong. The apparent discrepancy between the two examples exhibited is due to the fact that the *Venus* is fully finished, while the *Adonis* is a spoiled cast on which work was broken off. A fully finished version of this second model is in the Metropolitan Museum of Art.

121. A greatly reduced version of the *Adonis* formerly in the Emil Weinberger Collection, Vienna (*Versteigerung der hinterlassenen Sammlung des Herrn Emil Weinberger, Wien* (22–24 October 1929, No. 183. H. 10.5 cm.) is in turn bound up with a group of small bronzes of *Venus and Adonis, Actaeon*, and cognate subjects, which are wrongly connected by Tietze-Conrat (in *Jahrbuch des kunsthistorischen Institutes des deutsch oesterreichischen Staatsdenkmalamtes*, XII (1918), pp. 45–7) with Adriaen de Vries.

122. Bode, *Königliche Museen zu Berlin: Die Italienische Bronzen*, Berlin (1904), p. 22, No. 391.

123. Bode, *The Italian Bronze Statuettes of the Renaissance*, III, London (1912), p. 8, pl. ccxiii.

124. Borghini, *Il Riposo*, Florence (1584), p. 638.

125. Keutner, in *Kunstchronik*, XI (1958), p. 328. Beneath the wooden base of the figure is a manuscript label dating from the first half of the nineteenth century,

the concluding sentence of which reads: 'This model is the undoubted work of John of Bologna and was purchased in that city from the collection of Count Gini.' A bronze variant of the Bologna *Neptune* in the Landesmuseum, Zurich, is tentatively connected by Trachsler ('Zwei Renaissance-Kleinbronzen im Schweizerischen Landesmuseum', in *Zeitschrift für Schweizerische Archäologie und Kunstgeschichte*, XX (1960), pp. 139–146) with Adriaen de Vries.

126. *Amsterdam*, No. 134.

127. *Amsterdam*, No. 130.

128. *London*, No. 125 as Florentine (*c.* 1575). *Amsterdam*, No. 131 as Giovanni Francesco Susini.

129. *London*, No. 180 as Venetian (*c.* 1575). *Amsterdam*, No. 132 as Giovanni Francesco Susini.

130. *Amsterdam*, No. 133.

131. Royal Academy, London: Exhibition of Seventeenth-century Art in Europe (1938), No. 281, lent by Henry Harris.

132. Janson, *Apes and Ape Lore in the Middle Ages and the Renaissance*, London (1952), pl. xxxib, p. 173, lists a number of precedents for the subject of an ape nursing a human baby.

133. Planiscig, *Riccio*, Vienna (1927), p. 177, Fig. 191.

134. For these see Gramberg, in *The Burlington Magazine*, LX (1932), p. 191.

135. Bode, *Bronzes in the Collection of J. Pierpont Morgan*, II, Paris (1910), No. 158, p. 15.

136. Bode, *The Italian Bronze Statuettes of the Renaissance*, II, London (1908), p. 19, pl. cxlii.

137. Planiscig, *Piccoli Bronzi Italiani del Rinascimento*, Milan (1930), pl. clxiii, Fig. 283, as '*Venezia: seconda metà del sec. XVI*'.

138. Balogh, *op. cit.*, p. 67 n.

139. *Amsterdam*, No. 185.

140. Wittkower, in *Rassegna Marchigiana*, VII (1928), pp. 41–4.

141. Hess, *Die Künstlerbiographien von Giovanni Battista Passeri*, Liepzig/Vienna (1934), p. 211 n. A photograph of this or of another version of the model formerly in a German private collection is in the photographic files of the German Institute in Florence. An inferior version in

the Palazzo Schifanoia at Ferrara is reproduced by Medri: *I Bronzi artistici del Civico Museo Schifanoia* (1933), No. 82, Fig. 14, under an attribution to Domenico Guidi.

142. *Amsterdam*, No. 182. The statement in the London and Florence exhibition catalogues that the masks 'vary both in the casting and chiselling' is incorrect. All four heads seem to have been cast from a single model, but show some differences in surface working.

PORTRAIT OF AN ART HISTORIAN

1. Sylvia Sprigge, *Berenson: a biography*, London, 1960 .

Index